"Andy Austin does a remarkable job as a Chicago courtroom artist, and in her book, the truth comes through as vividly as in her sketches."

—Studs Terkel

"For those who think they've seen and read everything about what goes on in court, here is a new perspective: the engaging, incisive, and consistently interesting view of renowned courtroom artist Andy Austin."

—Scott Turow

"Gripping, beautifully written, *Rule 53* is essential reading for anyone who wants to understand the tangled threads of the high-profile courtroom cases that have shaped our country's direction for the last four decades. Andy Austin, as ABC's Chicago courtroom artist, had a front-row seat at every major trial from the 1969 Chicago 7 spectacle through Muhammad Salah's recent acquittal on terrorism charges. For fans of *Courtroom 302*, and anyone wanting to understand how justice really works in America, *Rule 53* is required reading."

—Sara Paretsky

"For years, Chicagoans have known Andy Austin as the brilliant court-room artist whose sketches revealed not just the appearance of judges, lawyers, jurors, defendants, and plaintiffs but their characters. Now it turns out that this brilliance has concealed literary brilliance. It seems that while Andy Austin was sketching away, her intelligence and sympathy were penetrating the nature of what was happening in the courtroom, the essential character of those involved, their relationship to each other and to the complex world in which they functioned or malfunctioned. She has worked for years to bring all this into a book and here it is—a triumph of sympathetic intelligence that reveals more about human beings than many a fine novel and is at least as engrossing."
—Richard Stern, Author of *Almonds to Zhoof* and *Pacific Tremors*

"I like Andy Austin's quick mind and quick eye. She sees the drama, the humanity and, yes, even the humor in Chicago's greatest theaters—its courtrooms. Her memoirs, beautifully illustrated, provide an amazing look at the inner workings of America's most ebullient city.
—Jon Anderson, *Chicago Tribune*

RULE 53

*Capturing Hippies, Spies, Politicians, and Murderers
in an American Courtroom*

By Andy Austin

First Edition

Lake Claremont Press
Chicago
www.lakeclaremont.com

Rule 53

Capturing Hippies, Spies, Politicians, and Murderers in an American Courtroom

Andy Austin

Published April 2008 by:

LAKE CLAREMONT PRESS

lcp@lakeclaremont.com
www.lakeclaremont.com

Publisher's Cataloging-In-Publication Data
(Prepared by The Donohue Group, Inc.)

Austin, Andy, 1935-
 Rule 53 : capturing hippies, spies, politicians, and murderers in an American court-
room / by Andy Austin. — 1st ed.

 p. : ill. ; cm.

 Includes index.
 ISBN-13: 978-1-893121-53-9
 ISBN-10: 1-893121-53-4

1. Austin, Andy, 1935- 2. Courtroom artists—Illinois—Chicago—Biography.
3. Social movements in art—Illinois—Chicago. I. Title.

NC953.8.A87 A3 2007
741.092
2007940399

11 10 09 08 10 9 8 7 6 5 4 3 2 1

To Sasha

and

the memory of John

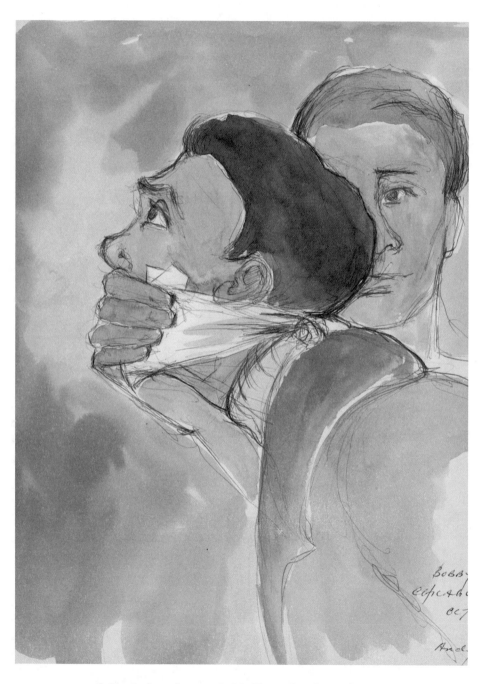

Bobby Seale with a marshal holding a hand over the gag.

CONTENTS

Rule 53. Courtroom Photographing and Broadcasting Prohibited

Except as otherwise provided by a statute or these rules, the court must not permit the taking of photographs in the courtroom during judicial proceedings or the broadcasting of judicial proceedings from the courtroom.

—from the *Federal Rules of Criminal Procedure*

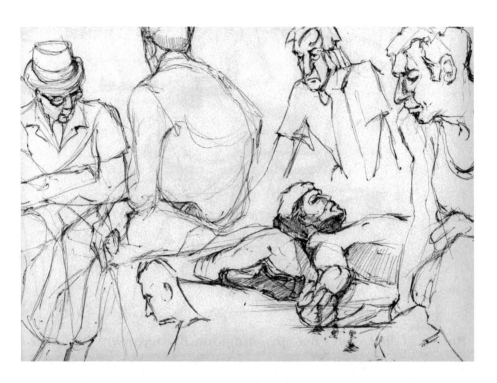

North Avenue Chess Pavilion.

1

THE CHICAGO CONSPIRACY 8

United States of America v. David T. Dellinger et al.

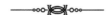

Pay Attention. Stare. It is the way to educate your eye, and
more—stare, pry, listen, eavesdrop. Die knowing something.
You are not here long.

—Walker Evans, quoted in the Afterword to *Many Are Called*

I've always loved to draw. Drawing is a way to capture the surrounding world and keep its memory from slipping away like sand from a shoe. So when I came to a point in my life when I had the opportunity, I started wandering the city in search of subjects to draw. Like a bag lady, I scavenged in the human debris of the urban landscape for usable faces and figures. A shaft of light sculpting the face of a bus passenger, the sorrowful slump of a drunk on a park bench, the bright scatter of children on the beach—all made me reach for my sketchbook. I drew at the chess pavilion where old men played until dusk, in the public library where they slept over newspapers; I drew on my program at concerts.

The worst part about trying to paint or draw at home, as I'd done when my children were little, was that there was nothing to listen to, no surprises from life as it is really lived. As I painted rotting oranges and apples in a makeshift studio that was the corner of our dining room, I grew bored.

Chicago was a city new to me then, and its streets were full of surprises. It was the late 1960s, and in the streets people noisily protested, not only against the Vietnam War but for everything from civil rights to raises for schoolteachers. I sketched the picket lines and protests and sometimes joined them. Outside the House Un-American Activities Committee hearings, fire department hoses drenched me; inside, lawyers shouted their frustrations at being forbidden to represent their clients as deputy marshals pushed them into their seats. I tried to sketch it all.

But these scenes were harder to capture than the quickest of art school poses. Longing for subjects who stayed more or less in one place, I decided to try drawing in court.

In 1969 the U.S. Justice Department indicted peace activists who had rioted during the Democratic Convention the year before. The government charged a disparate group of antiwar leaders with crossing state lines with intent to incite riots. This seemed a perfect chance to draw colorful characters while listening to exciting testimony.

On the 23rd floor of the federal courthouse for the Northern District of Illinois, deputies confiscated my paper and pens. "You can't draw here, lady," they said, "unless you're a member of the press." The second day, I brought a smaller pad and wrote on the top page: "paper towels, eggs, flowers, wine, bread." On the pages underneath, I sketched the men who would become famous as the Chicago Conspiracy 8 and, after what happened to Bobby Seale, the Chicago 7.

Each morning that September it became harder to get near the head of the line, more difficult to draw, squeezed between craning spectators. Only in the press section could one draw legitimately and comfortably, yet news organizations from all over the world had sent their best journalists to cover this "Trial of the Century," and there weren't enough seats even for them.

Calling and writing Judge Julius Hoffman did me no good. Friends in the news business merely smiled when I asked them for help. But Jim Hoge, then the editor of the *Sun-Times*, had an idea. "Telegraph the judge," he suggested. "Telegrams have a certain power."

It worked.

Judge Hoffman's minute clerk said to come to his office at lunchtime.

He let me in to the back of the courtroom, and from the vast empty space, I chose a folding chair close to the defense table. Then, terrified, I waited for the members of the real press to come rushing in and fill the seats around me.

During recesses I followed the reporters to the pressroom, where—in the midst of the wisecracking bustle, cameras, and equipment—courtroom artists imported from New York or California, calmly finished drawings in watercolor, marker, colored pencil, or pastels. I couldn't imagine working under such restraints, such pressure. How anomalous these artists seemed, there because the judicial system trusted them not to disrupt and distort the way cameras might, trusted because they could only make something subjective.

Late one October afternoon when the courtroom was full of people milling about, preparing to leave, an angry voice roared nearby, "What do you mean you can't be here tomorrow?"

A red-haired, florid-faced, cigar-chewing reporter berated a bearded artist from New York.

"We gotta have an artist here tomorrow!" he shouted through the artist's stuttered protests that he had to return to cover the Mary Jo Kopechne coroner's inquest.

Without stopping to think, I pushed myself in front of the man I recognized to be a local TV star named Hugh Hill. I told him I could draw, that he should hire me.

The next morning as I left to cover the Chicago Conspiracy 8 trial for ABC News, I grabbed a handful of pens and pencils, some half-used sketchpads, and my dried-up watercolors speckled with sand from the beach. I hoped the coloring I'd practiced the night before would work.

In court I started drawings and seldom finished them. With each line I seemed to hear a voice asking, "Why did you put that there?" The marks I made floated in white space; I had no idea what to do with backgrounds.

At lunchtime I tried to splash color on the figures freely and artistically as I'd seen the other artists do.

I tried to forget that in a few hours millions of people across the United States would see my drawings, no matter how awkward, messy, and ill conceived.

And yet the network kept me as their artist and even gave me a little raise. I brought to court a red bandanna, clutched in my left hand, to absorb the sweat. The bureau chief and the reporters and producers criticized me kindly and gave me tips. They told me to do something about those white backgrounds, so I painted them red and yellow—at least they looked exciting, like conflagrations. The reporters tried to get me to draw wide shots, so that the viewers could see there was more than one person in the courtroom. And the cameramen explained over and over that the television screen was a horizontal, not a vertical, format and asked me to please remember it was a four-by-three ratio. If I put something at either edge of the page, they wouldn't be able to shoot it. "That guy lower left, I can only see his nose," they would say, their faces bent into the viewfinders. "Let me show you," they would say, stepping aside so I could peer in at a miniature of my sketch.

I never did get the hang of it. Now, 37 years later, when the four-by-three aspect ratio has been joined by the more horizontal high-definition one, I have even more trouble. So sometimes, when a cameraman complains, I say, "Don't worry about it. Life crops."

The Conspiracy 8 were a squirmy, nervous bunch, difficult to draw. Abbie Hoffman and Jerry Rubin, foul-mouthed, kidding, irreverent, sporting wild clothes and Indian headbands, represented the Yippies, or Youth International Party. Tom Hayden and Rennie Davis came from more respectable student organizations: the Students for a Democratic Society and the Mobilization to End the War in Vietnam. John Froines and Lee Weiner—a chemist and a sociologist, respectively—were charged with planning to put a bomb in the Grant Park underground garage. David Dellinger, a lifelong pacifist, was the oldest and most convincingly passionate. Bobby Seale, the only African-American, was acting chairman of the Black Panther Party.

"The jury is directed to disregard the kiss thrown by the defendant Hoffman" was how Judge Hoffman first tried to contain the manic brilliance of Abbie Hoffman. He never succeeded.

All of us had read about Abbie and his fellow Yippies. Abbie had been

responsible for a "party" in Grand Central Station, a "love-in" in Central Park, a showering of dollar bills onto the floor of the New York Stock Exchange, and an attempt to "levitate" the Pentagon.

He was quoted as advocating drugs in the water supply and sex in the streets. He said, "You see what the whole hippie movement has done is to focus on the possibility that white people in this country, young white kids, can make their own dreams, their own visions, their own needs, their own aspirations."

His Yippie party created a cartoon version of American society, with a pig as its mascot and Yippie events its ironic celebrations.

As for their "lifestyle," a fresh new word, Yippies moved across the country with gypsy spontaneity, "crashing" at each others' "pads," getting high, attending and playing in rock and folk concerts, and organizing communes. Revolution was what the Yippies had brought to Chicago in the summer of 1968. People like President Lyndon B. Johnson and Chicago's mayor, Richard J. Daley, were the oppressors; the media was the organizing tool; and drugs, rock music, sex, and nudity were the strawberry shortcake that everybody would eat afterward.

"I would say five guys and a mimeograph machine could bring down any police force in the country," Abbie had written, long before fax and e-mail.

In court, Abbie Hoffman handed me a note. A frowning deputy marshal intercepted it, read it, smiled, and passed it on.

"What's a good-looking girl like you doing in a corrupt society like this?" it read.

The other Yippie, Jerry Rubin, had been arrested at an antiwar protest in California. His first day out of the marshals' custody was the first day I worked for the network; I drew him in the great dark red wig that covered his jail-house haircut.

Tom Hayden, a skinny kid in jeans, gave a "power to the people" salute when introduced to the jury. He had been quoted as saying that cracks begin to appear in a society "when students at Harvard and Stanford have questions, when children of the ruling class have questions." Every day, Hayden—big nosed, sleepy eyed, with shaggy bangs—sprawled in his chair, knees against the table, hair over the leather seat back, gnawing on his fingernails. Now and then he smiled a sardonic smile.

He sent me a note saying the way I kept looking up as I drew was sexy.

Tom Hayden.

He thought I should know this, as though he were being brotherly and protective.

Rennie Davis, relatively clean-cut and good mannered, was an Oberlin graduate and founder of the MOBE, The Mobilization to End the War in Viet Nam. He'd come to Chicago years before to judge a 4H Club chicken contest.

John Froines was a young professor of chemistry at the University of Oregon. He worried about the place of research in a military-industrial society, about science being used for weapons.

Lee Weiner, the only Chicagoan in the group, was a Ph.D. candidate in sociology at Northwestern. At the table, he read Lao Tzu, the *I Ching*, and science fiction.

At Christmastime, Weiner handed out cards with a black-and-white photograph of himself in his Rasputin-like beard and nothing else, embracing his equally naked wife. It read: "Make a New Year's Revolution, Kids... It'll bring you closer together."

He asked to see my sketches and told me they were bad.

It was rumored that one of the defendants was a government spy. If I had to pick one of them, I would have picked Weiner.

David Dellinger was 53 years old, and the others obviously looked up to him. He had the credentials of a 1930s liberal: He'd spent three years in prison for refusing to register for the draft, been an ambulance driver during the Spanish Civil War, and served as editor of a magazine called *Liberation*. Balding, paunchy, with a bit of a limp, humble, and kind, he wore professorial tweeds and knitted neckties squared off at the bottom.

Judge Hoffman called him "Mr. Dillinger" and, on occasion, "Mr. Derringer."

Bobby Seale was the only one who acted like a real defendant. On the first day of the trial, he was the only one to rise for the judge. Under indictment for conspiracy to commit murder in New Haven, he alone was continuously in custody.

Taut and lean in a simple sweater and black pants, he came from the lockup each morning clutching law books and yellow pads and slid into his seat while a marshal took the chair behind him. The other defendants and their lawyers treated him with respect but seldom included him when they bent their heads together in whispered conference.

Seale had only spent 24 hours in Chicago in the summer of '68; he'd come to give two speeches as a last-minute replacement for Black Panther Eldridge Cleaver. He'd never met his alleged coconspirators.

Prosecutor Tom Foran said later, "Seale had more guts and charisma than any of them."

William Kunstler and Leonard Weinglass came from the East Coast to lead the defense. Lest anyone forget they were not Chicagoans, Judge Hoffman constantly referred to them as "from out of town." Kunstler—tall, rumpled, poetic looking, his graying hair growing shaggy and shaggier— was charismatic, like an actor overplaying his part. The less elegant and less flamboyant, thatch-haired Weinglass struck a truer note.

The transcript of the trial could record only words, of course. On paper, Kunstler seems less melodramatic now, and the judge's Dickensian villain's trembling voice is silent. But I can hear and see both men in my memory: the histrionic head clutching of William Kunstler and the judge's long pointing fingers emerging shakily from his robe. Two actors born to play opposite each other, their verbal pas de deux were wonderful:

The court: "Mr. Kunstler, there is a great architect, Mies van der Rohe, who lately left us. He designed that lectern as well as this building, and it was a lectern, not a leaning post. I have asked you to stand behind it when you question a witness."

Kunstler: "Your Honor, the U.S. attorney questions from the back of his table and leans on his material."

The court: "I haven't seen the U.S. attorney put his elbow on that thing and lean on it as though it were a leaning post."

And later...Kunstler: "Your Honor indicated just before the luncheon recess that I was leaning on the lectern, that I should get behind the lectern, that Mies van der Rohe had intended that I be behind the lectern."

The court: "Oh, now, now, you are getting to be like some of the others. Be accurate. I happened to know Mr. van der Rohe, but he never mentioned your name... A lawyer stands at that lectern, he stands erect and not lean-ing as though he were having a beer someplace."

Judge Hoffman seemed to dislike the good-hearted, earnest Leonard Weinglass even more than he did the others. He never pronounced

Weinglass's name correctly. From the transcript, a list: "Weinstein, Weinberg, Feinstein, Fineglass, Weinrob, Weinramer, and Weinruss." At one point Abbie and Jerry held up a cardboard sign for the judge to read with MR. WEINGLASS written in red magic marker.

It did no good.

The government team, headed by U.S. Attorney Tom Foran and his assistant Richard Schultz, seemed stiffly military in contrast. As United States attorney, Foran had sent dozens of Chicago mobsters to prison. Richard M. Nixon asked this Democrat to stay on and prosecute *David Dellinger et al.*

A small, compact former boxer, Foran had a turned-up nose and chevron eyebrows that said, "Can you believe this crap?!"

Schultz, his assistant, never smiled. He made it his job to make sure the court reporter captured every sotto voce remark, every insolent incident.

Both Schultz and Foran acted personally angered by the trial. Foran was a good Kennedy Democrat, and he didn't like being cast in the role of a villain by these uppity out-of-towners. Neither man had patience for those who disrespected their Chicago.

Foran later told the Loyola Academy's Booster Club, "We've lost our kids to the freaking fag revolution!"

"We always talk of [Mayor] Daley as the founder of the Yippies," Abbie had said, and now he extended the honor to Judge Julius Hoffman, the whip-cracking ringmaster of this circus.

Under five feet tall and 74 years old, Judge Hoffman looked like a freshly hatched bird, some mutant progeny of the eagle in the seal of United States District Court for the Northern District of Illinois above him. Like the defendants, he had a sense of theater, and his high-pitched, autocratic pronouncements inspired them to ever-greater rudeness.

I didn't know enough to know it then, but Judge Hoffman's rulings were full of reversible error. It wasn't just leftist propaganda that said he was progovernment and antidefense. He refused to rule at the beginning of the trial on the legality of the government's wiretap evidence, saying he would do so at the end only if he felt the trial had been tainted. He ordered four pretrial defense attorneys arrested for their alleged failure to appear

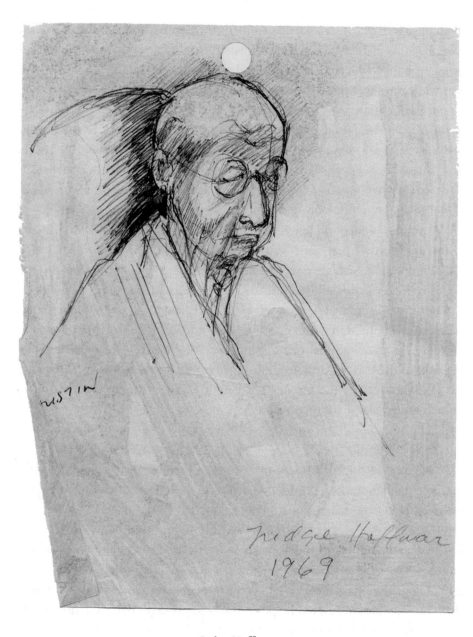

Judge Hoffman.

in court. He refused to ask all but one of the defense's *voir dire* questions to prospective jurors. He read the indictment to the jurors in such a way as to leave no doubt about his feelings.

A few days into the trial, two jurors' families received threatening letters signed "The Black Panthers." Judge Hoffman showed these letters to the jurors, in spite of the defense's objections. One juror, a young woman whom the defense had hoped might like them, said she couldn't continue. The other said she saw it as her duty to continue and the judge let her; she turned out to be one of the most proconviction jurors.

Of all Judge Hoffman's actions, the most inflammatory was not allowing a continuance so that Charles Garry, Bobby Seale's lawyer, could recover from gall bladder surgery. As a consequence, Seale noisily insisted on representing himself.

It couldn't have been a worse trial for a "studio" in which to draw. No one stayed still. The defendants' supporters—costumed in Army fatigues, dragging peasant skirts, tattered blue jeans, T-shirts with messages, tie-dyed undershirts, beads in profusion, headbands and tattoos, long hair on both sexes—stuffed into the pews, whispering, laughing, and shouting, "Right on!" They squeezed the "court buffs," the respectably dressed elderly gentlemen who came to watch trials; they rubbed against unidentified spectators who were rumored to be government agents. Some of them spent the nights in sleeping bags on the cold Adams Street sidewalk so they'd be there early enough to get seats the next day. Those with more privileged status scurried about delivering papers to defendants and lawyers.

The cream of the local, national, and often international press was also there: Anthony Lucas of the *New York Times*, Nicholas Von Hoffman of the *Washington Post*, Jason Epstein of the *New York Review of Books*, John Schultz of the *Evergreen Review*, the English writer Jessica Mitford, and many others were stuffed together taking notes.

Franklin McMahon calmly produced enormous powerful watercolors in the back row; Jules Feiffer and Larry Rivers each came to draw. Abbie passed me a note that said, "Andy, Larry Rivers is here to draw us, can you lend him your sketchbook?" Another night I came home with a pad full of original Feiffers.

All the television networks had at least two reporters; at least five artists scribbled away constantly.

Celebrities dropped by. "Did you see so and so?" people would ask. Dustin Hoffman, sitting behind the artists, remarked on how differently each drew the great seal over the judge's bench. Recently convicted of civil disobedience, Dr. Benjamin Spock sat tall and straight in the second row. When Attorney Kunstler offered to introduce him to the judge, the latter declined scornfully. "My children are grown!"

Marshals constantly ejected people. They gave beautiful society women in fur coats the seats of scruffier types. At night these women were rumored to entertain out-of-town journalists, defendants, and defendants' lawyers at wild parties in chic town houses.

The prosecutors had their claques also, and scattered throughout the audience were the so-called spies, who were probably only people up from other offices to catch a few minutes of the show.

We were so crowded we had to sit one back, one up, all along a row. Often I drew in tandem with other artists, my arm cramped, my paper constantly moving under it.

Deputy marshals watched everyone closely. One journalist described them as looking like 1950s bandleaders in their pastel suits, exuberant neckties, and high pompadours of hair. They received orders through buttons in their ears and mumbled into their wide lapels. As the hijinks of the trial escalated, and the animosity between the defendants' supporters and detractors grew worse, the marshals became more vigilant, more intense.

Once the marshals stopped the distribution of jellybeans by the defendants; once they confiscated a birthday cake about to be presented to Bobby Seale. "They arrested Bobby's birthday cake!" Abbie shouted.

They also removed a Viet Cong flag draped over the defendants' table on "Moratorium Day."

As they grabbed offending spectators by the wrists and hustled them out, we could hear "Get your filthy hands off me, you pig!" far down the corridor.

There was a rumor that Tony, the judge's ancient minute clerk, was packing a revolver under his tweed jacket.

Bobby Seale interrupted the trial many times. He yelled that he was being denied his rights by not being allowed to represent himself, to make an opening statement, to cross-examine witnesses. He yelled that he was being railroaded and called the judge a racist and a fascist.

Each time the other defendants joined in with "yeahs" and "pigs," the marshals lunged menacingly. Each time Seale would slink back into his seat, glowering like a taunted animal.

Judge Hoffman's reactions grew increasingly stern. He told Seale, "I am warning you that the court has a right to gag you…under the law you may be gagged and chained to your chair."

He was referring to the Allen opinion of the 7th U.S. Circuit Court of Appeals from July 1969 that allowed the binding and gagging of recalcitrant defendants.

I left the courtroom early on October 28 and didn't hear the judge's admonishment. This is my excuse for the mistake I was soon to make.

On the morning of October 29, the marshals outside the courtroom door inexplicably began to search members of the defense staff. When the judge came on the bench, Attorney Kunstler complained about the searching of the staff members and then about the "armed camp" aspect of the courtroom. Abbie Hoffman piped up that there were 25 marshals in the room.

Attorney Schultz addressed the judge. "If the court please, before you came into this courtroom, if the court please, Bobby Seale stood up and addressed this group." He was referring to some Black Panthers at the back of the courtroom.

"That's right, brother," came from Seale at the defense table. "I spoke on behalf of my constitutional rights. I have a right to speak in behalf of my constitutional rights. That's right. I told them to defend themselves."

Seale called the attorney "tricky Dick Schultz" and said that if he were attacked, he would defend himself. The spectators chorused, "Right on!"

The proceedings pitched and tossed for the rest of the morning; people rose and yelled and shook their fists, and marshals pushed them into their chairs. During momentary stretches of calm, Weinglass cross-examined an undercover agent who had spied on the agitators in the park. Then Bobby

Seale wanted to cross-examine him.

The court: "Let the record show the tone of Mr. Seale's voice was one [of] shrieking and pounding on the table and shouting."

Seale yelled at the judge again, he called him an old man.

Seale: "You have George Washington and Benjamin Franklin sitting in a picture behind you, and they were slave owners… You are acting in the same manner, denying me my constitutional rights…to cross-examine this witness."

The court: "I will tell you that what I indicated yesterday might happen to you…will you, Mr. Marshal, have that man sit down!!!"

Bobby Seale's slim form disappeared as the marshals surrounded him like a human cage. Someone else lunged from his seat and other marshals tackled him as well. The spectator section broke into cries, but the Panthers remained still in the very back.

My hands were shaking and slimy with sweat as I tried to draw the contorted faces, the figures jumping up and down.

Dick Schultz took charge: "May the record show, if the court please, that while the marshals were seating Bobby Seale, pushing him in his chair, the defendant Dellinger physically attempted to interfere with the marshals by pushing them out of the way."

And here is Foran: "Never have I been in a courtroom—again, for 20 years [I've been]…in courtrooms all over this state and in many instances all over the United States—have I seen the type of conduct that is not only constantly going on in this courtroom, with noise, with giggling, with laughter, with movement, and with refusal to stand when the court gets on the bench, with comments being made by defendants to a jury, with participation in this conduct not only by the defendants but by many of the spectators."

In the afternoon a grim and nervous quiet settled over the room. As the outbursts seemed no more than routine, I followed instructions and left the courtroom around 3:00 P.M. to return to the TV station.

I was finishing my day's sketches when the Midwest bureau chief came charging in, shaking with rage, waving a scrap of wire copy.

He thrust it into my face: JUDGE JULIUS HOFFMAN ORDERS BOBBY SEALE

THE NEW YORK TIMES, THURSDAY, OCTOBER 30, 1

Judge Has Seale Chained and Gagged at Trial of the Chicago 8

Continued From Page 1, Col. 2

Dellinger, another defendant, tried to shoulder past the marshals to help Mr. Seale but was pushed back.

Finally, in midafternoon, after the Panther leader once more jumped up and accused him of "racism," Judge Hoffman told the marshals to take Mr. Seale into an anteroom and "deal with him as he should be dealt with in these circumstances."

This was a clear reference to gagging and shackling, of which the judge had warned Mr. Seale yesterday following similar outbursts.

The marshals apparently had the equipment ready. Within 10 minutes they brought Mr. Seale back with a white muslin cloth tied around his mouth. He was placed in a gray steel folding chair to which his ankles were attached with leg irons and his arms with handcuffs.

However, the thin cloth gag did not silence Mr. Seale. Straining forward against the chains, he shouted several times and his muffled voice could be heard saying, "I want my right to speak on behalf of my constitutional rights."

Judge Hoffman told a marshal, "I don't think you accomplish your purpose with that contrivance," and declared a recess. A few minutes later, Mr. Seale was brought back into the courtroom with several strips of white adhesive tape, about 10 inches long, plastered over the gag.

Even that was not enough to completely silence the defendant. By the time defense attorneys finished cross-examining a Government witness, Mr. Seale had worked the tape loose enough so that his voice could again be heard quite distinctly: "Let me cross-examine the witness. I still want a right to cross-examine the witness."

Judge Hoffman ignored the muffled cry and adjourned the

recent case—a 1960 narcotics trial in a New York Federal Court—during which three defendants were gagged and shackled after one of them threw a chair at the prosecutor.

Chaining is somewhat more common, particularly in murder trials where the defendant is considered dangerous.

Last summer, the United States Court of Appeals for the Seventh Circuit, which includes Illinois, overturned a lower court's decision because an obstreperous defendant had been removed from the courtroom. It held that "the proper course for the trial judge was to restrain the defendant by

he declined to postpone the trial until Mr. Seale's lawyer, Charles R. Garry, recovers from a gall bladder operation. Judge Hoffman has ruled that Mr. Seale is adequately represented by William M. Kunstler, one of the defense attorneys who originally filed an appearance for him.

Mr. Seale contends that since his own lawyer is not present, he should be allowed to defend himself and specifically to cross-examine Government witnesses who tie him to the alleged "conspiracy."

Yesterday and today, he repeatedly demanded the right to cross-examine William Frapolly, an undercover Chicago policeman who has testified that he heard Mr. Seale give an incendiary speech in a park here during the Democratic convention.

Mr. Seale's most heated outbursts and the judge's warnings have occurred after the jurors were removed from the courtroom. But they had heard enough so that when they entered the courtroom late this afternoon to find Mr. Seale gagged and chained, they showed little reaction.

Nevertheless, the 74-year-old judge offered them an explanation for his action. "On occasions it is necessary to resort to stern measures to maintain order," he said. "But the measures taken here today are only to assure a fair trial."

At this, there were groans from the defendants' table and Mr. Seale rattled his chains vigorously against the chair.

The judge also told the jury that the restraints on Mr. Seale should not be taken as

Children Have Grown, So the Court Rests

CHICAGO, Oct. 29 (UPI)—William Kunstler, a defense attorney in the Chicago Eight trial, offered today to introduce to the court Dr. Benjamin Spock, the baby doctor and peace advocate who was listening to the proceedings.

Federal Judge Julius J. Hoffman turned down the offer.

"My children are grown," the judge said.

evidence of his or the other defendants' guilt or innocence.

Earlier this afternoon, there was a long argument between Mr Kunstler and Thomas A. Foran, the United States attorney.

Mr. Kunstler particularly objected to the presence of large numbers of Federal marshals in the courtroom, which he said created an "armed camp atmosphere." At times, newsmen counted up to 18 marshals standing in the aisle of the spectator section or at various doorways to the courtroom.

Mr. Foran, in reply, argued that such measures were necessary to control a courtroom "quivering with tension."

Among the other spectators in court this morning was Dr. Benjamin Spock, the pediatrician whose conviction on a conspiracy charge was recently overturned by an appeals court. At a news conference in the Federal Building today he backed the eight defendants.

Associated Press
Bobby G. Seale, Black Panther party leader, shown shackled and gagged during his trial for conspiracy yesterday in Chicago. The sketch is by Andy Austin, ABC-TV artist.

during the five-week-old trial and his outbursts have increased in frequency and intensity during the last two weeks.

The Panther leader contends that he has been deprived of his right to counsel of his choice because Judge Hoffman

New York Times *sketch of Bobby Seale gagged.*

BOUND AND GAGGED.

Someone called out that Jim Gibbons, a local news reporter, was on the phone—could I draw from his description?

Cradling the receiver against my collarbone, I asked questions and sketched as he talked.

What was the gag made of? How was it tied? How much of his face did it cover? What kind of chair was it?

With amazing calm, Gibbons answered my frantic questions in perfect detail. With his careful voice in my ear, I reached back into my memory of Seale, tried to feel what this shackled man must have felt, and sketched the horror as best I could.

The sketch was shown on network television that night; it was picked

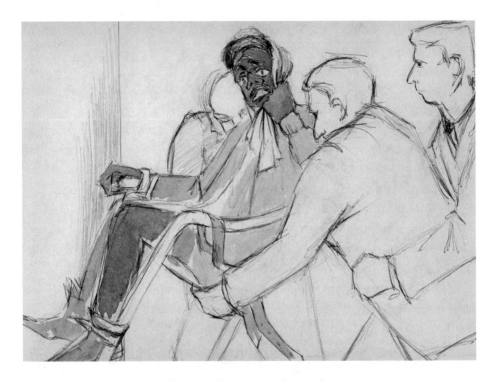

Bobby Seale being carried on a chair.

up by the Associated Press and appeared all over this country and abroad as well. A few days later it was in *Newsweek*. I was told that the "people in New York" wanted it, so I handed it over and was thankful never to see it again.

Jim Gibbons had saved my fledgling career.

That was the first of many times that he took over a difficult situation, made things work out. I was new, scared, unconfident—I hadn't a clue how the television world worked. Jim Gibbons watched out for me like a big brother.

On October 30 Bobby Seale was carried in on a metal chair, straining at leather straps, yelling into his gag. As he swung his head from side to side, the veins in his neck bulged. The marshals placed him at the defense table, and he sat there like a sideshow freak.

Attorney Weinglass addressed the court: "If Your Honor please, the

buckles on the leather strap holding Mr. Seale's hand is [*sic*] digging into his hand and he appears to be trying to free his hand from that pressure. Could he be assisted?"

The judge answered that if the marshals concluded that he needed assistance, "of course," and he excused the jury.

Seale, trying to free one of his arms, tipped over his chair. The marshals pounced on him, and suddenly fighting broke out with squirming, punching bodies all over the floor. Bill Kunstler rose to his feet. "Your Honor, are we going to stop this medieval torture that is going on in this courtroom?"

"This guy is putting his elbow in Bobby's mouth!" yelled someone.

"This is no longer a court of order, Your Honor, this is a medieval torture chamber. It is a disgrace. They are assaulting the other defendants also," continued Kunstler, on the verge of tears.

"Don't hit me in the balls, motherfucker!" yelled Rubin. "B-a-1-1-s, Miss Reporter, after that comes the word mother f-u-c-k-e-r!" He was spelling it for the court stenographer.

Kunstler continued, his voice emphatic above the cacophony. "Your Honor, this is an unholy disgrace to the law that is going on in this courtroom."

"Created by Mr. Kunstler," interjected Tom Foran.

Inches away in the press section, we jumped out of the way as the wrestling bodies on the floor rolled into our metal chairs and tipped them over. I tried to keep on drawing, but arms, elbows, ears, backs were all I could see of the writhing mass.

Seale had gotten his gag off.

"You fascist dogs, you rotten, low-life son of a bitch!" he yelled. "I'm glad I said it about Washington used to have slaves, the first president—"

"Somebody go to protect him!" shouted Dellinger.

Tom Hayden: "Now they are going to beat him, they are going to beat him."

Abbie Hoffman: "You may as well kill him if you are going to gag him. It seems that way, doesn't it?"

Hayden: "I was trying to protect Mr. Seale. The man is supposed to be silent when he sees another man's nose about to be smashed?"

Abbie Hoffman: "The disruption started when these guys got into overkill. It is the same exact thing as last year in Chicago, the same exact thing."

On Halloween the federal deputy marshals had a new treat for us. Out of the lockup they carried Bobby Seale like an Egyptian pharaoh on a heavy wooden chair. His feet were trussed to its legs, his hands strapped at its back, and across his mouth was a wide piece of adhesive tape.

When court began he was able to make noises through the tape, so they took him out of the courtroom.

When they brought him back in, he wore an Ace bandage that covered the tape, circled his jaw, and crisscrossed around his head to where they'd tied it at the top.

He rocked rhythmically the little bit that the straps allowed him; the marshal who sat close watching him had concern in his eyes.

Sitting just behind him, I saw that his skin had turned a grayish color, I saw the pain and anger in his bulging, watering eyes, I smelled the warm bandage, and I heard his muffled groans.

Weinglass approached the bench. "If Your Honor please, Mr. Seale is having difficulty. The marshal has noticed it. He is in extreme discomfort. He has written me a note that the circulation of blood in his head is stopped by the pressure of the bandage on the top of the skull and would it be possible to have those bandages loosened? He is breathing very heavily."

Later there were no citations for contempt for October 31, 1969. The judge had succeeded in subduing his courtroom.

The following Monday we arrived in court to see Seale slink out of the lockup under his own power. The animosity between Seale and the judge had not abated. The insults and threats continued, but the physical fighting was over and the restraints were gone.

The afternoon session began late on November 5. The judge finally came in at about 2:30, clutching a sheaf of papers to the front of his black robe.

"There is a matter that I wish to take up, gentlemen, before we proceed further with this trial," he announced.

"I must now, as I perceive my duty and obligation to, take proper steps to insure that the trial as it continues be conducted in an atmosphere of dignity…"

With dramatic and obvious delight he began to read. He cited Rule

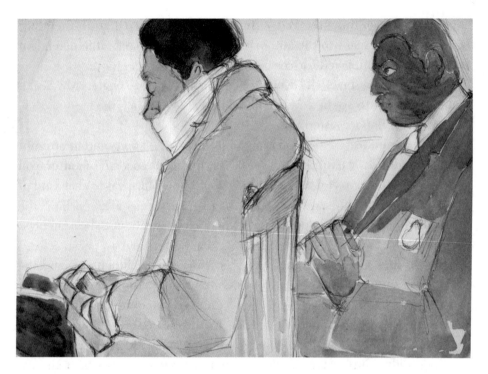

Bobby Seale and a deputy marshal.

42(a) of the Federal Rules of Criminal Procedure and Title 18, United States Code, Section 401, and he certified that he "saw and overheard" the conduct of Bobby G. Seale that he would refer to "in these observations."

He hadn't gotten far when Seale began to yell from his seat, "That's a lie!"

Again and again Seale interrupted as the judge read the 16 specifications of contemptuous conduct by the defendant Seale from the official transcript. He read them with gusto, imitating the voices. He did an amazingly good impersonation of Bobby Seale himself.

The emotions of the two men fueled my drawing. I forgot my stumbling self-consciousness as I drew the judge's bony fingers turning page after page; the black man, tense, indignant, lifting himself from his chair. "'That's—a—lie!'" I scribbled Seale's words at the bottom of a sketch.

Perhaps it was then that I learned the only way I could draw well was not to think but to listen.

After a long time the judge finished: "Accordingly, it is therefore ordered that pursuant to the authority vested in this court…the defendant Bobby Seale be punished for contempt."

After speaking briefly to Kunstler, he turned back to Seale: "Mr. Seale, you have a right to speak now. I will hear you."

Seale was flabbergasted.

"Wait a minute… Now you are going to try to—you going to attempt to punish me for attempting to speak for myself before? Now after you punish me, you sit up and say something about you can speak! What kind of jive is that?"

Seale could now speak legitimately, because he was about to be sentenced for contempt of court.

But Seale was unprepared to exercise his right to allocution, and the judge went on to sentence him to three months in prison on each specification to run consecutively. He declared a mistrial as to the defendant Seale in the underlying case on trial, severing Seale from *United States v. David Dellinger et al.* and causing the "Chicago 8" to become the "Chicago 7."

Seale didn't understand. "Wait a minute, I got a right, what's the cat pulling now? I can't stay?"

As court adjourned he was still yelling. "I want an immediate trial! You can't call a mistrial! I want an immediate trial! You can't call a mistrial! I'm put in jail for four years for nothing!"

The audience chorused, "Free Bobby, free Bobby!" as he was led away.

The atmosphere in the courtroom changed after Bobby Seale left. A month later, when Black Panthers Fred Hampton and Mark Clark were gunned down by state's attorney's police, there were only white men left on trial. Though these defendants remained passionate, the issues about which they felt so strongly seemed further abstracted when there was no black in their midst.

A few days later the government finished putting on its case in chief. When the defense began on December 8, the underlying conflicts of the trial, the "town versus gown, low versus high brows" aspects became clearer.

The prosecution's witnesses had been undercover agents, police spies,

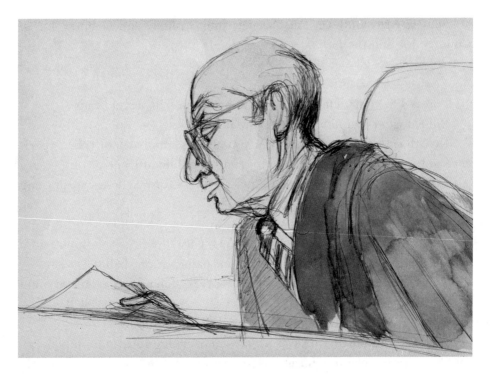

Judge Hoffman reading contempt citation.

and bureaucrats. The defense put on professors, folksingers, members of parliament, poets, and novelists. The defense witnesses might have been on the guest list for the White House dinner party of a liberal president. There were comedian Dick Gregory, preachers Jesse Jackson and Ralph Abernathy, and politician Julian Bond. There were authors William Styron, Richard Goodwin, and Norman Mailer; theater director Paul Sills; poet Allen Ginsberg; historian Staunton Lynd; and former attorney general Ramsey Clark.

Most of them tried to enlarge the sphere of testimony. They tried to discuss the greater problems that had brought the accused to Chicago in the first place. The prosecutors and the judge would have none of this, and there was constant squabbling over the rules of evidence.

Folksinger Phil Ochs, not permitted to sing, recited instead: "It is always the old to lead us to the wars; it is always the young to fall. Now look at all we've won with the saber and the gun. Tell me, is it worth it all?"

Singers Arlo Guthrie, Pete Seeger, Judy Collins, and Country Joe of Country Joe and the Fish all took the stand.

I drew LSD guru Timothy Leary in buckskin fringe and beads.

Bill Kunstler examined Norman Mailer.

Kunstler: "Now, Mr. Mailer, can you give us some idea of your experience in the political arena? Have you run for public office?"

Mailer: "Yes, I ran in the Democratic Primary for mayor last spring, and I came in fourth in a field of five."

The court: "You didn't say what city, sir."

Mailer: "I am sorry, Judge, in New York City."

The court: "I knew I haven't seen your name on our ballot."

Kunstler wanted Mailer to testify about the defendants' states of mind as they planned to protest in Chicago.

Mailer told of a meeting he'd had with Jerry Rubin.

"Mr. Rubin said that he was at present working full-time on plans to have a youth festival in Chicago in August of 1968 when the Democratic Convention would take place, and it was his idea that the presence of a hundred thousand young people in Chicago at a festival with rock bands would so intimidate and terrify the establishment, particularly the Johnson Vietnam War establishment, that Lyndon Johnson would have to be nominated under armed guard.

"And I said, 'Wow!' I was overtaken with the audacity of the idea and I said, 'It's a beautiful and frightening idea.'

"And Rubin said, 'I think that the beauty of it is that the establishment is going to do it all themselves. We won't do a thing... We are just going to be there and they won't be able to take it. They will smash the city themselves. They will provoke all the violence...'"

Mailer described the riots.

"I saw the police attack and they charged into the crowd wielding their clubs. They cut through them like sheets of rain, like a sword cutting down grass, and they would cut off a group of people down there on the street and then they would charge into them again and cut them into smaller pieces, cut them again into four, then into eight. They beat them up, left them on the street. Then they would come and pick up more people—in

other words, pick up these people who were beaten up and throw them into ambulances. As they did that, they would beat them further.

"The police kept attacking and attacking. When they had driven people in every direction, they then chased them into the park. They chased them into the barricade that had been set up by the police in front of the Conrad Hilton, where people who were just standing there watching the parade were pushed into the police, beaten up. They pushed, as far as I could see, they then pushed people into the wall of the Conrad Hilton. I was not able to see them push people through the plate glass window because that was out of my view."

Attorney Schultz, cross-examining, told Mailer to stick to the facts.

"Facts are nothing without their nuance, sir," Mailer replied.

At a recess when courtroom artists converged on Mailer for a closer look, he told us, "I'm not allowed to talk to you."

Poet Allen Ginsberg looked like a Buddha with his long hair, beard, and strange robes—a piece of museum exotica on display in the witness box. Like Mailer, he had been an eyewitness, and he took seriously every question that both defense and prosecution asked.

Weinglass directed him to tell the court and jury what areas he studied.

"Mantra Yoga, meditation exercises, chanting," he began, "and sitting quietly, stilling the mind and breathing exercises to calm the body and to calm the mind, but mainly a branch called Mantra Yoga, which is a yoga that involves prayer and chanting."

Weinglass asked him about a conversation he had in February 1968 with Abbie Hoffman. Did he recall what Mr. Hoffman had said?

"Yippie—among other things," answered Ginsberg. "He said that politics had become theater and magic; that it was the manipulation of imagery through mass media that was confusing and hypnotizing the people in the United States and making them accept a war which they did not really believe in; that people were involved in a lifestyle which was intolerable to the younger folk, which involved brutality and police violence as well as a larger violence in Vietnam, and that ourselves might be able to get together in Chicago and invite teachers to present different ideas of what is wrong with the planet, what we can do to solve the pollution crisis, what we can do to

solve the Vietnam War, to present different ideas for making the society more sacred and less commercial, less materialistic."

He testified about Jerry Rubin and Abbie Hoffman in Lincoln Park: "Jerry Rubin said that he didn't think the police would attack the kids who were in the park at night if there were enough kids there… He wanted to leave the park at 9:00 and would not encourage anybody to fight and get hurt that evening if the police did physically try to force everybody out of the park… Abbie Hoffman said the park wasn't worth fighting for, that we had on our responsibility invited many thousands of kids to Chicago for a happy festival of life, for an alternative proposition to the festival of death that the politicians were putting on, and that it wasn't right to lead them or encourage them to get into a violent argument with the police over staying in the park overnight."

Weinglass: "Now do you recall what, if anything, occurred at 10:30?"

Ginsberg: "There was a sudden burst of lights in the center of the park, and a group of policemen moved in fast to where the bonfires were and kicked over the bonfires… There was a great deal of consternation and movement and shouting among the crowd in the park, and I turned, surprised, because it was early…"

Weinglass: "Without relating what you said to another person, Mr. Ginsberg, what did you do at the time you saw the police do this?"

Ginsberg: "I started a chant, 'O-m-m-m-m-m-m-m, O-m-m-m-m-m-m-m.'"

The deep drawn-out sound resonated throughout the courtroom. People began tittering. Tom Foran rose to his feet with the familiar exasperated look on his face and said, "All right, we have had a demonstration."

"All right," echoed the judge.

Foran: "From here on, I object."

The court: "You haven't said you objected."

Foran: "I do after the second one."

The court: "After two of them? I sustain the objection."

Foran objected every time an "om" escaped from Ginsberg, and Weinglass finally protested. "If the court please, there has been much testimony by the government's witnesses as to this om technique which was used in the park. Are we only going to hear whether there were stones or people throwing things, or shouting things, or using obscenities? Why do we draw the line there? Why can't we also hear what is being said in the area

of calming the crowd?"

Foran: "I have no objection to the two 'oms' that we have had. However, I just don't want it to go on all morning."

And so a little later when the obedient Ginsberg hesitated and Weinglass asked him, "Have you finished your answer?" the poet replied, "I am afraid I will be in contempt if I continue to om..."

Between "oms" and objections, the questioning continued.

Weinglass: "What did you do when you saw the policemen in the center of the crowd?"

Ginsberg: "Adrenaline ran through my body. I sat down on a green hillside with a group of younger people that were walking with me at about 3:30 in the afternoon...sat, crossed my legs, and began chanting 'O-m-m-m, O-m-m-m.'"

Foran: "I gave him four that time."

Ginsberg: "I continued chanting for seven hours."

Weinglass said he was sorry but he hadn't heard the answer.

The judge was helpful. "He said he continued chanting for seven hours. Seven hours, was it, sir?"

Ginsberg: "Until 10:30."

The court: "I wanted to know what your answer was. Did you say you continued chanting for seven hours?"

Ginsberg: "Seven hours, yes."

Weinglass asked Ginsberg what happened at 11:00 that night.

Ginsberg: "The group I was with—Mr. Genet, Mr. Burroughs, Mr. Seaver, and Terry Southern—all went back to Lincoln Park... There was a great crowd lining the outskirts of the park...and there was a larger crowd moving in toward the center...where a group of ministers and rabbis who had elevated a great cross about ten foot high in the middle of a circle of people who were sitting around, quietly listening to the ministers conduct a ceremony...

"After, I don't know, a short period of time, there was a burst of smoke and tear gas around the cross, and the cross was enveloped in tear gas, and the people who were carrying the cross were enveloped in tear gas, which began slowly drifting over the crowd..."

Weinglass: "And when you saw the persons with the cross and the cross being gassed, what, if anything, did you do?"

Ginsberg: "I turned to Burroughs and said, 'They have gassed the cross of Christ.'"

Foran jumped to his feet. "Objection, if the court please. I ask that the answer be stricken."

The objection was sustained.

Weinglass: "Without relating what you said, Mr. Ginsberg, what did you do at that time?"

Ginsberg: "I took Bill Burroughs's hand and took Terry Southern's hand, and we turned from the cross, which was covered with gas in the glary lights that were coming from the police lights that were shining through the tear gas on the cross, and walked slowly out of the park."

Later as Ginsberg described another incident, Weinglass asked him, "How were you walking?"

Ginsberg: "Slowly... Our arms were all linked together and we were carrying flowers up to the back of the stage and so we distributed them around to the first rows of marchers so all of the marchers had flowers... We came to a halt in front of a large guard of armed human beings in uniform who were blocking our way, people with machine guns, Jeeps, I believe, police, and what looked to me like soldiers...

"The march stopped and we waited, not knowing what to do. I heard—all along I heard Dave Dellinger saying, 'This is a peaceful march. All those who want to participate in a peaceful march please join our line. All those who are not peaceful, please go away.'"

When the direct examination had been concluded, Foran requested a short recess before he began his cross-examination—"ten, fifteen minutes" was all he asked for. But as it was late morning, the judge decided we should recess until the usual afternoon starting time at 2:00.

Kunstler protested, "Your Honor, we have witnesses who are leaving the country this afternoon who are presently here. I don't think there should be any delay in the cross-examination."

A heated verbal melee began, Kunstler and Weinglass against Foran and the judge, each side interrupting the other. Ginsberg sat forgotten on the witness stand.

"I will grant the motion of the government," said the judge.

"You refused us five minutes the other day!" retorted Kunstler.

"You are going to have to learn..."

"I am trying to learn…why the different treatment?"

"I will not sit here and have you assume a disrespectful tone to the court."

"This is not disrespect."

"Yes, it is."

On and on they went—even a Giuseppe Verdi couldn't have captured the frantic intricacies of their quartet.

"You are shouting at the court."

"Oh, Your Honor!"

"Shouting at the court, the way you do…"

"Your Honor, your voice has been raised."

"You have been disrespectful!"

"It is not disrespectful…"

"And sometimes worse than that!"

But then our attention became slowly diverted by something else. As when a drum roll begins quietly in the back of an orchestra, we gradually became aware first of a vibration, then of a strange noise. It slowly built, louder and louder, until the great round vibrant sound filled the courtroom and stilled its occupants.

"O-m-m-m-m-m-m-m-m-m-m-m-m…" was coming from the Buddha on the witness stand.

Ginsberg's eyes were closed and his hands outstretched, palms down as in benediction. Shouting mouths closed and smiled instead.

Abbie Hoffman and Rennie Davis were the only defendants to take the stand in their own defense. Abbie went first, and Leonard Weinglass questioned him.

Weinglass: "Will you please identify yourself for the record."

Hoffman: "My name is Abbie. I am an orphan of America."

(Earlier, Abbie had renounced his last name, which the judge said later, "…grieved me sorely.")

Weinglass: "Where do you reside?"

Hoffman: "I live in the Woodstock Nation."

"Will you tell the court and jury where that is."

"Yes. It is a nation of alienated young people. We carry it around with

us as a state of mind in the same way the Sioux Indians carried the Sioux Nation around with them. It is a nation dedicated to cooperation versus competition, to the idea that people should have better means of exchange than property or money, that there should be some other basis for human interaction. It is a nation dedicated to…"

The court: "Excuse me, sir. Read the question to the witness, please."

(The question was read.)

The court: "Just where it is, that is all."

Hoffman: "It is in my mind and in the minds of my brothers and sisters. We carry it around with us in the same way that the Sioux Indians carried around the Sioux Nation. It does not consist of property or material but, rather, of ideas and certain values, those values being cooperation versus competition, and that we believe in a society—"

Schultz: "This doesn't say where Woodstock Nation, whatever that is, is."

Weinglass: "Your Honor, the witness has identified it as being a state of mind and he has, I think, a right to define that state of mind."

The court: "No, we want the place of residence, if he has one, place of doing business, if you have a business, or both, if you desire to tell them both. One address will be sufficient. Nothing about philosophy or India, sir. Just where you live, if you have a place to live. Now you said Woodstock. In what state is Woodstock?"

Hoffman: "It is in the state of mind, in the mind of myself and my brothers and sisters. It is a conspiracy."

Weinglass: "Can you tell the court and jury what is your present age?"

Hoffman: "My age is 33. I am a child of the '60s."

Weinglass: "When were you born?"

Hoffman: "Psychologically, 1960."

Weinglass: "Can you tell the court and jury what is your present occupation?"

Hoffman: "I am a cultural revolutionary. Well, I am really a defendant—full-time."

Weinglass took Abbie through the various other Yippie adventures: throwing money out of the Stock Exchange window, the fake "raid" at the Stony Brook campus in Long Island, the attempt to levitate the Pentagon.

Weinglass: "Now in exorcising the Pentagon, were there any plans for

the building to raise up off the ground?"

Hoffman: "Yes. When we were arrested they asked us what we were doing. We said it was to measure the Pentagon and we wanted a permit to raise it 300 feet in the air, and they said, 'How about ten?' So we said, 'OK.' And they threw us out of the Pentagon, and we went back to New York and had a press conference..."

This did not amuse Dick Schultz.

Schultz: "I would ask Mr. Weinglass, please get on with the trial of this case and stop playing around with raising the Pentagon ten or 300 feet off the ground... These are serious issues here, and if we could get to them so that he can examine the witness, I can cross-examine the witness, and we can move on."

Weinglass's retort got to the heart of the problem. "Your Honor, I am glad to see Mr. Schultz finally concedes that things like levitating the Pentagon building, putting LSD in the water, 10,000 people walking nude on Lake Michigan, a $200,000 bribe attempt are all playing around. I am willing to concede that fact, that was all playing around, it was a play idea of the witness, and if he is willing to concede it, we can all go home."

Later, Weinglass put the same thoughts another way: "We have attempted to lay a foundation that the festival of life was a further conceptualization of guerrilla theater and to give an idea of what their intent was in coming to Chicago to have a festival. You have to go back and see how the Yippie concept developed and grew...starting with the money at the Stock Exchange and coming through the mock raid at Stony Brook, right up through Grand Central Station and Central Park be-in, and on to Chicago. It's part and parcel of the whole history and pattern of why and how the Yippies came to Chicago and what they had in mind when they came here."

Bald, little Judge Hoffman peered down at the wild-haired witness, Abbie Hoffman, throughout several days of testimony. Now and then Abbie would turn around in the witness chair to inspect "the longhairs," the framed pictures of early presidents that hung on the wall behind him.

Weinglass asked Abbie to relate the substance of his conversation with Deputy Mayor David Stahl, to whom he had appealed for help at the time of the Democratic Convention. Stahl had been one of the government's first witnesses.

Hoffman: "Well, I said, 'Hi, Dave. How's it going?' I said, 'Your police got to be the dumbest—the dumbest and the most brutal in the country,' that the decision to drive people out of the park in order to protect the city was about the dumbest military tactic since the Trojans first let the Trojan horse inside the gates... I said that there were more people coming to Chicago...people coming Monday, Tuesday,... Wednesday night, and that they should be allowed to sleep, that there was no place to sleep, that the hotels are all booked up, that people were getting thrown out of hotels, that they were getting thrown out of restaurants, and that he ought to intercede with the police department. I told him that the city officials—in particular his boss, Daley—were totally out of their minds, that I had read in the paper the day before, that they had 2,000 troops surrounding the reservoirs in order to protect against the Yippie plot to dump LSD in the drinking water. I said that there wasn't a kid in the country, never mind a Yippie, who thought that such a thing could even be done, that why didn't he check with all the scientists at the University of Chicago—he owned them all. I said that it couldn't in fact be done. He said that he knew it couldn't be done, but they weren't taking any chances anyway."

Abbie testified about his arrest. "They grabbed me by the jacket and pulled me across the bacon and eggs and Anita over the table, threw me against the car, and they handcuffed me. I was just eating the bacon and going, 'Oink, Oink.'"

Weinglass: "Did they tell you why you were arrested?"

Hoffman: "They said they arrested me because I had the word *fuck* on my forehead... They called it an 'obscenary,' they said it was an 'obscenary.'"

Weinglass: "Can you explain to the court and jury how that word got on your forehead that day."

Hoffman: "I had it put on with this magic marker before we left the house."

Weinglass: "And why did you do that?"

Hoffman: "Well, there were a couple of reasons. One was that I was tired of seeing my picture in the paper and having newsmen come around, and I know if you got that word, they aren't going to print your picture in the paper, and secondly, it sort of summed up...what was going on in Chicago... I liked that four-letter word. I thought it was kind of holy, actually."

He was asked to relate what he said to a group in Grant Park.

Hoffman: "I described to them the experience that had happened to me in the jails of Chicago. I said that there were young people in the jails being beaten up, that they weren't being allowed to have their lawyers. I said it was typical of what took place in jails all around the country. I described the experience in the courtroom and the attitude of the judge, and I said it was particularly common among judges in this country. I said that Lenny Bruce had once said, 'In the halls of justice the only justice is in the halls.'"

At the end of his examination, Leonard Weinglass asked Abbie Hoffman the crucial question: "Prior to coming to Chicago, from April 12, 1968, on to the week of the convention, did you enter into an agreement with David Dellinger, John Froines, Tom Hayden, Jerry Rubin, Lee Weiner, or Rennie Davis to come to the city of Chicago for the purpose of encouraging and promoting violence during the convention week?"

Hoffman: "An agreement?"

Weinglass: "Yes."

Hoffman: "We couldn't agree on lunch."

The judge made us work Christmas Eve and New Year's Eve. The celebrity witnesses came and went, and the artists strained to catch their likenesses. When all the world knows how someone looks from media images, there is enormous pressure to get it right. There was no more rolling around on the floor, but people rose to shout at each other and spectators were often ejected. I dreaded each incident.

The anxieties of the job became transformed into a sort of physical fear that made me feel surrounded by danger in the courtroom. If I came into the room to find people huddled and whispering, if they were looking around anxiously, if the marshals suddenly started talking into their lapels I felt something almost like terror.

Then one day the defense called Mayor Daley as a witness.

To date, Chicago has had six mayors since the first Mayor Daley died in 1976, and the sixth one is his son. There was a time when people

couldn't imagine anyone other than Richard J. Daley ever being mayor of Chicago. The machine that he put together to run the city was famous for its corruption and its efficiency. He annihilated the Republican Party in Cook County, and it was said his manipulation of the Illinois vote won the presidency for John F. Kennedy. My children called him "Maley Daley" and believed he was responsible for making it snow.

No one's face was as frightening to draw. It was not only that everyone knew what he looked like; he was the true villain of this drama, the honorary Yippie, the power behind the police who had given the "shoot to kill all arsonists and shoot to maim all looters" order during the riots after Martin Luther King Jr.'s death, the malapropist who had proclaimed, "The police are here to preserve disorder" during the Democratic Convention riots.

I had prepared a large sketch with an empty place on top of the witness box for Daley. When the time came, I put in this hole lines to convey his pink jowly face, bald head, stiff and ample navy blue suit.

The mayor looked amazingly harmless on the witness stand; the judge, peering down, referred to him as Mr. Witness.

The defense wanted to call Daley as a "hostile witness," so that the rules of evidence would allow them to ask leading questions, as though cross-examining. But Kunstler neglected to ask for the "hostile witness" ruling when he should have, before beginning.

Kunstler: "Mayor Daley, on the 28th of August 1968, did you say to Senator Ribicoff—"

Foran jumped to his feet. "Oh, Your Honor, I object!"

Kunstler continued: "—'Fuck you, you Jew son of a bitch, you lousy motherfucker, go home'?" (Kunstler was quoting what a lip reader had claimed Daley said while listening to Ribicoff's speech on the Convention floor.)

Foran was red with indignation. "Listen to that. I object to that kind of conduct in a courtroom. Of all of the improper, foolish questions, typical, Your Honor, of making up questions that have nothing to do with the lawsuit."

Kunstler: "That is not a made-up question, Your Honor. We can prove that!"

Foran: "Oh, they can? That is so improper. I ask that counsel be admonished, Your Honor."

Kunstler: "I direct your attention, Mayor Daley, to March 28, 1968. Do you recall having any conversation or meeting with Mr. Stahl on that day?"

Daley: "Well, being the deputy mayor, I would meet with him several times a day."

Kunstler: "Do you recall any conversation or meeting with him with reference to the Youth International Party?"

Daley: "I gave Mr. Stahl the same instructions I gave any other department, certainly, to meet with them, to try to cooperate with them, and do everything they could to make sure that they would be given every courtesy and hospitality while they were in the city of Chicago…"

Kunstler: "In view of what you said, did you consider that the use of nightsticks on the heads of the demonstrators was hospitable?"

Foran: "Objection, Your Honor."

The court: "I sustain the objection."

When Kunstler finally did ask that Mayor Daley be declared a "hostile witness" so that he could continue to ask leading questions, the judge refused in his sweetest voice: "Nothing in the witness's behavior indicates that he is hostile; his manner has been that of a gentleman."

Now more like a politician himself, Kunstler continued to ask provocative questions.

"Do you believe that people have the right to demonstrate against the war in Vietnam? Can you indicate what you said to Senator Ribicoff on that day? Have you been familiar at all with the report of President Johnson's commission to investigate the causes of violence at the Democratic National Convention? Do you agree with that commission's finding that a police riot took place in the city of Chicago?"

A pattern of a question by Kunstler followed by an objection by Foran sustained by the judge forced the mayor to be passive.

Later when Judge Hoffman cited Kunstler for contempt, he said that on this day Kunstler had asked "no less than 83 questions that were objectionable."

Returning early that day from lunch, I found the fat little mayor already ensconced on the witness stand in the nearly empty courtroom. Suddenly the main doors flew open and Abbie Hoffman came bounding in followed by supporters. He stopped when he saw Daley. Flinging his fists in the air and laughing, he called out, "Hey, it's the mayor! Hey, Mayor, how about you and me settle this right here and now—man to man?"

People gasped, worried what the mayor's reaction would be. But Mayor Daley's jowly face rearranged itself into a beguiling grin.

Like most Chicago juries in those days, this jury was made up of blue-collar workers, retired people, suburban housewives, and the unemployed. None were college graduates, only one was younger than 40. There were two white men, eight white women, and two black women.

It seemed unimportant compared to the jury that both the defendants and prosecution were playing to: the media and, beyond them, the people of a country torn by an unpopular war.

But this jury heard evidence for many long winter weeks, it watched the commotion in the courtroom, heard the shouting and the jokes. It saw Bobby Seale bound and gagged and disappear to show up later as a witness for the defense. It heard David Dellinger say, "Oh, bullshit!" during the examination of Deputy Chief of Police James Riordan, which led Judge Hoffman to revoke his bail. It heard Abbie and Jerry call the judge "tyrant" and "schtunk" and other Yiddish insults. It saw Abbie and Jerry sitting at the defense table in judge's robes fastened by safety pins.

The rest of us wondered what these most important decision makers in the room were thinking. They were, of course, consistently silent, as still as the figures on a marble frieze.

On February 10 the jurors began to listen to four days of closing arguments. On the fourth day in the last argument, Tom Foran told them, "Outbursts in the courtroom are not something you need ignore. You may look, sense, and listen."

Foran, the tough Chicago prosecutor, jabbed and pointed with fists and fingers, marched back and forth in front of the jury box, as his pretty blond wife and children watched from the spectator section.

"I mean, what has happened to us? Are we going to get conned like that: The bad people are policemen! The bad people are FBI agents! The bad people are people who give their lives to government! The bad people are a kid who goes in the navy! That you're only a good guy if you like the homosexual poetry of Allen Ginsberg...? We can't let people use our kids

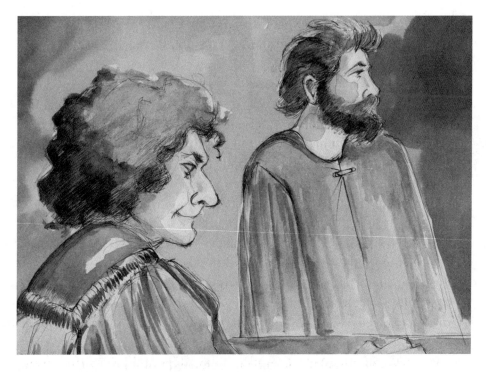

Abbie Hoffman and Jerry Rubin in judges' robes.

like that. We can't let them do it because what they want to do...they want
to stand on the rubble of a destroyed system of government, the new leaders
of arrogance and uncertainty...

"The vision and ideals that our forefathers had just can't be corrupted
by the haters and the violent anarchists. 'The future is with the people who
will be truthful, pure, and loving.'

"You know who said that? Gandhi. Dr. King.

"Truthful, pure, loving.

"Not liars and obscene haters like those men are. Can you imagine: You
know, the way they name-dropped—can you imagine?—and it is almost
blasphemous to say it. They have named St. Matthew and they named Jesus
and they named Abraham Lincoln. They named Martin Luther King... Can
you imagine any of those men...can you imagine those men supporting
these men if they—"

Just then a woman's voice screamed out from the back of the courtroom,

"Yes, I can. I can imagine it because it is true!"

The judge ordered, "Remove those people, Mr. Marshal!" and Dellinger shouted, "That's my daughter!"

Another girl yelled, "I won't listen to any more of these disgusting lies!" and Dellinger, standing at the defense table, shouted, "That's my other daughter. Thank you. Right on. Right on!"

The marshal raised his arm to lead one of the girls out and Dellinger shouted, "Don't hit my daughter that way. I saw you. That man hit her on the head for saying the truth is here!"

"The marshals will maintain order," threatened the judge.

"Yes, but they don't have to hit a 13-year-old girl who knows that I was close to Martin Luther King!"

"Mr. Marshal, have that man sit down."

Foran turned back to the jury. "You see? You see how it works: 'Don't hit her.'"

"He did hit her!" insisted Dellinger.

"Oh bunk," said Foran.

"The lights that Camelot kids believe in need not go out," Foran continued. "The banners can snap in the breeze again. The parade will never be over if people will remember what Jefferson said: 'Obedience to the law is the major part of patriotism.'... These seven men have been proven guilty beyond any doubt... They have been proven guilty beyond all doubt of each count in those indictments that charge them with these crimes... Do your duty."

(One evening at the TV station, after the verdict had come in and Tom Foran was allowed to talk to the press, Hugh Hill came rushing in with a very sweaty, rumpled Foran in tow. "Go ask Fahey if Tom can borrow his makeup!!" yelled Hugh as he hustled Foran into the studio. I ran down to head anchorman Fahey Flynn's office. "Quick," I blurted out, "Tom Foran is about to go on the air, and he needs to borrow Fahey's makeup!" "Tell him only 'freaking fags' use makeup," said a reporter.)

On Valentine's Day, a Saturday, at 9:30 in the morning, Judge Hoffman read the jury its instructions. After the marshals who were to guard their deliberations had been sworn, and the jurors had filed out to begin their

deliberations, the rest of us remained in the courtroom.

"Now we have another matter here," began the judge. He read a definition of *contempt* and continued by describing the remedies available to him for punishing contempt.

The court: "This was a case marred by continual disruptive outbursts in direct defiance of judicial authority by the defendants and defense counsel. I will specify here the instances of conduct of record which I consider to have been contemptuous, ...and I also make the entire record of the case of *United States of America v. David T. Dellinger et al.*, 69 CR 180, a part of this proceeding.

"Much of the contemptuous conduct in this case does not show, of record. The constant murmurs and snickering emanating from the defense table were not captured on the printed page. No record, no matter how skillfully transcribed, can adequately portray the venom, sarcasm, and tone of voice employed by the speaker. No record, no matter how skillfully transcribed, can adequately reflect the applause, the guffaws, and other subtle tactics employed by these contemnors in an attempt to break up this trial. I have not focused on these cheap theatrics, histrionics, and affectations. I note them for the record lest my silence be construed as approval."

And then after brief attempts at protest from the defense counsel, the judge began to read from the transcript, starting with the citations against Dellinger. He read with the same flourishes and obvious relish that he had weeks ago when Bobby Seale had been the subject.

For two emotional and exhausting days he read, pausing after each list of citations to hear each defendant and each defense attorney speak in his own behalf. And then he sentenced each, including Kunstler and Weinglass, to prison for contempt of court. He sentenced them to between 48 months (Kunstler) and two months (Lee Weiner). After each sentence was pronounced, the defendant was hustled off to the lockup to the cheers and raised fist salutes of the spectators. The lawyers were not jailed.

John Froines, one of the last to be sentenced, had his toothbrush sticking out of his back pants' pocket. I saw it too late in the drawing made by Marcia Danits, the CBS artist, and I admired and envied her for noticing.

With these contempt convictions, the Chicago Conspiracy, once 8 and then 7, now—with the addition of Kunstler and Weinglass—became known as the Conspiracy 9.

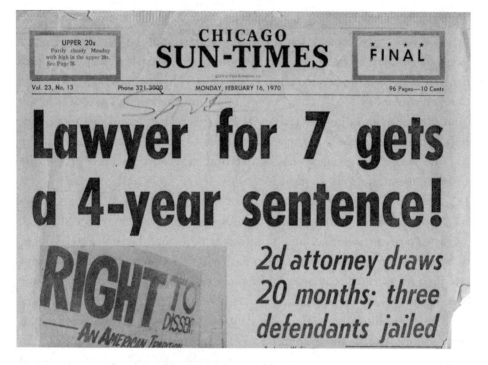

Chicago Sun Times, *February 16, 1970.*

The jury deliberated for two more days. I drew the door to the corridor that led to where the jury was ensconced. Stunned by the quiet, I sat alone in one of Mies van der Rohe's Barcelona chairs and stared impotently at the black-rimmed glass doors marked PRIVATE NO ADMITTANCE.

On February 18, after four days of waiting, we learned that the jury had reached a verdict. At the courtroom door, even the press lined up to be searched.

When we were finally allowed in, the courtroom seemed chilly and darker. As though it were my own future being decided, I felt numb with doom.

Trapped in this vast, dim box of a room we waited.

Finally, the defendants filed out of the lockup and took their places at the table. They looked glum and tired, the worse for wear after their nights in the federal tier of the Cook County Jail.

Dick Schultz approached the bench.

"Your Honor, I just have a couple of matters…before the jury is brought in…. Considering what has gone on in this courtroom before, considering the fact that we have had a number of fistfights in the courtroom and miniature riots right here in this courtroom…especially culminating last week…with the staff members…who have been thrown out repeatedly…we would ask Your Honor to have the court cleared of all spectators except the press, your staff, the marshals, the defendants, and the attorneys."

The judge agreed and the courtroom was cleared except for the aforementioned.

"We will dance on your grave, Julie," rang out a voice as the spectators were hustled out, "and the graves of your pig empire!"

The verdict, when it finally came, was ironic. Dellinger, Hoffman, Rubin, Hayden, and Davis were found guilty of crossing state lines with intent to incite riot. Froines and Weiner were found not guilty. No one was found guilty of conspiracy.

The only thing that they were all guilty of together was contempt of court. Judge Hoffman had finally forged their conspiracy.

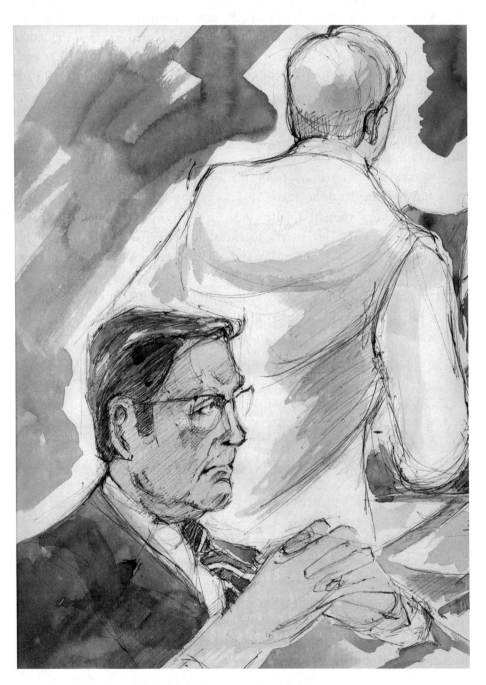

Otto Kerner and Paul Connolly (back to Kerner).

2

THE SEVENTIES:

The Black Panthers and the Trials of Edward Hanrahan and Otto Kerner

Chicago is a great American city. Perhaps it is the last of the great American cities.

—Norman Mailer, *Miami and the Siege of Chicago*

Death be not proud... For thou art slave to Fate, Chance, Kings, and Desperate Men.

—John Donne, *Holy Sonnets*

The Conspiracy 8 trial had been like a dramatic spectacle set up under a tent, a tent tied to spikes at the corners with the wind tugging it. It had been a performance by a troupe of players who had traveled to Chicago because that's where the convention and the riots had been. After it was over, they packed up their headbands, armbands, message buttons, fake judicial robes, Viet Cong flag, and other props, as well as Jerry Rubin's wig and Abbie's ponchos, and left town.

In spite of some of the roles having been played by local actors like

Julius Hoffman, Tom Foran, and Mayor Daley, the drama enacted had only marginally been about Chicago, or about Chicago in its position as *the* American city. Instead, what it had mostly been about was the country as a whole, its prejudices and frustrations, ideas and counterideas. The trial was also about itself, as the findings of contempt had shown.

When the convictions were overturned later, it turned out that no crime had even been committed. All the stress, the tension, the posturing for the press—none of it had been for a legal matter so much as for a strange sort of cultural revolution. For Abbie Hoffman, who committed suicide in 1989, the trial had been about a failed revolution.

At sentencing, Abbie Hoffman told the judge, "Our only beauty is that we don't want a job. We don't want a job there, in that system. We say to young people, 'There is a brilliant future for you in the revolution. Become an enemy of the state.... You will save your soul.'"

The Black Panthers case was a sudden immersion into another 1960s anomaly, another surreal event of that warped and fascinating time.

The West Side of Chicago had come crashing into Judge Julius Hoffman's courtroom on December 4, 1969. Early that morning bullets from the guns of the state's attorney's police had ripped the walls of a West Monroe Street bungalow. Entering from front and back, the raiders found they had killed Black Panther leader Fred Hampton and his lieutenant, Mark Clark. Hampton's pregnant girlfriend, Debra Johnson, was cringing over her lover's body on a bullet-torn, blood-soaked mattress. Another man and woman lay wounded behind a door.

The survivors were arrested, the press was called in to view the scene, and Ed Hanrahan, the Cook County state's attorney, praised the bravery of his men.

Downtown on the 23rd floor of 219 South Dearborn Street, angry people who had heard the news filled Federal Judge Hoffman's courtroom. I learned it from them when I arrived to sketch that day's proceedings.

Before the jury was seated, Defense Attorney William Kunstler addressed Judge Hoffman. "The defendants respectfully ask the court for an adjournment for trial today because of the murder of Fred Hampton early this morning by police officers here in Chicago. We ask this for two reasons:

one, out of respect for Mr. Hampton and his dead associate, and two, because the defendants—"

The judge interrupted him. "Will you wait a minute? I have to send a note to somebody who is on the telephone...."Then, a little later, "You may continue."

Kunstler explained that it was not only out of respect for the dead that he wanted to recess but "because of the emotional reaction of the defendants to...a wanton murder of an associate of many of us."

The judge, denying his motion, snorted, "The so-called Black Panthers, whoever they are, an organization that I have no familiarity with except as the name has been mentioned here...is no party to this indictment."

Had the state's attorney had sufficient cause to invade the lair of Black Panthers? Had there been a gunfight, or had these men been murdered as they slept? It wasn't only the radicals on trial in the federal building who asked these questions.

Soon the interest of the press shifted to the Cook County Criminal Courts Building at 26th and California and the blue-ribbon coroner's inquest to be held there. Assigned to cover my second legal proceeding, I went as well.

In the notorious courthouse, the press was told to sit at a heavy table in the middle of the well of the courtroom. There were no magnetometers, X-ray machines, or guards patting people down in those days, and we joked about being in the line of fire between families of the Panthers and the police witnesses. A scowling woman passed me a note covered with scribbles and a cartoon of a figure drawing. At the bottom it read: "a lovely likeness of you, Skinny's Pig."

Gray-haired, dark-suited doctors and lawyers, educators and clergymen filled the leather chairs of the jury box. They were blue-ribbon jurors appointed to help the special coroner decide how Fred Hampton and Mark Clark had died.

On a table beneath the high bench where the judge had been supplanted by the coroner, guns and boxes of ammunition lay in neat rows; they were the guns found in the Panthers' apartment.

The ballistics expert who testified took each gun, snapped it open, looked inside, snapped it together again, raised it to eye level, sighted along the barrel, and pulled the trigger. Not yet used to this world of real cops,

real guns, and real criminals, I jumped each time he did this.

The special coroner's jury found justifiable homicide. The Panther shootout was laid to rest, only to be exhumed a few months later by a federal grand jury and then a special Cook County jury.

I went back to draw at the Conspiracy trial.

The People of the State of Illinois v. Edward Hanrahan et al.

The windows faced west, looking out on the Cook County Jail, and in the late afternoon the sun slanted in and made Barnabas Sears's spectacles sparkle. Barnabas Sears—old, plump, pink, venerable—sat back in his leather chair, his hands folded over his ample stomach, over his waistcoat, over the chain of his pocket watch. He would sit there for hours with his eyes closed, listening to his adversaries: the intense young lawyers defending Cook County State's Attorney Edward Hanrahan and other law enforcement officers. Hanrahan and his men were about to be indicted by a special Cook County grand jury for the Panther raid.

Barnabas Sears had been a special prosecutor once before, during the Summerdale scandal, when the Chicago police were accused of stealing television sets and other bounty. He had won convictions, and Superintendent Orlando Wilson had been brought in to reform the department and teach Chicago cops how to talk, how to use big words like *proceeding* and *indicating*. Now Barnabas Sears seemed to sleep in a shaft of sunlight.

When he was standing, his thumbs in his waistcoat pockets, rocking back and forth, he delivered his arguments slowly, like baroque pronouncements. I imagined him imagining himself Clarence Darrow.

On the opposite side of the room, in shadow under the glowing windows, State's Attorney Ed Hanrahan sat tensely, an animal sensing danger.

The defense lawyers would become the best in the city. They would become judges, a United States attorney, and famous attorneys with highly placed corporate and political clients. They fought hard for *Hanrahan et al.*; there was nothing somnambulant about them.

Some of the lawyers for the Panthers would come to be well known as "cause lawyers"; one became the first black corporation counsel for the

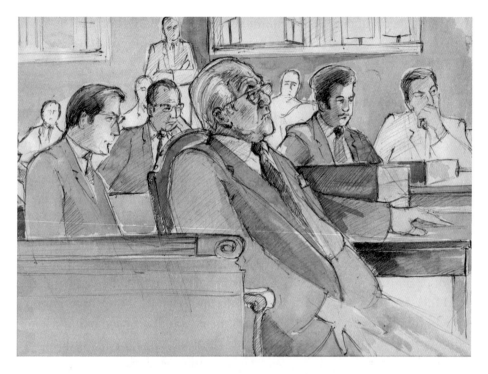

Barnabas Sears, Edward Hanrahan, and others.

city. Their left-of-center politics were evident in their arguments, their choice of clients, and their scruffy clothes.

There was no air-conditioning at 26th Street that summer of 1972; a whirring fan was all the relief we had from the sultry afternoons. Hanrahan remained stiff in his dark suit, but some young lawyers took off their jackets and, in their shirtsleeves, made their arguments to Judge Philip Romiti. They challenged the constitutionality of the grand jury system, the fact that only the state's evidence is presented in secrecy to the roughly 20 jurors; the fact that a defendant has no right to challenge or rebut anything. The state's attorney himself made this attack on the grand jury, though his office, in ordinary circumstances, could hardly operate without it. Judge Romiti listened patiently for days.

I worked with Hugh Hill, the local ABC station's political reporter. Hugh was not easy to please. Looking over the sketches, he would yell, in front of everyone, "Who the hell is that supposed to be?"

But I liked Hugh's backslapping swagger and the fact that, if I could convince him that he was being unreasonable, a twinkle would come into his eyes.

Unlike later reporters who felt artists were only necessary evils, Hugh liked sketches to illustrate what he wanted to report. He had a sense of narrative flow and would write a line to match each sketch. Often he would demand that I illustrate some idea that I found undrawable. When he wanted to tell about the state's attorney appearing before the grand jury, he had me hide in a stairwell and then jump out and draw Hanrahan and his entourage as they came marching back from the grand jury room.

A lover of Chicago history, he later had me illustrate documentaries or "mini-docs" on Leopold and Loeb, John Dillinger, and Terrible Tommy O'Connor. From the warden he got permission to film and activate the trapdoor under the old gallows from which O'Connor had escaped.

Once Hugh bellowed at me when I complained I didn't have enough time to draw some request. "Whaddaya mean you don't have time? You got 45 minutes. For Christ's sake, you could do the Mona Lisa in 45 minutes!"

Hugh wasn't the only reporter who made me draw in awkward circumstances. Defendants often escaped in those days; when the alarm sounded, judges—with robes flying—flounced into chambers, jurors were hurried into jury rooms, and the rest of us had to wait nervously in locked courtrooms. Reporter Larry Buchman, toupeed and eager, once pushed me out into the corridor when an escaped prisoner was on the loose. As the alarm shrieked, my hands shaking, I sketched armed deputies crouching at the stairwells. The prisoner caught a cab, and Buchman was reprimanded back at the station.

Judge Romiti and later the State Supreme Court ruled in favor of Barnabas Sears. The true bill would be allowed and the indictment would not be quashed. The trial of the people of Illinois versus their own state's attorney for obstruction of justice began, and Hill and I went out regularly that fall to cover it.

The state, as usual, went first. Their dollhouse replica of the Panthers' apartment had tiny holes in its tiny walls, and the ballistics expert pushed sticks through them to show the trajectory of the policemen's bullets.

They lugged the mattress that Fred Hampton had died on into court and pointed at the stiff brown stains.

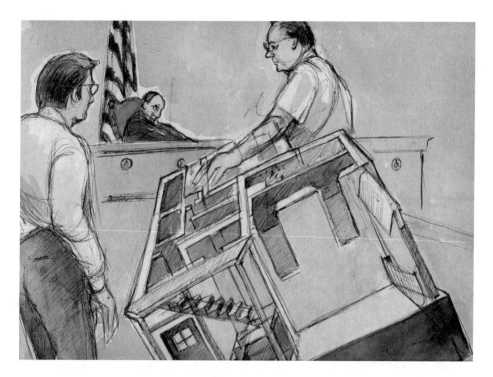

Panther apartment model.

The Panther survivors, including Debra Johnson (who had since given birth to Fred Hampton Jr.), testified about that early December morning when the bullets woke them.

At midtrial the defense made the usual argument for a directed judgment of acquittal. They claimed that the evidence, even when taken in the light most favorable to the state, was not adequate for conviction. After a tense weekend of waiting, Judge Romiti granted it.

Ed Hanrahan lost the next election to a Republican. The Panther survivors sued for damages in federal court and eventually won. While those proceedings were in progress, I ran into one of the defense lawyers in a Criminal Courts Building elevator. He was now defending against a civil suit brought by the Panthers. "I'd settle," he said, "but then they would go on TV and say, 'Government lawyer admits cops killed Panthers illegally.'"

In 1973, in a federal case of two policemen involved in murders, a small black man named Willie O'Neal took the stand for the prosecution. He had

Edward Hanrahan and Judge Romiti.

been an informer for the FBI, and on cross-examination he admitted that before that he had been a Black Panther. He went on to describe how he had turned against his fellow revolutionaries in the late 1960s to go on the FBI payroll. As the head of security for the Chicago Panthers, he had been in a position to let the authorities know that Fred Hampton, Mark Clark, and the others would be sleeping ducks in their heavily armed headquarters on the night of December 3. Some had said at the time that Hampton had been drugged before going to bed; O'Neal could have been the one to do it.

Then O'Neal disappeared back into the Federal Witness Protection Program. On January 17, 1990, a small item in the *Sun-Times* headlined INFORMANT IN PANTHER RAID KILLED BY AUTO read, in part:

> A former FBI informant who infiltrated the Black Panther
> Party at the time Fred Hampton was killed in a police raid
> has committed suicide by running in front of an auto, police

said Tuesday. The death of William O'Neal, 40, who lived in a north suburb with his wife and young son, was called a suicide by State Police and the Cook County Medical Examiner's Office.

The Conspiracy 8 had been a traveling carnival, but the Panther case, though political as well, had brought me closer to the real Chicago. What I came to know next was truly indigenous, deeply rooted in Chicago, and its branches reached into all corners of the city's life.

United States of America v. Otto Kerner and Theodore Isaacs

On the first day of the trial, Hugh Hill clapped the defendant Otto Kerner on the back and boomed, "Well, you gonna beat it, Judge?" and the dignified Kerner smiled up at him as though Hugh had asked about his golf game.

Otto Kerner's father, Otto Sr., a distinguished public servant in his own right, had been a close associate of Mayor Anton Cermak. Cermak had been assassinated while riding in a parade with Franklin Roosevelt, leading people in Mob-obsessed Chicago to suggest that the bullet had been meant for the mayor, not the president-elect. It is more likely, however, that his death was collateral damage caused by a mad man's faulty aim. Otto Jr. had married Cermak's daughter and, when a drunken driver killed her daughter by a former husband, Kerner adopted the small children Anton and Helena. Now in their early twenties, Cermak's grandchildren were a good-looking man and woman who obviously adored their adoptive father. They attended every day of his trial.

Otto Kerner, Jr. had worked his way up through Chicago politics to be appointed U.S. attorney, and was later elected governor. After the racial riots of 1967 Lyndon Johnson made him chairman of the National Advisory Commission on Civil Disorders and one phrase from its report has been remembered ever since: "Our nation is moving toward two societies, one black, one white—separate and unequal."

Governor Kerner was a respected public figure when he, like his father before him, was appointed Federal Appeals Court Justice for the Seventh

Otto Kerner with James R. Thompson in the background.

Circuit. But his portrait had not yet been hung on the wall of the 27th-floor appellate courtroom when he went on trial himself in a smaller courtroom a few floors below. Kerner and his codefendant and friend, Theodore Isaacs, were charged with taking bribes from racetrack owners in exchange for awarding favorable racing dates.

When Nixon appointee, James R. Thompson, became U.S. attorney soon after the conspiracy trial, young assistant U.S. attorneys began to wear aviator-style eyeglasses like his. A good-looking, energetic bunch, they were very different from the tense Democrats Foran, Schultz, and Hanrahan. In the early 1970s they vowed to dig out, once and for all, political corruption in Chicago. They indicted aldermen, the county clerk, and the mayor's press secretary, but the biggest prize of all was U.S. appellate judge and former governor Kerner.

The new U.S. attorney prosecuted the case himself. Young, blond, and lanky, he had an "aw shucks" air about him.

As small as Thompson was big, as stiff as Thompson was relaxed, Otto Kerner sat with perfect posture in his neat gray flannel suits and blue Oxford-cloth shirts. Good looking in a delicate way and polite to a fault, Kerner's formal manner seemed wrong in a Chicago courtroom.

Instead of hiring local talent to defend him, he picked Paul Connolly, a lawyer from Edward Bennett Williams's law firm in Washington, who talked down to the blue-collar jurors from the neighborhoods.

Filling two or three spectator rows, the elderly men known as court buffs marveled at how the defense attorney's beautiful suits never wrinkled. They debated how much the suits had cost, how much the lawyer had cost. The raffish racecourse crooks who testified under grants of immunity made a bigger hit with the buffs, and apparently with the jurors as well, than either Kerner or his attorney.

When Kerner took the witness stand in his defense, he sat militarily straight, put his elbows on the edge of the box, and then brought the tips of his fingers together as though playing "Here's the church, here's the steeple."

I quoted the beginning of his testimony on the bottom of my sketch: "After I returned from the wars...."

When Thompson rose to cross-examine, the courtroom seemed to hold its breath. With mock deference Thompson called the witness *Judge Kerner* and led him gently and firmly, as though he were a dog walking on its hind legs. Kerner strutted right into Thompson's trap; Thompson's deft questioning made Kerner's old world dignity project as arrogance from the witness stand.

Kerner had the usual character witnesses: the nun and the priest, the "leading members of the business community," and so on. Thompson asked popular sports announcer Jack Brickhouse if it was okay to call him Jack— he said he couldn't think of him as *Mister* Brickhouse.

A trial becomes a temporary community, and the Kerner trial was no exception. Camaraderie develops between the groups, even sometimes between defendants and those who prosecute them—certainly between the lawyers and the press. Court proceedings are full of delays, and there is time for chatting and telling jokes.

Otto Kerner later in tax court.

Often, while waiting for a case to begin, the reporters, Marcia Danits, the CBS artist, and I would play Facts in Five. The winner wrote down fastest the most examples of categories beginning with a certain letter. Sometimes Jim Thompson would come over and join in. Thompson and other males won when the category was sports or cars, but Marcia and I excelled with names of flowers or colors. "Asters, anemones, apple blossoms; aubergine, alizarin, auburn," we would write. The men only knew mums and roses; yellow, red, green, and blue.

The jury convicted Kerner on all counts, making him the first of three convicted Illinois governors I would draw. The verdict finished his career, ruined his name, and sent him off to prison, where he and Isaacs were put in charge of the prison library.

Months later an older, shrunken Kerner was brought from prison to Federal Tax Court. His gray flannel suit no longer fit, and my pen described dark areas where the button-down collar fell away from his neck. The dispute

that put him again at the defense table was over how much of a deduction he should be allowed for the gift of his gubernatorial papers to a library.

Experts testified for both sides. His claimed that "even laundry lists" have their historical value; the government's insisted that most of his papers were routine requests for information.

A documents expert from Boston called them worthless, the sort of thing he left outside his back door for neighborhood boys to carry off. He went on to say, as the ailing Kerner listened, that never had he seen letters with so little personality; it was almost as though there were no human being behind them at all.

Otto Kerner—author, governor, federal judge, convicted felon—died of lung cancer after spending most of his last years in prison.

After the Kerner trial, Hugh Hill and I covered the cases of many politicians brought to trial by Jim Thompson and his assistants. Jowly old men in dark suits and shiny ties, they suffered the indignity of being hauled before federal judges, being chased by TV crews, being drawn by TV sketchers.

In the early '70s I settled into the routine that never became routine. Phone conversations with the assignment desk began the mornings, and when pagers came along, the little black rectangle tethered me to those who decided things at the TV station.

I liked not knowing each day whether I would work or where I would work—in what county, at which courthouse.

After the Conspiracy trial, court proceedings were never so crazy or difficult to draw again. Participants usually sat politely and waited their turns to speak, and security officers, whether federal deputy marshals or county deputy sheriffs, mostly left people alone. The courtroom, in fact, was a civilized and safe place for an artist to work after all.

Because I came to love so much what I was doing, it didn't seem like work. I had once gotten up at 3:00 A.M. to brew coffee, clean bathrooms, and make beds in a ski lodge. I had spent so many hours as an office filing clerk that I thought the world was arranged in alphabetical order. I had sold sportswear, children's books, fine china, and souvenirs. I had carried coats, suits, and evening dresses to show rich lady shoppers until I was nine

months pregnant. All these jobs had been temporary, fit in between schools and children, but they had given me a taste of what real work is. I had known work, and this wasn't it.

Furthermore, the stories I heard as I drew fascinated and educated me. I learned that nearly everything that happens in a contemporary city ends up in court, that the courthouse is the grand bazaar of American life, everything is on display there. What I heard and what I saw began to sketch in a portrait of the city I had come to love.

I was assigned to draw in every kind of courtroom in Cook and surrounding counties. I drew in police courts hidden in neighborhoods I had never guessed existed. I lugged my big black case of art supplies into the Juvenile Court Building when it was still Dickensian and shadowy, later into the neon-lit windowless brown box that replaced it, and later still into its bathroom-white postmodern addition. I drew in gun court, in drug court, in women's court at the central police station at 11th and State while the El roared outside the windows. I drew among the swarm of confused people in traffic court, in the vertically splendid new Daley Center rising above the Picasso bird/woman, and, of course, in Mies van der Rohe's Federal Building. I drew in scruffy little courtrooms like schoolrooms scattered through the suburbs, in grand nineteenth-century county buildings like fortresses on their green rectangles. And as the population and its problems spread and expanded, I drew in consolidated courthouses so alike that, once inside, you could forget whether you were in Markham or Bridgeview or Rolling Meadows.

My favorite place was the Cook County Criminal Courthouse at 26th Street and California Avenue, the place that Chicago author Nelson Algren said should be a part of every young writer's education.

Inside the pseudo-Egyptian stone edifice, black, Hispanic, hillbilly, Greek, Polish, and Italian inhabitants of the neighborhoods swarmed the corridors. Every possible body, hair, skin, race, sex, and age type was represented, as was every possible disability, disease, or deformity. Instead of downtown attorneys in well-cut suits, hurried lawyers with bursting briefcases tried to explain the justice system to slouching clients as they waited for elevators, at least half of which were always "out of service." Instead of plainclothes deputy marshals, as found in federal court, uniformed Cook County deputy sheriffs, their bodies draped with keys, handcuffs, and other hardware, kept order here. Sam the

peddler sold ivory elephants, plastic water pistols, vinyl records with pictures of the Holy Family that played Christmas carols; a shoeshine man buffed the shoes of chatting lawyers outside the first-floor snack bar with its smell of cooking bacon.

"What are you here for?" I heard one lawyer ask another.

"Just shit, what else," came the reply.

Upstairs in the vast courtrooms, natural light streamed through tall windows, agitating the dust, chopping faces and figures into planes, throwing deep shadows into secret recesses, suggesting countless possible compositions. I could never do justice to the pillars, the paneling, the stenciled ceiling designs, the rococo radiator covers, the elaborate hat racks; all my time was taken by the alleged murderers, rapists, child molesters, drug dealers, and arsonists whom I had been sent to draw.

The building was already old and about to sprout ugly modern additions when I first came to know it while covering the Panther proceedings. Mayor Anton Cermak had it built in his Bohemian neighborhood in the 1920s, when civic taste in Chicago was not much different from that in Mussolini's Italy.

I was driven there by the couriers, men who worked for the TV station ferrying film and people. The couriers who drove me were usually Chicago cops, with guns in their glove compartments and baby shoes dangling from their rearview mirrors. Irish, Greek, Polish, or German, they worked this second job to send their kids through college. They told elaborate jokes and wild stories about adventures in the line of duty.

One had been in the Chicago Police Red Squad in the '60s; he'd used his telephoto lens to ogle braless protesters. Another ferried a stripper to bachelor parties as his nighttime job. He put bath towels down so she wouldn't get whipped cream on his seats.

"Goddam white-wine-sipping, brie-eating liberal!" a third always greeted me cheerfully.

My favorite was a grouchy-looking character known cynically as Officer Friendly. A brilliant mimic and a superb joke teller, he and I dispensed with hellos and good mornings and greeted each other with punch lines. On long trips we made up endless nonsense we found hysterically funny and which I was never able to explain to anyone else.

Our trips were full of delights for one whose Chicago had been only a

narrow strip beside Lake Michigan, who had known only the best parts of big cities and, nearly every July and August, the pastoral elegance of coastal Maine.

As we drove away from the lake to Ogden Avenue, we would pass the Curtis Casket Company, where tattered curtains fluttered like ghosts from broken windows. Further on we came to Malcolm X College, its low black steel like a safe deposit lock box, and then the enormous Cook County Hospital complex and its helicopter landing strip. Next came the always expanding Juvenile Court Building and Lulu's Italian Beef, then the old factories and warehouses: Schwartz Pickle, General Sausage, Lyon Healy Harps, Acme Barrel, and Royal Knitting Mills.

Deep in the Chicago slums the litter of generations of different uses gave each block its separate character. One street had rows of little houses like broken teeth; another, empty lots of junk. In the hot weather, people hung over paint-chipped sills of apartment buildings; a dirty teddy bear propped open a window. Along the once grand boulevards, people lounged on the breastlike porches of scarred and crumbling dowager houses; children shrieked with delight in the gush of fire hydrants and chased the brown liquid as it rolled away down the gutter.

In the summer the prairie burst through the asphalt. Summer was when empty lots, alleys, and yards came alive with weeds and wildflowers: Queen Anne's lace and orange day lilies in July, yellow butter-and-eggs in August, black-eyed Susans and goldenrod in September. All this time, whenever the sun was out or had recently set, the whole West Side smelled of barbecue.

Over the years, acres of jail—somber correctional buildings with barbed wire, guard towers, checkpoints, and barriers—have grown up around the courthouse. A low-lying Mexican neighborhood bright with buildings of pink, aqua, yellow, orange, and green surrounds this city of prosecution and punishment. On every wall or fence are hand-painted cacti, sombreros, rebels, and Virgin Marys. Ice cream cones, fish, and vegetables cheerfully advertise local enterprises; only the great gray walls of the jails have not been decorated.

For many years across the railroad tracks on California Avenue was Jean's, a tiny place that looked as though a medium-sized gust of Chicago wind could blow it over. Jean's was where the state's attorneys drank while

their juries deliberated. There were stories of lawyers so drunk that they could hardly stand when the jury foreman announced the verdict.

Sometimes everyone went a few blocks away to Febo's, whose motto was "Famous for Nothing."

The equivalent restaurant downtown near the federal building was Binyon's. After Hugh Hill stopped covering so many trials and Jim Gibbons took over, Gibby and I must have had a hundred lunches at Binyon's. One of a handful of women in the dark room, I would be served piping hot old-fashioned food by white-aproned waiters who looked like nineteenth-century anarchists, surrounded by the clink and mutter of judges and lawyers lunching. Binyon's was where the print reporters went to drink after work with their contacts in the U.S. Attorney's Office; it was where the marshals took juries to eat. When we were waiting for a verdict, we could always feel safe at Binyon's; the maître d' would tell us when the jury had left to continue deliberating.

I spent a lot of time in the two courthouse pressrooms: at the federal building downtown and at 26th and California on the West Side. I came to know the print reporters as well as the television reporters with whom I worked.

These pressrooms were cluttered with desks, broken chairs and sofas, filing cabinets and years of accumulated debris, dust-covered objects that no one owned and no one threw out. They were elephant graveyards for phased-out equipment; even now, typewriter carcasses are probably strewn about in dusty corners.

Pressrooms have changed. They were once noisy because reporters had to call in their stories to editors; now only a radio reporter filing a report or an older guy swearing at his computer disturbs the silence. Once attorneys used to drop in to chat and borrow phones; today everyone has his own in his pocket or her purse. Once full of both cigarette and cigar smoke, the air today smells of microwaved garlic or French fries from McDonald's. There is still plenty to look at on the walls: movie posters, cartoons, and news photos irreverently recaptioned.

In one pressroom at 26th Street, someone had pasted in an open fuse box a cut-out photograph of Al Capone. Tiny wires in a spaghetti knot of many different colors bunched around the little picture. (Perhaps it wasn't a fuse box, perhaps it had to do with telephones or computers.) The photograph

Sam Skinner and James R. Thompson.

had faded but you could make out the slick hair, the semicircle black eye-
brows, the big eyes. I liked seeing him there, half-hidden in his Joseph Cornell
box, the king's ghost watching us as we went about our business reporting on
his successors.

Jim Thompson went on to be elected governor of Illinois, and his first
assistant, Sam Skinner, became U.S. attorney. The four artists who had
begun at the Conspiracy trial—Marcia Danits, Verna Sadock, Lance
Dolphin, and I—kept on drawing for our respective TV stations. As the
years went by and the number of TV news outlets proliferated, Lou
Chukman and Carol Renaud joined us. Sometimes there was enough work
for six artists, almost always for three.

People asked continually, "What are you going to do if they let cameras
in the courtroom?" The artists watched nervously as all over the country
states were allowing them, but Indiana and Illinois stayed mercifully old-
fashioned.

"The Cook County judges will never let them in," someone said. "They
don't want the public to know how drunk they are."

The reporters came and went over the years. The newer TV reporters
were better looking, less like real journalists.

Over the years the crooks changed, and while some crimes stayed the
same (murder, rape, and so on), others (computer hacking, computer child
pornography, identity theft, terrorism) went in and out of fashion. After
9/11 more defendants had Arabic names.

The lawyers and judges, and often the deputies who guarded the
courtroom, went on to other roles or the same roles in other dramas. I
would meet them again, and I would draw them as they aged, as their hair
thinned or grayed and their bodies stooped or widened. State lawyers
turned into private attorneys and sometimes into judges; attorneys and
judges sometimes turned into defendants. Defendants were convicted
and sentenced and sometimes served their sentences, were released, and
started all over again, becoming defendants again.

Cases I'd covered years before turned up cited as precedent in new
cases. I would hear them named in arguments and felt I had been a witness
to legal history.

Trials almost never end completely like a book, whose cover you can close and put away, or a play, which comes to an end with the final applause. Even then in the beginning years, I began to see connections weaving through my life both in and out of the courts—my life as a participant, my life as an observer.

On occasion the TV station sent me to draw in a place that wasn't a courtroom but where cameras weren't allowed: a hearing room in the morgue or the mayor's office or an ad hoc courtroom set up in a hospital.

In the early spring of 1976, a reporter, a crew, and I were driven to a state institution for the very old or sick to cover a hearing in which a 15-year-old boy, mortally wounded by gunshots, would identify his assailant.

Some officials met us in the lobby, and like boats at the locks on a river, we waited until everyone had assembled: Bob Greene from the *Sun-Times*, Jane Pauley from Channel 5, and a few others. We—the press people, the hospital administrator, and someone carrying a huge American flag—fit into one elevator.

The long corridors were hot and smelled of sickness. On both sides, people slumped in wheelchairs showed no interest in our parade with the red, white, and blue flag. When we came to a linoleum-floored recreation room, several people began to work at finding a way to make the flag stand up as it would in a courtroom. The rest of us took our places in folding chairs, and I pulled mine close to the young victim.

The black kid who had been shot was the same age as my own son and, like John, was good looking and tall for his age. Lying on a hospital bed, he was attached to wires and tubes, which in turn were attached to a machine that hummed beside him. I despaired of drawing all that apparatus and only put in my sketch the fat ringed hose that led into his neck. He lay there impassively and listened to other witnesses until he himself had to testify and identify his assailant. This he did with great effort, the lawyers and judge and court reporter leaning close to decipher what they could.

He was still alert when the doctor testified that they expected him to die within weeks.

My sketch of him appeared on the front page of the *Sun-Times* the next day, and someone from the hospital called and asked if I would mind giving

Wounded boy (TV graphic).

the original to the boy. They said he wanted it very much. So I sent it off. He received it just before he died.

Two weeks later a call came at 4:00 in the morning. There had been an accident. For hours my husband and I waited to be let into the intensive care unit to see John. After a while a doctor came to talk to us about swelling in the brain. I asked him what we should hope for, but he wouldn't answer me. Then we waited in a different room, one with a view over the rooftops to the south. I discovered that the only place I could rest my eyes was on the wisps of white smoke curling up into the now clear blue sky. I watched these curls of smoke for a long time, until the doctor came for us.

We looked down on John in the midst of the machines. His hair was muddy and his nose was broken. Each breath the machines made for him shook his unconscious body. The doctor said it would be a long time before

they would know anything and that we should go home.

So we went.

John had been thrown from the backseat in a crash on Lake Shore Drive that smashed three cars, two with John and his teenaged friends and one in which a young Korean father was killed. The press started calling as soon as we got home. In fact, around 10:00, when I took the call from the doctor, I thought at first it was another reporter. "John is no longer with us," he said.

A woman I knew from one of the newspapers called to find out John's condition, and I told her. She must have turned away without putting her hand over the receiver. "Three dead!" I heard her yell to her colleagues.

Later she showed up at our door with a pot of still-warm baked beans and joined the throng of gray-faced friends in our living room.

For the next few days, our apartment was full of people. Some of my friends in the press came as journalists, most as mourners, some as both. A distraught and embarrassed reporter I knew from a rival TV station requested an interview, but I turned him down. I could see the camera trucks parked across the street from the church when we went in for the funeral. And yet I never felt they intruded. I felt a strange sort of comfort in knowing the media were there; if my wonderful kid should die, all the world should know it.

At the coroner's inquest, two of Chicago's best lawyers, men I had drawn for years, represented the drivers (who had survived) of the two drag-racing cars. One lawyer I had drawn being pushed into his chair at the HUAC hearing, another had defended one of Hanrahan's codefendants. In the familiar morgue hearing room, a policeman told of finding bodies "laying all over" by the side of the road. As we listened, the other dead boy's mother squeezed my hand as though she were drowning.

Stupefied by sadness, I felt no anger at those friends of John's, whom youth and beer and the April night had turned into murderers.

John, age 11.

John, age 13.

John, his sister Sasha next to him, and their cousins.

William Kampiles.

3

A SPY STORY

United States of America v. William Kampiles

From the highest sky [Icarus] looked down terrified at the sea... The hapless father, now no longer a father, yelled out "Icarus!" and again "Icarus, where are you? Are you flying under the sky?"...And he saw the feathers on the waves.

—Ovid, *Ars Amatoria*, translated by Sasha Austin Schmidt

To reach the federal courthouse in Hammond, Indiana, you drive south along the lake and then east to the Chicago Skyway, making a graceful arch over the steel mills, climbing the pockmarked tarmac to the top. Far below is the mouth of the Calumet River, with its tiny barges, tugboats, bridges, and cranes, mountains of strange substances, one a beautiful robin's egg blue. You come down again into a landscape of factories and foundries on the Indiana border, past smokestacks that disgorge clouds of rolling gray, past pipes that hold aloft torches of fire. On your right is man-made Wolf Lake, where Leopold and Loeb hid Bobby Franks's body in a culvert, where Leopold lost the eyeglasses that would later incriminate them. Because Hugh Hill had me illustrate the story for one of his "mini-docs," I knew the crime's geography.

In the late '70s this "rust belt" was ailing, much of the industry having

moved south, and its abstract scenery had taken on the wistful quality of ruins. Sulfur and malt and gas mix together here to give the air an unpretty smell. A cameraman once told me it's the smell of blood that seeped into the earth at the long gone stockyards; to me it can sometimes seem as nostalgic as the scent of lilacs on a hot spring night.

For a while in the Indian summer of 1978, Jim Gibbons and I drove every morning over the Skyway, past men fishing from the fingers of land sticking out into Wolf Lake, across railroad tracks, around vast fields of gas drums, to Hammond, Indiana. We had been assigned to cover the espionage trial of a young man named William Kampiles.

We set off after Gibby reported the weather on the early morning news—it was part of being the "environmental reporter." He joked with the anchorpeople and then pointed at swirls and wiggles of high- and low-pressure areas, storms and cold fronts on a blue background. Because of how the equipment worked, he was really waving at a blank wall and had to look in an off-camera monitor to see what to do.

Gibby knew this edge of the world because, as the environmental reporter, he did stories on gas leaks and industrial accidents. Once he returned from covering a toxic chemical spill shaken and upset. If he ever got cancer, he said, it would be because of what he had been exposed to that day.

He also knew this area because he'd grown up on the South Side. He was born to Irish immigrants in the parish of Visitation Church, or Viz, as it was known. He'd shown me the tumbled-down neighborhood at 55th and Shields where he'd lived as a skinny boy nicknamed Sticks. In affectionately recollected stories, he told me about this neighborhood, the Irish bars, the factory workers, the drunks, and the juvenile delinquents. When he and his pals needed a car to take girls to a dance, they'd steal one off the street and abandon it when they were through. He was a romantic about his working-class background, but he saw all sides of people, and when he told of an old codger who played "I'll Get By as Long as I Have You" on the tavern jukebox over and over, it didn't sound sentimental.

Gibby had showed me other neighborhoods as well. Sometimes when we had time coming back from a story, we would duck into some corner

Jim Gibbons (Gibby)
from the Chicago Tribune.

of the city he knew, a place by the lake that sold shrimp to ironworkers, a store in Chinatown, the rocky beach at La Rabida Children's Hospital pounded by gray surf. More than anyone, Gibby was my guide to Chicago; more than anyone else, he represented a part of Chicago at its best.

When a group of us were sent to Bridgeport to cover the first Mayor Daley's funeral, Gibby wore his best navy blue pinstriped suit, even though his assignment was to report from a rooftop. "It's the mayor," he explained. "It's his funeral."

Later when we returned to the station (and he had a hole in the back of his jacket), he made sure I was invited up to the general manager's office to watch the broadcast with the others. I had been the only uninvited member of the press to talk his or her way into the funeral, I'd made mental notes watched by a disagreeable mayoral crony, and I'd sketched from memory the casket surrounded by dignitaries. It had been a triumph for me, and Gibby made sure I got credit.

Unlike some media people, Jim Gibbons was careful and considerate, never in too much of a hurry to listen. Slightly stooped as though apologizing for being six feet five inches tall, he had a patient, polite demeanor. Everyone liked him and called him the Gentle Giant, or Gentleman Jim. "That guy is a real prince," people said. For years the federal building court buffs distributed a hand-printed newspaper, and in it Roy, the editor, called me Andy Austin, "Jim Gibbons's chic sidekick." It was my favorite compliment ever.

Gibby cared about people and he knew how to listen: These were his great gifts as a reporter and as a friend.

From far away we could see the pale green tile and art deco designs of the building next to the federal courthouse. Parking was not a problem because the streets were empty except for a stumbling derelict or two. The

building across the street from the courthouse advertised itself as "The World's Largest Sunday School," and in fact, it always felt like Sunday morning on the streets of Hammond. To me this was the Midwest without Chicago.

William Kampiles was the 23-year-old son of a Greek cleaning lady. Like Jim Gibbons, he had grown up in a South Side working-class Chicago neighborhood. While attending Indiana University on scholarship, he was recruited by the CIA. Even though he was only a clerk, his diligence and charm helped him obtain access to the manual of the Spy Satellite KH-11. He left the CIA in November 1977, and when he went on vacation in Athens the following March, he took one or more copies of the manual with him. In Athens he handed over a copy to a Russian named Michael Zavali, whom he presumed to be an agent for the KGB. Zavali gave Kampiles $3,000 in exchange.

Kampiles was tall, dark, at home in his body and his clothes as if he understood how good looking he was. He dressed in East Coast preppy-style gray flannel suits, Oxford cloth shirts, and conservative neckties. In a time before the "dress for success" doctrine, you could tell bankers from bagmen by the width of their ties and lapels. These were the days of roaring bad taste—electric pinstripes, checks, and flared trousers—when politicians wore enormous pinky rings and cufflinks, mobsters wore black silk shirts under white ties, and a well-known Irish-American defense lawyer sported a bright Kelly green suit.

As usual, the prosecution sat at a table near the jury box, and the defense at another one opposite it. But at this trial there was a third table, a smaller one near the wall, where two stern-faced U.S. deputy marshals guarded a padlocked box. In the box was the top-secret KH-11 Spy Satellite manual itself.

It seemed appropriate that it have its own table, that it be kept guarded and apart like a holy icon or perhaps a lump of radioactive matter. In fact, the marshals had a special lead locker built for it in the basement of the Hammond courthouse.

As always happens, witnesses told pieces of the story, each offering his part toward a complete narrative. Then this narrative branched out toward

Box with the top-secret KH-11 Spy Satellite manual.

two possible endings between which the jury picked.

The testimony told of how William Kampiles was recruited by the CIA when in college. While he was in Virginia being trained, he began attending Washington dinner parties. On the witness stand, a glamorous brunette woman almost twice his age, wearing enormous white-framed glasses, told about his success as a young man-about-town.

The prosecution claimed he sold the spy manual for the money, which seemed a little hard to believe because $3,000 isn't much for a soul.

Perhaps he really did feel that this was an intelligent step he had taken on the way to becoming a double agent. That was his defense: that he was only trying to get the Russians' confidence and then he planned to counterspy for us. In any case, on this vacation to Athens in March 1978, he carried a copy of the manual for the Spy Satellite KH-11.

Kampiles, standing alone in the dusk, heard music coming from a party at the Russian embassy.

William Kampiles on the witness stand.

My husband, daughter, and I had been in Athens in the summer of 1977. Numb with grief, we stumbled about the ancient ruins, hoping we could learn to live without John, hoping our family of three would survive. It was so hot that hundreds died in the streets all over the Mediterranean, and after lunch we would lie motionless on our beds in the dark room on Kolanaki Square, waiting for the worst to pass.

The military attaché from the Russian embassy who had accepted the spy manual had lived in Kolanaki Square, and I liked to fantasize that we had been in the same house at the same time.

Our elderly landlady was forced to take carefully recommended boarders into her lovely un-air-conditioned house. Being an aristocrat, she was not really Greek but that mixture of German, English, and Danish from which the kingdoms of Europe have often drawn their rulers. She sat all day in the front hall in a negligee of cascading lace, always ready to terrify and bewitch me. I listened in awe to her haughty reminiscences and pronouncements on matters of taste, hoping I would not have to speak myself. At night she reappeared in a smart silk print dress, pearls, white shoes, and matching purse, reminiscent, though much more elegant, of my grandmother's friends in Maine.

During the day the house was silent and dark, the shutters closed against the sun. But at night when I couldn't sleep, it came alive with strange mutterings and cries; footsteps fell and toilets flushed. In the next room someone seemed to be dying of consumption.

No meals were offered besides the café au lait the maid brought in the morning, so if the Russian Michael Zavali had been there, we would not have known.

Our days in Athens allowed me to place scenes mentioned in the testimony into remembered settings. I could imagine the early spring night, perhaps warm and fragrant, when Kampiles, standing alone in the dusk, heard the seductive Russian music.

Somehow he got past the guards and joined the crowd on the embassy terrace; somehow he got himself introduced to Zavali. He claimed later that he only wanted to tease the Russians with the offer of a later delivery of the manual, that they paid him the money only to show "good faith," that he then planned to go back to the CIA and offer his services as a double agent.

But the information from the manual turned up in Russian hands, and

the effectiveness of the satellite was destroyed. Until that time the Russians had not even been aware that the device had reconnaissance capability.

For one evening and the following morning the jurors deliberated. Jim Gibbons and I and the other reporters, artists, and crews waited in the sleepy courthouse and ate in a lively steakhouse. It was afternoon when the jurors announced they had reached their decision. They had reached a guilty verdict.

When he heard it, William Kampiles put his head down on his folded arms and began to sob silently. Michael Monico, his lawyer, his own face full of grief, embraced his client's shoulders. Then from the back of the courtroom, a woman began to scream. It was Kampiles's mother. Another woman answered her cries, whether in sympathy or opposition, we couldn't tell. Other women joined in and soon the air was full of their shrieking. The marshals hustled the crowd out into the hall except for the artists who stayed to finish their sketches.

Though she had been taken away to another room, we could hear Mrs. Kampiles through the walls, screaming and wailing in agony, over and over as though she could never stop. I wanted to put my shaking hands over my ears, but I had to keep drawing the open mouth of the inconsolable mother.

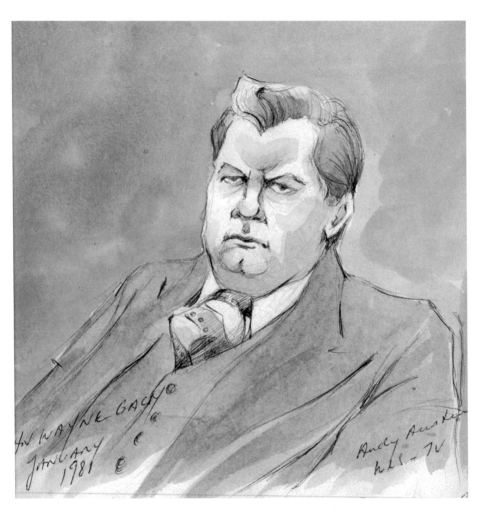

John Wayne Gacy Jr.

4

THE CHIEF OF SINNERS

The People of the State of Illinois v. John Wayne Gacy Jr.

If I am the chief of sinners, I am the chief of sufferers also.

—Robert Louis Stevenson, *Dr. Jekyll and Mr. Hyde*

Though I did not know it at the time, my first brush with the phenomenon of John Wayne Gacy came one cold December evening in 1978 in the tiny courthouse of suburban Des Plaines. Downstairs in the lobby stood a Christmas tree that schoolchildren had trimmed with handmade ornaments.

My reporter, a gum-chewing Texas beauty, and I were exhausted after covering the trial of a middle-aged housewife who had killed her husband. Now we had to wait till God knows what time for the jury to reach a verdict. We were delighted when the deputy sheriffs offered to share pizza with us in a drab conference room next door to where the defendant waited with her daughters.

Suddenly, Terry Sullivan, an assistant state's attorney whom I'd known at 26th Street, stuck his head in the doorway and announced, "Ladies, if you want a scoop, hang around after the verdict!" He wished he could tell us more, but what we were covering now was nothing compared to this other thing that was "going down."

An hour or so later after the not guilty verdict had been announced and

sketches, interviews, and sound track put together to report the story, I reminded the reporter that she should check out Terry's scoop. A courier had driven out from the city to fetch me, and I left without seeing Terry again. It wasn't until a week later that we learned what it was that had so excited Terry Sullivan.

Just days before Christmas, between the countdown of shopping days, canned carols, and exhortations to be merry, came news about murders in Norwood Park. Human remains had been discovered in the muddy crawl space under the house of a building contractor named John Wayne Gacy Jr. In the glare of searchlights, behind a barricade of police vehicles, evidence of Gacy's crimes was exposed to the frozen night, to horrified neighbors, and to those watching TV.

Four bodies were found before digging was suspended for Christmas; 29 would be exhumed in all. Four more, including that of his last victim, 15-year-old Robert Piest, were recovered from the Des Plaines River.

For days, a team of police officers and evidence technicians dug in the stink of the crawl space. Dr. Robert Stein, the medical examiner, insisted that the discoveries be catalogued with "archaeological precision." Most of the bones had come unattached, and unless there were shoes, socks, or gloves to hold them together, feet and finger bones were lost in the mud. The diggers kept one another's spirits up with black humor and ceased to think of the putrid objects as body parts. One of them told me later that after work every night, they attacked Gacy's 29 cases of beer in his kitchen, until there was only a six-pack left.

Families who had lost their sons came to watch. Dental X-rays of runaways were matched to newfound teeth; casts were made to show how various victims had looked in life; names of missing boys were linked to skeletons. Dr. Stein was on television nearly every night.

When I first saw John Wayne Gacy Jr., we were at the Des Plaines courthouse again, but this time a SWAT team patrolled the roof. Below in the courtyard, scores of cameramen, soundmen, producers, artists, and reporters from magazines, wire services, television, and newspapers

jostled and shoved.

There was nothing extraordinary about the man I finally glimpsed between the elbows of deputy sheriffs as they hurried him by. Gacy, plump and graying, wore a leather jacket. He had a bulbous nose and Kewpie doll lips under a trim mustache. He resembled the suburban businessman that he was; if I'd come across him in a dark alley, I wouldn't have run.

I drew John Gacy in pretrial proceedings for about a year. The police had confiscated everything he owned, and his defense lawyers bought him the brown sports jacket, brown slacks, brown tie, and white shirt that he wore to every session. We learned later that John Gacy hated the color brown but was too much of a gentleman to tell his attorneys.

A building contractor who specialized in constructing and remodeling drugstores, John Gacy looked much older than 36. He had been married and divorced twice and had had two children. He had served on the boards of the local water and street lighting districts and was prominent in the local chapter of the Jaycees. He boasted about the big shots he knew; he had had his picture taken shaking hands with First Lady Rosalynn Carter when he organized the Chicago Polish Constitution Day Parade.

Each year, he invited his Norwood Park neighbors to a theme party. In '76 he was costumed and bewigged like George Washington. The Southern Jubilee year, he was a Kentucky colonel; a third year, an Italian peasant.

As a "licensed clown," Gacy performed at parades and at the openings of shopping malls, and he entertained sick children in the hospital. When masqueraded as Pogo the Clown, he took his duties seriously. Investigators who searched his house found a whole room full of clown pictures, some painted by Gacy.

"Clowns can get away with murder," he told the policemen before his arrest.

During all of 1979, interest in Gacy was high. Gawkers drove by his house, or what was left of it, took pictures and pocketed pieces of concrete. People at cocktail parties discussed whether he was crazy. People asked me what he was like to draw.

On January 7, 1980, Judge Louis Garippo held a hearing at 26th and California on the defense's motion for a change of venue due to excessive publicity. I sketched Gacy sitting at the defense table beneath a bulletin board covered with newspaper clippings, the headlines of which included:

DIG FOR BODIES AT BURIAL SITE
BODIES OF 3 TEENS FOUND, 29 MORE ARE FEARED SLAIN
FIND FOUR BODIES—HORROR STALKS A SUBURBS
FIND 5TH BODY IN HOME
ANOTHER GACY BODY FOUND, TOTAL UP TO 31
WHY DIDN'T GACY KILL ME? EXCLUSIVE PHOTOS PAGE 10

Judge Garippo ruled that an uncontaminated jury could not be found among the citizens of Cook County. A compromise was reached to keep the trial at 26th Street but to gather the jury from elsewhere. On Monday, January 28, 1980, jury selection began under heavy security in Rockford, Winnebago County, 90 miles northwest of Chicago.

The press moved into the Clock Tower Hotel. Television stations and newspapers booked rooms for their reporters and artists alongside those of the judge, the state's attorneys, the investigators, and the defense attorneys.

Every morning my reporter and I got a lift into town with various lawyers and then sat all day listening to Judge Garippo question prospective jurors about employment and family, whether they had served on juries, their feelings on homosexuality, insanity, and the death penalty.

John Gacy lounged in his chair like a gentleman in his private club. Never more to wear brown, he showed off four new suits: the powder blue, the gray tweed, the flat gray with the vest, and the one that we called Gacy Green, a pistachio ice cream color.

He seemed to be more interested in the press than the Rockford citizens who'd decide his fate and turned his chair to keep an eye on us. He grinned and winked often.

My reporter wanted a sketch of him smiling. To catch him smiling, I had to smile at him first. And so I did, persistently, until I caught his eye and his face became transformed with delight. He smiled back, jabbing his lawyer and pointing to me. The two of us smiled at each other like the two happiest people in the world until the sketch was finished.

This was before the days of communications satellites, remote capability, and live TV trucks; every afternoon a courier drove up from Chicago, picked us up at the courthouse, drove us back to the hotel, waited for the sketches to be shot and the sound track recorded, and then drove to the airport, where he would give the tape to a helicopter pilot to fly back to the city. Then he would drive back himself.

"I met myself coming and going at the tollbooth," said Frank Golonka. "If I was coming, he was going, and if I was going, he was coming, but we was both me!"

The Clock Tower Hotel was like a luxurious pressroom. Through the open doors you could see, all along the corridor, reporters—from the *Sun-Times*, the *Tribune*, the Associated Press, and so forth—typing away at identical dressing tables.

In the morning dry snow squeaked under our heels as we started sleepily off to court; we peered through windshields sparkled with frost. At night we would drink in the bar with the judge, lawyers for both sides, and investigators and then pile into cars and go off down the icy highway in search of a new roadhouse, as pseudo-medieval as the Clock Tower, with the same wagon-wheel chandeliers and molded Formica furniture. On those festive evenings in wintry Rockford, even the opposing lawyers showed none of the usual enmity toward each other.

The conversation was always about John Wayne Gacy. There were many both funny and disgusting stories told, "off the record," by those who had worked on the case. Before his arrest Gacy had invited the officers watching him to come in out of their cold squad cars and fed them hot coffee, told them jokes and stories. This strange man charmed and fascinated everyone, even those who held him captive.

Judge Louis Garippo's father had been a Democratic Party official, and Garippo Jr. was often cited as an example of how patronage could be a good thing. He was a lanky, friendly man with a handsome big-nosed face and a boyish haircut. His robe hanging open, he squirmed and fidgeted on the bench, making him difficult to draw. Later, after he became a defense attorney, he joked that when he heard his words read by a court reporter, they never made sense. He may have had a Chicagoan's loose way with syntax, but when he needed to, he could be succinct, allowing no nonsense.

Terry Sullivan in the early '70s had prosecuted 16-year-old Patty

Colombo for killing her family with the help of a much older lover. Terry was tall and swaggering; he flirted with female reporters and kidded with the men. His straight blond hair was long over his ears; his suits had double vents in the back and flared at the ankles.

Sullivan's partner, William Kunkle, the highest-ranking state's attorney on the case, was dark, chunky, and heavy browed—a bull ready to charge. Wearing a motorcycle jacket, cowboy boots, and a ten-gallon hat, he strode into the Clock Tower bar at night like a movie sheriff.

Sam Amirante and Robert Motta represented John Gacy. Motta, a slight man with a brown mustache, was taciturn, but Amirante loved to joke. Short and stocky, the former marine with curly black hair and pinstriped suits looked like a Mafia big shot.

Young, leather-jacketed, mustached detectives hung about, keeping a little to the side, looking it all over with their steady eyes, like cops everywhere.

It took four crisp, sunny, frigid days in Winnebago County to pick a jury.

The Rockford jurors were bused down to Cook County and sequestered in a Chicago hotel. They were in the jury box, and we, the press, were in the first spectator rows when the trial began in Judge Garippo's tense, highly guarded courtroom on February 6, 1980. John Gacy sat with his two attorneys near the windows, two deputies beside him. Behind him two enormous exhibits tilted on easels: one, a map of Gacy's property with numbered orange rectangles showing where each boy's body had been found, and the other, a slotted board on which to display photographs of the victims.

The John Gacy who had smiled in Rockford now picked up his heavy wooden chair and slammed it down at an angle so his back was toward the spectator section. The jury saw his profile, and we saw less of this man who never joked again.

Gacy's crimes were related in opening statements. The details of the horror stories were filled in. We learned how Gacy had met 15-year-old Robert Piest at Nisson's pharmacy and taken him to his house to talk about a summer job. "You're not qualified," Gacy had told him and then asked if he would like to make money doing a sex act.

John Wayne Gacy and deputy sheriff with chart of graves.

When Piest told Gacy no, Gacy told the boy that he would show him some magic tricks. The first would be the "handcuff trick." He then hand-cuffed Rob and stripped him naked, threw him across the bed, and tried to have oral sex.

"Not getting the results he wanted," said the prosecutor, "and Robby crying, Gacy said, 'Don't cry, I'll show you the rope trick.'"

He strangled Robby and left his body on the floor and then got into bed and went to sleep beside it.

Marko Butkovich, whose son John had worked for John Gacy and was his first known victim, took the stand as the prosecution's first life-and-death witness.

"Mr. Butkovich, how many children do you have?" boomed Bill Kunkle.

"Now I got five," answered Butkovich.

"Prior to July 31, 1975, Mr. Butkovich, did you have a son named John?"

"Yes."

"How old was he at that time?"

"Eighteen, not quite," answered Butkovich.

Bill Kunkle showed Butkovich a picture of John and asked, "When you last saw your son on July 29, 1975, was he alive and well?"

"Yes," answered Butkovich.

"After he walked out of the door of your house, did you ever see him again?"

"No."

"Nothing further, Your Honor," said Kunkle.

After showing the picture to the jury, Kunkle strode over to the display board and placed the picture in the slot over John Butkovich's name.

Dolores Vance, a lady from Uptown with scraggly blond hair and missing teeth, told how she had gone to the police when her 18-year-old son, Darryl Samson, disappeared in April 1976.

"They made a missing report and they told me that he had just ran away," she drawled.

So she hired her own investigator, "and that didn't turn up nothing and since then I been looking all on my own."

She told us in her Southern accent how she had "searched and searched and searched," from the streets of Chicago all the way to Virginia. She said she "burnt out four cars" looking for him.

When she was shown his picture, she burst into tears.

After her, Bessie Stapleton testified about her 14-year-old son, Samuel Todd, who also disappeared in 1976. Upon being given his chain bracelet to identify, she began shaking and sobbing and called out, "God, why?" and then she crumpled down in her seat. The deputies rushed her into the back, and the judge called a short recess.

Myrtle Reffett testified about her son, Todd, and Shirley Stein testified about her son, Michael; Esther Johnson told about Rick and Eugenia Godzik and her daughter about Greg. Violet Carroll and Rosemary Szyc told of their boys, William and John, respectively.

All of them broke down. As I struggled to draw, I learned the pattern of the mothers' behavior: the hesitant but brave beginning, the gradual

disintegration as the questions continued, and the final collapse into tears as each was shown the picture of her son. Always the deputy would bring a paper cup of water and put it beside the sobbing heap on the witness stand. Water, that most impotent of beverages, always seems to be offered when comfort is impossible.

I felt ashamed. Those kids billed in the press as derelicts, delinquents, runaways—all had had relatives who cared, who had "searched and searched and searched."

The next day life-and-death witnesses for the remaining 12 identified victims told their stories.

Elizabeth Piest had to wait the longest; Rob had been Gacy's last victim. Her voice trembled as she answered Terry Sullivan's questions. When asked how many children she had, she answered, "I have three."

"You have three children now?" asked Terry, clearly appreciating the dramatic value of her mistake.

"No, I have two."

She told about Rob, how he had been a sophomore in high school, on the gymnastic team, on the honor roll in his freshman year. He was only two merit badges away from making Eagle Scout, she said, "which he wanted very badly."

She fell into sobs when Terry handed her Rob's blue parka.

The mothers—big, little, fat, tiny, some like grandmothers, some like girls, some hillbillies, some respectable suburban matrons—for two days they were called out of the back room to the witness stand.

My son had also been 15. He had also disappeared in 1976. But even had I not been connected in that way, my eyes would have stung and started to water as I drew the mothers.

What must it have been like for those women in that room, waiting to testify? Sitting all day in that community of grief?

I saw the trial stretching out ahead into the darkest part of winter. I worried about it filling my waking hours and leaking into my dreams, as I knew trials could, driving away the faces of family and friends who were still alive.

Because the jury was sequestered, we often had to work Saturdays; that first Saturday the prosecutors began building the story of Robert Piest's disappearance. They put on three people who had seen Gacy with Rob when they first met at the pharmacy and then two policemen who had gone to question Gacy the next day, unaware that Piest's body was in the attic above them.

Sullivan on redirect examination extracted from the second policeman one of Gacy's most famous remarks. Gacy's favorite uncle had died in a hospital at about the time Gacy was strangling Rob Piest. When the officers wanted Gacy to come to the police station, Gacy complained that he couldn't because he was in the middle of making his uncle's funeral arrangements.

"He asked the question," the policeman testified, "'Don't you have any respect for the dead?'"

The following week, teenaged boys who had worked for Gacy, whom for some reason Gacy had felt no need to kill, gave the jury a look at Gacy's after-hours life.

Robert Zimmerman, dressed as though for church in a navy blue blazer, necktie, and white shirt, testified that he was a guest at one of the big parties that Gacy gave every summer. He said that there weren't many young people in attendance, and yet, "[Gacy] was with us a lot, and it struck me kind of odd that he was smoking pot with us. I asked him [if] he didn't care about his older friends knowing it. He said, 'No, if they don't like it, they can lump it.'"

Anthony Antonucci described how Gacy once got handcuffs on him, but he was able to get them off because they weren't properly closed, and he got them on to Gacy instead.

David Cram had been 18 years old on the night in July 1976 when he was hitchhiking and Gacy picked him up. There was a PDM ("painting, decorating, and maintenance") contractor's sign in the window of Gacy's car, and he hired Cram to help paint Oppie's hot dog stand. Cram rented one of Gacy's extra bedrooms for $25 a week.

"Did you ever notice any drugs in his house?" Sullivan asked.

Cram: "Yes.... He had them in the refrigerator, behind the bar, in a couple of places, behind the pictures."

"Did he ever offer these drugs to you?"

"Yes...just about any time that I really wanted them...if we were all

dragged out in the morning, he used to give us a pep pill and speed to get us going."

Cram explained where Gacy got the drugs. "As we were remodeling the drugstores, we'd have complete access to everything."

Asked about Gacy's own drug and liquor consumption, Cram testified that if Gacy was affected, it was "just once in a great while."

"For the most part, he did a tranquilizer and had two drinks and it just turned him in…. He just dozed off in the middle of a conversation."

Cram was asked to step off from the witness stand and demonstrate how he dug trenches to Gacy's specifications in the crawl space under the house. This was important testimony for the state because it implied that Gacy's murdering was sane and premeditated.

Cram told of how the morning of Gacy's arrest, Gacy broke down and cried and said he had confessed to 30 killings. He told Cram that they were "syndicate-related killings."

That day Sullivan and Kunkle carried into the courtroom the hatchway to the infamous crawl space and placed it in front of the jury box. The artists fell to drawing the beat-up, cratelike structure, grateful for a subject that was unusual and that stayed still.

The witness Michael Rossi was asked to leave the stand and identify the strange object on the floor of the courtroom. The jurors peered down over their railing.

Gacy had told Cram and Rossi he was going to install drain tile under the house and ordered them to dig a trench.

Rossi said the trench sides came to between his knees and his hips, approximately a foot wide. He said that while he was digging, he saw no drain tile.

Robert Schultz, one of the policemen involved in surveillance before the arrest, testified about "using the washroom" in Gacy's house when the heat "kicked in," sending up the stench of the buried bodies.

That Gacy would let an officer of the law so close to his secret fitted the Gacy paradox: The genial host was a serial murderer, and his powder room covered graves.

Ron Rohde, Gacy's "best friend" and fellow contractor, testified.

John Wayne Gacy witness with crawl space model.

"I thought I knew this gentleman very well," he said. "He was just as normal as everybody else.... He was kind of a bragger, but we all brag once in a while.... He came to my 25th anniversary party. He drank scotch and water. He was like any other normal person. If he had too much, he would throw up and pass out and that was the end of it. We'd put John to bed."

Rohde sat squirming on the witness stand, trying not to look at his former buddy as he told of the good times they'd had, the parties they'd attended, and the trip they once took during which they'd shared a hotel room. He seemed to shudder when he recalled the latter; never in the world did he suspect Gacy might be queer—as though this were worse than being a murderer.

Rohde told about Gacy's visit the day he was arrested.

"He was kind of ragged, like he was up all evening. The first thing he asked me for is a drink, Scotch and water on the rocks." After he had his drink in the kitchen, Gacy said he had to go to the cemetery. "He says, 'I

really came to say good-bye to my best friends for the last time.' I says, 'What the hell are you talking about?' He told me. 'Well, them son-of-a-bitches out there are going to get me.'

"He walked up and put his hands on my shoulder, and he starts crying and he says, 'Ron, I have been a bad boy.' I look at him. 'Oh, come on, John,' I says, 'you haven't been *that* bad.' He says, 'I killed 30 people, give or take a few.' I didn't know what the hell to say. I looked at him, and I says, 'John, the only bad people I know is Jesse James and Billy the Kid, and they are all dead.' He was crying.

"'OK, John,' I said. 'You're full of shit.' I thought I knew this gentleman very well. It would be like somebody's best friend giving you a shot right between your eyes."

When Gacy picked up his coat to leave that morning in Rohde's kitchen, a rosary fell out onto the floor.

"I says, 'Hey, you son of a bitch, when did you turn so religious?'"

Bill Kunkle asked if Gacy had been a regular churchgoer. "No way," answered Rohde.

Rohde testified that he grabbed and shook Gacy. "'John,' I says, 'for once in your life tell me the truth. Do you know the Piest boy?' He says, 'Ron, I swear, if he walked through the door, I wouldn't know him.'"

Then Gacy asked for a gun.

"'John,' I says, 'no way am I going to give you a gun. What do you want a gun for?' He says, 'If I'm going to go down, I'm going to take a few of those son-of-a-bitches with me.' I says, 'My friend, if you're going to go down, you're not using one of my guns.'"

Rohde told of Gacy calling from the county jail in July 1979. "He kind of caught me off balance. I says, 'How did you get phone privileges, John?' He says, 'Oh, I'm a celebrity here.'

"'John,' I says, 'explain one question to me—how the bodies got under the house.' There was a little silence. He says, 'There's going to be a lot of surprises—there's a lot of keys out to my home.' I said, 'Well, hey, you son-of-a-bitch, I ain't got one!'" At this nearly everyone in the courtroom laughed, including the jurors.

On cross-examination, Sam Amirante asked Rohde, "You are extremely hurt and aggravated by this man, aren't you?"

Rohde: "I don't have the hurt that some of the people in this room have.

My hurt is completely different.

"I believed John," he said moments later, "until the first body came up under his house."

The evidence technician who had been the first to discover the body parts in the crawl space testified. The hatchway was now resting on a table, making it the same height it had been in the house, and the officer, in a three-piece gray suit and silk tie, dropped to his knees on the floor beside it. While the jurors craned their necks to watch, he crawled on the floor, describing how he had dug in the narrow space and slid on his stomach under the center support beam. He told of black puddles and red worms.

Another officer testified about questioning Gacy at the Des Plaines police station late that same night. He told how Gacy tried to explain that there were four John Gacys, each with a different personality. One of them, Gacy had said, was named Jack Hanley, and it was Jack Hanley who actually did the killing.

The second week of trial, Larry Finder, a young assistant of Sullivan's, described how Gacy had been sitting alone in an interview room at the police station when he beckoned to Finder to come and talk to him. Finder warned him that he was a state's attorney and anything Gacy said could be used against him.

After having been given his Miranda rights, Gacy described to Finder his time with Rob Piest and how he showed the boy the "rope trick."

Bill Kunkle asked Finder to come down off the witness stand. Handing him a rosary and a ballpoint pen, Kunkle took the microphone from Finder with his left hand and offered his right in a fist. Carefully, Finder knotted the rosary around Kunkle's enormous wrist and inserted the ballpoint pen as Gacy had shown him. The two navy-suited lawyers demonstrated to the courtroom how the religious artifact became a weapon. When they were through, Kunkle raised his fist to show the jury.

Next Kunkle had Finder describe a diagram that Gacy had drawn showing where he had buried the bodies in the crawl space.

"Your Honor, I didn't draw that drawing!"

We were stunned—it was the first time there had been any comment from the defendant. His lawyers whispered to him, and Kunkle continued as though nothing had happened.

Judge Garippo dismissed the jury and called Gacy to the bench.

"Mr. Gacy," he said, "during the course of this trial, it is not proper for anyone to just get up and begin to speak. If you wish an opportunity to testify, you may testify...but we cannot have you getting up, especially in front of the jury, and making statements like that. You understand?"

Gacy said he understood.

I often enjoy technical testimony, listening to experts who know about fingerprints, fibers, and bugs—arcane areas that most of us tread over like careless Gullivers.

After Cook County abolished the coroner's jury, Dr. Robert Stein became the medical examiner, and he would testify in important cases. He would describe autopsies almost gleefully. "First, vee haff made an incision, zen vee haf removed zee horgans."

Patiently, tenderly, he'd point out, on his own gray-haired and gray-suited corpus, entry and exit wounds. He would bring diagrams and slides, bright with oranges, purples, and reds, and sometimes a skeleton, its skull and limbs dangling jauntily from a metal hook like the ones we'd danced with in art school. Quite cheerfully he would explore the metamorphoses that a human body goes through on its way to becoming a piece of meat.

Now on the stand in the Gacy trial, he began with a lecture on death. In his high-pitched voice, he explained the difference between the "cause" and the "manner" of death.

"The cause of death is the initiating agent or agents which cause the demise of that individual. It could be chemical. It could be physical. It could be biological."

As for the manner of death, there were five possibilities: homicide, suicide, accident, natural causes, or undetermined.

Stein testified about his first visit to the crawl space, the investigation, the recovery of bodies, and the laborious process of identification.

As Kunkle showed him Samuel Todd's identification bracelet and began

questioning him about it, Bessie Stapleton, Sam's mother, began sobbing loudly in the spectator section.

Judge Garippo excused the jury and warned the spectators that there was more grim testimony to come; anyone who might not be able to handle it should leave.

Upon the jury's return, Stein was asked to give his opinion as to the causes of death. In the case of six bodies with ropes around their necks, he said it was "asphyxia due to ligature-strangulation." In the case of 13 bodies with clothlike material, sometimes underwear, in the throat area, the cause was "asphyxia due to suffocation."

As to the manner of death, Stein said that in his opinion they were all homicides.

(Sometime after the Gacy trial was finished, Dr. Stein sought to open a "mortuary museum" to display the artifacts of his profession. The authorities decided that this was not a good use of taxpayers' money and turned him down.)

After two days of putting on witnesses who clarified various aspects of the case, such as the recovery of the bodies from the river, the state's attorneys rested. On Thursday, February 21, the defense began its evidence.

Defense Attorney Sam Amirante asked his first witness, Jeff Rignall, the important question. Did he think Gacy could conform his conduct to the requirements of law, the legal standard for insanity.

Rignall answered, "No."

"How did you reach that opinion?"

"By the beastly and animalistic ways he attacked me."

Rignall, a 27-year-old student from Florida, had been walking on the Near North Side early one morning in March 1978. Gacy pulled up in his big black car with the spotlight mounted on top, complimented Rignall on his suntan, and asked him if he wanted to share a joint of marijuana.

Rignall testified that, though he also had sexual relations with women, he preferred men. He had just had an argument with his girlfriend, and so he got into Gacy's car.

They were passing the joint between them, when suddenly Gacy hit Rignall in the face with a wet cloth.

"I immediately started having like a buzzing-bee sensation in my head, and I went unconscious."

Rignall said that when he came to, he was strapped in his seat and saw "amber lights going out of the car window above, like they were a spaceship flying by, one right after the other."

Gacy hit him with the rag again, and he passed out. When he finally awoke completely, he was on a couch in a room with a bar, and there was a clown picture over the bar. Gacy was fixing drinks.

"'Why did you do that to me?'" he had asked Gacy. "[Gacy] came back with a very stern, deep tone in his voice and said, 'There is a gun under the bar and I'd just as soon kill you as look at you.'"

Again Gacy hit Rignall with the rag, and when he regained consciousness the next time, he found he had been stripped naked and restrained on a flat wooden board with holes in it. Gacy made it clear, testified Rignall, "that he had total control of me and he was going to do what he wanted with me, when he wanted, and how he wanted, and he had the power over me."

Gacy beat him and raped him for hours and then chloroformed him one last time. Rignall woke up, bruised and bleeding, in a park near where he'd been originally picked up. He was lying in the snow at the foot of a statue of Alexander Hamilton.

He testified of the difficulty he had getting any attention from the police once he admitted to them that he was homosexual.

On cross-examination Bill Kunkle pointed out that Rignall had written a book about his adventure; Rignall's testimony might be designed to promote the book's sales.

Kunkle began to go over in relentless detail the tortures that Gacy had performed on the witness. As he continued to testify, Rignall started to cry.

Rignall had testified that he had been under psychiatric care since the attack and that his therapist had accompanied him to court. Now his doctor came to stand nearby. Everyone waited quietly for Rignall to regain his composure each time he collapsed into sobs.

As Kunkle explored the rape still further, Rignall pitched forward, his head hitting the wood in front of him with a thud. The psychiatrist and Stanley, the courtroom captain, held his shoulders while he vomited on

Witness Jeff Rignall vomiting on the stand.

the witness stand.

The second defense witness, Lillian Grexa, Gacy's next-door neighbor, told the jury that, though Gacy could be stern, he was a good father and a generous, warm, and good man, always helpful and smiling. The only complaint she had about him was that he refused to trim the tall hedge between their houses.

On cross-examination she didn't answer the way the defense wanted. She said, "There is no way I am going to say that John is crazy. I think he is a very brilliant man."

James Vanvorous, another contractor, testified that Gacy was hard-working, demanding, and trustworthy. Thomas Eliseo, a psychologist who had interviewed and tested Gacy, followed him to the stand. Eliseo was the first of the many psychiatric witnesses for both sides.

Dr. Eliseo said that when he examined Gacy, he appeared to be "of superior intelligence, about the top 10 percent of the population—very bright."

He said Gacy showed no signs of major brain damage but suffered from a "continuing and uninterrupted mental disease that began some time early in Mr. Gacy's life...borderline schizophrenia or borderline personality." He was "a person who on the surface looks normal but has all kinds of neurotic, antisocial, psychotic illnesses."

Eliseo, answering the key questions, said that Gacy could not conform his conduct to the requirements of the law; he lacked capacity to appreciate his conduct's criminality.

Kunkle fought him tooth and nail. He objected continually and several times the judge called the lawyers to the right of the bench, where they whispered furiously.

On cross-examination Kunkle asked Eliseo how many cases he had seen of psychotics going as long as 20 years without being diagnosed or treated.

"Few," answered the doctor.

Kunkle: "Would you name those?"

Eliseo: "Particularly with paranoid schizophrenia...Richard Nixon."

Kunkle: "You have treated President Nixon?"

Eliseo: "No, from what I have read and seen. King George III of England."

People had begun to laugh when Judge Garippo interrupted. "I have heard enough. You may step down."

One Saturday I expected to have off, the phone rang.

"The ex-wife is on the stand," announced a panicky voice from the assignment desk. The courier was on his way.

The car screeched through empty weekend streets black with old snow as we sped to California Avenue. Carole Gacy was on the stand when I squeezed onto a bench and began to draw.

The second Mrs. Gacy was an attractive woman with short, fluffy dark blond hair; she wore a simple dark dress with a pointed white collar. She seemed very gentle and sad.

Amirante was asking her about Gacy's behavior when he was drunk.

"If he had too much and just couldn't handle it anymore," she answered, "he would just be very quiet and sit down and pass out, or just fall right on the floor."

She told how he'd always been a good husband and lover and a generous stepfather to her two little girls. For a while they had all been happy together. But less than two years after they were married—it was Mother's Day, she remembered—they made love, and then Gacy told her that it was the last time they would have sex. Four months after that they were separated.

She had known of Gacy's "bisexuality," as he called it, for some time. Sometimes, she said, they would go to bars together and, looking around the room, she would pick out the young men that she thought would appeal to him, and they would laugh about it.

She had never suspected that John Gacy had brought her as a bride to live in a house that marked a grave. But she had noticed a bad smell in the utility room and little black bugs flying around. When she asked Gacy to call an exterminator, he told her no, it was just dead mice and he would set traps for them.

Amirante asked her if the John Gacy she had seen on the news was the

same man she had been married to.

"No, not at all," she answered.

"Sitting here in court today, how do you feel about John?"

"I feel sorry for him. My heart goes out to him."

She was sobbing now and Gacy himself had his head down, his face covered with one of his big hands.

We were hearing about two different men, not the John Gacy–Jack Hanley dichotomy that Gacy himself had put forth, but two aspects of the real John Gacy. It became apparent that sitting in our midst was someone who meant different things to different people. To people like Jeff Rignall, the police, the press, and the prosecution, he was a depraved and cruel predator, a "chicken hawk" who cruised the night streets seeking out victims. To people like Lillian Grexa and Ron Rohde, he was a good friend and neighbor, someone who cared about their problems, as well as those of the lighting district, the Polish Constitution Day parade, and little kids in the hospital.

Carole Gacy was another of the people who loved John Gacy. To her and the others, Gacy had been decent and compassionate, tender and thoughtful; the worst they would say was he was braggart, a hard taskmaster, and sometimes hot tempered.

The testimony of these people was anguished as they strove to be loyal to a person who they must now doubt ever existed.

The stories being told on the witness stand remained parallel stories, they were about two Gacys—and the good one didn't absolve the evil one. When the defense witnesses sketched a picture of the gentler John Gacy, it had been a shock that the horror could be mitigated at all.

On Monday, as a furious snowstorm whirled outside the tall windows, Gacy's 72-year-old mother, Marion, testified. Dressed in Easter egg green, she came into the room inch by inch on a walker. She was short and plump and her hair a fluff of little gray curls. When asked to identify Gacy, she said, "That's John over there smiling at me."

She testified intelligently and calmly—trying to help, yet full of

compassion for her only son. She said he had always been a loving, caring boy. She admitted there had been a few unusual incidents in his childhood, as when her underpants were missing and then found where he'd buried them, in the sandbox under the house.

"He loved the feel of silk," she said.

When at a recess Gacy left the courtroom escorted by deputies, she was still on the witness stand. She reached her plump arms out to him, and he fell into her embrace; they hugged each other sobbing.

Yet another mother who had lost her child, she told the courtroom, "I love my son, I still don't believe any of it. I can't believe it…not my son, I'd just like to erase everything."

Afterward on the icy courthouse plaza, the press waited for her. A tiny woman in white bobby socks, she clung gratefully to the deputies' burly arms as they helped her down the steps. Moving backward in front of her, half a dozen cameramen recorded the trembling descent. At the bottom she thanked the deputies profusely.

All that day we heard testimony about Gacy's childhood, after his mother, from his sister and two old friends. We heard him described as a "typical teenager" and a "nice person"; we heard about the "blackouts" or "fits" he'd had two or three times when growing up. We heard about John Stanley Gacy, his father.

Both mother and daughter said Mr. Gacy Sr. worked very hard at his job and every night when he came home went straight to the basement. There he drank heavily, talking to himself in two voices, like "Dr. Jekyll and Mr. Hyde," while upstairs they waited to serve dinner. They characterized Gacy Sr. as a cruel perfectionist whom young John could never please.

"No one ever praised him," testified his sister of her older brother, "no one ever said, 'Hey, John, you did a good job.'"

She told about John buying her a new freezer when her old one broke down. "It was with love," she said.

"He had the biggest dream in life to help pay off me and my sister's mortgage so we wouldn't have to work…. John always came through from the heart."

Both mother and daughter clearly loved this man who had always

been good to them—and who now sat between the deputies, accused of 33 murders. The grief and anguish of the victims' relatives had a legitimate forum, but the defendant's relatives must have felt a grief just as devastating, and much more complicated.

Even the mothers' testimony wasn't as upsetting as that of Dr. Lawrence Z. Freedman, a psychiatric expert for the defense.

An imposing man in a black suit, Dr. Freedman had heavy black eyebrows and a scholarly demeanor. He did a sort of vivisection on the soul of John Wayne Gacy and exposed the confusion deep inside.

In a low, gravelly voice with a Massachusetts accent, he began by answering the questions that would qualify him as an expert witness. He offered long lists of degrees, honors, and awards, committee chairmanships and university positions. Dr. Freedman said he was a psychoanalyst who presently occupied a chair in psychiatry at the University of Chicago. Dr. Freedman was qualified as an expert without objection.

"Mr. Gacy is a very complex man," testified Dr. Freedman.

"I found Mr. Gacy one of the most complex personalities I have ever tried to study."

Dr. Freedman said that he did not believe that Jack Hanley was some alternate personality. "It is very common for middle-class men to protect their reputations when they solicit boy prostitutes, to use a false name. In my opinion, however, it goes beyond that. I believe Mr. Gacy is, in fact, troubled, uncertain about the two aspects of his personality: the driven aspects and the one which expresses such extraordinary aggression and sexual perversion."

Dr. Freedman's hands never stopped as he described Gacy's "psychotic core"; his long pointed fingers seemed to sculpt his concepts in the space in front of him. He said that Gacy had shown a pattern of "at least neurotic and psychosomatic illness from early childhood. . . . The beginnings of a psychosis probably occurred about the time of Christmas of 1969, when he was at a very low point in his life, an inmate at Anamosa [prison in Iowa], a failure as his father had always predicted. His father died on Christmas. He had wanted to present his father with a painting. He asked one of his friends at the prison to make a painting. He was unable to go to the funeral. I think

that triggered…the development of a psychosis."

He described how "Mr. Gacy, from the time of his birth, according to his mother, has always been considered to have had physical problems…. His mother believed that when he was born, he had respiratory distress because of congestion of fecal matter in the womb. Year after year…[he] would be told that he had heart diseases, so his anxieties, which were very great, tended…to be translated into…preoccupation with himself."

Freedman then began a narrative about a scared little boy, the son of a loving, long-suffering mother and an angry, alcoholic father. The father, who was a "man's man," was "extremely disappointed in his son. He wanted his son to do the things that he did, and he found him inept. He was very brutal toward him; he gave him the feeling he was dumb and stupid…over time, Mr. Gacy developed serious concern, anxiety which he would deny about his sexual identification: how masculine he was, how feminine he was…. He made serious efforts to establish meaningful relationships with women."

Freedman described the mother's powerlessness to protect her children from her husband's drunken rages. He described how John Jr. tried to please his drink-blinded father and always failed, how he found solace in the feel of silk, took his mother's underclothes, and buried them under the porch.

He told of the contractor, a friend of his father's, who "would come by and take John…to look at his construction…. He would get John to wrestle with him, and John would find himself with his head between the contractor's legs." This, as well as the fact that "every relationship he had with girls during this period was severely punished," added to his sexual confusion.

He described how as a teenager John once fought with his father. "His father began to curse and say, 'Hit me, hit me, you coward!' And John replied, 'I love you, I won't hit you, I love you, I won't hit you!'"

"This mixture of aggression and love," Freedman went on, "indicates an enormous strain on the psychological structure of the individual. The next day, as typically happened in that family, nothing was said…. It was as though nothing had happened."

The courtroom hushed as everyone listened. It was as though the testimony of brutal and bizarre happenings in this sensational murder case was temporarily forgotten. Instead, the witness was describing the behavior of unhappy, but not unusual, people trying to lead their lives in an impossible

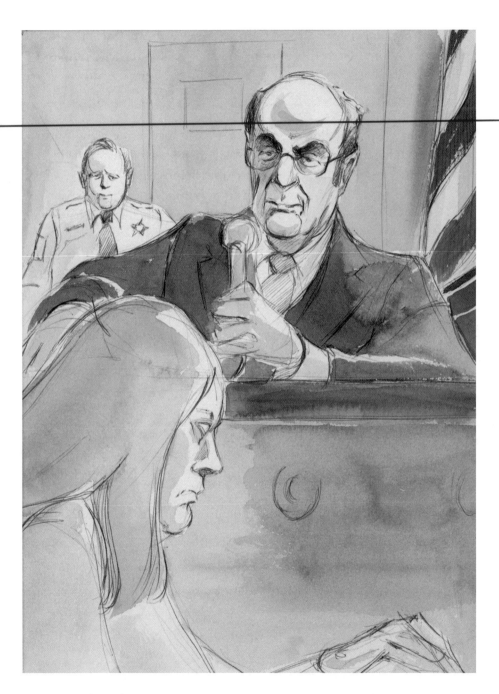

Dr. Lawrence Freedman on the stand at the Gacy trial.

situation. Freedman had directed attention away from Gacy the insane murderer and onto Gacy the unhappy kid.

Gacy's shoulders were heaving slightly and his head was down. When he thrust a handkerchief to his face, it became obvious that John Gacy was crying.

Freedman explained how Gacy couldn't admit that he was a homosexual, how he hated homosexuals, how he must kill them, because he needed to kill that which in himself he hated, that which was homosexual.

"He thought of [his victims] as trash, to be put out of their misery by these methods: a projection of his own feelings—which might have been turned against himself—turned against them."

Yet the physical type that Gacy preyed upon was different from his own. "These were muscular teenagers," while the young Gacy had been "a flabby and inadequate teenager, and these boys represented what he had never been able to attain."

In Gacy's case, the normal activity of repression had taken "an abnormal turn."

Freedman explained, "When the stress is too great, the things which are being covered by other forms of activity, in a sense, explode.... At the time of his accosting the Piest boy, his uncle, who he once slipped and called his father, was dying. This whole relationship with the Piest boy was mixed up with this death in the family, which, perhaps meaningfully, was occurring just as the Christmas season approached, just as his father had died at Christmas."

The murder of Rob Piest, Freedman felt, was unlike the others and was probably designed to get Gacy caught.

Finally, Amirante came to The Question.

"Now, have you reached an opinion, based on your knowledge and experience in the field of psychiatry, as to whether or not, at the time of the alleged occurrences, Mr. Gacy either lacked the substantial capacity to appreciate the criminality of his act or to conform his behavior to the requirements of law? Have you reached an opinion on that?"

"No," replied Dr. Freedman.

The courtroom was stunned. The whole point of putting such an expert on the stand in an insanity defense is to elicit an affirmative answer to this question. Before John Hinckley's assassination attempt on President

Reagan, one could be found not guilty by reason of insanity if he could prove he had been psychologically incapable of conforming his actions to the requirements of the law.

But Amirante wasn't upset; he knew his witness would answer this way, and he seemed proud of the august psychiatrist. "Now, would you please explain to His Honor and the ladies and gentlemen of the jury why you have not reached that opinion?"

Kunkle objected, and the lawyers and judge went to sidebar. When they returned, the jury was excused, and the doctor explained his strange answer.

"I am a psychiatrist and I have studied violence and sexual deviancy for some 35 years. I consider myself…competent…to make an evaluation in a case like Mr. Gacy's. The question you just put to me goes to the legal and social thresholds of punishability. I am aware of this because I was one of the team that wrote the Modern Penal Code, and every judge and lawyer told me that it was not a psychiatric question but a legal question. And I feel that these questions are outside my level of competence."

In the middle of a sordid murder trial a philosophical issue had been raised: "not a psychiatric question but a legal question," the doctor had said. The languages of these two disciplines, of law and psychiatry, could not speak to each other—their two worlds were incommensurate. *Insanity* was a legal concept, an attempt to accommodate some compassion for those who can't help what they do in a system intended for rational men. *Insanity* was apparently not a concept the psychiatrist was comfortable with. His concerns were those of a doctor, a researcher into the deepest parts of the mind, parts not easily mapped with legal instruments.

When the jury returned to the room, the judge sustained Kunkle's objection and Freedman was dismissed.

After the defense rested its case in chief, the prosecution's psychiatrists, called to rebut the defense's, said that John Gacy was not insane and could have indeed conformed his actions to the requirements of the law.

Thomas Phillips had been sodomized by Gacy when Phillips was a

teenager in Iowa. He was the first prosecution rebuttal witness to take the stand. He was a pale, big-boned young man in a light blue T-shirt with wild and frightened eyes behind little round glasses. Though prematurely bald on top, his hair hung in limp wisps to his shoulders, making him look like a skinny Benjamin Franklin. As he sat quivering on the witness stand, it became clear why the lawyers had chosen to first question him out of the presence of the jury.

Prosecutor Bob Egan examined him patiently but with little success, waiting each time for a stammered response, going on to the next question when there was none. Finally, Phillips managed a whole phrase. "I am totally bent out of shape," he told the courtroom.

Egan soon turned him over to Motta for cross-examination, and Motta began by asking him if he was seeing a psychiatrist.

Phillips: "Yes, sir, I am."

Motta: "How long have you been seeing him?"

(No response.)

Motta: "For a while?"

(No response.)

Motta: "All right, we will..."

Phillips: "Ever since I heard that Gacy was out of prison. Yes, I have had problems."

Motta asked if Phillips was presently under medication.

"I drank one beer for breakfast," replied the witness.

The lawyers and the judge went to sidebar to decide what to do. As they turned back to their places, the judge ordered the jury brought in.

Again Egan attempted to examine Phillips; again he got almost nowhere. All Phillips was able to say was that Gacy had come on to him sexually. The victim of Gacy's first serious crime was unable to articulate real answers. Egan finally withdrew Phillips, and Garippo later struck his testimony.

Even though the jury was thus supposed to ignore Phillips and disregard the little he had said, he had become the most damaging prosecution witness yet. His pain made the strongest statement possible: Gacy had perpetrated on him a horror beyond words.

That day was devoted to witnesses from Gacy's previous life in Iowa. There were ex-teenagers who had worked for Gacy, played pool with him

in his basement, been propositioned by him; there were businessmen who had been in the Jaycees with him; there was his former counselor from the prison at Anamosa; there was an ex-convict who had served time with him there.

This last witness, Raymond Cornell, now the Iowa prison ombudsman, said he'd felt grateful for Gacy's support at a bad time in Cornell's life. He also described how Gacy had been a big shot at Anamosa, making friends with the guards, wearing civilian shirts, and somehow obtaining his favorite cigars. He said Gacy was the director of the prison's Jaycee chapter, served as its chaplain, and became its "most decorated member" by winning the Sound Citizen Award. As prison chef, Gacy had improved the quality of the food and seen that the kitchen was kept spotlessly clean. He served the inmates filet of beef with mushrooms. At Christmas he played Santa Claus.

Together, these witnesses described the whole Iowa chapter of Gacy's life: his career as manager of his first father-in-law's Kentucky Fried Chicken franchise (where he was known as the Colonel); his Jaycees' activities; his forays into vice and petty crime and finally sodomy; his arrest, conviction, and incarceration.

We heard that in Iowa, as in Chicago, there had been good friends and neighbors; there had been victims and rapes but no deaths. It was as though this chapter had been a short story that he would later develop into a novel.

That afternoon Judge Garippo excused the jurors for their first two-day weekend. He told them to get some rest and take some vitamin C for they were "fighting all kinds of bugs."

As the winter wore on in its drab monochrome, people had fought bugs and lost—myself included. The pressure was intense and aggravations accumulated. My reporter and I argued, which had seldom happened before. She wanted me to sketch scenes I hadn't seen, and I refused. I sat drawing and sniffling, sick and exhausted.

Once the Associated Press was photographing my sketches in the lobby and the best one, a full-face portrait of Gacy, was missing. Since Rockford, we had never seen Gacy head on again, and I needed it. I searched frantically, scanning the floor between the moving legs. Finally in the crowded

corridor; Gacy's face stared up at me from the floor, the brown stippling of a boot print across its ocher cheeks.

Horror stories continued to be told from the witness stand. A scholarship student in law and government described being bound by Gacy, urinated on, threatened with a gun, raped, tortured, and almost drowned in a bathtub. He punctuated his narrative with quotes of Gacy: "'My, aren't we having fun tonight?' 'Aren't we playing fun games tonight?' 'Aren't these good games?'"

At one point the young man put the microphone down on the witness stand and cradled his face in his hand. He managed to say, "I could feel his knees and he, he put his knees between my legs and he grabbed onto my shoulders…"

Then sobbing, he cried out, "This is hell, this is hell!"

Judge Garippo looked down at him from the bench. "Let's take a recess," he said.

When court reconvened, the witness testified about the support his girlfriend had given him, how she had helped him to go on after the terrible experience. Then he continued relating in horrifying detail how Gacy entertained himself throughout that night.

When it began to get light outside the bedroom window, Gacy made him take a shower, told him to get dressed. Gacy told him that they were going for a ride. "I'm going to kill you," he announced to his handcuffed victim.

But Gacy didn't kill him. He drove him downtown and left him on the sidewalk outside the Marshall Field's State Street store. Before driving away, Gacy told him not to go to the police, saying, "'The cops won't believe you anyway.'"

Later that day the victim's uncle took him to Area Six Police Headquarters, where he filed a complaint with the homicide/sex investigation unit. Though Gacy was arrested, the charges were later dropped when an assistant state's attorney from Felony Review decided they weren't worth pressing.

"They didn't believe me."

Gacy sat smirking and shaking his head as though *no* reasonable person

should believe such a story.

The state also put on the stand eight rebuttal witnesses from Iowa, the executive director of the Cook County Jail (who testified that Gacy was a "very well-behaved inmate"), and five psychiatrists and psychologists. They made the prosecution's case even stronger than it had been at the end of its case in chief. The two sides' doctors canceled each other out. What mattered was the testimony of the victims.

On the morning of March 7, out of the presence of the jury, Judge Garippo announced, "Over two weeks ago, Mr. Gacy wrote me a letter with a few complaints. I gave that letter to his attorneys and was assured that there was no problem. Today I have received another letter from Mr. Gacy. Mr. Gacy, if you will step forward."

A deputy sheriff on either side of him, Gacy stood before the bench. The judge asked him if he wished to say anything before his letter was read into the record. Gacy seemed unhappy. "Well, it's written to you," he told the judge. "The letter is between you and I."

The judge explained that the letter must be made part of the record and began to read.

"'Over two weeks ago,'" read Judge Garippo, "'I asked that my trial be stopped and I haven't heard from you. When I asked my attorneys as to why we are not putting on more witnesses, I am told that we don't have money to bring in experts.'"

The letter asked for a mistrial because the prosecutors had "planted seeds" unfairly in the jurors' minds about Gacy being set free if found not guilty by reason of insanity. The judge continued reading Gacy's letter: "'I think that you can give them instructions until you are blue in the face and you won't take that out of their heads....

"'And,'" threatened the letter, "'I am taking back my word in regards to not saying anything in the courtroom. The prosecution continued to tries [sic] to make me mad while the trial is going on with the taking of my PDM Contractor labels and putting them all over the place. That's receiving of stolen properties, as I have never given permission.... I await to hear from

you and will abide by your word.'"

The judge put the letter aside and looked down at the defendant. He explained that at no time had Gacy been denied the right to bring in experts, that he had been allowed all that the defense requested, and that their compensation had been provided for. Garippo asked if Gacy still intended not to deal with his attorneys.

"That's correct," said Gacy. "While I may not be capable of defending myself, I was against the insanity defense. I'm sure Mr. Amirante and Mr. Motta will both tell you that."

"Have a seat," Garippo told Gacy.

Garippo asked Gacy's attorneys for their comments, and Amirante said that because of Gacy's "deep and penetrating mental illness" they had never felt he could completely cooperate with them.

"I did not commit the crimes!" came from Gacy in his seat.

Judge Garippo: "Based on my observations of the defendant in the courtroom, his demeanor, and all of the evidence in the trial, I would enter a finding right now that the defendant is in fact fit to stand trial."

He called Gacy before him again. "Do you stand by your statements relative to your disagreement with your attorneys?" he asked.

There was a long, long pause while Gacy stood before the high wooden bench looking down at his feet. Finally, he answered. "I don't know," he said.

After lunch Gacy wanted to address the court again.

"Everything I seem to say," said Gacy, standing in front of the judge before the jury was brought in, "has been misconstrued by the press. And I would like to set the record straight that I did not fire my attorneys. It's just that I do not understand everything that is going on, and I am against the insanity defense because I don't truly understand it myself.

"All the statements, in retrospect, that I have given, are confusing enough to me, that at the time I make the statement, I believe I would have confessed to the St. Valentine's Day Massacre, if it was put to me.... I would like to know myself if I committed the crime. I had talked to Dr. Freedman for a long time.... I have seen doctors for over 300 hours. And in doing so, I have been still left in the same confused state that I am in right now.... While I am not denying the commission of the crime, I don't understand it...why it happened, and that is why I don't understand the proceedings. I have been called every name under the sun in this courtroom, and half the

time I leave not even knowing who I am...."

On Saturday the defense presented a married clown couple who attested to the good character of Pogo the Clown. After the defense rested, Gacy made a brief statement out of the presence of the jury, explaining his decision not to testify.

"I don't feel I could add anything to something that I don't understand myself," he told the judge.

The very last witness, the state's re-rebuttal witness, was an unhappy-looking middle-aged man in a sport coat and tie. He said his name was James Hanley. He testified that he was a policeman with the hit-and-run unit and he'd met Gacy, whom he only knew as John, in the summer or fall of 1971 at Bruno's, a popular hangout for policemen, where Gacy had worked as chef.

Terry Sullivan asked Hanley how he was known at the tavern.

"By my last name," answered Hanley.

Sullivan: "Officer Hanley, to your knowledge, did the defendant ever know your first name?"

Hanley: "He never knew my first name."

It was Hanley's last name and existence as a Chicago policeman that Gacy had appropriated for his alias and his shield.

Gacy, fidgeting as he never had before, ran through four to five positions in a minute—hand to face, other hand to face, up in chair, slouched in chair—back and forth.

Sam Amirante's cross-examination provided a Dada touch.

Amirante: "You don't go cruising around Bughouse Square, do you?"

Hanley: "No, sir."

Amirante: "You're not John Gacy, are you?"

Hanley: "No, sir."

Amirante: "Nothing further."

Both sides rested.

As he began his final argument for the state, Terry Sullivan told the jury, "Today is March 11, 1980. On Thursday, March 13, two days from now,

John Mowery would have been 23 years old, if he had been allowed to live. Instead, his body was recovered from John Gacy's crawl space.

"On Sunday, March 16, Robert Piest would have celebrated his 17th birthday. Instead, his body was recovered from the Des Plaines River, the very river that he had volunteered to clean to become an Eagle Scout.

"Thirty-three boys were dead and the lives of parents, brothers, sisters, fiancées, grandmothers, friends were left shattered. Even though technically he left some surviving victims, they were little more than void shells—you saw them—and perhaps described best as 'living dead.'"

Sullivan turned and spoke directly to the pudgy man in the chair who was looking up at him with a smirk on his face.

"John Gacy, you are the worst of all murderers, for your victims were the young, the unassuming, the naive. You truly are a predator.... John Gacy, you have pilfered the most precious thing that parents can give...human life.... You have snuffed out those lives like they were just candles. You have snuffed out the very existence of those 33 young boys— forever."

That afternoon Sam Amirante had his last chance to help his client. Short, stocky, and intense in his wide-lapelled dark suit, the former marine moved around in front of the jury box punching with his fists, pointing with his fingers, making up with eagerness what he lacked in reasoned argument.

He reminded the jury of Gacy's sad childhood. "[He] tried so hard when he was a little kid.... He tried so hard to be good. But he was caged in his own flesh. He was eaten up by his raging illness.

"The man wanted to be good," Amirante went on. "He tried so hard to consume all of his time because he knew that there was this raging disease inside of his mind, something he could not control."

Amirante suggested that if psychiatrists had been more perceptive and diagnosed Gacy's illness earlier, all these lives could have been saved. "The man should have been studied," he asserted.

"A man does not have to be a bulging-eyed monster to be insane or to be mentally ill. He can walk around, and that is the most dangerous kind.

"It is frightening: a neighbor, a brother, a friend, a man with such a deep, dark, hidden, sick pervasive disease, and nobody can see it."

Amirante read from Robert Louis Stevenson's *The Strange Case of Dr. Jekyll and Mr. Hyde*: "'If I am the chief of sinners, I am the chief of sufferers also. Both sides of me were in dead earnest.'

"John Gacy is truly a Jekyll and Hyde, despite what psychiatric terms you put on it. He is the personification of this novel written in 1886—he was so good and he was so bad, and the bad side of him is the personification of evil."

Gacy, Amirante said, "did not want to do [the murders]. He could not control himself.... When you look at the whole picture, you will find that the state has not met their burden of proving Mr. Gacy sane beyond a reasonable doubt. We expect you to return a verdict of not guilty by reason of insanity."

The next morning, Bill Kunkle began his rebuttal argument. Tough, pugilistic, a football player swatting butterflies, Kunkle attacked the defense's psychiatric arguments of "predestination."

"When you turn that around, what it really means is that no one is responsible for his actions." He paused. "We can't run society that way."

He demolished all the defense's arguments and went after their metaphors as well. He pointed out that Mr. Hyde had come to enjoy the power that Dr. Jekyll's potion gave him, "the power of playing God, the power of deciding who will live and who will die." Gacy loved this power, too, he said. "He could torture victims to within seconds of their death and still maintain that God-like power to let them live."

Toward the end, he walked to the display board where the day before Terry Sullivan had placed the photos of the dead boys. One by one he began to remove them, and one by one he showed each picture to the jurors before letting it flutter down into the door of the crawl space that lay on the courtroom floor.

"We are not asking you to show sympathy—don't show sympathy!" he bellowed, waving the pictures around. "Show justice, show justice! Show the same sympathy and pity that *this* man showed when he took *these* lives and put them *there*!" His movements accelerated as he took the remaining pile of photographs and flung it with an expression of utter disgust into the rectangle at his feet.

After the instructions to the jury in the early afternoon, the prosecutors invited some of us up to their office "to celebrate." They served champagne in

plastic cups, and Terry Sullivan gave out green St. Patrick's Day carnations.

When reporters suggested this might be premature, they hadn't won yet, the prosecutors laughed.

"We're not worried," they said and showed us around their office, which boasted a treasure trove of Gacy-nalia: garish paintings of clowns, leaning on the tops of filing cabinets and against windowsills, and other clown paraphernalia. The photograph of Gacy with Rosalynn Carter was prominently displayed.

They gave out, like party favors, Gacy's business cards and ballpoint pens that read "P.E. Systems Contraction, John W. Gacy, Proprietor."

The lawyers for both sides, as well as some reporters, hardly had time to gather at Jean's, a block down California Avenue, when the bartender got a call that the jury was back. It had been less than two hours.

The verdict was guilty on all counts; the insanity defense had been rejected.

The next day we reconvened to listen to arguments on whether John Gacy should be put to death.

At the end of his final summation, Amirante asked the defendant to stand. "Look at John Gacy," he said. "You have heard him described a lot of ways, both good and bad. All those things do not put aside the fact that he is and always will be a human being. He was born the same way you and I were born. He had a mother and father. He grew up. Somewhere, somehow, something went wrong. Only God can judge his blackened soul.

"They are asking you to put him to death. Does that make any sense at all? How could, on one hand, we condemn a man for putting somebody to death and then just turn right around and do it ourselves? Are we collectively John Gacys?"

When his turn came, Kunkle bested Amirante again: "We are asking you to follow the law of Illinois. John Gacy is not an innocent man. He is not a human being like you or like Mr. Amirante. He is a convicted killer.

"This is a case that cries out, not only with the voices of 33 dead, but the voices of 33 families, but yes, the voices of every single citizen of this state, and that voice says, 'John Gacy, enough! Enough!'"

It didn't take much longer than it had the day before for the same jury,

eager no doubt after all these weeks to get home to Winnebago County, to decide against John Gacy again.

After accepting their verdict of death, Judge Garippo thanked the jurors for their sacrifice and complimented them on their diligence. He told them how recently he had met with some visiting Russian officials who had been amazed that our system would even bring to trial a defendant accused of such crimes as Gacy's.

"A lot has been said about how much this case has cost, and I don't know what it cost. But whatever the cost was...," he said, and he was obviously very moved, "it's a small price.... My voice is cracking because I really, truly feel it's a small price that we paid for our freedom.

"What we do for the John Gacys," he continued, "we'll do for everyone."

The next day John Gacy, surrounded by his pals the deputies, stood before the judge in his pistachio ice-cream green suit and was condemned to death.

Judge Garippo put it as simply as he could. "I sentence you to death per draft order," was all he said.

The people who had covered the trial decided to have a party. Mixed with the relief of no longer having to listen to the horror stories, a nostalgia was beginning for the community the trial had become. I volunteered my apartment.

Judge and Mrs. Garippo; Stanley, the deputy sheriff; print, TV, and radio reporters; courtroom artists; the lawyers and investigators for both sides—everybody came. The prosecutors brought a case of champagne, the defense attorneys a bottle of Bénédictine and Brandy, my reporter brought a cheese ball with nuts stuck in it like shrapnel.

Even one of the defense's psychiatrists showed up.

None of us would be quite the same again after the Gacy trial, and it made sense that we marked this with our own Gacy theme party. So we did, mixing gaiety with horror, covering terrible knowledge with layers of cheer and normality, just as the John Wayne Gacy phenomenon had from the beginning.

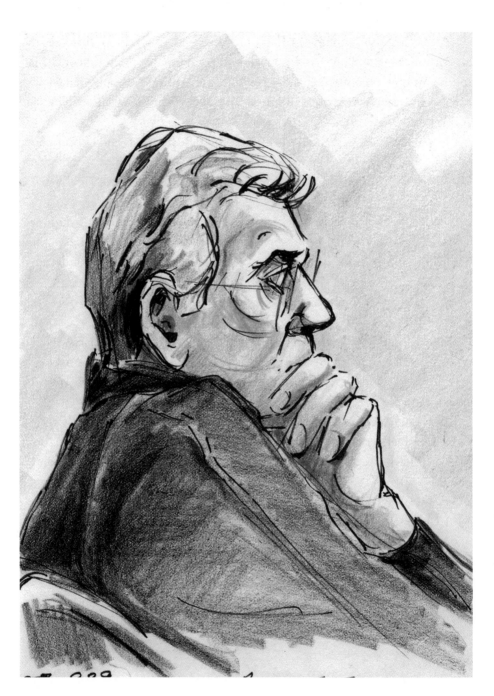

Albert Tocco.

5

A ROGUES GALLERY:
THE MOB, I

Like all big cities it was made up of irregularity, change,
forward spurts, failures to keep step, collisions of objects and
interests, punctured by unfathomable silences...it was like a
boiling bubble inside a pot made of the durable stuff of
buildings, laws, regulations, and historical traditions.

—Robert Musil, *The Man without Qualities*, translated by Sophie Wilkins

For de tings you did an' de tings you said
You, you Mother Fucker
You oughta be dead

—Heard on an undercover FBI recording

By the 1990s I had received an odd, if fleeting, education sitting so many hours in courtrooms. The course syllabus contained every possible field of study, from infractions of leash laws and petty prostitution cases to multibillion-dollar civil suits. Or perhaps I was like a tourist, traveling to every corner of the earth. Each time I entered a foreign domain, I learned a bit of the language, some of the customs, got to know

a few citizens. And while there, in that land, I was totally absorbed.

I enjoyed civil cases the most. The latest science was often involved and lots of money. Civil litigants could usually pay for better lawyers than could criminal defendants, and their experts testified to all kinds of arcane bits of information. They told how to make perfume, write popular songs, market video games, build airport people movers. Civil trials were also more passionate than criminal trials, those concerning sports the most passionate of all, as though people cared more about money and reputation than about life and death.

I hated personal injury cases, an amputee testifying, "I didn't know such pain was possible." I liked bankruptcy court, the room packed with pilots, baggage handlers, weeping flight attendants. I liked cases where the stakes were high but nobody died—and where children were not directly involved.

I detested juvenile court.

John Gacy's complex character made his trial an exception, but most murder trials are not only sad, they are more or less alike.

During murder trials the procedures, witnesses, and evidence produce predictable patterns. There is seldom any law argued; constitutional issues are not usually involved. The most dramatic testimony comes at the beginning when the life-and-death witness identifies a photo of the deceased, says that the last time he saw him, the victim was alive and well.

The first police officers to arrive on the scene report what they saw in earnest monologue, their descriptions full of "approachings" and "proceedings," the way Superintendent Orlando Wilson taught them to talk.

The evidence technicians slow things down further: the ballistics expert, the fingerprint expert, the fiber expert, perhaps an entomologist fixing the time of death through the life cycle of maggots. After DNA testing became available in the early 1980s, we would see the twisted ladders of genetic molecules projected on a screen, hear the expert announce the confusing double negative of astronomical odds against the defendant not having committed the crime. All too often this testimony is like forlornly remembered grammar school science classes. There is much identifying of paper bags and vials of fluid, pointing at charts, the court reporter interrupting constantly to have polysyllabic words spelled. "Can I look at my report?" the witness asks again and again.

Eyewitnesses tend to say the same things at murder trials: "I heard a noise like a firecracker." "I saw this suspicious car." "I was looking out the window waiting for my daughter to get home."

The arresting officer testifies how he gave his Miranda warning: "I read it off this little card that I keep in my hat." And the young assistant state's attorney from Felony Review describes how he asked the defendant if he wanted to call a lawyer, if he wanted cream and sugar in his coffee in the little room late at night at Area 6 or wherever the statement was taken.

On the defense side there is probably an alibi witness: "He was drinking with me and my buddies." Or a mother will testify that she knows her boy could never do a thing like that, no way.

Far from the passions of the moments surrounding a death, far from the implications of one human being taking the life of another, far from the devastating idea that when a man dies, a little world comes to an end, the murder trial lurches down its well-laid track. Its routine procedures do no aesthetic justice to the act that gave it life.

Bit by bit a small mountain of evidence is built; its material counterparts sprawl over the prosecutors' table, tumble out of shopping carts. I draw what I can of it, a still life of red-tagged and yellow-stickered boxes, plastic bags, facedown photographs, rust-colored, stain-stiffened clothes, perhaps a pair of athletic shoes. I draw the gun or the knife or the rope or the baseball bat.

Not far away the freshly barbered defendant slouches in his new sweater or suit, "showing no emotion," as they say, while outside on the wide ledges of the 26th Street courthouse, pigeons sleep.

In 1970 the Federal Racketeering Conspiracy Act, or RICO, was enacted, and as time went on more drug cases and more murder cases were tried in federal courts. "Freelance" murders—crimes of passion, insanity defense murders, child and cop killings—continued at 26th Street, but RICO gave the U.S. Justice Department tools to go after organized crime, and under RICO murders organized by big conglomerates were added to federal indictments. And it wouldn't have been Chicago without the Mob.

Covering murder cases in federal court felt different from covering

murder cases at 26th Street. In the federal Mob trials, a veneer of comedy covered the underlying tragedy. Watching the funny-looking defendants with funny nicknames made one want to know which came first. Did the mobsters learn from movies, or did movies learn from the Mob? Their machinations really did seem to take place in a foreign land, where foreign laws were obeyed; they didn't seem close enough to home to feel threatening or sad.

In February, 1983, Ken Ito was shot several times in the head, left for dead by the side of a road. I tried to make out the scars on his scalp when I drew him testifying against his pals, Little Joey and Big Joey.

I drew Jasper Campise and his sidekick John Gattuso looking worried at their first court appearance after they'd botched the Ito hit. Their next appearance was in a car trunk at O'Hare.

I drew a hit man who kept a shovel in his car trunk to dispose of bodies efficiently before he began cooperating. The agents asked me to black out the face in my drawing.

I drew Frankie "the German" Scwheis, a porn shop owner who complained, "There goes the neighborhood," when an art gallery moved next door. I drew him again in 2006, as he appeared in court, bent and wrinkled on a new indictment of ancient crimes. He, like Joey "the Clown" Lombardo, disappeared when their April 2005 indictment was announced and then resurfaced months later in orange MCC jumpsuits. The charges included 18 murders.

In 1982 I had chased Joey around the courtroom trying to get a sketch after the Teamsters tried to bribe a U.S. senator; he hid among the court buffs in the next to last row. We became friends later when he made coffee for everyone every morning before court.

I watched Harry Aleman be acquitted of murder by a fixed state judge in spite of flawless eyewitness testimony. And I made countless sketches of Allan Dorfman, the Teamsters' pension boss, whom Irwin Weiner later led into the sights of a .22 caliber automatic outside the Lincolnwood Marriott one bright January day in 1983.

Weiner once told me, "You don't draw me good, I get the full force of organized crime against you." Luckily, he had a twinkle in his eye.

Year after year the federal government hauled these gentlemen into court. And gentlemen they were, treating everyone with respect, moving

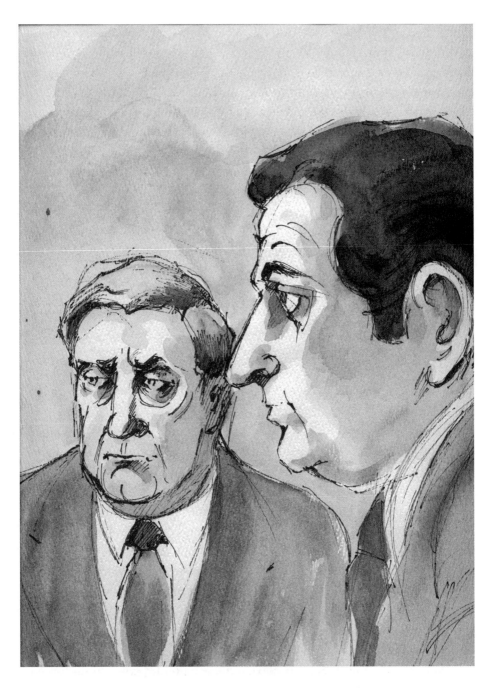

Doomed hitmen later found in a trunk.

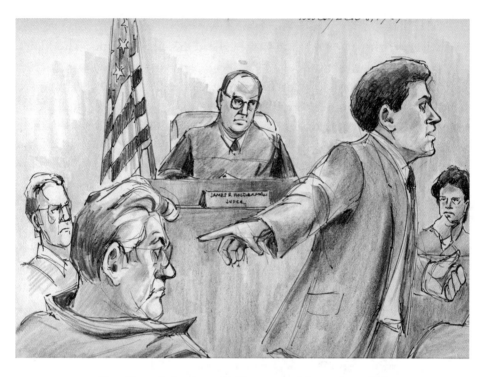

Albert Tocco, Judge James Holderman, and Larry Rosenthal.

around so the artists could get a better view, humbly polite to the judge, shaking hands with their prosecutors, opening doors for ladies, complimenting me on my green-framed half-glasses as they, in handcuffs, and I rode together in an elevator.

Albert Tocco, a well-known career hit man, winked at me when his ex-wife, who had ratted on him, testified about their favorite love song. He autographed and passed me a *New Yorker* cartoon in which an attorney tells the judge, "In order to save the court the expense of a trial, my client has escaped."

Tocco had escaped when the agents were bringing him back from Greece. As part of his disguise, he'd dyed his hair red.

"*Blond!*" shouted Tocco from the defense table every time anyone mentioned his red hair; then he'd wink.

The lady marshal came over to where I sat. "What's going on between you and Albert?" she asked, laughing.

Tocco explained on the witness stand why he had refused to plea bargain. Like a leopard, he had "spots," he said; he'd had them a long time. "They don't wash off," he said.

Jim Gibbons gave me a poster, "Armies of the Chicago Outfit," that the Chicago Crime Commission published in 1983, so I could understand where these men fit into the Mob's hierarchies and how to spell their names. He had someone in the Art Department letter at the top, "Andy Austin's Special Family Tree." From photographs of Joseph Aiuppa and Tony Accardo, the chart branched out into pictures of five street crew bosses, each with long lists of lieutenants and soldiers underneath. I put a red dot sticker next to each mobster's name after I'd drawn him, and as the years went on, the red dots accumulated.

These men were in some ways like John Gacy and in some ways very different. They were good family men and good community men, loyal, loving, and polite. Charm was only one of their virtues.

Like Gacy, they belonged to what I came to think of as the enigma of the beloved murderer. But with Gacy there was, if not the proof of insanity, at least the suspicion of it. The Mob killers seemed perfectly normal.

United States of America v. John D'Arco Jr.

John D'Arco Jr. was not a murderer, but he grew up in a business where "murderer" was one of several job descriptions. "Politician" was another, and that was the job the Mob had assigned to the younger D'Arco. When I first drew him in a federal courtroom, he had been a state senator for 13 years.

His father, John D'Arco Sr., was an alderman and then since 1952 the First Ward Democratic committeeman; as such, he was the Mob's main connection to Chicago politics. With the infamous party hacks, Pat Marcy and Fred Roti, he ruled a fiefdom that contained the Loop—the gritty heart of Chicago, where City Hall, the federal buildings, and the great banks, law firms, and businesses are.

John Jr., the 46-year-old crown prince of this traditionally corrupt and colorful First Ward, was a particularly valuable prize for the federal government. His trial for bribery and extortion in 1991 was a short but

comprehensive course in the sociology of Chicago politics. For anyone who knew about Chicago's wild and woolly beginnings, who had read about Hinky Dink Kenna, the Everleigh Sisters, and the First Ward Ball, it was another chapter in the history of the city. It brought things up to date and showed how little had changed since Chicago's adolescence as a muddy prairie town between the railroads, the river, and the lake.

I had met the younger John D'Arco a few years earlier at a flashy new restaurant where scores of people crowded around an enormous bar, a place where, under the din, hundreds of little transactions were undoubtedly taking place. When D'Arco and his entourage came in, the mass of people reshuffled itself; some people gave up their barstools. My architect friend designed buildings in the First Ward, so he knew the senator and introduced us. D'Arco didn't sit—he remained standing to the side, deep in conversation with one or two men. He paid no attention to the rest of his group, the provocatively dressed women or the thick-necked men, who were probably bodyguards. I was struck by how small and neat he was, like a well-designed pocketknife. Though he was surrounded by all the playboy trappings, he seemed not to be playing.

Edward Genson, D'Arco's attorney, objected continually to the government's opening statement. Ed Genson had already become a legend by 1991. Years before I'd done a sketch that made him look like an eighteenth-century dandy; all he needed were silken hose and pantaloons fastened at the knee. But since then various ailments had turned him into a limping, cane-brandishing, semi-invalid who practiced an old-style flamboyance that the court buffs adored. He appreciated that people need to be entertained, and he never disappointed.

Genson's stuttering interruptions of Assistant U.S. Attorney Tom Durkin's statement were undoubtedly designed to tangle its carefully woven threads. It was an intricate case, an unusual one—it was important to the government that the jurors understood what the crime had been, important to the defense that they didn't.

It had been a government-manufactured crime. For all the scum of wrongdoing that the feds had scraped off in their previous Greylord and Gambat prosecutions of political corruption, when it came to John Jr.,

they'd made something up. The main charge here was the kind of charge that always makes people ask, "But isn't that entrapment?"

Between interruptions, the prosecutor told how John D'Arco had accepted $7,500 from his old friend Robert Cooley to introduce legislation in the state senate. Unbeknownst to D'Arco, Cooley was working for the government, and the money was actually from the FBI. On FBI instructions, Cooley had pretended to represent travel agents who wanted to sell different kinds of insurance along with reservations: insurance against a missed plane, lost luggage, and so on. There would probably have to be a new statute introduced, and this is what Cooley's "people" were supposed to be paying the senator for. This was the sting.

But entrapment is not an easy defense to make, and it was not going to be made here.

When it was Ed Genson's turn to address the jurors, he began, "Lemme tell you about John...."

In a quivering, tender voice he went on: "He's got the introspection of a poet and the toughness of a ward politician."

Genson limped about the room, huffing and puffing, as he attempted to make his client into a lovable character. He also worked to make his client's nemesis, the undercover mole, into a villain. He called Cooley a "flim-flam artist" and "walking slime." He had a huge pad on an easel with diagrams, notes, and quotations; he kept flinging up pages like a magician swooshing his cape.

At the lunch recess, D'Arco, his lawyers, and his relatives ate sandwiches at the defense table. Anna De Leo, John's sister, was with them. She and I used to talk in the ladies' room about clothes when her husband, Pat, was tried for corruption and bribery in another Gambat case. She came and looked at my sketches and pointed out that her brother's nose was wider at the bottom than I'd drawn it.

Robert Cooley, in a bright blue suit and a red, white, and blue tie, was the first witness. Two FBI agents brought him in before the jury came in and then sat discreetly at the side.

For years we'd been hearing about this FBI "mole," and then, when his cover was blown, we began to hear him testify in court, to hear the tapes he made while wearing a wire against his former friends. Cooley's help with Operation Gambat had been invaluable in the fight against First Ward

Robert Cooley with witness protection agents.

corruption. Cooley had taped and testified against the secret merchants of Chinatown, against judges and aldermen, and against the mobster Mario D'Amico. But D'Arco Jr. was the closest of his old associates whom he had betrayed; Cooley and D'Arco Jr. had once been law partners.

Now Cooley boasted of his previous life. He claimed that before offering his services to the government in 1986, he had bribed at least 29 judges, as well as state's attorneys, clerks, and police officers. He recited his history in the language of attorneys and crooks—the swaggering phrases of an insider, someone familiar with the world in which he operates. "I went along with the program," he kept saying. He used phrases like "bagman," "moved his money," "took some lip," "money court," "money judge," and "First Ward favor" and court terms like "S.O.L." and "Noly Pross," as though everyone knew what they meant.

Cooley was boring the way plastic furniture in a waiting room is boring: repetitive, flat, ersatz. "And, again," or "Well, again," or "Again"—Cooley

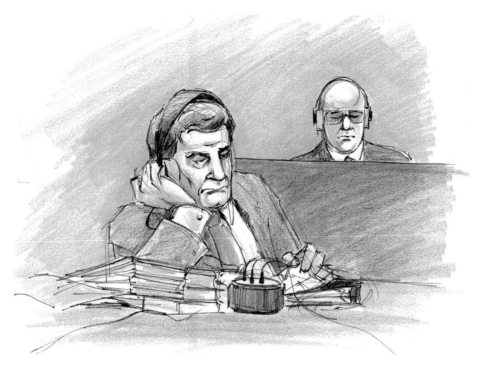

John D'Arco Jr. and Robert Cooley.

repeated one of these phrases before nearly every answer. He talked his tough-guy clichés and mangled the Queen's English: "I was talking in circles, I was talking in semantics, like I do sometimes." He overworked the phrases "indicated" and "proceeded" like the ex-cop that he was.

Cooley had a weak little smirk on his pink face, like a naughty kid who doesn't give a damn or a goody-goody kid who enjoys getting other kids into trouble. I'd seen him up close; his eyes were hooded like a snake's.

For two days the government played damning tapes that Cooley had made of himself and his old pal D'Arco talking.

When Cooley first brought up his scheme to have D'Arco introduce insurance legislation in exchange for money, the two men were at an Italian restaurant; we heard D'Arco ordering decaf, Cooley a cheese omelet with extra cheese—cheddar and mozzarella.

In another tape, Cooley took D'Arco into his car, illegally parked on LaSalle Street near City Hall, traffic noises muddying the voices. After the

doors clanked shut, Cooley paid D'Arco $5,000. We could hear the swooshing sound of cash being counted.

"You don't mind new bills, do you?" Cooley asked D'Arco.

"No. That's all right," answered D'Arco.

After Cooley had paid the money, he became very talkative, almost manic.

In the tape of the second payoff, at the Essex Inn, a run-down hotel on South Michigan Avenue, Cooley handed D'Arco $2,500 without counting it out.

The old law partners did a lot of eating as one taped the other. At breakfast in the Prairie Restaurant, D'Arco ordered granola with bananas, and Cooley ordered English muffins, ham, and hash browns. One time Cooley ordered three eggs over easy and hash browns and asked about the sausages. Another time they ordered a matzo ball soup, which Cooley sent back. "There's something wrong with the matzo balls." Cooley was the higher-cholesterol consumer and the exuberant one, the initiator. D'Arco was reserved, dignified—a man of few words and few calories.

The tapes let us eavesdrop on the First Ward community.

They told where people ate and what they ate, how D'Arco's mother made her special gravy for him and then froze it. They told where people bought their clothes, where they got discounts. "Morris and Sons...you ask for Sy," says Cooley.

The two men talked in flat, tough Chicago accents, interrupted occasionally by sweet-voiced waitresses trying to please, while the silverware tinkled and Muzak played in the background.

Cooley and D'Arco talked about Counsellors' Row Restaurant and the annoyance of the listening device the FBI had planted near the First Ward booth. If the First Ward was the heart of the city, Counsellors' Row was the heart of the First Ward. Marcy, Roti, D'Arco Sr., and other party hacks hung out there. Ed Genson, the great stage designer, had described the famous table (how, above it, framed photos of pols and their pals reached to the ceiling), the private telephone, and the "dingy" offices of the First Ward upstairs.

Cooley's suave actor's voice on the tape says that he's sure no real business is conducted there at that table, but it could be embarrassing anyway—everyone will want to hear what their friends have to say about them. He

imagines how it will be: "Hi, how ya doin'?" to someone coming up to the table, and then, as that person leaves, "That asshole, what a jagoff!"

On the stand Cooley twirled his finger over his head to show how one of the First Ward cronies had let him know the place was bugged.

The next time we heard a tape where money was passed, Cooley counted it. They were eating again, cream of wheat for D'Arco and steak and eggs for Cooley, in a nearly empty restaurant at the Bismarck Hotel.

After each portion of a tape was played, Assistant U.S. Attorney Mike Shepard would ask Cooley to explain what we had heard.

On the second day, D'Arco, usually expressionless, began shaking his head and smiling sarcastically. Once after Cooley had given a damning interpretation of some inaudible words, D'Arco suddenly yelled out from across the room, "You're the best, Bob!"

The lawyers had been headed to sidebar. Genson turned back, and as his hands massaged D'Arco's shoulders, he admonished his client in a loud whisper, "Don't ever, ever do that again."

In his cross-examination, Genson went after Cooley's sleazy background. He made Cooley admit that he was kicked out of college, that he was a crooked cop and a crooked lawyer. He tried to paint Cooley as a gambler who owed money to the Mob, who lied when he first went to the Justice Department Strike Force: his reasons for "wanting to help" weren't altruistic.

Genson staggered and stuttered, brandishing his cane, not letting Cooley "complete his answers." But Cooley was cool. And Shepard was the perfect straight man, gently amused, going along with Genson's jokes but not taking any guff.

Shepard and Genson were visually perfect adversaries: Shepard, Dick Tracy thin, dark, with minimal expression except for a sardonic smile; and Genson, pale and plump, damp strawberry blond curls rolling down the back of his thick neck bounding around limping. Under the defense table waited his Optifast diet drink, in a garish pink-and-white plastic container, a hospital straw sticking out of the top. Once he asked the judge if we could take a recess because he was "starting to sweat."

Trying to discredit Cooley, Genson went back over the Greylord

investigation's history. He talked about Judges Devine, Murphy, Pompey, Sodini, Olson, LeFevour, Scotillo, Reynolds, and McCollum, as well as the courtroom people and lawyers, Harold Cann, Steven Birnbaum, Ira Blackwood, and others. I had drawn them all.

Cooley testified that he was giving a stag party the night the news of the investigation broke in August 1983. At first he was worried, but after a while both Pat Marcy, the First Ward boss, and an attorney named William Swano assured Cooley that no one was going to name him.

For days Genson stumbled energetically around the courtroom on his cane. Sometimes he plopped himself down in the first row for a minute or two to rest.

Shepard frequently objected that Genson was editorializing and not allowing the witness to finish his answers. At one point Shepard rose and began to object. "Ah...ah...ah...," he started.

"Ah, ah, ah!" mimicked Genson, sticking his sweaty face under Shepard's. "Is that an objection?"

Judge Lindberg allowed that Shepard probably was trying to object and that Mr. Genson should be patient. So smiling sweetly, toe to toe, Genson gazed up into Shepard's face. "OK, let's get it out," he said and waited with mock patience while Shepard made his point to general laughter.

Judge George Lindberg was a relatively new judge who usually presided in one of the smaller courtrooms. He had to borrow Judge Leinenweber's room for this case, so "Judge Lindberg" was handwritten on a piece of white paper taped over Judge Leinenweber's brass nameplate. Lindberg's was the mildest personality in the courtroom, and he had trouble controlling the theatrics of the Genson, Cooley, Shepard trio.

Genson had Cooley describe how, when he first met Johnny D'Arco at Loyola University, they got into a fistfight. But a few years later they met again. John D'Arco Sr. had congratulated Cooley on his trial talents and suggested that he teach his son, recently graduated from law school, how to try cases. His son, who liked to write poetry, had been at Haight-Ashbury during the '60s, not a very First Ward thing to do. Senior felt that Junior could use a little help from Cooley about how to operate in the real world. Cooley described their years as law partners, how Johnny didn't like

trying cases and after a while stopped going to court altogether.

Cooley testified that John D'Arco Sr. had another task for Cooley. The old man didn't want Johnny seen with organized crime figures. He told Cooley that whenever any came around, Cooley should get Johnny out of the way.

This was more than Genson wanted to elicit, and Cooley kept doing this, kept trying to say more than Genson wanted him to, kept trying to paint a broader picture of the First Ward. Cooley dropped into an answer the disclosure that D'Arco had "bribed other judges."

"Oh, how many have we got now?" exclaimed Genson. "We're really going good!... Is there anything you won't say to help the government?"

The days started with D'Arco's wife, whom everyone referred to as Maggie Murphy, bringing coffee to the defense table before joining Anna De Leo in the pews.

In court D'Arco wore what could have been the same well-cut gray suit and dark red tie every day. The artists like it when a defendant wears the same clothes—they can use sketches again.

At a break he came over and looked at all the artists' work. "Can't any of you get me right?"

One day I came to court late. Marcia Danits turned her drawing up so that I could see her sketch of Ed Genson banging his cane on the defense table. She'd made comic strip slashes for motion around the cane. TV news wants action, and I had missed the best TV moments of the day. I had to "re-create" two incidents that I'd missed: Genson with his cane and one that Marcia described—D'Arco jumping from his chair at the recess and yelling at the prosecution attorneys.

"You've slandered my name all over the world! Fuck you!" he had shouted and then, as he left the room, "Motherfuckers!!!"

This was the fifth day of cross-examination, and Cooley had been dropping the usual little hand grenades into his answers, kept hinting at crooked dealings that weren't charged in the indictment. For instance, Cooley had begun an answer by saying, "The same day that Johnny contacted me to fix a case...."

"Judge, I move for a mistrial!" Genson exploded more than once.

Edward Genson with cane.

Bob Cooley, with that incipient smirk on his darning egg face, never gave a "yes" or "no" answer and often slipped in references to other First Ward misdeeds. The ex-law partner was the ultimate tattletale.

During the lunch recess I worked inches away from the picnicking group at the defense table. The lawyers and their client were laughing about how Genson almost broke his cane beating the table with it.

"Then you got *me* going!" kidded D'Arco.

I showed my sketch of D'Arco yelling to D'Arco. "Is that how you looked?" I asked him.

"Yeah, that's good!" he said and then cheerfully demonstrated how Genson had hit the table with his cane.

On October 29, before trial started, Judge Lindberg lectured the participants about behaving themselves. He said that Cooley must make more of an effort to give yes or no answers and, in an exasperated tone, told Genson that if he didn't stop beating his cane on the table, he would take it away from him.

Cooley testified that if some of his associates had known that he was working for the government, he would have been killed.

He seemed to take pride in the fact that people had had these plans for him. In the world of the Mob, you weren't really a man until somebody wanted to get rid of you.

Genson finished his cross-examination of Cooley, and Mike Shepard began his redirect.

Cooley was directed to tell the jury about the infamous Pat Marcy, the power behind all First Ward dealings.

Cooley: "[He was] the man to see to fix a court case, to buy a judgeship, to win a top police post, or to run for office in Cook County."

Cooley described how Marcy had been called Pasqualino Marchone at birth, that he was the "liaison" for "some of the top organized crime people in Chicago."

"At least once a week," Cooley said, "Marcy, secretary of the First Ward Regular Party, huddled with the Mob's 'main enforcers' in Counsellors' Row Restaurant, across the street from City Hall."

Marcy, the host at this table, had emerged as an eminence grise, a medieval wizard, in this case. More and more it seemed that Johnny D'Arco, often described as being "a question behind," was only one of the minor goblins.

Ed Genson was Marcy's lawyer, too, and Marcy was under indictment. None of us knew then, of course, that Marcy would beat the rap by dying.

On the afternoon of November 7, Senator D'Arco had just returned from Springfield. He had been excused by Judge Lindberg to vote on a bill he cared about, a bill he had tried and failed to pass before.

"Judge, I want to thank you for this," the senator told the judge, statesmanlike, before the government or jury came in. "We won by one vote."

At a break, he proudly explained his bill to reporters. It was a bill to make it easier for the elderly and handicapped to use public transportation.

While Ed Genson cross-examined FBI Agent Bowman about the investigation that had led to the indictment, Johnny D'Arco started to sob. He covered his face in his hands and sobbed more and more until he was crying so hard that he had to use his handkerchief to mop his face as

well as the table in front of him.

Judge Lindberg excused the jurors. As soon as they left, Maggie Murphy ran over to John, knelt at his feet, and cradled his head in her arms.

At a recess Marc Martin, D'Arco's other lawyer, told reporters that what had set him off was the testimony about the investigators going after D'Arco and his father, because they were "big fishes."

Both D'Arco's father and mother were sick at the time—maybe this upset him. Or maybe it was the triumph in Springfield contrasted with the humiliation of sitting for 19 days being attacked in the claustrophobic courtroom.

Special Agent Bowman had taken the stand in the government's case a couple of times, but mostly he sat silently at the prosecution table and worked the tape machine. In front of him were three stacked boxes of audio equipment, and from these a jumble of different colored wires protruded, wiggled over the table, fastened here and there with silver duct tape, and cascaded to the floor. Next to this high-tech tangle sat the little Nagra machine. It looked simple, this miniature reel-to-reel tape recorder with its tiny parts. When Agent Bowman picked it up in the palm of his hand, he did so lovingly.

One day, leaning forward from the first row during a break, I asked Agent Bowman about the *U.S. v. Infelise et al.* trial, which had started two floors above. A witness had testified that Hal Smith, the murder victim in that case, had paid $4,000 a month street tax to Mob bookie Marco D'Amico. Marco D'Amico had become a familiar name in this trial, too. D'Arco Sr. hadn't wanted D'Arco Jr. seen with D'Amico; otherwise nothing substantial was said, just the name, a dark note sounded here and there in testimony.

Agent Bowman, a taciturn man with a leprechaun's face, opined that between the two big trials in the building, the government might "do some damage." He said that the traditional Mob was on its last legs but that there were new mobs, "black, Hispanic, and white," taking over. He said these new mobs were more violent, more dangerous than the old ones and that they were only just beginning to be understood.

On November 14, while they were waiting for the judge, the defense lawyers and John D'Arco played with their new toy, a laser flashlight that

John D'Arco Jr. on the stand with prosecutors Mike Shepard and Tom Durkin.

shined a brilliant pink circle wherever they pointed it. They boasted that it had cost $300. Genson joked that he was "sterilizing" the assistant U.S. attorneys with it. He made the pink dot dance on their rear ends as they bent over their papers.

The defense put on the usual selection of character witnesses: a cripple, a doer of good deeds in the slums, a priest, a couple of nuns. A nice middle-aged black lady said about John D'Arco, "My opinion is he's a good man, he's an honest person, and I just love him."

John D'Arco took the witness stand late in the afternoon. He hadn't been sitting there long when he started weeping. It was after the questions "Are you married?" and "How long have you known Maggie Murphy?" that he began.

Recovering, John D'Arco went on to answer Marc Martin's other questions. He had attended St. Ignatius Preparatory School and Loyola University. In the 1960s he went out to San Francisco. "I was searching for

myself, for my identity," he said.

He was married the first time from 1969 to 1979, and he had children from that marriage. His writing meant a great deal to him, he told the court. "I love to write," he said. "I've been writing all my life."

When asked what he liked to write, he replied, "I write philosophy... plays."

Martin asked him if his work as a writer had been well received. John D'Arco gave a little smile. "My work? No, it's never been accepted."

Chicago Tribune columnist Mike Royko, delighted to make fun of Chicago pols, had been printing excerpts from D'Arco's poetry. Royko had quoted more than once from D'Arco's "Golden Tooth":

> *I dreamed I found a golden tooth.*
> *The natives were attacking.*
> *I realized there would never be*
> *An opportunity like this again.*
> *So I left it there.*

D'Arco filled in some of the details about when he first met Bob Cooley. In the Loyola cafeteria the different ethnic groups sat at different tables, so John sat with the Italians and Cooley with the Irish. One day Cooley was being obnoxious and John said, "Bob, if you want, I'll fight you."

When they went outside to fight, D'Arco found that Cooley had a gun. In spite of this, they fought to a draw.

D'Arco was picked by the city Democrats to be a state representative when he was still in law school. Someone had died, so there was a vacancy to fill. He commuted to Springfield when he didn't have classes, or when he couldn't attend, he had someone tape the lectures. He became a state senator in the same way—appointed, by the First Ward people, to fill a vacancy.

On November 15 Marc Martin and John D'Arco got to the important part of the defense.

"No, he never gave me any money," D'Arco said about Cooley. Then he quickly took a gulp of water as though to wash something down. He had been drinking gallons of water on the witness stand, pouring it from the thermos pitcher into a paper cup. Once while the judge and lawyers were

John D'Arco Jr. and his jury.

at sidebar, he left the witness stand and sneaked off to the men's room.

What a bad witness he was. His deep-set eyes darted back and forth like an animal's. After every answer he glanced at the jury like a woman checking her reflection in store windows. The jury didn't return his gaze.

Watching John D'Arco on the witness stand was painful. During direct he managed to tiptoe through the minefield of his own lies, but in the cross-examination he shrunk to an insect, pinned and dying.

Cool and lethal, Mike Shepard called him Senator every chance he got. Shepard forced D'Arco to say he lied and to say he took money from Cooley to bribe Judge Scotillo and pocketed it. Shepard got him to admit that he made mistake after mistake on direct testimony. Shepard's masterful cross-examination helped D'Arco to weave an even more tangled web, and what emerged was a defense that seemed worse than the crime alleged.

"As I understand your testimony, Senator...," Shepard would say, and his paraphrase reeked of absurdity.

D'Arco barely managed to keep his cool, but he seemed strongest when he answered a question about his father.

"My father's name has been battered around for 40 years or more—I'm accustomed to it. It's politics."

He walked out of the courtroom gray and diminished, like a condemned man, at a recess.

Anna De Leo sat in the back of the room and didn't chat with me anymore. When she talked to Maggie Murphy in the hall, she turned her face away; it was wet with tears.

On the witness stand her brother continued to drink gallons of water. Once he peered down inside the thermos pitcher and then motioned for Marc Martin to get him another one. Shepard continued to go over the transcripts of the tapes line by line, boring in further and further, like a dentist who keeps changing the tips of his drill. The squirming witness searched in vain for an alternative to what was clearly the sorry truth.

The cross-examination went on for days. On November 19 Shepard asked, "You said that all this business with Cooley was kind of unreal, didn't you?"

D'Arco agreed.

"Haven't you said that a coward is someone who refuses to accept reality?"

"'A Coward Is a Person Who Refuses to Accept Reality' is something I wrote years ago—I guess that's what you're asking."

"It is and you've answered it," said Shepard. He sat down—his cross-examination was complete.

Maggie Murphy looked like a professional mourner with her long face and black clothes. She didn't say good morning to me anymore.

In the pressroom reporters talked about a conversation they'd had with D'Arco, each telling what he'd like to have if marooned on a desert island. Senator D'Arco had told them he'd take lots of marijuana and smoke it as he lay on the beach watching the sun go down.

The closing arguments took place on December 4. It was as though the

judge realized this was his last chance to control his courtroom, and he adamantly limited each side to two hours, over the government's objections. The prosecutors had to talk fast and rely on their charts, but for Genson, who didn't have a lot to say, it was probably a blessing.

"I got a new haircut and a new cane for you!" he told the smiling jurors.

Genson huffed and puffed around the courtroom, waving his new cane. He "zap-you're-steriled" the government with his pink light pointer and reacted to objections with sputtering outrage. He spent a long time perched on the edge of the government's table, speaking in hushed tones about the "very unique" John D'Arco, politician and poet.

Wobbling off, he bellowed, "This is a crime of words, not of acts!" Brandishing his cane like an Old Testament rod, he quoted the Midrash and read from *A Man for All Seasons*. He let his voice tremble and seemed to be on the verge of tears; then, his time up, he sat down.

"I did my best," he panted.

The jury deliberated all the next day. On the day after that, we received a call in the pressroom that the verdict would be announced at 1:00, so when we gathered it was not in the usual chaotic manner.

It was 1:23 before Judge Lindberg arrived on the bench. John D'Arco waited with his chair turned toward the audience, staring over the crowd almost defiantly. He was wearing the usual gray suit, but for the first time, he wore a tie that wasn't red or blue. This tie was defiant as well, black with large modernistic gray-and-white designs on it.

All I could see of Maggie Murphy, in the second row beside a nice-looking young man, was her beautifully manicured, long-fingered hand resting in the crook of his arm.

When the jury walked in, the court buffs began chattering like squirrels. "They're not looking at him!" "They're not looking!" they told each other. In court lore, when jurors don't look at the defendant, it means they have found him guilty.

The forewoman handed the verdict to the marshal, who handed it to the judge, who inspected it and then handed it to the clerk. Knowing, perhaps, that she would read the verdict today, the clerk wore a vibrantly aqua suit and a black-and-gold turban. She stood regally and read.

John D'Arco had been sitting with his hands clasped on the table in front of him, his head down. He didn't change when he heard himself pronounced

John D'Arco Jr. verdict.

guilty, and there was no discernible reaction from anyone else. After the jury was excused with the judge's thanks, Maggie strode over to John. Her upper lip was pulled down hard over her teeth in an effort not to cry, but she and John didn't reach out for each other or say anything that one could hear. They simply put on their coats and left the courtroom with everyone else.

Downstairs the media waited to ambush the jurors. Their lights and cameras, microphones, tape recorders, and notebooks pinned the forewoman against the granite wall.

They yelled their questions at her, including what she thought about Robert Cooley. "Well, I wouldn't date him!" she answered, but she said she had believed him when he testified.

As for the crooked politicians and the Mob, she said she'd only known about such things in the movies.

"I wish it had stayed in the movies," she added.

Bobby Bellavia and Rocco Infelise.

6

VALENTINE'S DAYS:
THE MOB, II

United States of America v. Rocco Ernest Infelise et al.

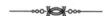

Complementarity can be formulated without explicit
reference to physics...as two aspects of a description
that are mutually exclusive yet both necessary for a
full understanding.

—Abraham Pais, *Niels Bohr's Times: In Physics, Philosophy and Polity*

Solly was made last night. I sponsored him. I was surprised,
they still use fire and water.

—Rocco Infelise, undercover tape transcript

I t was, appropriately, Valentine's Day, exactly 62 years after the famous massacre of 1929, that the case of the *United States v. Ernest Rocco Infelise et al.* began its life in court. The defendants were charged with racketeering conspiracy, extortion, tax fraud, gambling, bribery, prostitution, and three murders. The murders were not charged directly but as "overt acts" under the racketeering, or RICO, counts.

It was an afternoon dark with sloppy snow when the big group was hauled in before Judge Ann Claire Williams for the preliminary hearing. They were a varied bunch, skinny and obese, tall and short, old and young. They looked like a casting call for a Mafia movie, every one of them a caricature.

The bond hearing took several days; in the jury box the press listened to agents testify and to tapes of gravelly voices planning shakedowns, stalkings, and murders. The trial a year later would be an enlargement and elaboration of all this. As some of the best defense lawyers in the city had been engaged, the court buffs were looking forward to it, and so was I.

On October 15, 1991, defendants and lawyers waited in the hall for Judge Ann Williams to come on the bench.

Puffing on cigarettes, chatting, and joking, they peered through the little window in the courtroom door. Defendant Louis Marino stepped in front of the door and pretended to bar it with his body.

"Naw, ya can't go in there," he said. "Nothin's happening in there!"

He looked stern and threatening and did a fine imitation of a mobster barring people from going where he didn't want them.

Defense Attorney Allan Ackerman, in cowboy boots, messy wash pants, and nylon bomber jacket, said outrageous things and made people laugh. The most entertaining lawyer in the city, he was defending the most vicious hit man in the city. His client Harry Aleman was not on bond.

Ackerman was a favorite with the reporters, artists, and court buffs. He spoke in a Shakespearean actor's voice, and his arguments were far-fetched and original. He referred to the place where most of his clients resided as the Bastille.

The court buffs chuckled about how great it was going to be to spend several weeks watching not only Ackerman but the famous Bruce Cutler, who was coming from New York to defend Infelise's codefendant Salvatore DeLaurentis.

Like a small village looking forward to a carnival, the minor mobsters, their lawyers, the press, and the buffs were in a festive mood.

But the trial kept being put off because Bruce Cutler was still defending the New York crime boss John Gotti's brother, Peter, in New York. The Gotti jury was still deliberating; by October 17 the Gotti jurors had sent out 38 notes.

In pretrial motions the defense asked the judge not to let the government use the words *Outfit*, *Mob*, *Mafia*, or *Cosa Nostra* in front of the jury. Those were fantasies of law enforcement officers, said Pat Tuite, Infelise's lawyer, used to obtain grants and entertain the press. Tuite told the judge that the defense wouldn't contest much of the government's evidence, except for the murder of bookie Hal Smith. The murder of Smith was the crux of the case, he said.

Channel 7's lawyer made a motion, too; he argued that the judge should change her previous ruling and allow sketch artists to draw the jury. Because they would be deciding the fates of mobsters, the jurors would be given numbers, their names kept secret. Mitchell Mars, for the government, and Judge Williams both quoted Chief Justice Rehnquist, who has said that of all the elements of a trial, sketches and sketch artists are the least important.

Judge Williams ruled. "I'm not going to have sketches of the jury."

On October 23 everyone finally gathered for the first day of trial to find that Harry Aleman and Allan Ackerman were with the judge in chambers. Ackerman had made a deal for Aleman to plead guilty to the lesser charge of accepting money as a convicted felon. They would no longer be a part of the trial, disappointing the buffs, the reporters, and me.

I had been drawing Harry Aleman for years, including when Judge Frank Wilson acquitted him of murder in 1977. Like everyone else, I had been surprised; there had been an eyewitness, and it should have been any easy conviction.

Aleman's guilty plea removed one of the three murders in the *Infelise et al.* indictment, that of Anthony Reitinger, shot to death by two masked men while eating in a quiet Italian restaurant. Everyone claimed to know that it had been Harry's work, but apparently the government didn't feel they could prove it. Now five defendants remained: Rocco Infelise, Salvatore DeLaurentis, Robert Bellavia, Robert Salerno, and Louis Marino.

As I began to draw Rocco Infelise's imposing bald head, large nose, heavy mouth, and piercing eyes, he looked up and gave a disarmingly benevolent smile.

I moved on to Solly DeLaurentis, "Solly D.," Rocky's right-hand man. He seemed older than 53, his handsome face full of fragile detail. His teeth had the regularity of dentures, his mouth was thin and expressive, his nose fine and pointed. His raccoon eyes had irises so dark that they reflected the

papers on the table. The legend "Solly D." was stitched on his left shirt cuff in cursive.

Robert Bellavia also sat at the first table, the table for the defendants in custody. Bobby, also known as Gabeet, had short little arms that came together on top of his belly. Often he stuck his hands into his belt, as though cold, wrinkling up his sweater. His cowlicky little boy's hair was gray, and his shirt collars came to his ears like the shell of a turtle.

Louis Marino, rugged, pink faced, with bedroom eyes under parallel black eyebrows, sat at a further table.

Like Marino, Bobby Salerno was out on bond. The gum he constantly chewed made a little pink circle on his lips. He sat next to his son, Alexander, who had recently passed the bar and was assisting in his father's defense. Father and son looked alike, but there was something more refined about the younger man.

Whenever I drew the defendants, I found myself putting Bruce Cutler in the sketch as well. His thick-necked figure was smoothed of detail, his head fringed with a bare bristle of hair. Deep in his comic strip face, his small eyes seemed incongruously beautiful. He constantly adjusted the lapels of his broad-shouldered suit and made sure that his two-button shirt cuffs showed and the silk handkerchief peeked out of his breast pocket properly.

On October 24 in the evening, in the warm, smelly courtroom, the jurors and alternates were finally picked: ten women and eight men. More than 100 people had sat for two days answering the judge's and lawyers' questions. When they were excused, the ones who weren't picked cheered and clapped and called, "Bye, bye!"

Mitchell Mars in his opening statement for the government referred to the defendants as members of "the Outfit" and said their business was "murder, violence, threats, and extortion." He showed a big chart with colored blocks, the top one titled "The Ferriola Street Crew." Underneath was "James Torello, died 1979," and underneath that "Joseph Ferriola, died 1979," and then "Rocco Ernest Infelise."

Mars said Infelise was a top assistant and then boss, at which time Solly D. and Louis Marino were his top assistants. Robert Salerno and Robert Bellavia were their employees. Mars gave a business-like explanation of the

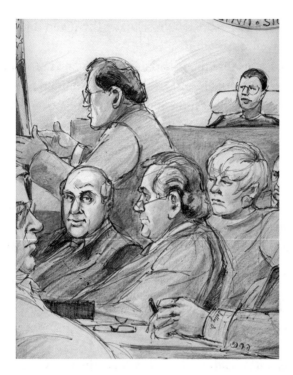

Bobby Bellavia, Rocco Infelise, prosecutor Mark Prosperi (standing),
Pat Tuite, Jo-Anne Wolfson, and Judge Ann Williams.

RICO acts and described the two murders. He talked about the gambling charges, the charges for collection of unlawful debts, and the charges for not paying income tax.

Bruce Cutler's opening statement propelled him all over the courtroom and almost into the jurors' laps. Posturing and crouching, he waved a cup of water and made gestures like squeezing oranges in the air.

"I represent the United States of America, too," he bellowed in a Brooklyn accent, "but I do it one man at a time!"

He referred to Prosecutor "Maaaaars," drawing out the long *a*, as though Mars were a science fiction villain.

Cutler: "[Mars] couldn't just call [the defendants] dear friends, that they love each other...."

Shouting, rapping on the government's table where lawyers and agents sat stiffly, Cutler yelled: "They called this party! They sent the invitations out!"

He lowered his voice as though to make the jurors his coconspirators: "Together we'll walk through it."

He said that the government had a hidden agenda, a vendetta, and was persecuting the defendants because "their names ended in vowels."

After several long sidebars, the judge said that if Cutler had any evidence of governmental misconduct, he should bring it to the court's attention. Otherwise, all of this had no place in an opening statement.

Mrs. Ann Infelise came to her husband's trial every day. She was a plump little woman with the skin of someone who has been in the sun too much. The first day, she wore a black miniskirt and black stockings with a run behind one knee; her lipstick was like the frosting on a hot cross bun. I imagined her in a Florida condo with white carpeting, blond furniture, and sculptures of glued-together shells.

She seemed to be enjoying the trial. "So dramatic," she exclaimed more than once.

After Bruce Cutler had finished cross-examining a witness with a typical flourish, she turned to the man next to her and said, "Just like going to the movies, huh?!"

The defense group was obviously proud of Bruce Cutler. Every time he rose to his feet, they perked up. On his way out during a recess, Louie Marino bent over me and asked, "Ya like him?"

An IRS agent testified about November 13, 1983, when at 4:00 in the afternoon he and his colleagues made simultaneous raids to gather evidence of illegal gambling. They entered Rocco Infelise's condominium in River Forest by having one of the agents dressed in "clerical garb."

When Bruce Cutler cross-examined, he asked, "Whose idea was it to utilize the ruse of a priest...on a Sunday?"

He shouted about the Fourth Amendment and the right to be free of unreasonable searches and seizures, until the judge admonished him not to comment in this way.

Cutler's technique was to assert something and then to ask, "Fair statement?!"

He strode around the courtroom and sometimes into the spectator section so that he was behind the artists. He crouched as though to pounce, he pointed as though firing a gun in the air, and he strutted with his hand on his hip.

Cutler used anything that got in his way as a prop. Once after finishing a cross-examination, he pinched Bellavia's chipmunk cheek as he returned to his seat. Another time he walked backward into the chair of Bellavia's lawyer, Robert Simone.

"Are you OK, Mr. Simone?" Judge Williams asked, laughing.

"Cutler and the judge are a great pair," whispered a defense lawyer.

Judge Williams constantly reprimanded Cutler. "Excuse me, Mr. Cutler, when there is an objection, shut your mouth and wait for the court to rule on it."

On Wednesday, November 6, Ann Infelise wore a beige jacket, a beige miniskirt, beige shoes, and an ankle bracelet. She carried a beige purse. She got a charge out of the undercover tapes that were played during the testimony of bookie Steve Hospodar.

The 75-year-old Hospodar, pinkish brown and shiny like a baked apple, said that his legal businesses had been a used car lot and taverns; his illegal ones, "bookmaking and fencing." I soon realized that the image of the little man dressed in white, with a painted heart on his chest, brandishing a long graceful sword, was not an accurate one. He meant something else by "fencing."

Prosecutor Mark Prosperi asked Hospodar what street tax was.

Hospodar: "You pay the street tax or you don't go."

Hospodar described how he had been taking bets on basketball and football at his car lot for some time before one day when two guys showed up.

The men told him they'd heard Hospodar, "got a pretty good book and...[had] gone a long time without paying tax."

They told him to go to a restaurant where Harry Aleman was waiting in the back room. Hospodar told the courtroom what happened in that room.

"Harry Aleman did all the talkin'," said Hospodar.

"'You'll pay 20 thousand of back taxes,'" Hospodar testified Aleman told him.

Hospodar told Aleman he would quit bookmaking.

Aleman said, "Fifteen."

Hospodar again said he'd quit.

Aleman said, "Ten."

A third time Hospodar said he'd quit. Aleman banged on the bar, related Hospodar.

This made the lawyers and their clients at the defense table giggle. Prosperi pointed this out to Judge Williams, and she admonished them not to show any reaction.

Hospodar went on with his story.

Aleman told him, "'You gotta pay five [back taxes],'" and Hospodar agreed.

"Harry says I'll pay one thousand a month street tax," testified Hospodar, and so he did.

Prosperi asked what the bookie expected in return for his money.

Hospodar: "He'd give you protection, maybe help you collect bad debts …so nobody would give you trouble."

And if the bookie didn't pay?

Hospodar: "You'd get hurt."

In 1980 Hospodar was arrested after the government found cash and gambling records under a rose cone in his girlfriend's garden. Because the government confiscated all his money, Hospodar couldn't pay the Mob the $11,000 that he owed. So Hospodar decided to cooperate, and the agents gave him a wire to wear. A meeting was arranged with Solly D. and Lou Marino at the Willow Restaurant.

The jurors, the judge, and Prosperi put on big black earphones like plastic earmuffs to hear the tape Hospodar had made. From the speakers placed around the courtroom, the rest of us were also able to hear DeLaurentis asking where the money was.

"Soup's good," answers Hospodar.

Hospodar says he's going to sell his business because he doesn't have the money, and DeLaurentis says, "I'll hit ya in the fuckin' head with this cup!"

Hospodar replies, "Well, you better hit me with the cup," because he couldn't pay the money.

We heard the noises of the men frisking Hospodar in the men's room, and later we heard them yelling at him in the parking lot.

Marino then said, "I'll be goin' to sleep with you at night!... You will bring the fuckin' money tonight! You hear what the fuck I'm telling you? ...'Cause I'm gonna be in your house on your doorstep, I'll shake every motherfuckin' thing down in there!"

Listening hunched over at the government table, IRS Agent Mort Moriarty's eyes were like surgical incisions. He was the agent who developed most of the evidence over many years of hard work. This was his case.

On Thursday, November 7, Ann Infelise wore a bright red minidress, with a gold zigzag pin like a lightning bolt near her left shoulder, and carried a coat made of white string that looked like fur.

Louie Marino's lawyer, Jo-Anne Wolfson, wore tight black pants stuffed into high-heeled boots and an oversized tweed jacket that matched her short gray hair. She cross-examined Steve Hospodar as though she were a juggler tossing him in the air, never dropping him once, smiling and pirouetting all the time. With her dusky movie-star voice and perfect timing, she managed just the right mix of flirt and den mother.

Wolfson: "I'm not supposed to ask where it was, but you were wearing a wire, weren't you?"

Hospodar (with a little smile on his face): "Yes, ma'am, yes, ma'am."

Hospodar was also a great performer and didn't let any of the defense lawyers push him around. He called Cutler a liar more than once.

Cutler reminded Hospodar that he had bought used cars at auction. "Shitpots," Hospodar had called them; he'd paid with checks that later bounced.

And he didn't ever get locked up for that, did he? Cutler asked.

Hospodar replied, "No, sir, I'm like the congressmen and the senators."

The Congressional Bank scandal had just taken place, and everyone in the courtroom laughed.

On December 3, after the lunch break, William Jahoda, alias B.J., the government's star witness, was expected. At the defense tables and among

the families seated nearby, people laughed and joked and ate more chocolate than usual.

Before the jurors took their seats, two agents brought William Jahoda in from the back of the courtroom. A tall, confident man, he wore a pink open shirt and a gray golfer's cardigan sweater.

When the jury was in place, William Jahoda gave his name, his nicknames, and the five aliases that he could remember. Mitch Mars reminded him of several more. William Jahoda used the aliases, he said, "to camouflage myself in my business dealings, both personal and illegal."

He said that he had been a bookmaker and, from 1979 to 1989, a member of Rocky's crew. Mars asked him to identify Infelise and to describe what he was wearing, to which Jahoda responded, "A sort of brown suit and a very attractive tie."

At the next recess, Ann Infelise exclaimed delightedly, "Did you hear what the witness said? That Rocky had on a very attractive tie!"

Jahoda, in a nasal twang, gave steady, articulate, and intelligent answers. He explained the federal sentencing guidelines better than many lawyers are able to. He was going to be a powerful witness.

Mitch Mars asked if Jahoda had known someone named Hal Smith. Jahoda answered that Hal Smith was an independent bookmaker, "reputed to be one of the biggest in the country."

Mars asked when Jahoda last saw Hal Smith.

Jahoda answered that it was on February 8, 1985. "He was basically sprawled on my kitchen floor."

We'd heard a tape at the detention hearing in which Jahoda had put it more graphically: "sliced and diced on my kitchen floor," he'd said.

Mars asked him if Smith was still alive when he saw him.

Jahoda: "Yes, he was."

This was just a tease, like a movie trailer; Mars wasn't ready to ask about the murders yet.

William Jahoda was the perfect insider to present the anthropological data; in his laconically efficient way, he described life at the center of the Chicago Mob.

He explained the Mob's gambling business, its hierarchy and connections. He described how organized crime divided the city and some suburbs into street crews, each with its own turf, as well as its own bookies and bettors,

money collection, and paid protection. He complimented Infelise on his management of the Infelise street crew. He said that Rocky "ran a pretty good ship," that he "let people use their own judgment."

Jahoda discussed the finances of the business he called the Good Ship Lollypop. He told of the millions in revenue that were taken in, the allocations of this money to rents, salaries, bribes, Christmas gifts, and the Legal Defense Fund. He told how the Mob paid money to people who protected their fellows by refusing to testify against them. If, after being granted immunity from prosecution by the government, they still pleaded their Fifth Amendment rights against self-incrimination and were jailed for contempt of court, the Mob supported their families while they were doing their time.

He testified about the Libertyville Yacht Club, the crooked casino that the crew operated for a few months in bucolic, wealthy Libertyville— nowhere near any body of water—where riding to hounds, not boating, was the traditional sport. They had rented a long-vacant house in which the owners had been murdered, a murder that had nothing to do with the Mob.

Meticulously, Prosecutor Mars took Jahoda through the initial financing and setting up of the Libertyville Yacht Club, including the ordering and building of the special gambling equipment (the craps table cost $30,000) and the refurbishing of the house to include two cocktail lounges, as well as the paying of $1,000 a month in street tax to the Mob and $1,500 a month to the Lake County Sheriff for protection.

Jahoda respectfully described the arcana of illegal gambling: how the crooked craps tables worked and the battery-operated dice with microchips in them. He demonstrated how a blackjack "shoe" was rigged with a mirror so only the dealer could see which card was coming up. He defined the terms that bookies and bettors employed, like *shilling* and *scuffling*; he used the slang and nicknames of the underworld.

Jahoda listed the employees: bartenders "Race Track" Debby, Gizmo, and Steve; doorman Lester the Molester; and Sleazy Richard, one of the experts in crooked craps and other strange toys. He mentioned the kid who was supposed to work the microchipped dice on opening night but was too nervous or too drunk to do so. They had to take the remote control away from him and put it in Charley Burge's armpit. Charley Burge was the engineer of the crooked contraptions.

Jahoda told of the car jockeys who parked the cars in a "prairie-type atmosphere behind the house" and of the shills who pretended to be happily gambling.

He said that Rocky was in charge of the whole operation, Solly was pit boss of the crap game, and Louis was head of security.

The monthly $1,500 to the sheriff of Lake County bought them good protection. They never had any trouble for the 15 or 16 nights they were open for business that spring. The plan was that one upstairs phone was never used—it was there "strictly in event of an emergency"—and if someone ever called on it and said, "The guy's coming to fix the furnace," they would know the heat was on.

But when they heard reports that they were under surveillance, they got nervous. One day Rocky announced, "We're close to having headaches here.... Close it up."

In the less than three months it was open, the Libertyville Yacht Club grossed "well over half a million," according to Jahoda. They returned $75,000 to the person who, not realizing what sort of operation it was, had invested with them and a $9,000 profit on top of that, "with Rocky's blessings."

Jahoda: "We didn't intend to take advantage of this guy; we could have, but we didn't."

The net profits were approximately $440,000, and of that, $325,000 went to Infelise.

At that, a loud "Hmmmm" came out of one of the ladies in the second row.

The defendants' female relatives sat behind me in the second and third rows. Between the dark-haired, jogging-suited Mrs. Bellavia's gum chewing and Mrs. Infelise's enthusiastic comments, there was always noise coming from that direction.

One day they were particularly agitated because Rocky was putting his finger in his nose.

"He doesn't realize he's doing it," said a feminine voice.

Another said it didn't look good in front of the whole courtroom, in front of the jury.

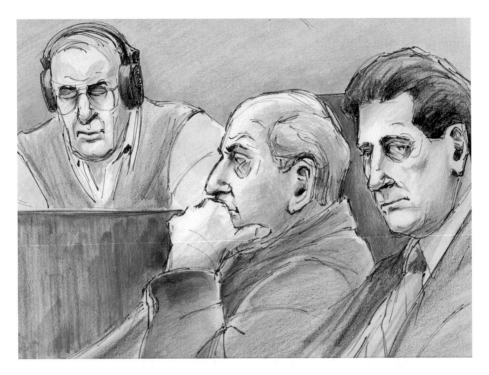

William Jahoda, Rocco Infelise, and Solly DeLaurentis.

When Infelise looked sheepishly over in their direction, Ann Infelise said, proud but exasperated, "He looks at me when he does it."

For several days we listened to "Title Three" tapes made on tapped phones of Jahoda talking to his friends. After Jahoda described how he had turned himself in to the government, we listened to "consensual" tapes made on the body recorder that he wore thereafter.

By the time of the Christmas break, William Jahoda had been on the stand for more than two weeks.

Monday, January 6, 1992, was the first day of court after the holidays. When the defendants came out of the lockup, there was much hand shaking and embracing. "How ya doin'?" "Good buddy." "Hello, Rock." "Happy New Year."

Then there was a lot of pulling the black leather chairs around, looking

at the chairs' legs, and exchanging of chairs. People had their favorites.

Ann Infelise, sporting a ribbon headband, and Bruce Cutler had both been in Florida. They commented on the weather there, how "winds gusting up to 40 miles an hour" prevented either of them from playing golf.

Pat Tuite said that someone had sent him a Christmas card that said "Rocky Infelice Navidad."

The names of the murder victims—Robert Plummer and Hal Smith—were mentioned in the last tapes played the afternoon of January 7. Jahoda and the defendants were heard discussing their fears that the old murders, of Plummer seven years before and of Smith five years ago Valentine's Day, were being investigated.

Everyone listening to the tapes, including Mrs. Ann Infelise, knew that we were getting closer to testimony about these murders.

While the jury was filing out, she stood up, leaned over the back of the first pew, and announced to the defense tables that she might not come the next day. Those were terrible tapes played today, she said; she hadn't been able to understand a word.

But on January 8, Ann Infelise showed up as usual, wearing her bright red minidress, black shoes and stockings, and purple eye shadow.

The government played a breakfast conversation between Infelise and Jahoda at the Paddlewheel Restaurant in River Forest. The audio wasn't good, and perhaps Ann Infelise was unable to make out the part when Rocky talked about her. Her name came up as the two men discussed their colleague Albert Tocco.

Jahoda: "Somebody told me that Tocco's wife was in the fucking paper saying that she drove her old man [to commit a Mob murder]."

Infelise: "She rolled, she rolled over on him. Took all his fucking money.

"OK, I don't give a fuck how long you know a woman. . . . Here's a broad that—I mean, I trust Annie with my life. She grew up in this fucking. . .she grew up in this. . ." (He pauses and doesn't finish his thought.) "But still, she ain't going to know. . .she knows none of my fucking business. Nothing. . . I don't go out much at night. Now when you go out and say you're with the guys, she's no fucking dummy.

"She only, she once, in all the time, she says, 'Where you going?' I give her a fucking look, I said, 'Up State and down Clark.' That was it. That was the end of that conversation.

"All she ever says, you know, is 'Bye bye.' She says, 'Be careful,' ...that's the end of it. And I told her, I said, 'Listen, if I go out and I don't come home, you don't ask nobody nothing. Somebody will be here.' And that's the end of it. And that's the end of the apple tree."

The prosecution played tapes in which Rocco Infelise and Solly DeLaurentis each told Jahoda how he shouldn't worry, that they would be loyal to him.

We heard Infelise's taped voice say, "God forbid if anything happens to me.... There ain't nothing that's going to happen to you as long as Solly's living or anybody else."

DeLaurentis's voice added, "I'm not going to let anybody fuck with any of our guys, you know that. Pride alone wouldn't let me.... I'll be real honest with you, B. If, let's say, God forbid, something happens to Rocky, right?... While I'm still here, nobody can fuck you...nobody can do nothing."

A sense of doom, a feeling of things coming to an end, colored these conversations between the aging mobsters. As well as the prospect of the older men retiring or dying, and the younger ones taking their places, there was always the specter of the grand jury and of jail.

We heard Infelise tell Jahoda that he was tired. "I'm at a point where I don't really give a fuck—I mean that."

Jahoda: "I don't know how you do your job."

Infelise: "...I don't want to go to jail no more than anybody else. But it don't fucking bother me. I'm at a point they can fuck themselves.... I know there's enough there for my family.... That's the only worry you know. They're set. Fuck it."

Rocky talks about his real estate in Florida and about his mother-in-law, the Basil Queen, who grows basil and makes wonderful dishes with it.

Just before the morning recess, Mitch Mars said that he was about to switch to a "new topic." A little shudder of apprehension could be felt in the room. When we came back, Mars asked Jahoda about a meeting he'd had with Rocky and Lou Marino in May 1982. They had talked about Robert

Plummer, a bookmaker.

Jahoda had thought Rocky was asking him what kind of guy Plummer was, that Rocky was thinking about taking Plummer into the business.

Plummer was a great guy, said Jahoda, he liked him a lot, he was a real "classy guy."

But Jahoda hadn't understood.

"'No, that's not what I mean,'" Rocky had told Jahoda.

Then Rocky asked, "Can you get him over to the casino?'"

Jahoda told of how he set up a meeting with Plummer for the next morning at the Libertyville Yacht Club.

Jahoda: "I told him I wanted to show him how the casino operated... told him to keep it discreet and confidential."

Jahoda told Plummer to come alone.

Jahoda reported back to Rocky. Rocky said, "There'll be a couple of guys..." and that he, Rocky, wouldn't be there.

Jahoda: "When I realized Rocky wouldn't be there, it sounded slightly menacing."

Jahoda told the courtroom that he worried about a case of mistaken identity. He and Plummer were about the same height, same weight.

He said to Infelise, "Rock, I don't want to get close to the smell of blood, that's not my role," he told Infelise.

But Infelise told him not to worry. "'It's nothing like that,'" he said—Jahoda couldn't remember the exact words. "'We're just going to sit him down' or 'straighten him out,' that's all."

"'Just walk him through...and keep on going.'"

Prosecutor Mars put some enlarged photographs and diagrams of the Libertyville Yacht Club on easels. We had seen these huge cards before, the day that Jahoda described the casino operation with its crooked craps table, rigged dice, shills, and scufflers.

Jahoda testified that the next morning he went to the house a little before the appointed time. "When I pulled in, there were no signs of life."

Then, in his peripheral vision, he saw Infelise walking toward him. He noticed that Rocky was wearing golf gloves on both his hands. Rocky told him to turn his car around so it was facing the road.

Rocky went back into the house before Plummer arrived.

Jahoda: "My recollection is that [Plummer] was timely."

Mars asked if he had any conversation with Plummer.

Jahoda: "Outside it was just generic, 'Hello, how are you,' and 'Let's take a look at this thing.' ..."

Every time Jahoda used the word *generic* instead of *general*, Bruce Cutler had winced and corrected him under his breath. He did so now.

Jahoda described how he began to lead Robert Plummer through the seemingly deserted house.

Mitch Mars stopped Jahoda's narrative at each room so he could plot their progress on the chart for the jurors: dining room, living room–cocktail lounge, hallway—you could almost hear their footsteps.

On the witness stand, Jahoda suddenly looked very tired, his face gray and scared. He reached inside his open collar as though to brush something off his back. But he went on testifying, told how they got to the stairs.

Mars: "For the record, I will mark 'Stairs'..." (And he drew a symbol on the chart.)

Jahoda: "I was first, he followed me several steps behind.... I was about halfway up the stairs when I heard a loud bang...like a door slamming... Plummer said, 'Oh, my God, what was that?'"

Jahoda said that he turned and saw a flash of light—he didn't know whether it was "physiological" or what. Then he saw Plummer pinned to the wall by the throat by a man in a mask, "right there on the landing!"

He couldn't see the assailant's features, just that he was hairy under the nylon mask. "He had a very hairy...." He hesitated. "Like a five o'clock shadow."

Jahoda saw the masked man's other hand pull back before Jahoda turned and continued to the top of the stairs. It was then that Jahoda heard another noise.

"I'd never heard anything like it.... It didn't sound human.... It was rhythmic, metallic, almost a staccato kind of sound.... It lasted three to four seconds!

"I basically froze in my tracks. My thought was, 'Am I going to get out of this house alive?' I still had to get through that casino."

The courtroom was hushed, waiting. At the defense table, Bruce Cutler had his hand on his client's shoulder.

Mars: "And did you get out of that casino?"

Jahoda (dryly): "Obviously."

He continued, saying, "I recalled my instructions," and he went on to describe his trip through the house in reverse: descending the back stairs, going back through the empty rooms, one by one, slowly, Mars marking his retreat on the chart.

At the back door he saw Rocky Infelise again. Infelise still had the golf gloves on.

Jahoda testified that he felt himself shaking all over, trembling from head to foot. "I truly felt myself incapable of speech.... Rocky said, 'If anyone else comes, they're going to get the same thing.'"

"I replied," Jahoda paused for a long time, perhaps to mimic how long he had paused at the time or perhaps to frame this last remark in a theatrical silence, "'don't—forget—to—lock—the—door.'"

Jahoda went on to tell that after he went home, "I made no inquiries about what happened.... I received no calls about it.... I just tried to conduct myself as normally as possible."

That night he went to the casino, which was open for business as usual, the usual workers there.

Jahoda: "They were just doing whatever.... When I felt I was alone, I walked over the area.... I examined the walls.... I didn't see nothing.... [except that] it appeared to me that part of the wall had been washed... [and] the carpet was damp...."

Jahoda testified that a local newspaper reported that Robert Plummer's autopsy showed he had died of a heart attack. After reading the article Rocky had said, "Good."

"What a story, what a story!" exclaimed Ann Infelise at the lunch recess, as though she were glad she had come today after all. She gave her husband the thumbs-up sign as he was led out, and he winked in her direction before disappearing into the lockup.

The next day, William Jahoda described leading a second man, Hal Smith, to his death.

"In my mind I've always described it as the 'Stalk of 1984,'" said Jahoda of the long search for Hal Smith, an independent bookmaker whom the crew considered a snitch. All the defendants except for Solly D. were involved in this search, and it took them from country clubs and golf

courses to restaurants and parking lots.

At the detention hearing the year before, the government had played tapes of Jahoda and Bobby Bellavia talking about those days. Government agents had instructed Jahoda to get his pals to reminisce about the old murders.

On tape we'd heard Jahoda say to Bellavia: "That particular summer, you know, during the stalk.... You know looking for the guy.... The golf course day, do you remember when you went out there, I was behind you?"

Bellavia: "Yeah, yeah."

Jahoda: "It was like you were there for 20 fucking years. You were like a muriel [sic]. You were part of the building. Just stay in there and blend."

Bellavia: "It's nice, you know, when you can do what you have to do and don't get no notoriety, it's the best thing."

Jahoda: "It's a gift."

Now Jahoda testified that during the summer of the stalk, the four defendants spent a lot of time getting things ready at the house Jahoda was renting, a secluded place in the country on seven acres of land.

One day Jahoda came home to find their cars all over his backyard. Bobby Salerno was taking a nap and Gabeet Bellavia was splashing in the pool. Later Salerno climbed up into a tree and Bellavia hoisted a huge canvas bag up to him. Jahoda could see antennae sticking up out of the top.

As Mrs. Infelise clucked her tongue in the second row and Solly DeLaurentis hissed, "This guy's nuts!" under his breath, Jahoda described female twins who aided him in the search for Hal Smith. They were crack shots, archery experts; their business cards read Double R Productions.

Jahoda: "There was a legitimate promotional value with these twins."

As the group compiled information about Smith and his habits, Rocky had become impatient. In February he told Jahoda, "This has got to be done."

He told Jahoda to lure Smith to his house, "as soon as possible."

The pretext would be Smith's taking over Jahoda's horse bets while Jahoda was on a Mexican vacation.

Jahoda: "I didn't think I could refuse, I had my marching orders."

At 4:00 in the afternoon on the day before Jahoda was to leave for

Mexico, Rocky Infelise, Louie Marino, Bobby Salerno, and Gabeet Bellavia arrived at his house.

Salerno and Bellavia disappeared downstairs into the den and stayed there, "except to come up for a pop or a candy bar or something."

Infelise explained to Jahoda that he should meet Hal Smith at the Long Grove Tavern and then drive to Jahoda's house in Smith's car.

Infelise instructed Jahoda to have Smith come through the kitchen and that he, Jahoda, should wait in the garage. Someone would come and get me."

Jahoda met Smith for a drink.

Jahoda: "We had a generic bookmaking conversation."

Bruce Cutler grimaced at the *generic*.

From his previous meetings with Smith and his wife, Jahoda knew him to be a "family man," so he was surprised when Smith wanted to talk about women. This might be a good way to lure Smith, so Jahoda told him they could have a little party as well as talking business at his house.

"I got my cleaning girl there and my girlfriend...."

Jahoda and Smith drove to Jahoda's house in Smith's car.

"I said to Hal, 'Go in and make yourself at home, I'm going to go around and pick up my mail.'"

The light in the kitchen was on, but it was dark in the garage where they had parked the car. Jahoda saw Smith trying to find the doorknob with the flame of a cigarette lighter. Then the door was open and light from the kitchen came into the garage.

Jahoda: "I clearly saw Bobby Salerno facing him."

The door closed and Jahoda waited.

"Within a few seconds Rocky came out.... He stepped into the garage without speaking a word."

Infelise went to the passenger door of Smith's Cadillac to open it but realized he didn't have the keys.

When Rocky went back into the house, the kitchen door swung open completely.

"I had a full frontal view of Salerno," Jahoda told the courtoom, "Hal Smith was slumped on the floor...his back was against the counter...his legs were straight out."

Jahoda quoted Rocky: "I need the keys!"

Prosecutor Mars, who had been slowing the narrative by plotting each

move on the diagram of the house, asked if Smith was conscious at that point.

Jahoda: "Smith's eyes were open, he was conscious…he was looking directly at Salerno's midsection."

Infelise came out to the garage with the keys and told Jahoda, "He pulled a gun on Louie."

Jahoda said that he started to say, "Rock, there ain't gonna be a third time," but thought better of it.

"I didn't say a word…. We drove silently, wordlessly back to the Long Grove Tavern."

Before leaving him, Infelise instructed, "'B., burn your clothes and your shoes.'"

"Once Rocky told me what he told me, I know this is a murder.

"'Where's my drink?'" Jahoda asked back in the tavern.

"'I thought you'd left,'" said the bartender.

"'I was on the phone,'" said Jahoda.

A long line of people waited to go through the metal detectors, many more than the usual court buffs. People had been talking about "that fellow from New York…John Gotti's lawyer" and heard he was about to cross-examine the government's star witness. Lawyers from outside the building played hooky to come and watch.

Inside the courtroom Bruce Cutler, in a navy suit with a gray handkerchief stuffed in the breast pocket, paced alone all over the room, as though trying to get a feel for its dimensions. He seldom made conversation, so I was surprised when he commented on the size of the line and said he hoped he wouldn't disappoint people.

After as many as would fit packed into all the rows except the first, Cutler rose and said, "May it please the court, Your Honor."

He stood almost in the spectator section himself and bellowed across the vast space at the witness.

Cutler: "In August nineteen hundred and eighty-nine did you go to the home of Solly DeLaurentis and give him a birthday gift?

"In August nineteen hundred and eighty-nine did you go to the home of Solly DeLaurentis with a book?"

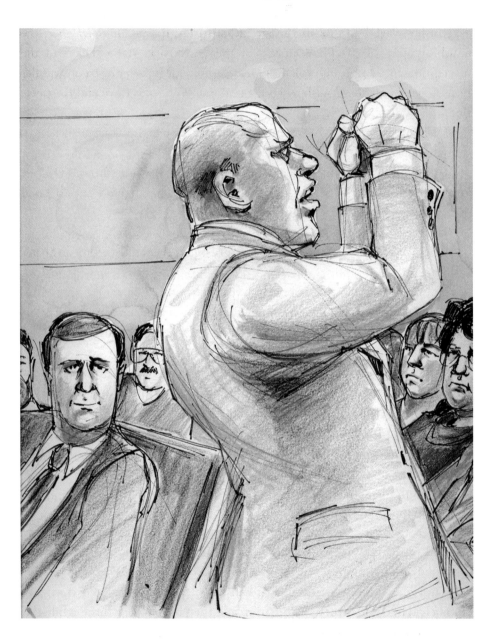

Bruce Cutler.

Cutler waved a book in the air like a torch; it was *Man of Honor*, the autobiography of Joseph Bonnano of the New York Mafia. He read the inscription in a booming voice: "'Dear Solly,... My warmest congratulations. With every good wish to you, a real man of honor. Love and Respect, Bee.'

"When you wrote 'My warmest congratulations,' did you mean it?"

Jahoda: "I meant it in terms of his birthday."

Cutler: "'To a real man of honor'—do you know what honor is? Do you know what it means to be loyal...what it means to be a friend? ... 'To a real man of honor'—did you mean that?"

Jahoda: "I'm not sure I did."

Cutler: "When you wrote, 'Love and respect, Bee,' did you mean that?"

Jahoda: "In all honesty, no."

Cutler: "Who was it that brought you this book?"

"I tried to buy it," began Jahoda sheepishly. Then he admitted that it was the federal prosecutor with whom he was working at the time "who happened to have a copy at home."

Cutler was now directing the theatrics of the courtroom, trying to cast Jahoda as the hypocritical turncoat to Solly DeLaurentis's tragic hero. He clearly also wanted the jury to believe that everything his client knew of the Mafia came from reading this book.

His booming questions, followed by murmurs and titters from the audience and then Mars's objections, became a familiar routine.

"Get up, Mr. Mars!" said Cutler in anticipation of one of them.

"I *am* up," answered Mars.

The acrimony between Cutler and the judge had also become familiar. She had called him a "Mack truck" for the way he continued after she had sustained an objection; he had called her "a leopard waiting to pounce."

Cutler, as he now pointed out, had sat silently for the 13½ days that Jahoda had been on direct examination and then for another three while the other lawyers had crossed.

Cutler's client, Solly DeLaurentis, was not named in the murder counts, and because much of Jahoda's testimony was about murders, there had been less reason for Cutler to object. But he hadn't been totally quiet: he had made sotto voce comments; he had whispered "Christ," more than once; he had commented with disgust whenever Jahoda used the word *generic*.

Now when Jahoda used the word *generic* in an answer, Cutler exploded into gibberish. "You, know this generic nonsense…. What is all this main in Spain, rain in Mundelein!"

Cutler had the single-mindedness, energy, and concentration of a great actor; under the spell of his angry oratory, you could almost believe that the government—the "G," as his clients called it—was evil, that the lawyer was fighting for the liberty of wronged men.

Like other good attorneys, Cutler could paint with words, thinking on his feet as he constructed a compelling picture. The ridiculous gestures were conduits for the words; the words excited, not just with their meanings but as noises. He strung them out, isolated them with scorn, mispronounced them—for instance, "Ja-do-ha" instead of "Ja-ho-da" and "Prosecutor Marrrrs." He chose words for their associations: Jahoda's "pact" with the government reminded of "pact with the devil," and "collaboration" suggested "collaboration with the Nazis." He called Jahoda a "bum."

For a day and a half Cutler pranced and postured around the courtroom, waving his arms as though conducting some private orchestra.

At lunch in the pressroom, the reporters were not impressed. John O'Brien of the *Tribune* said only if he *had* to, he "could make something out of it"; the black reporter from WBBM radio said, "Cutler must have been celebrating Martin Luther King's birthday."

But the ladies in the second row, more packed in than usual, had loved it. In their bright clothes and careful makeup, their extravagantly coifed hair and high heels, they laughed, tittered, and almost applauded. The pit bull from New York was snapping at the government's heels on behalf of their men.

Cutler pointed out that a roommate of Jahoda's used to work at Cherie's Magic Touch, a massage parlor. He named the names of women Jahoda had dated. He asked if it wasn't true that Jahoda could do anything he wanted in the bedroom of the apartment the government rented for him on Lake Shore Drive. He wondered why Jahoda let the secret video camera see him in his underwear. The innuendos hung in the air like stale cigarette smoke.

Cutler prefaced his questions with sarcastic insults that spurred Mitch

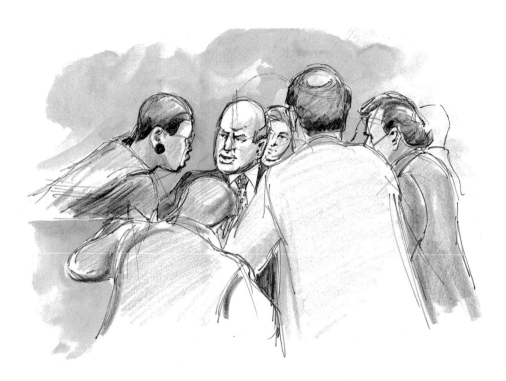

Judge Ann Williams, Bruce Cutler, and other lawyers in a heated side bar.

Mars to continue popping up and down with objections, "like a Mexican jumping bean," Cutler put it.

Cutler refused to truncate his phrases, refused to stop when they had been objected to.

"Irrelevant!" "Speculative!" "He's making a speech!" Mars kept calling out.

The judge kept answering, "Sustained." "That's not a question." "Disregard the speech, ladies and gentlemen." "Speeches are for final argument." "Cut the speeches, Mr. Cutler."

And later: "I have ruled, Mr. Cutler."

Cutler: "Your rulings are wrong!"

Judge: "As long as I'm wearing the robes, I'll make the rulings.... If this happens again, I'll hold you in contempt."

The ladies in the second row chewed their gum faster and faster while their eyes followed Cutler around. As he marched up the aisle like a drum major, their heads swiveled to watch him.

Each time Mars objected, Cutler said, "Come on, Mr. Marrrrs!!!!!" Each time Cutler complained about the judge's ruling, they went to sidebar. Way across the room we could hear Cutler shouting at the judge.

Finally, she took them out in the hall; we could hear Cutler through the wall: "I won't stand for this, I won't stand for this!!!"

The ladies in the second row were laughing; the jury was laughing. Then it grew quiet; the judge must have moved them into her chambers. We waited a long time.

When they finally came out, Cutler looked like a little boy who had just been torn away from a fistfight; Judge Williams had her arms folded regally against her black robes.

She told Cutler that he might continue.

Cutler: "In light of the court's order to change the subject…how do you feel today?"

Jahoda: "Fine."

Cutler: "How did you sleep last night?"

"Fine."

"How much sleep did you get?"

"About six hours."

"Were you comfortable?"

"Yes."

"Did you have dinner?"

"I had a room service cheeseburger."

"What else?"

"A slice of raw onion."

"What else?"

"After dinner I had an apple."

"Did you have anything to drink?"

"I had two cocktails prior to dinner."

"What kind of cocktails?"

"I had two martinis."

Cutler changed the subject again and then asked a question that prompted Mars to object that it was "speculative." The judge sustained him.

Cutler: "Speculative, Your Honor! Our lives are on the line and you call that 'speculative'! … Come on, Mr. Mars, keep the truth out of the courtroom, that's what he's doing!"

Judge: "I think it's time to take our luncheon recess," and she excused the jury.

Judge: "Mr. Cutler...I've repeatedly warned you about making speeches...about playing to the jury.... This is not New York."

Cutler protested that Mr. Mars's "technical objections" were preventing a fair trial; he threw back his chest and pointed at the flag in the corner.

Cutler: "This is still the United States of America, that's still our flag, Your Honor, we're presumed innocent!"

Judge Williams said that court was recessed, gathered her papers in her large elegant hands, and left the bench.

I asked one of the defense attorneys if she had held Cutler in contempt during a sidebar.

"Yes," he said, but he thought it was "under seal."

In the afternoon Cutler glowered behind a stack of transcript pages festooned with yellow Post-its and objected repeatedly to Mars's redirect examination. Once when his objection was sustained, he asked that the witness be admonished. Judge Williams told Jahoda that his answer had been improper and informed the jury that they should disregard it.

Cutler, popping up again, said, "I ask that you admonish the witness not to be a smart aleck.... I ask for a stronger admonishment...from the majesty of the court!"

When his turn came to recross, he simply stood up and said, "No further questions, thank you, Your Honor."

During a recess, John O'Brien, the *Tribune* reporter, read an article in the *New York Times* about John Gotti's trial, which was going on at the time. The *Times* described Gotti as "serenely confident and bronzed from weekly sun-lamp treatments."

Not far away the Chicago mobsters sat at the two defense tables, a cluster of potbellied suburban men in ill-fitting clothes, their women two rows behind them. Only Solly DeLaurentis was slick looking enough to hold his own with Cutler's other client.

O'Brien said that in New York they really love their Mafia; nodding toward the relatives across the aisle, he said in New York the relatives would be giving interviews.

The *Times* article read, "Over the Long Island Expressway, a giant sign hung yesterday that read 'Good luck, Mr. Gotti.'"

O'Brien said, "The highway department probably put it up themselves."

In spite of the defense lawyers' pretrial threats to prove William Jahoda was the real murderer in the case, to paint Jahoda as a "liar and a cheat" (Tuite) and "a rat, a fink, and a swindler" (Cutler), as well as an alcoholic, Jahoda remained at the end of his 20 days on the stand as strong a witness as he had been at the start.

When he was through, William Jahoda turned to the judge and said, "Thank you for your patience and courtesy, Your Honor."

After Jahoda had been taken away by the marshals and the jurors had left, Robert Simone protested to Judge Williams about Cutler's contempt citation. He said it was tough to argue before a judge who already had a "closed mind." He yelled and pointed and acted like Cutler himself. "The famous Judge Julius Hoffman held a New York lawyer in contempt... William Kunstler!"

Simone said he wondered if, because he was also from New York, Cutler was being held to a different standard. He told the judge he wanted time to study the case of William Kunstler; he wanted the contempt order rescinded, until he could review *in re David Dellinger*. He quoted the Seventh Circuit opinion that decided against Judge Hoffman, that found "a vigorous advocacy" does not constitute contemptuous conduct.

Judge Williams looked unusually feminine and vulnerable; her voice shook. She said it had been difficult to deal with all that "yelling and screaming." Judge Williams looked as if she were going to cry.

She spoke of the need for lawyers to follow the rules. She said that she had given Cutler as much leeway as she possibly could. "He has stretched it just to the maximum.... This court has demonstrated extreme patience."

Judge Williams continued, "I have never, ever had any problem in my court before!"

She stayed the contempt order until they had time to file briefs.

On Monday the government called a series of witnesses to corroborate William Jahoda. They included a hairdresser and two bartenders who testified about seeing Jahoda the night of Hal Smith's murder.

The witnesses who saw Jahoda after he'd returned to the tavern said Jahoda had spent the rest of the evening of February 7, 1985, going from bar to bar, drinking, laughing, and joking.

A defense lawyer: "Not appearing as if he had seen a tragic accident or anything like that?"

Witness: "No."

Nick Monaco, the fourth witness of the morning, came limping in on a cane. Hunched over in rumpled, pale silk clothes, hair parted in the middle like a 1920s movie star, he could have been a burnt-out playboy, someone you might see hobbling along the boardwalk at a second-rate European spa. He had an out-of-season look about him.

Monaco: "Most of my life I've been in the theatrical business." Recently he had managed a "model studio," Cherri's Artistic Touch.

A terrible witness, he got that name wrong as he got the name of the Long Grove Tavern wrong, and he seldom understood the questions. Somewhere along the way, bits of his memory must have floated off in the oceans of alcohol he said he drank.

With his German shepherd and French poodle, he had come to live in Jahoda's basement when the heat in his trailer gave out, the winter of Hal Smith's murder.

According to Monaco, on the morning of February 7, Jahoda had said to him, "Stay out of the house, stay out of the house."

Monaco: "I thought he had a lady friend coming over or something so I stayed out."

He spent the night with a lady friend of his own, "Gwen...a very dear friend of mine."

With Jahoda gone, the courtroom became less crowded, the line outside less long. The court buffs were there as usual, and in the second row a few Mob ladies sat, dressed in pale colors, as Nick Monaco had been. They dressed as though they didn't know they were in the middle of a Chicago winter; they shared hand lotion, rubbing it in as they listened. A sparrowlike older woman in expensive clothes, dramatic blond curls, and the body of a 20-year-old had joined them. The skin around her cheeks and eyes was smooth pink and blue, but the skin at her mouth and chin fell in little creases.

She was Doodles Torello, the widow of Turk Torello, who had been boss

of the Ferriola street crew. Her husband's name, James Torello, was displayed on the top of the large chart that Mitch Mars used in his opening statement.

She had been mentioned on one of the tapes of Infelise and Jahoda; it was at about that time that she showed up.

During the lunch recess, lawyers from both sides looked over the evidence technicians' colored photographs of Hal Smith's body. They stood around the prosecution table and laughed and joked. The defense attorneys passed the pictures back and forth, planning which to object to as being too inflammatory.

One was of something inside an open car trunk; another looked like a melted face with long red streamers hanging from it.

When the judge resumed the bench, Robert Simone told her that there was no need for the photographs to be in color.

Mitchell Mars countered that the color was important to show the variations in the wounds—to show that one man, acting alone, couldn't have inflicted the damage in the short time that Jahoda was in the house that evening.

The court reporter, turning her head toward the pictures as she typed, looked disgusted; above her the judge's mouth was open, as though she didn't want to breathe through her nose. The pictures were a real presence in the room.

On January 29 Patrick Gervais, an ex-butcher at Treasure Island Supermarket, testified in a fast, cocky twang that he had talked on a bugged phone and worn a wire for two years for the FBI.

He said he ran whorehouses in strip malls in Mundelein and other suburbs. He let other mobsters and the Infelise crew fight over his business while the FBI listened. He had helped the FBI catch the notorious Victor Spilotro.

Like William Jahoda, he had nerve; both men knew what can happen to a Mob snitch.

He testified that in April 1982 DeLaurentis asked him if he could give him the names of "renegade bookmakers," who didn't pay street tax. But every time Gervais mentioned Hal Smith as one of these renegades, DeLaurentis would answer, "Don't worry about him."

The prosecution played tapes that Gervais had made of Hal Smith at Smith's house; the voices of Smith's family and the sound of kids playing could be heard behind Smith's confident bragging.

Smith: "I've been a renegade...all my time...I'm not hooked up with anybody, but now I've become too powerful, they can't even talk to me.... I tried to make peace, and...they don't wanna really sit down and talk so I said, you know, so fuck it.... I never liked those guys to begin with, because they're slime.... They're just not honorable.... They are ruthless motherfuckers."

Hal Smith's voice, blustering and profane, came from speakers around the courtroom, inches away from where the photographs of his body lay facedown on the government's table.

On cross-examination Gervais said that Smith was the one person of this bunch that he really liked; he felt bad about having to wear a tape against him.

When Cutler cross-examined Gervais, Gervais kept asking him to speak up. Cutler seemed to have mellowed; the lawyers weren't called to sidebar at all that day.

The issue of the contempt citation seemed to have been forgotten.

"I'm certainly not going to bring it up," Robert Simone said.

The phrase "trunk music" was the only real evidence that linked DeLaurentis to the murder of Hal Smith.

DeLaurentis, Hal Smith, and a man named Robby Hildebrandt met in a restaurant in Arlington Heights in 1983 or 1984. The controversy about the date was crucial; the government alleged it was the fall of 1984, closer to the time of Smith's murder.

Robby Hildebrandt's girlfriend, Joy, testified that she witnessed this meeting from just out of earshot.

Solly had said to her, "Let me buy you a drink, Hon. You go sit at the bar."

Robby Hildebrandt was the next witness. He testified that he was there when DeLaurentis demanded that Hal Smith should pay $6,000 a month in street tax. Smith had pushed $3,000 in bills across the table at Solly and said that was enough. DeLaurentis pushed it back. Smith added another $500 and pushed it across. DeLaurentis pushed it back.

"Six thousand," DeLaurentis had insisted.

Their voices became louder as the argument escalated.

Hildebrandt said he exclaimed, "Would you two idiots knock it off; we

don't know if there's any cops in here!"

Hal Smith let loose with an eruption of racial epithets.

Hildebrandt quoted Smith: "'Get your ass on a boat back to Sicily... you fucking dago, guinea'—words to that effect."

"'Nobody talks to me that way,'" Hildebrandt testified that DeLaurentis had said. "'You are trunk music, my friend.'"

Solly DeLaurentis had gotten up and left the restaurant.

Hildebrandt testified that he saw Smith on the day he was murdered and that Smith had told him, "'The assholes were making noises about taxes again' and [that] he was going to meet Jahoda."

On cross-examination Cutler did a good job of what the court buffs called "Brucifying" Hildebrandt. He got Hildebrandt to describe his drinking back then, how he had 25 to 30 drinks a day and twice that on weekends; he got Hildebrandt to admit that sometimes he was drunk when he gave statements to the authorities, that there were "mistakes" in his statements, that he didn't remember a lot.

Cutler (from across the courtroom): "If I counted up all the beers and whiskeys [you have had in your life], what number do you think I'd reach?"

Cutler (yelling): "Does it reach at least into the thousands?"

Hildebrandt: "Oh, yes."

Cutler asked him if he knew what that did to brain cells, and by the time Cutler sat down, he had made Hildebrandt seem a sodden mess.

Nevertheless, Cutler had not been able to erase the impression that Solly had been very angry with Hal Smith, that he had told the murder victim, "You are trunk music, my friend."

Ann Infelise hadn't been in court for a while. Doodles Torello told me in the ladies' room that her mother, the Basil Queen, had died. "If it rains, it pours," Doodles said wistfully. Now Mrs. Infelise was back wearing a sparkly white sweater and a tiny white skirt. When I told her I was sorry about her mother, she thanked me and held my hand for a long time.

Though the witnesses of those first days of February were minor actors—a golf instructor, a pimp, and a cook—to the spectators, most

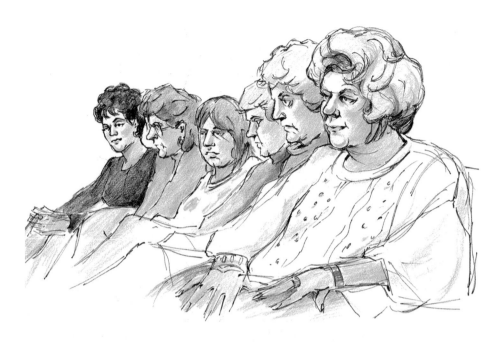

Ann Infelise (right) with mob wives.

were funny and worth the price of admission.

Michael Smith, the son of the dead man, was a slight, bespectacled, balding 35-year-old. He described his father's bookmaking business, the five wire rooms with five phone clerks, which, during the football season, could bring in "a couple of million dollars in one week." Michael said that his father wore loud sports jackets and jewelry, and in 1985 he drove a light-colored 1983 Cadillac Seville.

An Arlington Heights policeman testified about finding Hal Smith's body in the Cadillac's trunk in the Arlington Heights Hilton parking lot. As he described how "the body was somewhat curled up and slightly twisted over," murmurs and whispers came from the second row.

"It appeared to be frozen and there was a great deal of trauma around the head and neck area."

There was a gold necklace in the trunk and a gold watch on one of the body's wrists. On the other wrist was a gold and diamond bracelet engraved with the letters *H A L*. Smith's glasses were on the backseat.

Later that day Robby Hildebrandt voluntarily gave a statement describing

the "trunk music" argument with Solly DeLaurentis. Hildebrandt was drunk.

"I wouldn't have let him drive," said the policeman.

The Arlington Heights police requested that DeLaurentis come over and talk to them.

DeLaurentis arrived without a lawyer and answered their questions politely. He said that he'd met Hal Smith a few times.

"Frankly, he didn't know what business he was in."

DeLaurentis told the police that the two men had had no problems.

The policeman continued, "He leaned toward me with a sort of Cheshire cat smile and said, 'You know I don't know anything about this.'"

On Wednesday, Ann Infelise wore a headband studded with bright-colored gems of glass that made her look like a space goddess. After the lunch break, as the defendants were sauntering in from the lockup, she called out to DeLaurentis, "Whatjoo eat?" and he answered, patting his abdomen in mock satisfaction, "Tuna fish."

Infelise had been having trouble with his trousers lately, and now he made a familiar gesture, hiking them up with a twisting motion. Seeing he had his wife's attention, he pulled out the waistband all around with his forefinger to show her how much weight he had lost.

"We're going to bury my mother tomorrow," she called in a loud whisper. "I won't see you tomorrow."

Phil Caliendo, the pimp, was a deflated cream puff of a man. He sunk his pompadoured head down on a cushion of chins and kept it there as he answered questions about Bobby Salerno. There hadn't been much testimony about Salerno. He'd climbed a tree as part of the "Stalk of the Summer of '84," and he'd shown up in black leather the night Smith was killed. We'd heard tapes of Jahoda trying to get him to talk at Fishy Business, Salerno's seafood store, but most of the testimony so far had been about Infelise, DeLaurentis, and Marino.

Caliendo testified that he'd owned the Mansion Club, Western Health Spa, Paradise Leisure, and Plato's Castle, as well as an adult bookstore on Western Avenue. He said that Bobby Salerno had shown up one day when

Caliendo was first getting started in the prostitution business.

"He told me that this was an illegal business and these businesses belong to them.... I didn't argue, I agreed.... I felt that Bobby was very powerful at that time; they'd just defeated the Rush Street crew."

Until now Bobby Salerno's son, Alex, had sat quietly by his father's side, taking notes. He hadn't joked around with the other lawyers; his youth and his silence made him seem an outsider.

As he rose to cross-examine, he introduced himself both to Caliendo and to the jury.

"Bobby Salerno, he's my father, so if I refer to him as 'my father'...."

Alex Salerno's cross-examination was deft and confident. When Caliendo, his eyebrows going up and down, mopped his brow or clutched his head and didn't respond for long minutes, Alex Salerno waited politely.

At the defense table, Bellavia turned around to comment on the witness in a loud whisper: "Looks like he had a lobotomy.... I don't know where they go to get these people! One day they're talking about murder and the next they have a witness that everyone's laughing at!"

Attorneys often ask the judge, "Could I have a moment, please?" just before ending their examinations. It gives them a chance to check to see if they've covered everything. Alex Salerno asked the judge's permission and then went over to Terry Gillespie, Bobby Salerno's main lawyer. Gillespie rose, leaned across the table, and put his arm around Alex's shoulder.

"You did a fine job," he whispered, clapping him on the back.

"Nothing further," Alex Salerno said to the judge.

Bobby Salerno squeezed his son's arm, and the other attorneys shook his hand. Bruce Cutler got up from his seat and went over to offer his congratulations as well.

By Valentine's Day the witnesses seemed like the street sweepers at the end of a parade. They were a motley collection of gamblers, federal agents, and tax preparers. As far as "news value" was concerned, *United States v. Rocco Ernest Infelise et al.* had already produced its best moments and people's interest in it was waning.

Ann Infelise was absent all week, but Doodles Torello came regularly—one day in a dark pinstriped suit like a 1920s gangster. Bobby Bellavia's wife

sat chewing and popping gum in her usual jogging suit. On Tuesday Bellavia's toddler grandson sat on a relative's lap in the audience. At a recess he raised his solemn face obediently when they pushed him forward to kiss his grandfather.

Defense lawyer Jo-Anne Wolfson asked the boy what his name was; getting no answer, she persisted in cross-examining him. "Don't you know, or are you just shy?"

I gave the little boy a piece of paper and a red pencil so he could do his own courtroom sketching.

The pathologist, who had autopsied Hal Smith's body, testified. He said that Hal Smith was 5 feet 11 inches and weighed 220 pounds. He described ten areas of injuries on Smith's neck and then broke down each area: "stab wounds," "incise wounds," "bruises," "abrasions," "lacerations," and "ligature marks." He explained that an instrument like a knife could make both a stab wound and an incise wound.

He said that he had counted more than 20 injuries on the head and face; he had found five on the lower back, three on the chest and shoulders.

At the defense tables Bobby Salerno fidgeted a bit, while Louis Marino looked bored. Rocky Infelise was hidden behind one of the lawyers. Some of the lawyers studied pieces of paper with diagrams of the front and back of a human body, arrows pointing to various parts.

Gum popping was the only sound from the second row.

There were 12 injuries on the arms and legs, the pathologist said. Holding up his own left hand, he pointed to places below the fingers, where "defensive wounds" were made by the victim himself.

There were seven evidences of internal injury, he said. Hal Smith had previously had a triple coronary bypass, and his heart had been enlarged. Smith had hemorrhaged as he died.

The prosecutor brought the photographs over to show the defense before showing them to the jury. From the third spectator row a young man stood and stretched to see.

"Please be seated!" boomed the deputy marshal.

The defendants and their lawyers watched as each juror studied each photograph and passed it on. There is never much overt reaction when

autopsy pictures are shown to a jury—usually just a subtle flicker or shift of expressions, as though a mood has changed. A couple of the jurors wrote in their notebooks; one wiped her eyes. Most of them, when they had finished, looked over at the defendants. The courtroom was very quiet; even for those who couldn't really see them, the photographs were again a powerful presence.

The prosecutor asked the witness about torture. "These wounds could be consistent with torture, yes."

As for the cause of death, the pathologist stated, "My opinion is that Hal Smith died of strangulation."

The next day everyone was jolly again. At a break Pat Tuite brought one of the marshals by the elbow over to the defense's relatives. He pointed to the gold button on the marshal's lapel and said wasn't it cruel of the government to make all employees who have AIDS wear these buttons? He got a big laugh from the second-row ladies as well as from the marshal himself.

Bobby Bellavia introduced the marshal to his wife. He told her that he was a good guy, that he didn't put the handcuffs on too tight.

"They shouldn't have handcuffs at all!" huffed one of the ladies.

All week the spectator rows were full of the defendants' families. Ann Infelise was back from Florida, having buried her mother—"a sad trip," she said. One day her daughter was there, too. Joanne Bellavia sat chewing her gum, her brother next to her. Bellavia's son, pregnant daughter-in-law, and a cousin were there, as were DeLaurentis's parents, aunt, daughter, and daughter-in-law-to-be. A minor hoodlum, A-One Mike, who had been mentioned in testimony, attended, and one day Toni Giancana, known for her autobiography, *Mafia Princess*, showed up. Mrs. DeLaurentis would have been there but was home with a sick baby. So many of them squeezed into the second row that I could only see bits and pieces of arms, thighs, and knees. Doodles Torello seemed to have lost her tiny body altogether. They huddled cheerfully, making room for the latecomers, as though they were loaded into a pleasure boat headed for a family picnic.

Toward the end of the government's case, Assistant U.S. Attorney Buvinger, who had said so little in the trial that the judge forgot his name, read aloud a stipulation: a list of names of men who refused to testify against

their friends in the grand jury and were jailed for contempt. There were eight of them on what must have seemed a sort of honor roll to the Mob families.

Some photographs were introduced into evidence and more tapes were played. At a recess Louis Marino caught me reading the transcript of one of them.

"Don't look at that garbage. The guy's name is Louis Schwartz. It's not me. The truth will come out."

At 3:37 on Thursday, February 20, Mars addressed the judge. "Your Honor, we have no more witnesses. At this time the government rests its case."

Bobby Bellavia let out a big sigh. "At long last!" he said softly.

The defense called Northwestern University professor Donald Austin as its first witness. His academic demeanor, abundant white hair, and friendly twinkle made him likable. Bellavia nodded approvingly and Cutler grinned.

While on sabbatical, Austin had rented his house at 4285 Hilltop in Long Grove to William Jahoda. This was the house on whose kitchen floor Hal Smith had been murdered.

Austin spoke earnestly and helpfully as each side questioned him. Both defense and prosecution asked whether someone standing in his garage could have seen, when the door opened, three men in front of the kitchen stove. When Terry Gillespie meticulously examined, it seemed one could *not* have; under Marc Prosperi's cross, it seemed one *could*, if one got close enough. The jury would have to decide whether Jahoda really saw Hal Smith "sliced and diced" on the kitchen floor that night.

The defense also put on William Jahoda's brother, who testified that William was a liar.

At 11:47 P.M. Tuesday, February 25, after less than four hours of testimony, the defense rested. In the audience a voice said, "I don't believe it."

In the world outside the courthouse, a fifth season seemed to have inserted itself into the Chicago year. It was neither winter nor spring; there was neither snow nor buds and leaves. The world seemed monochromatic, a badly lit freeze-frame from a documentary film.

Perhaps luckily there were no windows from which to look out on the gloom in Judge Williams's 19th-floor courtroom, where an almost carnival atmosphere prevailed. Outside in the hall by the marshals' table, those who didn't make it in waited their chance. There were about to be closing arguments in the case of Rocco Infelise et al., and the defense, after calling only a few meager witnesses, would have their last chance to persuade the jury.

After lunch before the jury came in, Judge Williams called the defendants to the bench, where they stood in a scraggly semicircle beside their lawyers. She asked them the routine questions about whether they understood they had a right to testify and whether they waived that right. They all answered affirmatively and shuffled back to their seats.

When the jurors were seated again, Judge Williams turned to them.

"I'm happy to tell you that we've heard all the evidence and are ready to hear closing arguments."

Mitch Mars argued for five hours on Tuesday and Wednesday. His presentation was organized, interesting, and passionate.

"Who are these defendants?... Who are they that they get to excise street tax?... Where do they get their power...to commit criminal acts?"

They were members of organized crime, Mars said, and this gave them "the power to—almost—get away with murder!"

His voice shook when he described what happened to Robert Plummer and Hal Smith.

Terry Gillespie, arguing first for the defense, made much of Professor Austin's testimony. He explained how it was impossible for someone in the garage to see into the kitchen at the Austin house; he said that Jahoda had been lying.

Former judge George Leighton, Louis Marino's lawyer, tried to convince the jury that gambling was OK; it was human nature to "speculate about the future." He tried to discredit Jahoda by calling him "this bizarre mentality."

Robert Simone argued for Bobby Bellavia, suggesting that William Jahoda had killed Hal Smith; after all, Smith was murdered in his house.

Pat Tuite argued for Infelise. Even before he had convinced a jury to acquit one of the Greylord judges, Tuite was considered one of best defense lawyers in Chicago. There were more erudite lawyers, more flamboyant ones like Sam Adam, Ed Genson, or Allan Ackerman. Tuite, however, was able to strike the right balance between earnestness and theatrics that

sometimes works in a Chicago courtroom. He liked to say it was because one of his parents was Jewish, the other Irish.

He was wearing a green-and-red tie with a racehorse streaking across it. Flipping it out with his thumb, he showed it to the jury. It looked like the work of Leroy Neiman, an artist he admired.

As he often did, Tuite invoked the Magna Carta. Since this was a gambling case, he told the jury, it was interesting that the Magna Carta had been signed in "Twelve-fifteen...seven hundred and seventy-seven years ago!... Seven seven seven!"

Tuite charmed and cajoled, entertained and soothed; he also plausibly explained the facts or offered alternate possibilities. He made it seem a civil rights case; all Italians aren't gangsters, he said, just as all Irishmen aren't drunks. "I'm not a drunk; Terry Gillespie's not a drunk!" He pointed at the red-haired Gillespie, sitting against the far wall.

Gillespie, grinning, held up his hand, leveled it, and wiggled it to show that maybe he was just a little bit of a drunk; everyone laughed. When the judge looked over to see what was funny, Terry did it again for her.

Tuite was polite until Mars made an objection and Tuite snapped at him. When the judge overruled it, Tuite apologized. He apologized again at the end, as though he wanted to behave as differently as possible from the New York lawyer.

Bruce Cutler argued last. It was late afternoon when Judge Williams told him he could begin. The federal building is notoriously either too hot or too cold, and the judge added that she had called about having the heat turned down.

As Cutler rose to his feet, he said, "We're used to the heat, Your Honor."

After acknowledging all the participants, Cutler went to the jury box and leaned his big hands on its rail; he asked the jurors to pretend it was still early in the day and to pay close attention. He told them that they'd better fasten their seat belts and hold on tight.

Cutler, in his tight gray suit, began moving all over the room, shouting from different parts of it.

William Jahoda had called their gambling business the Good Ship Lollypop, and now Cutler repeated the phrase and made it into a metaphor for the prosecution. He said that IRS Agent Thomas "Mort" Moriarty was the ship's villainous captain.

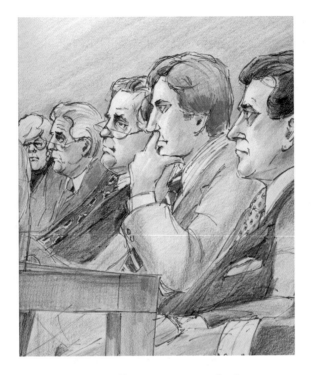

Pat Tuite, Solly DeLaurentis, and others.

Cutler: "Mort's Good Ship Lollypop!... Mort as in Mort the mortician!" He drew the name out as though it were two syllables.

Mort brought witnesses "who would sing the tune" on board the Good Ship Lollypop by offering them a "ticket to freedom!"

"Like Noah who built an ark, they took two of every bum they could find!... 'Solly D.' was the password that got you on the Good Ship Lollypop!... Jahoda had the main stateroom on the Good Ship Lollypop!"

Cutler stood over the prosecution table and pointed down at the skinny Moriarty. The agent glared back up at him, chewing furiously on his gum— an attack dog straining on his chain.

On Friday the families were back for more. Rocky strode out of the lockup wearing the same navy blue suit and navy-and-red tie he'd worn the day before. Ann Infelise told everyone proudly that it was the tie he'd worn to their wedding. "He loves that tie, he wears it all the time."

Finishing up his argument, Cutler alternated between anger and

sentiment; he didn't address much of the evidence.

He called people names, he scoffed at William Jahoda with his "martinis and cheeseburgers" paid for by the government, he spoke of Hildebrandt with his "brain of mush," and he called Charley Burge, the man who designed the cheating gambling equipment, a "dirty, rotten, lying, cheating hillbilly they found under a rock in Arkansas!"

He called Chicago the "city of the big shoulders"; he said it was an honest city and a no-nonsense city. He kept calling the jury "an American jury."

He spoke tenderly of his client, Solly DeLaurentis. "Solly, he's a human being.... I never said he was a saint.... I never said he doesn't have a temper.... I never said he's not a man.... I know he's handsome.... He takes pride in his appearance.... See how he sits there!"

Everyone turned to look at DeLaurentis, very straight in his black suit, burgundy tie, and matching handkerchief; as usual, "Solly D." was stitched in cursive on his shirt cuff.

"They call him a gangster.... They want you to think all kinds of things, from the movies, from novels, from television."

He held up the book *Man of Honor*, the book that Jahoda had given DeLaurentis for his birthday, and announced that he was going to give it back where it came from. With a loud bang Cutler slammed the book down on the government table.

Coming to the end, he told the jury that he'd be in the jury room with them "in spirit." And he concluded, saying, "Thanks, folks, thanks, Your Honor."

When Cutler returned to the table, DeLaurentis reached out to embrace him.

Mark Prosperi, in the final rebuttal argument, spent a lot of time on the Hal Smith murder.

"Smith made the fatal mistake of fighting the Outfit.... This is a lesson murder.... They don't just murder—they murder with relish."

He said that Jahoda couldn't have murdered Smith. "*One* man can't do that...to another man, can't torture another...it's a message murder."

From the relatives came the sound of short intakes of breath and tongue cluckings. Bobby Bellavia turned his chair around, so his back was to Prosperi, and sucked a chocolate lollypop.

When Prosperi told the jurors that they had been taken on an excursion to the underworld, a relative whispered, "On the Good Ship Lollypop!"

Prosperi pointed at DeLaurentis.

"Only in this underworld can the truth be so twisted that *he* can think of himself as a man of honor!"

As soon as Prosperi finished and the jury was excused, Robert Simone handed Mort Moriarty a cartoon in bright red marker on yellow foolscap. Titled "Good Ship Lollypop," the cartoon showed a ship with a crew of smiling stick figures, each labeled with the name of a trial participant. Moriarty, without smiling, looked at it briefly, folded it, and put it in his inside jacket pocket.

The ladies in the second row discussed how to spend their time while the jury deliberated. Ann Infelise instructed the others, "Just try to keep busy and keep your mind off it."

When someone else said they should go and play golf, Mrs. Infelise laughed. Rocky came over and told them they shouldn't hang around the courthouse.

Infelise said, "Nah, not this week. You could come here every day for nothing."

Ann Infelise said she didn't mind—she would sit in the cafeteria.

The lawyers seemed in good humor as they put away their papers and prepared to leave.

"I don't want to forget my gift!" exclaimed Mitchell Mars jovially, as he picked up Solly DeLaurentis's birthday book, *Man of Honor*.

Tucking it under his arm, he followed the government's evidence carts out of the room.

The jury deliberated the whole of the next week. On Friday, Cutler and Tuite appeared before Judge Williams to discuss instructions in the forfeiture proceedings that would occur should their clients be found guilty of RICO conspiracy. Some family members showed up as well, and

Ann Infelise was as cheerful as ever.

"What's shaking, boys?" she asked the defense lawyers.

Mort Moriarty arrived late dressed in jeans, a blue-and-white striped shirt, and a red windbreaker, as though he really were the captain of a ship.

Ann Infelise wore a windbreaker, too; hers was silk and splashed with Fauvist magentas, aquas, pinks, greens, and reds. She sat next to Doodles Torello.

I wondered if she knew that, if the jury found them guilty of the RICO charge, Infelise and DeLaurentis might have to forfeit everything they owned, even their homes.

Tuite told the judge that Infelise didn't use the family home in his business, and anyway he sold it to his wife in 1983 with a quitclaim deed.

Tuite came over and sat on the first bench. He twisted around to talk to Mrs. Infelise in the row behind us. As they whispered, she leaned toward him, placing her hand with its long magenta nails across his back.

The judge called in all the participants on Friday afternoon so that she could instruct the jurors about the weekend. They had now been deliberating for most of five days. The defendants were back at their tables and their families in the spectator rows near them. Everyone's faces looked pouchy with tension.

Bellavia's family had brought his little grandson and were trying to get him to "blow Grandfather a kiss."

When Rocky Infelise came in from the lockup, Ann Infelise and some other ladies chirped cheerily, "What's up? What's up?"

It took them a while to get Infelise's attention because he was going around to both defense tables, leaning over each of his codefendants, conferring with each, his arm over each of their backs.

When the jurors came in, they too looked tired. Not one looked at the defendants. The judge told them that they must suspend their thoughts about the case over the weekend and admonished them as usual not to watch television, look at newspapers, listen to the radio, or discuss the case. She told them to have a nice weekend.

On Monday, March 9, Sam the court buff, shaky with age, speculated in the corridor. He figured the jury had been deliberating for 25 hours and

quoted the old rule of thumb: one day of deliberation for each week of trial. But he couldn't remember how many weeks of trial there had been.

When at 12:45 Rocky's and Solly's lawyers gathered for the ruling on forfeiture instructions, the courtroom seemed humid and smelled of damp carpeting. The black leather chairs, new at the time of the Conspiracy 8 trial, showed crumbs of stuffing at their seams. Some were patched with black tape.

The judge said she'd heard nothing from the jury. Spreading out her big graceful hands, she repeated, "Nothing…they all showed up on time and they're going at it."

After they finished with the forfeiture matters, she said, "We won't resume again until next Friday unless we hear something."

But at 4:00 there was a note from the jury. When the judge called the lawyers into her chambers, Pat Tuite left a copy of the jury's note on the table and the reporters pounced on it.

"Dear Judge Williams," it said, "We have reached a verdict on a number of counts; however their [sic] are a few counts that we can't come to a unanimous verdict on. Further, we the jury need to know how to sign the verdict form—with names and numbers or with numbers only. Thank you."

The note was neither signed nor numbered.

At 9:30 on Tuesday, March 10, Judge Williams informed the lawyers that they were still waiting for one juror to arrive; in the meantime, she turned her attention to another case, that of Anthony Fort, Jeff Fort's son. Jeff Fort was a famous gang leader, whose gang the federal government was attempting to destroy. A small black man in prison fatigues, Anthony stood shaking his head, telling his attorneys what to say. His trial on drug charges was to be Judge Williams's next assignment.

While Judge Williams dealt with the Fort case, the Mob relatives gathered. DeLaurentis's grandsons tumbled around, smiling and waving at their grandfather. DeLaurentis's dark face relaxed with pleasure, looked soft and nearly vulnerable.

When the jurors were seated in the box, the judge read them the *Silvern* instruction. A frustrating admonishment, its elegant paradoxes really only tell a jury to "keep at it."

Everyone seemed to expect a verdict soon.

"Stick around," Pat Tuite told the ladies.

The court security officers forbade anyone to enter the courtroom, because they were picking jurors for the Anthony Fort trial. In the hall, people chatted in knots of three and four, the air was thick with smoke from cigarettes as well as from Cutler's and Simone's cigars. Ann Infelise perched on the marshal's table, swinging her feet slowly back and forth. She wore a pink one-piece outfit like a baby's, its trousers tucked into white socks and white high heels. Doodles Torello stood nearby, in tiny high-heeled boots with rolled tops, a coat folded neatly over her arm.

Finally, just before noon, people were allowed back in the courtroom. The ladies had requested Bruce Cutler's business card; in a courtly manner, he was opening a fancy case and putting several into each outstretched hand.

"Is this a 24-hour number?" someone asked.

When the defendants came out of the lockup, Tuite and Infelise shook hands. One of the ladies said, "Rocky looks plump in that sweater."

"He looks good," countered Ann Infelise defensively.

"He doesn't look any the worse for all that wear and tear."

"He wears it well."

When the jurors were seated, Judge Williams asked each in turn whether any further deliberations would help. Each in turn answered no.

"All right," said the judge and instructed them to go back and fill out the verdict forms.

"Knock when you're ready."

We waited for what seemed a very long time. The judge was off the bench, so the defendants milled about, chatted; people made nervous jokes. Bobby Salerno stood next to one of the marshals.

"I told this guy to get the cuffs ready," Salerno joked.

Solly DeLaurentis, his smile very tight, rubbed his hands over and over. "The fat lady will sing shortly," he announced.

A verdict is the most difficult of all courtroom situations to draw.

Solly DeLaurentis and Bruce Cutler.

People's reactions are unpredictable and can come from anywhere, so if I concentrate on drawing one person, I may miss something more important somewhere else. And in cases such as this one, where the trial had taken such a large part of my life, I have my own reactions to deal with as well.

When Judge Williams began to read the verdict, I started several sketches, only to abandon them on the seat next to me.

I knew the indictment in this case well. I'd made a chart of the counts and the overt acts under each count, so I could hear through the judge's recitation of the numbers, what she was really saying.

It started out well for the defense; the jurors found Bobby Salerno not guilty of the RICO count and reached no verdicts on his other counts. Bobby Salerno and his son embraced; some people cheered and clapped.

The jurors found Bobby Bellavia guilty of RICO, and within that count, they found he had agreed to the conspiracy to murder Hal Smith. But they could not decide whether he had agreed to the murder itself! Nor

did they have a verdict on the counts of conspiracy to murder Hal Smith or the murder itself. Louis Marino's verdict was much the same.

When the judge got to Solly DeLaurentis, she read that, though he was guilty of RICO, in the "overt act" under that count—conspiring to murder Hal Smith—he was not guilty. However, he *was* guilty of conspiring to murder Hal Smith under count 8! He had not been charged with count 9, the actual murder, because Jahoda had not put him at the murder scene. It seemed that the "trunk music" threat, the only link of DeLaurentis to Hal Smith, had meant more to the jurors than all of Jahoda's testimony about the others.

DeLaurentis looked dead. Bruce Cutler, next to him, was shaking his head and saying, "It doesn't make sense, it doesn't make sense."

Judge Williams read Rocky Infelise's verdict last. I tried to draw Ann Infelise and Doodles Torello as they listened, but I couldn't find the distance, either spatially or psychologically, to see them as objects. Instead, we listened together.

The judge got to count 1, act 8, and read that the jurors had found Infelise not guilty of this count. That meant they believed he did not agree to murder Robert Plummer. The ladies only heard the numbers, and they kept asking me what was happening.

In 17a the jurors found that Infelise had agreed to the conspiracy to murder Hal Smith, but in 17b, the actual murder, there was no verdict. They found Rocky guilty of RICO and gambling conspiracy and all the gambling counts, but when she got to 8 and 9, the judge read, "No verdict."

Ann Infelise asked in a whisper, "What did that mean?"

"He's OK on the murders," I heard myself say.

I explained that he was found guilty of RICO and gambling and taxes but not the murders, either of Robert Plummer or of Hal Smith.

She asked if that meant her husband would not go away for such a long time. I didn't answer.

After the jury was polled, the judge took the lawyers to sidebar. After a long time, Judge Williams thanked and excused the jurors and recessed court.

All over the room people clustered, exclaiming, questioning, comparing notes. "It doesn't make sense, it doesn't make sense," Cutler kept saying.

At their table the government lawyers, heads down over their pencils,

were trying to work it out.

The reporters also compared notes, wondered what to report, on some counts disagreed with each other.

"Was Solly guilty on 8?"

"Yes, he seemed to be."

Nobody could believe that Solly DeLaurentis was the only one guilty of the actual conspiracy to murder. He was the only one that Jahoda hadn't mentioned in his long testimony about the two murders. Yet the jurors seemed to have convicted him of murder, just on the "trunk music" threat.

Infelise sat rubbing his forehead with his fist, chuckling to himself.

DeLaurentis, his face ashen, stood and addressed his relatives. He shrugged his shoulders. "We may be happy. I don't know."

(And as it turned out, they *were* happy, at least relatively speaking, because it turned out there had been a mistake and later the jurors let it be known that they hadn't meant to convict any of the defendants, including DeLaurentis, of murder.)

As the defendants headed for the lockup, Infelise stopped in front of the spectators. Grinning mischievously as the ladies watched, he held up a yellow legal pad and behind it made a gesture as though he were masturbating.

"I love you!" Ann Infelise called out as he was led away.

In the corridor by the elevators, Sam the court buff was not confused. To him it was obvious that Terry Gillespie had saved the four whom Jahoda had tried to place at the Hal Smith murder. Terry Gillespie was brilliant, he said, better than any of those "high-priced fancy lawyers." Gillespie had established reasonable doubt by questioning whether Jahoda could have actually seen from the garage into the kitchen of Hal Smith's house. By so doing he had saved them all.

But their salvation would be temporary. Bobby Salerno was retried and found guilty of conspiracy to murder. When Judge Williams sentenced the others, she used the murder testimony from *Infelise et al.* to give them more time in custody. She was upheld on appeal.

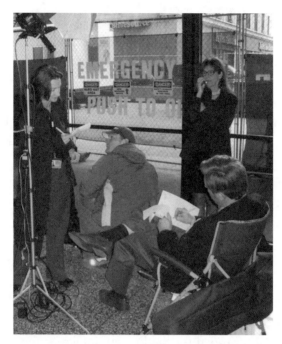

Andy Austin (r), Jane Brouder Stephens (l), and Paul Meinke.

Andy Austin and husband Ted Cohen.

Andy Austin outside 26th and California.

*John Drummond, Greylord judge Raymond Sodini, Jim Gibbons,
and Sodini's lawyer, Pat Tuite in the* Chicago Tribune.

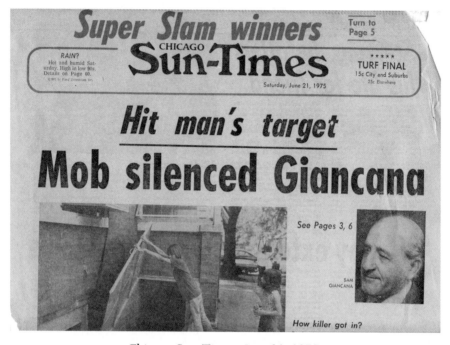

Chicago Sun-Times, *June 21, 1975.*

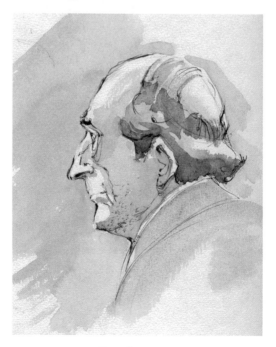

Sam Giancana.

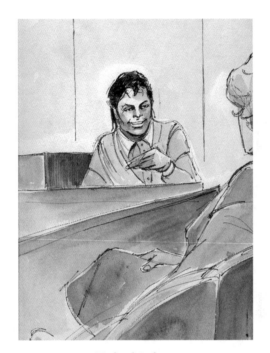

Michael Jackson.

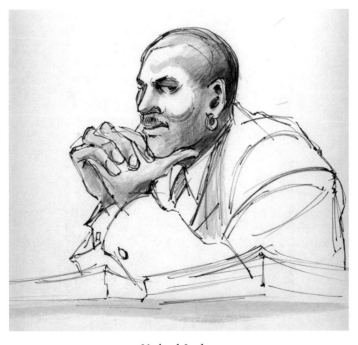

Michael Jordan.

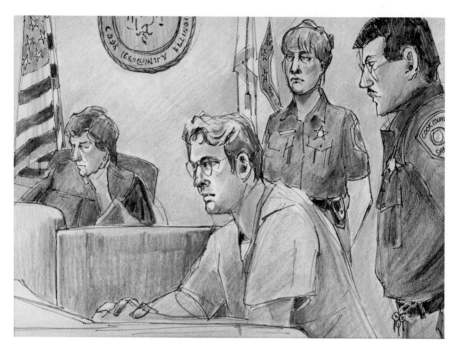

Helmut Hofer at his bond hearing.

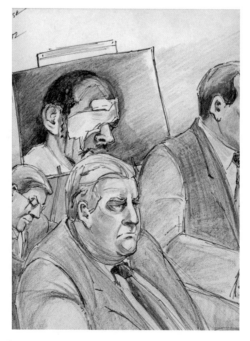

Then Police Commander Jon Burge and photo of Andrew Wilson.

Three defendants at 26th Street.

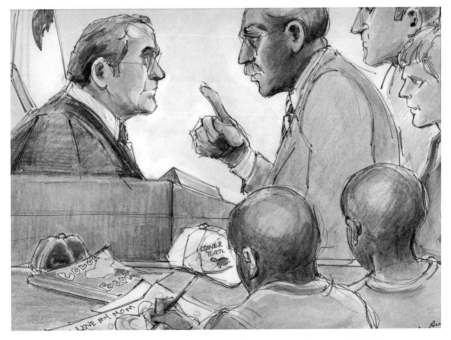

Defense attorney R. Eugene Pincham in juvenile court, 1998.

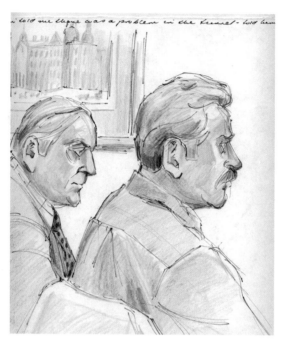

City engineer (right) at hearing for 1992 Chicago River flood.

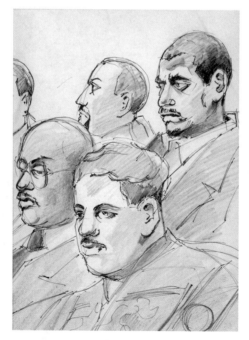

Gangleader Willie Lloyd and other gang members at 26th Street.

Enaam Arnout.

Louis Almeida.

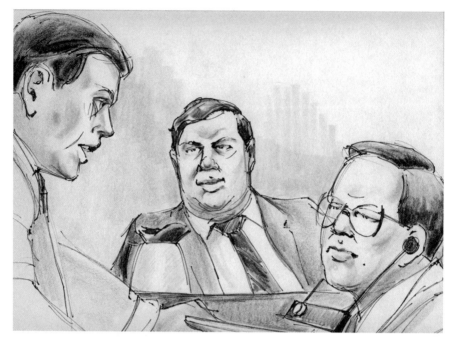

Dan Webb at the Chinatown trial.

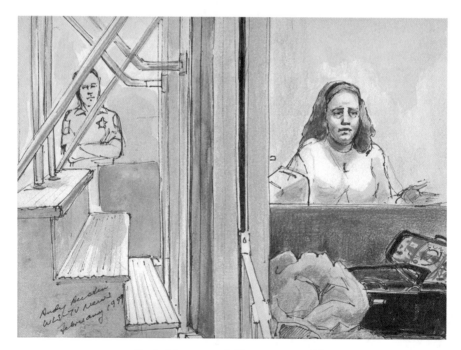

Rachel Barton and Metra train model.

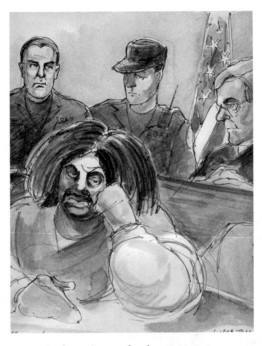

Anthony Porter, death row prisoner.

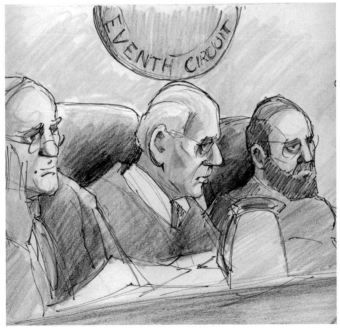

Seventh Circuit Justices Daniel Manion, Richard Posner, and Frank Easterbrook.

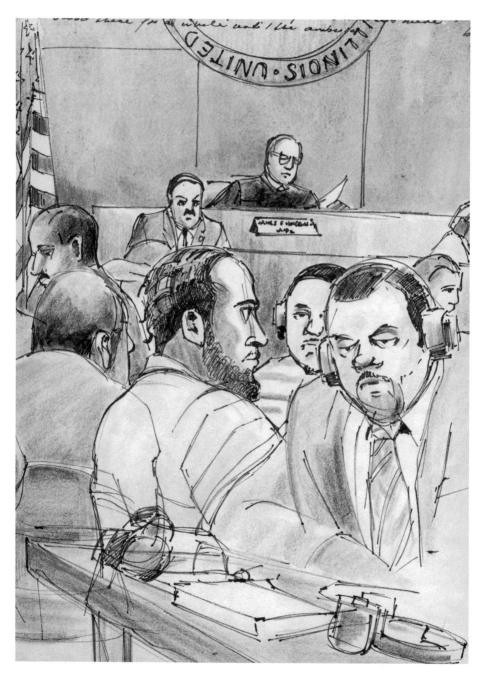

Ambassadors' trial.

7

THE SLUMS' REVENGE:
THE EL RUKN TRIALS

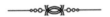

*The stone which the builders refused is become the head stone
of the corner.*

—Psalm 118, Verse 22, *King James Bible*

*The slums take their revenge. And you can take your pick of
the avengers...at any district-station lockup on any
Saturday night.*

—Nelson Algren, *Chicago: City on the Make*

Since the early 1970s I had been drawing members of a crime organization that was far more dangerous and more bizarre than even the legacy of Al Capone. I drew them as they metamorphosed from a group of teenage toughs hanging out in a church basement into a metagang, with branches all over Chicago, its suburbs, parts of Wisconsin, and every prison in the Unites States. Originally called the Blackstone Rangers, after Blackstone Avenue, these men came to be known as the El Rukins, and for more than 25 years they followed Jeff Fort, an illiterate but charismatic kid from Mississippi. They stole for him, dealt drugs for him, fought for him,

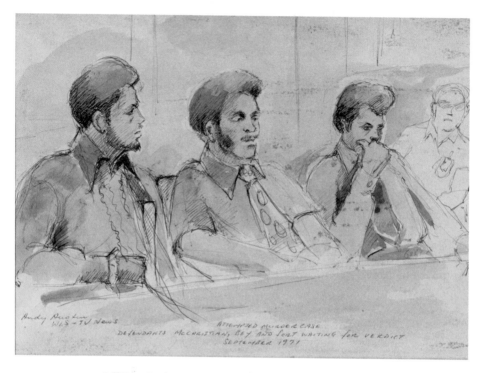

Jeff Fort (right) and Blackstone Rangers on trial, 1971.

killed for him, went to the penitentiary for him, and gave up not only their youths but often their whole lives for him.

He in turn gave them lives more glamorous than the dull slums could provide. He gave them a culture, a language, a hierarchy in which they could climb—even a religion. At least in some cases he gave them reasons to live.

Jeff Fort was born in Aberdeen, Mississippi, in 1943. When he was little, his family came to Chicago like many others, because the sharecropping life had become impossible. But in Chicago life was not any easier. While the mothers of these families were away from home working in factories or as domestics, and the fathers were nowhere to be found, the teenage sons hung around the dilapidated tenements, fighting, stealing, and selling marijuana and cough syrup. They joined whatever gang controlled the few blocks or the building where they lived. Jeff and another young man, Eugene "Bull" Hairston, organized many of these gangs in the early '60s.

A turncoat witness later described the evening when the Rangers met

in the First Presbyterian Church. At every street corner, he said, boys would meet other boys until there were crowds of them heading down the streets and sidewalks on their way to 64th and Kimbark. In the church basement each faction sat with its own leader holding a sign with its name: the Outlaw Four Corner Rangers, the Suicide Stones, and others. When called upon, each leader would stand and announce his area and how many men he controlled.

Fort and Hairston managed to bring nearly all the gangs of the South Side to this church, where a white minister let them meet and keep their guns. Fort and Hairston placated the gang leaders, whose gangs they had consolidated, by giving them "cabinet-level" positions and calling them the Main 21.

The only gangs they didn't incorporate were those that owed their allegiance to the Disciples, and the Disciples remained their deadly enemies. All of Chicago, and all the prisons in Illinois, were for years divided into these two groups of gangs: the People (the Rangers/Stones/El Rukns and their allies) and the Folk (the Disciples and their allies).

In 1967 the Office of Economic Opportunity awarded the Blackstone Rangers a grant of $927,000 to set up job-training programs in their neighborhoods. The Rangers took advantage of the liberal optimism of the time by continuing their gang business in the training centers. Not long after the program started Fort and Hairston were both arrested on murder charges and soon the program was abandoned as an embarrassing failure.

In 1968 the city of Chicago erupted in violence, first in the black slums when Martin Luther King Jr. was killed, and then in the white parks when the Democratic Convention came to town. Mayor Daley issued his infamous order to kill arsonists and to maim or cripple looters in the first of these eruptions. Many credited Fort with preventing the South Side from going up in flames that spring.

Fort was invited to attend President Nixon's 1969 inauguration, and though he didn't go, Senator Charles Percy brought two Blackstone Rangers with him to an inaugural ball.

I covered the federal trial resulting from the Rangers' misuse of the OEO job-training funds. I drew the slight, intense, Afro-haired young Fort

surrounded by members of the Main 21 lounging in the black leather chairs, graceful in their defiance. Witnesses testified that they had taken the federal money and spent it on beer and bowling, drugs and pool.

A couple of Fort's henchmen came up to me outside the courtroom and told me, "Jeff say, you draw his wife, he break your legs."

"OK," I said, "I won't."

Jeff Fort and his followers were in and out of courts for years. For a 26th Street trial, they showed up in coolie hats, braids, and flowing robes. There was talk in the optimistic '70s about the gang opening respectable businesses.

In 1987 Fort was tried for conspiring to perform terrorist acts for Libyan dictator Muammar Qaddafi. Fort had been in federal prison in Texas on drug charges; now they brought him back to Chicago to be tried with five others in Federal Judge Charles Norgle's 17th-floor courtroom. The old Blackstone Rangers, later the Black P. Stone Nation, had become Muslim and now called themselves El Rukns. In court they wore long white tunics and white skullcaps, or kufis.

(Now that September 11, 2001, has changed the world, I often think of that crazy trial and wonder in what ways it would have been different if it had been tried today.)

During this trial the phenomenon of the El Rukn language came to light. Fort had been in prison for four years, and on a monitored, bugged pay phone, he had managed his enormous drug-selling organization through his officers, "generals," "ambassadors," and "soldiers." He had ordered murders and other crimes through a code constructed painstakingly over this phone. In court the government played hours of tapes that the FBI had harvested from their conversations.

After a jury found him guilty, Judge Norgle sentenced Fort to 80 years in prison. Fort was the first of the six to be sentenced, and when Judge Norgle was through, he told Fort he could leave. Jeff Fort, now bulging with jailhouse muscles, surveyed the large courtroom with a twinkle in his eye. Nodding toward the main entrance and freedom, he asked, "By that door?"

Later that winter the state of Illinois tried Fort and four others for the

murder of a rival gang member. At 26th and California the press watched the trial through what we assumed was bulletproof glass, our own reflections competing with the image of the stocky bearded man in the white hat on the other side.

After that guilty verdict Fort was sent away for another 75 years. Those of us who had covered his trials for so long would never see him in person again.

On October 27, 1989, federal and local police raided the El Rukn headquarters, the Fort, at 39th Street and Drexel Boulevard. Immediately afterward the U.S. Attorney's Office announced the indictment of 64 El Rukns and a local businessman named Noah Robinson for 20 murders, seven attempted murders, conspiracy to murder, racketeering, racketeering conspiracy, witness intimidation and retaliation, kidnapping, obstruction of justice, narcotics, and firearms violations over 24 years.

The U.S. attorneys had wanted to try all the men together, but Chief Judge Marvin Aspen ordered that, because of the number of defendants, the cases must be divided. In the spring and summer of 1991, the first of eight trials, which were supposed to finish off the El Rukns for good, began.

Fort wasn't one of the defendants, but more than 60 of his followers were, and another group took the witness stand against their former colleagues. This other group, all men who had held high rank in the El Rukn Nation—including Henry Harris, alias General Toomba, alias Noodles; Earl Hawkins, alias General Manzur, alias Zoom; Derrick Kees, alias General Nassua, alias Nasty; Eugene Hunter, alias General Salim, alias Maurice Wright; Jackie Clay, alias Doc Ishmael; and Harry Evans, alias Bebop—had become "doorknobs." They had turned against their leader and would let the government in on the gang's secrets.

In Judge James Holderman's courtroom, hulking, sullen black men lolled among their court-appointed attorneys at three defense tables. Most wore jail-issue navy blue overalls, some had on bulky ski sweaters, one a suit with wide lapels. Most of them had prison-built physiques: thick necks and round shoulders. Except for the one with cornrowed braids, closely trimmed hair made their heads look small and very round. Watching over

them were clean-cut, pink-faced deputy marshals. The marshals stuffed the front row on the defense side, flanked the jury box, sat near the judge, and stood by the front door; two of them perched on the other first row, where a pasted sign read "RESERVED ARTISTS."

This trial that began in April, before Judge James Holderman, was called the ambassadors' trial because the defendants had held the rank of ambassador in the hierarchy.

Jeff Fort was there, but not at a defense table. Instead, his enormous mug shot, waiting to be introduced into evidence, leaned against the jury box. It was perhaps two feet by three feet and so enlarged that the brown skin was paled to a light ocher and the black hair to a fuzzy gray. Its intense eyes seemed to follow the proceedings, a visual counterpart to Fort's recorded voice that would fill the courtroom from speakers set up around the room.

Though we would not see him again in person, we would come to know Fort better than ever through his words and those of his followers—those whose devotion had turned to hate and those who still loved him.

Assistant U.S. Attorney Ted Poulos asked the witness to recite the homecoming speech Jeff Fort gave when he was paroled to Milwaukee in 1976. It was called "The Chief Malik Lesson," and every El Rukn had been required to learn it. Then the young prosecutor stood back from the lectern, arms folded casually as though he knew he could take a break, and waited.

"It's been a long time," the witness said, but after a second of demurring, he puffed himself up and, swinging his head slightly to one side like the MGM lion, let loose. "'Today we gather to understand the total significance and meaning of the symbolic and illustrious Black Stone,'" he roared.

"'The Black Stone which sits as a cornerstone...in the holy city of Mecca, ...once thought rejected, has become the head stone of the corner.... It sits as a symbol to the fact...that the Ishmaelites...has ended up inheritance of the kingdom of almighty father, God Allah.'"

Henry Harris, alias Tombstone, alias General Toomba, but known to all as "Toomba," was the star witness in the El Rukn trials. He would tell his story over and over until all his codefendants were convicted. Harris's fellow turncoats would also tell of their lives in the gang, but no one told his story better, with more passion and manic delight, than Toomba. A stocky

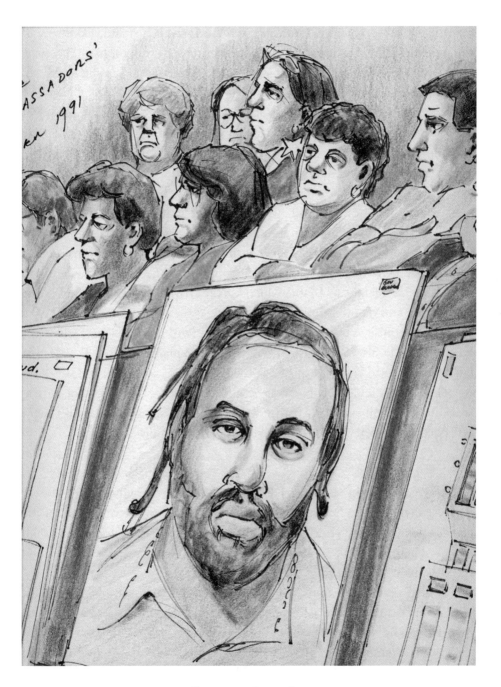

Jeff Fort mug shot and jury.

man in an olive green sweater, he wore a Van Dyke beard and, like many of the defendants, a little canal sliced out of his close-cropped hair. The large round glasses on his large round face mimicked the two O's in the middle of the word *Toomba*.

Rocking back and forth, he declaimed, "'We, who once called ourselves Blackstones, and whom the world viewed as utterly rejected people, has now become the head stones of a corner, returning back to…our forefathers' ancient and divine creed, and resume in our rightful place in affairs of men and nations.'"

Around the room defendants' eyes shone as they heard the familiar words. Several smiled and some mouthed the words along with Toomba as though they were in church. He continued reciting, "'Therefore we are returning…Christianity back to the European nations.…While we, the El Rukns, are returning to Islam, which was prepared by our forefathers for our earthly and divine salvation.'"

Toomba finished by shouting the words: "Islam! Islam! Islam!" And then, when he made his way out of the trance, he explained to Ted Poulos that later Jeff Fort had changed this coda to "El Rukn! El Rukn! El Rukn!"

Though Toomba had been an enthusiastic gang member for years, working in its Milwaukee prostitution and drug businesses, he didn't meet Jeff Fort until April 1976 when Fort returned from prison.

As I covered these trials, I learned about the neighborhoods the El Rukns ruled—only a few miles from where I lived but the other end of the earth. I advanced my education by looking at transcripts, documents, and copies of handwritten papers. Among the latter was what the lawyers called the Toomba chronicles.

Twelve years later, himself in prison, Toomba wrote in his chronicles, with a ferocious disregard for spelling and punctuation, about the day he met Fort. The document, now copied and passed around by laughing defense lawyers, was replete with undecipherable improvisations and blobs, crossed-out sections, and meanderings:

> We all heard of his coming home…so all of us started get-
> ting ready for his arrival.… Two days before…came to

Milwaukee Eugene Hairston…known as Bull…and Alan Knox, known as Gangster and Popcorn which was Main 21. We made the brothers comfortable when they arrive.

They demonstrated how we should set things up for Fort. They…said we should dress up in all black with red tams…. We should stand foots Eagle form. And the right hand over the left, placed at the navel. The cars pulled up. A black Cadillac first and second a limousine, then another Cadillac, plus two bus loads….

The cars stop in front of the house, two men jumped from the 1 and 2 Cadillacs and surrounded the Limo.

Fort, the Angel turned and hit his chest and said "Stone Love."

After Fort was in the house the Bull… said on the walkie-talkie, "Fall in." Over 300 to 400 men started proceeding to the front of the house. You would have thought the president was there.

Once Fort was in, it got quiet. Fort raised his hands and bowed his head and said, "Let us pray."

A soft voice spoke… "Allah, the father of the Universal, the father of Love, Truth, Peace, Freedom and Justice, Allah is my protector, my guide and my salvation."

He raised his hand and said, "I am Chief Malik, leader of the El Rukns. There are no more Stones from this day on. There is but one leader and that's me, the Chief. There is no Bull, no more Main 21 ones. We are just one big family.

"I will make generals to assist me in my time of stress. If anyone disagree with this let him speak now or forever hold his peace."

No one spoke, you could hear a pin drop.

At that time my name was Profit Tombstone. I was told…that I must change my name, order of Chief Malik. I said, "Yes, sir." Chief say, "You are not a profit [sic], there is but one profit, Muhammad. May Allah bless him."

…I changed my name quick. When I look into Chief's eyes I seen power and strength. I thought the man was God.

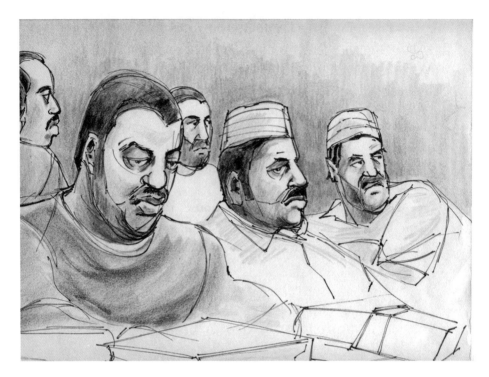

El Rukns on trial.

In Judge Holderman's courtroom, Toomba told how Fort had picked Toomba for the honor of being his bodyguard at this, their first meeting.

Poulos: "What type of relationship, Mr. Harris, did you establish with Jeff Fort during this time period?"

Toomba: "Mr. Fort and I became very close. I would say that Mr. Fort played the fatherly figure in my life at that time, and I was treated like his son."

Toomba testified that he married Jeff Fort's daughter seven years later with Jeff's permission and thus became a member of the "royal family." They were still married, Toomba explained, though they didn't have a current relationship.

Toomba told how from 1980 to 1982, the El Rukns acquired their real estate with proceeds from trafficking in Ts and Blues, marijuana, codeine, cough syrup, and cocaine. Large colored photos leaning against the jury box showed buildings with cornices and curlicues, twisting columns, and miniparapets, buildings with a wispy glamour reminiscent of Chicago's

pre–Prairie School days. They were in a neighborhood not known to most white people, near where a hundred years earlier the Columbian Exposition spread its glittering white edifices. Now the golden minarets of the Regal Theatre and the dome of Elijah Muhammad's temple pierce the sky over empty lots, fast-food joints, and gas stations.

The El Rukns had named their buildings the Pyramid Towers, the African Hut, the Peace and Love Building, the Harper Building, the Minerva Building (also known as the Morocco Plaza), Wedgewood Towers, and, confusingly, the Fort. Poulos showed the photos to the jurors as Toomba testified.

The Alhambra—or, as Toomba pronounced it, "the Alla Hambra"—was acquired by more violent means. Toomba described the day in the summer of 1980 when Jeff walked into the Khabar Room and said, "Let's ride out!"

They grabbed their weapons and formed a caravan of "15, 16, 17" cars. No one asked where they were going; they just knew to follow the car with Jeff in it.

Their cars pulled up to a building owned by a rival dope dealer.

"Jeff say, 'I want 'em out, I want all the vagabonds out! Everybody's got families can stay,'" said Toomba, convincingly imitating his leader.

"Our forces moved in," and they entered the building yelling, "El Rukns, El Rukns!"

According to Toomba, they were "kickin' in doors…escorting people out…. 'El Rukns takin' over, El Rukns takin' over!'"

The El Rukns moved into the Alhambra and made it their own.

Toomba: "The whole complete floor on the right, every apartment. We knocked down walls and made one big ol' living quarters for Mr. Fort and his family."

For days Toomba testified about El Rukn exploits.

He told how Jeff ordered Eddie Franklin to shoot a man in the Crest Hotel who had been "messing with the brothers and something needed to be did about it."

The man, said Toomba, "was talking back to Jeff, you know, like he didn't know who Jeff was."

After Franklin shot him, "The guy just laid there," related Toomba, his eyes as round as his spectacles. "I was scared…. Jeff said, 'Get a carpet, and roll him up in it.' …Eddie Franklin went into another part of the basement,

got an old carpet, and we rolled the guy up in the carpet."

Poulos: "What happened after you guys rolled him up into the carpet?"

Toomba: "Well, we stumbled with the body for a minute rolling him up. Franklin had one end, and I had the other end. We lost balance of the body, and it rolled back out.... I jumped, I bumped into Jeff, and...Jeff grabbed me.... He says, 'Take it easy, Tombstone, take it easy.'"

Toomba told how in 1983 Fort had been arrested for hiding a man who was wanted for murder. His men raised his bond money in their usual way, by "shaking trees," asking local businessmen like Noah Robinson for contributions, but Fort knew he wasn't going to win at the trials, that his freedom was temporary. Before the gates clanged shut behind him, he wanted to reorganize the El Rukns and create a class of officers whose loyalty he could count on from afar.

Toomba: "He was concerned about the future of the organization.... He was concerned about a lot of the generals being lazy...the generals are older now, they are up in age, they have families, children, and just can't go out there and act like they was acting in the '60s when they was with him when he was coming up. They needed a new spirit."

Fort ordered all the El Rukns, except the ranking members, to gather in the ballroom of the Pyramid Towers in "single-file formation" and then to be brought in to him to be interviewed.

Toomba: "Each man would step in. Mr. Fort would greet him, 'El Rukn love.'

"The brother would respond, 'El Rukn love, Chief.'

"Jeff would ask him about his parents, or are his parents living....

"Then Jeff would ask did he have a girlfriend and was she part of the organization....

"Then Jeff would tell him that he needs the brother's support, he wants the brother to become a part of a force...to protect the members, the brothers and the sisters of the organization.

"'But in the middle of peace, be prepared for war.'

"And the brother would say, 'Yes, sir, Chief, yes, sir! Yes, sir, Chief!'

"He'd hit the brother on the shoulder, pat him on the shoulder. The brother...ain't got to answer to nobody now but Jeff...."

Henry Harris, also known as Toomba, at El Rukn trial (with notes).

Fort required them to learn "Moorish literature," to do calisthenics, to learn how to march and how to box, on the roof of the Pyramid Towers. He hoped to arm each of his key soldiers with a pump shotgun, a 9-millimeter, and a bulletproof vest.

Toomba described the Khabar Room in the Fort, at 39th Street and Drexel Boulevard, where government meetings were held. "We have a long conference table. The generals would be sitting at the conference table, and the ambassadors would be surrounding us on the outside."

Poulos: "And what was at the head of the table?"

Toomba: "Jeff Fort's throne, his seat.... A big wooden throne made out of tree bark with a chair that sits directly in the middle, with a prayer rug hanging across the top of it."

"And what was over the throne?"

"A picture...of Jeff."

After Jeff Fort was incarcerated, the throne was empty, and the object

of veneration became a telephone.

When their chief called collect from prison, he would tell the operator his name was Mr. Wood, Toomba explained, "We would talk about organizational business, we would talk about drugs, we would talk about what's going on outside the organization...if any of the members have any problems with rival groups, hard-headed peoples, or whatever."

Soon after Jeff Fort settled into prison in Texas, he and Toomba and Eugene Hunter created the El Rukn language so Jeff and his followers could talk over bugged lines. They should have had a language anyway; as a separate society they had every other cultural artifact. They had their pseudo-Moorish religion with readings from the Koran every Friday (followed by a disco). They had their royal family and their palace. They had the inspirational "Chief Malik Lesson" and all the attendant mythology. They had their hierarchy of groups with the men boasting pseudo-military ranks and the women in one catchall category of Moabites (pronounced "Mo-BITE-us-es"). They had their initiations and holidays and costumes and rules and special El Rukn stance. And, of course, they had their own laws.

The U.S. Attorney's Office designated Toomba and Eugene Hunter translators of the El Rukn language. They worked for 12 months over the tapes and transcripts made from bugging the Fort's and "Mr. Wood's" prison telephone.

At six in the morning he would be taken out of his cell, Toomba told Judge Holderman's courtroom, and he wouldn't get back until ten at night. The whole time he would be drafting the translations that appeared in the right-hand column of the transcripts in the big black evidence notebooks.

"Experts in a foreign language" is how Judge Holderman characterized Toomba and Hunter when the defense lawyers objected to their translations. He compared the El Rukn code to pidgin English and allowed the government to play the tapes.

Each tape began and ended with the El Rukn greeting, a jumble of Arabic words; on each tape, the cool, laconic voice of Jeff Fort was heard in concert with the eager, obsequious voices of his followers. "Nan, Iman, Nan, Iman...yes, sir, yes, sir! Yes, sir, sir!" We heard this over and over again from the speakers set up in the corners of the courtroom.

The El Rukn language sounded poetic, until you found out what the words meant. *Love, truth, peace, freedom, justice,* and *time never was* stood for

"one," "two," "three," "four," "five," and "seven." The talk was sprinkled with *all principles, manifest, in the signs of* —, and, particularly, *demonstration*. *Demonstration* or *to demonstrate* was a sort of wild card, joker of a word, used to mean whatever the context required. There was a pseudo-Arabic cast to some of the language. *Mecca* stood for "Chicago," and the Iman was Jeff Fort. Some of it was playful pop culture. The *Up Scene* was the airport and a *Perry*, after Perry Mason, was a lawyer.

"I'm Local's Perry," Robert Simone, Noah Robinson's lawyer, said when he introduced himself to the jury in the second El Rukn trial.

In this second trial, the generals' trial before Judge Marvin Aspen, Toomba testified that he tried to tell Jeff Fort that the feds would be able to crack their code; they were, after all, able to crack the codes of whole countries. But Jeff wouldn't listen.

Toomba: "Mr. Fort say you talk in code, you talk in code.... We had people in the phone company telling us the phone was bugged, we had lawyers telling us. But Jeff *did not pay attention*—now we all in jail!"

The main business of the El Rukns was drugs, and the biggest part of the testimony in the El Rukn trials was about drugs. The reason that these trials took so long was that all the drug evidence had to be gotten into the record.

To sparsely populated courtrooms, Toomba described what was called the Gorilla family, the name for the El Rukns' alliance with a major freelance drug dealer, Alexander "Ghost" Cooper.

A few years before, Cooper had been the first federal defendant in the country tried for murder in connection with a drug deal, after Congress made such a conviction punishable by death. It was such a big case that Fred Foreman, then the United States attorney for the Northern District of Illinois, tried it himself. Cooper was convicted but the jury decided against the death penalty.

(The men who would prosecute the El Rukns, Bill Hogan and Ted Poulos, came to visit this trial. I was in the first row drawing when two tall, nice-looking young men—one very light, one very dark—sat down beside me. The first row was reserved for artists and reporters, and I snapped at them, "You members of the press?" Poulos graciously explained that they were there because they were going to try a companion case.)

Cooper ran his business as an efficient capitalistic enterprise any CEO should envy. Toomba described how Cooper wanted to talk to the El Rukns about going into a fifty-fifty partnership to sell heroin, a commodity for which Cooper was famous. When Jeff called from prison, Toomba relayed Cooper's proposal to him. "Well, I was trying, Mr. Poulos, to explain it to Jeff, using our coded language and I wasn't coming through to Mr. Fort, so he told us to come down there."

So Toomba and Melvin Mayes traveled to Bastrop, Texas. With IDs of Jeff's brothers, they got themselves into the federal penitentiary for a visit.

Toomba relayed to Jeff that Cooper had said: "We had enough man-power that we can make millions and millions of dollars selling heroin.

"[Jeff] thought about it for a minute, he was objecting to it, that was just for a couple of seconds, and then he say 'millions and millions of dollars, huh?'"

Toomba and others met with Ghost Cooper again.

"Cooper had some of his peoples go down and buy a chalkboard, bring it back to Luke's Lounge. And Mr. Cooper start...informing us about heroin, letting us know what heroin was all about, America's number one painkiller, and excedera [sic]. We started having classes periodically."

On a diagram of 75th and Kingston, Cooper "put circles representing individuals, and on each one of the circles he put a name. [Such as] Eyes, Delivery Man, and the Money Man."

Cooper explained that to the El Rukns LTDs stood for "Loyal, Trusted Dope fiends," or junkies.

If the Eyes saw trouble coming, if the police were in the area, he would make a gorilla-like gesture to signal the others. On the witness stand, Toomba imitated a gorilla, scratching the top of his head with his left hand, his armpit with his right.

"The LTD would come up, purchase the narcotics, this man...will be the lookout man, this man will be the man to give him the bag, this man will get the money...and we could have walkie-talkie control informing each other police coming, or excedera...."

Then Toomba heaved a great sigh. "We never got this program right, Mr. Poulos," he admitted. "We tried our best to get the program right. Eventually, it did work out, but it took a lot of classes.... We had to con-stantly, constantly come, learn, learn, learn over a period of maybe two weeks of learning."

Alexander Cooper also taught the El Rukns how to mix heroin, both Mexican mud and black tar heroin, and eventually they set up shop at 75th and Kingston. In the first hour of the first day, they sold 50 dime ($10) bags of heroin, and by the end of the day, they had sold 500 dime bags of heroin for a total of $5,000.

The next day on the speakerphone they proudly told Jeff Fort about their success.

"We in business," said Fort.

The El Rukns were not murderers in the sense that John Gacy was a murderer. Nor did their killings have much in common with the work of Harry Aleman, Rocco Infelise, and their colleagues. The imperialist El Rukns—"an occupying force," as Ted Poulos called them in his opening statement, eager to expand and protect their territory—seldom used the word *murder*. They used the expression *Rider* or *in the signs of the Rider* when they meant "to kill." If Jeff Fort said "like the Rider," it meant that they were out for blood and must be dressed in dark clothing, ski masks, and gloves. Toomba explained by describing a picture that hung at the Fort at 39th Street and Drexel Avenue.

"It was a picture of a guy on a horse, and he was dressed in a military—a Roman military, you know the shield and all this here. And that come from a term, an Italian term...a term we used where when we look at that picture, we holler out 'caveat emptor!' OK? ...In some Bibles it's translated that *caveat emptor* mean 'cast out the dead,' and we used that term to represent the Rider."

Toomba quoted Jeff on enemy gangs: "'Whenever those chumps get out of line, we kill the leaders, and make them pick a new leader every month so they back down.'"

Though murders were supposed to always be authorized by Fort himself, often the wrong people were killed, often there were witnesses that had to be killed, and each murder spawned retaliation. Thus there were chains of murders, each one interlocked with the next.

Though Toomba was the best of the storytellers, many other witnesses told stories of the El Rukn escapades. They told them from both sides: from

Don Conner, with notes on his brother's death.

the perpetrators' point of view and from the victims'.

Don Conner stuttered. When he testified at the second El Rukn trial, the generals' trial, it took him long seconds to make the staccato sounds preceding each answer. S's seemed to be easier for him, so when he had to say a difficult word, he would start by saying "something like." But he told the story of his little brother's death like a trained orator.

By 1974 the South Side housing projects had been carved into territories by the two great gangs: the Disciples (the Folk) and the P. Stones (the People). Conner testified how the P. Stones began to move into the Ida B. Wells Homes controlled by the Disciples where he, the head Disciple, lived with his parents and siblings.

Having found that some Blackstone Rangers, now known as P. Stones, occupied an apartment on the eighth floor, he and his brothers shot through the door, not to kill anyone, "just telling them to bag off."

Next a fight began in the elevator when one of the Stones acted "dis-

respectful" to one of the Conner girlfriends. Everyone knew there would soon be trouble.

Some of the Conners and their pals were sitting around the Conner apartment on Mother's Day night when they heard a knock on the door. They were expecting 14-year-old Gilbert Conner, who had been at a concert, so they opened it. A flash of gunfire erupted. Don Conner said that he was only able to see the first two men of the threatening cluster in the hallway: Anthony Sumner, alias Sundown, and another El Rukn, named Dog.

The prosecutor asked Conner if he recognized anyone in Judge Aspen's courtroom who was there that night. Conner—a tall, lean, bearded man in a white shirt, skinny black necktie, and an Italian-cut black jacket like one worn by a silent movie villain—rose from his seat. He scrutinized the two defense tables.

"That's Dog over there with the jailhouse suit on," he said, pointing to Sammy Knox.

Conner sat back down and went on with his story. He said they heard more shots and then pounding on the door.

It was Gilbert. They could hear him crying, "I'm hurt!"

Conner: "I pulled open the door and he fell in."

Gilbert was bleeding heavily. Conner continued, "So as soon as I could I laid him on his side so he wouldn't drown in his blood.... He was gurgling ...then he died.... The police came and they looked at him and they said there weren't nothing they could do and they put him in—some kind of a paddy wagon."

Conner told how he went to Michael Reese Hospital with his little brother. He was in the emergency room with him and then in the morgue. He called the rest of the family and told them what had happened. Then he brought home a sack with Bert's clothes in it, which the hospital staff had given him.

I felt a jolt as I listened, for I was reminded of the brown paper bag that Northwestern Hospital had given me when John died. It contained his jeans and his wallet.

Judge Conlon was young for a federal judge and had long blond hair that spilled onto her black-robed shoulders. She kept her courtroom cold and

dimly lit so it was hard to see and hard to draw. But it was an appropriate setting for the first day of the third El Rukn trial, the day the government put on more evidence about the chain of Disciple murders.

The Disciples had killed an El Rukn general, so the Stones killed Disciple leader Mouse Smith.

The assistant state's attorney who prosecuted the murder testified in Judge Conlon's courtroom. He said the only person who'd seen Smith's shooter was a frightened neighbor named Audriana Thomas. His office kept Ms. Thomas hidden from the El Rukns for months, changing her location three times. They worked hard to get her to testify against Rudy Bell and Orville Miller, the El Rukns whom she had fingered as the killers.

William Swano, whose name Bob Cooley had mentioned in the D'Arco trial, was the El Rukns' lawyer. As part of the "discovery" in the Bell-Miller case, he ordered that Audriana Thomas be produced for the defense to question. The state's attorney told Swano that he could come to his office to talk to her.

A telephone call came for Ms. Thomas during the interview.

The Witness: "Audriana picked up the telephone...screamed very loud and ran out of my office. That morning her sister Rowena had been gunned to death on the streets of Chicago."

The state's attorneys found Audriana again and got her to the court-room where Bell and Miller were on trial.

The witness described the 26th Street courtroom filled with El Rukns including Jeff Fort. They were wearing red hats and blue medallions that looked like poker chips with Eastern symbols on them.

The Witness: "[Audriana Thomas] was near collapse.... I believe she began to vomit. We had to take a recess."

Rowena James's stepfather testified that one rainy morning in the autumn of 1977, Rowena and her two small children came to pick him and his wife up so that they could drive to work together. At the intersection of 98th and Wentworth, their car stopped for a red light. Another car pulled up beside them.

The Witness: "I heard two shots!...[Rowena] fell over."

Rowena's mother described the same event, adding that it was storming so hard she thought the noise had been thunder.

Ernest James III, shy and sad at 19, testified that he had been five years

old that September morning when, from the backseat of the car, he saw his mother's head blown off.

The El Rukns had confused Rowena James with her sister Audriana Thomas. They had known about Thomas from the police homicide file on Tyrone Smith, which William Swano presumably had given them.

In 1978 the El Rukns gunned down another Disciple, named Michael Bell. In retaliation the Disciples murdered El Rukn "Wild Child" Pearson in May 1983.

Turncoat witness Earl Hawkins told the story in the first El Rukn trial. Earl Hawkins was missing front teeth, and his arms hung out from his muscle-bound body as though ready to punch anyone who got close.

Softly and monosyllabically, he described El Rukn ambassadors, officers, and generals sitting in circles at their Royal Council meetings, where the "Nation's business" was conducted. He explained that his job had been to "enforce the code of the organization…beatin' people and shootin' people."

During his testimony, Hawkins had to be constantly told to speak up. But when he started talking about the murders, his big mouth opened to show all its glorious gaps and his muscular arms beat the air around him.

On the second day of his testimony, he quoted people and imitated their voices and the sounds they made, like a one-man radio show.

Hawkins testified that in May 1983, "Wild Child, he got gunned down and killed." Jeff decreed that everyone had to go to Wild Child's funeral.

At the funeral Fort said, according to Hawkins, "'Whoever did this to our brother gonna have to pay….'" But Jeff was about to go to prison, and he didn't want it taken care of until after he had left.

"When he in jail ain't nobody can blame him for it," explained Hawkins.

Someone had seen Disciple Ronnie Bell shoot Wild Child. At a meeting of the generals in June, Jeff Fort, on the phone from prison, gave the green light for his killing. Earl Hawkins and Derrick Kees were appointed to take care of it at the gas station where Bell worked. J.L. Houston would drive.

Hawkins recalled, "We started to watch his movements and we was planning how we was gonna kill him…. We was looking at Ronnie Bell working at the gas station…. We pretending we had a flat and we was watching him through the fence. We saw him coming off work. We drove

the car past.... Just look at him, don't stare at him, just see what he look like.... All of us had saw him.... We know his face.

"We was telling we gonna wait till he coming down the street, then we gonna shoot him, gun him down.... We made the plan that we gonna use two cars.... We supposed to park it [one of the cars] in Jewel's Grand Bazaar...."

They parked the two cars, and Hawkins, Kees, and Houston sat in one of them across the street from Concord Oil all day.

At about 7:00 P.M., Ronnie Bell left work and started to walk home through the dusk-softened streets of the Far South Side.

Hawkins continued, "Ronnie Bell was coming out of the gas station.... He was walking...south down Egleston.... We made a U-turn and follow him down Egleston. He went to 88th Street. He started to walk east on 88th. As he got close to the viaduct, a car pulled up.... There were some people in the car.... He went up and started talking to the people in the car....

"He might get away today cause he might get in the car."

But the car pulled away and Ronnie Bell continued to walk toward the dark mouth of the viaduct.

"Derrick Kees say, 'I'm going to catch him before he get to the corner!' ...He run out.... We caught up with Ronnie Bell.... When Kees come up to him he shot him *boom! boom! boom! boom! boom!* about eight times, after Kees got through shootin' him, I shot him, *boom! boom! boom!*...five or six times."

Kees and Hawkins jumped back into the car and took off.

"J.L. Houston was driving the car.... You could hear the police siren, *woowoowoowoo....* We was supposed to take the guns and put them in Kees's car and park it in Jewel's Grand Bazaar.... Someone say, 'I hope the police car don't recognize any of us.'...*woowoowoowoo....*"

Panicked, they didn't go back to get the other car. The police found the car and J.L. Houston's ID in it. The police arrested J.L. Houston's brother, Elton, and another man, when the two went to claim the car, and charged them with murder. Elton was not an El Rukn, but J.L. said nothing and let his brother be convicted and begin serving a 35-year prison sentence. Years later when Hawkins and Kees cooperated with the government, they admitted to the murder of Ronnie Bell, and on October 30, 1989, after

serving six years in prison for a crime they didn't commit, Elton Houston and his codefendant were finally freed.

Earl Hawkins was a perpetrator of the Vaughn-White murders, the most terrible of all the murders. Jeff Fort hadn't authorized the hit—it was strictly a freelance job. Hawkins and Anthony Sumner, high on drugs, decided to rob some dope dealers and things got out of hand. They hacked and then shot to death a couple as their children watched the slow and sloppy process through a crack in a closet door. Hawkins told the story over and over in the El Rukn trials. He told it in the same gripping, almost possessed way he told his other adventures, but he seemed to tell it more reluctantly. Later this hideous act would lead to the downfall of all of the El Rukns.

In the meantime, the El Rukns went to war with the Titanic Stones, founded by Bull Hairston after Jeff Fort kicked him out of the El Rukns.

In the fall of 1982, Jeff Fort ordered a standing hit order against a Titanic Stone drug dealer named Duke Thomas. For months the El Rukns stalked Thomas in his white Cadillac. In January someone saw the automobile parked in front of an apartment building at 55th and Michigan. "Reach for swords!" was the battle cry at the Fort; the El Rukns piled into their own cars and headed out into the winter streets.

Three of them converged on the white Cadillac. William Doyle and Derrick Kees jumped out of the first one and emptied their guns into the parked car. J.L. Houston screeched up in the second car and, seeing hands reaching up from the floor, further peppered the vehicle with bullets.

But Duke Thomas hadn't been in the white Cadillac. Inside were the two girls who were waiting for him, Sheila Jackson and Charmaine Nathan. Sheila recovered and testified at the El Rukn trials; Charmaine was killed.

Much later, at the sixth or seventh trial, I saw a photograph of Charmaine Nathan's face taken at the morgue. The eyes were swollen closed and the swollen tongue pushed out of the mouth, forming a third, plumper, paler lip. At a recess the lady deputy marshal held the photograph, and I peered over her shoulder. No one could tell her, she said, why they bothered

to bandage the wounds on the girl's face when she was already dead.

"All rise!" A booming voice silenced the chatter of reporters and spectators in the magistrate's crowded courtroom. Clutching paper, pens, and pencils, I struggled to stand like everyone else. At the doorway in blue Metropolitan Correctional Center coveralls, surrounded by an entourage of marshals, stood the infamous Noah Robinson. People groaned, laughed, and sat back down when they realized the defendant himself had called out the order.

Arrest had not squelched Noah Robinson's delight in mischief, though his indictment charged him, among other crimes, with selling drugs to the El Rukns and hiring them to kill in South Carolina and Texas. Bill Hogan, one of the prosecutors whom I had met at Ghost Cooper's trial, argued against bond and won.

Robinson was still incarcerated when he was tried with his two brothers and his wife in 1990 for skimming $650,000 in profits from his three Wendy's franchises. He testified with all the charm and sincerity of an old-time carnival barker and was convicted.

In May 1991 in the El Rukns generals' trial, Noah Robinson was the only defendant wearing a business suit. His mustache dipped way down on either side, and his hair scrolled into little curls in back. The curves of his ear lobes and the wings of his nostrils were daintily indented—grace notes in a baroque gigue. (Later when I came to know his handwriting from exhibits, I saw that it was decorated with similar flourishes.)

Glasses high up on his forehead, head down studying documents when he wasn't whispering to attorneys, he sat at the defense table, looking like an accountant and a riverboat gambler in one.

His codefendants, all but one of them generals, looked markedly different from Robinson and had nothing to say to him. Some wore kufis and were indistinguishable from the other El Rukns in the Judge Holderman ambassadors' trial upstairs.

There had been testimony about Robinson in the other trials. We knew that they called him the Local (as in a commuter train), Our Friend, or I

Jesse Jackson and Noah Robinson at a Robinson hearing.

Am I Am's Brother. I Am I Am was their name for Jesse Jackson, because, said Toomba, that's what "he be chatting all the time."

"I am somebody!" the Reverend Jackson was known to shout with his parishioners at Operation Breadbasket.

The same businessman from Greenville, South Carolina, who fathered the illegitimate Jackson was the father of Noah Robinson. Robinson was ten months younger than his stepbrother.

Robinson grew up in a large house in Greenville with a huge *R* affixed to the chimney; he attended the Wharton School of Business and became successful like his father. He moved to Chicago and tried various businesses, restaurants, and real estate; he supplied janitorial services to the Chicago City Colleges until they "terminated relations" in 1982. He also dealt drugs.

Toomba testified that he first met Noah when Robinson tried to sell the El Rukns some bad marijuana and Toomba had been sent to inspect it. "The smoke was watered down," reported Toomba.

In 1983 when Jeff Fort was arrested for harboring a fugitive and the gang members needed to raise bond money, they called on Mr. Robinson.

"We...had a program called 'shaking trees,'" testified Toomba, "where we would go out and we would hit up on other guys, businessmens, excedera, even..." (here he named some familiar politicians, both black and white) "...for contributions toward Mr. Jeff Fort's bond."

Robinson had helped them out, not only with money but by putting them in contact with narcotics dealers in Greenville and in New York. He had "led them to the well."

It was after Jeff went to prison in 1983 that Robinson became more intimately connected with the El Rukn gang. In spite of the speakerphone, in spite of the code, Jeff Fort left a leadership vacuum when he went off to Texas.

Fort had come to power in the '60s, when the civil rights movement was turning militant, with the Black Panthers, Stokely Carmichael, Malcolm X, and the concept of black power. Some young blacks felt their struggle legitimized illegitimacy, allowed crimes against an oppressive establishment. Jeff Fort understood this.

Noah Robinson was getting a proper education and starting businesses while the illiterate Fort was organizing slum kids. Robinson emerged into adulthood as the "me generation" replaced hippies and agitators; "yuppie greed" supplanted Martin Luther King Jr. and Malcolm X.

As Jeff Fort had perverted the ideals of the civil rights movement, so Noah Robinson was a new man for new times.

"This man," exclaimed Hogan, in his opening statement in the generals' trial, pointing across the room at Robinson, "had delusions of being at the top of an organized crime structure.... He had delusions of being the head of an army of killers and using them to launder his narcotics profits."

Hogan told the jury that in his office, Noah Robinson sat beneath a poster of Marlon Brando as Don Corleone, the Godfather.

On June 20, late in the day, Eugene Hunter took the witness stand in the generals' trial. A short, tough man in a white business shirt, red tie, and green suspenders, he had a low furrowed brow, eyes that slanted down at the corners, and a quizzical expression.

Hunter testified that Jeff Fort had instructed him to spend his time

observing and learning from Noah Robinson.

Hunter quoted Fort: "'Brother, I want you to get as close to "Our Friend" as you possibly can because he is a very smart man.'"

Hunter seemed to enjoy telling how it was when the El Rukns decided it was time to join the mainstream, to "come out of the dashikis and the braids," and put a respectable front on their drug-dealing operation.

Hunter: "We desperately needed to change our image.... We wanted to show the people we were no longer on the left side of the tracks."

With the help of Noah Robinson and the long-distance blessing of Jeff Fort, Eugene Hunter (who had studied business in college) and the El Rukns tried to get involved in local business and politics. In 1983 they started the Young Grass Roots Independent Voters.

Hunter: "Every organization strives to get a link into the power structure of the city...a political link."

They campaigned for Mayor Jane Byrne; State Senator Larry Bullock; Aldermen Edward Vrdolyak, Timothy Evans, and Dorothy Tillman; and U.S. Congressman Bobby Rush, a former Black Panther.

Hunter: "[We hoped to] put our own man in city government."

The El Rukns decided to create a new persona for Eugene Hunter, very different from General Salim, his El Rukn identity—a straight reputation for use in the outside world. Perhaps Jeff Fort wanted to make Hunter into his own Noah Robinson, one he could more easily control. Hunter would pretend to be a millionaire businessman, he would get a new name or, in the El Rukn language, a new Henry. *Henry* meant "John Henry," which meant "John Hancock," or "signature."

He also needed a legitimate source of income so if he were arrested with cash on him, the police wouldn't assume it was drug money. In order to establish credit for this Maurice Wright, whom Hunter would become, he had to start taking out loans and paying them back.

Hunter testified that Noah Robinson took him to the Drexel National Bank to apply for a $250,000 loan. Hunter mimicked himself as he acted that day. On the witness stand he arranged imaginary papers and then shrugged comically.

Hunter: "Having the loan application before me, it was clear there was nothing to put on it!"

He testified that Robinson said he'd help the El Rukns get into the

restaurant business.

Hunter quoted Robinson: "'You guys need a way to cover your money. Your paperwork need to be in order. You need to have two sets of books. Make sure your records balance out. You better have one book for yourself, and one for the government. In your case you need one for Jeff... You know where Jeff's money came from, I know where Jeff's money came from....'"

As much as Jeff Fort admired Noah Robinson, far away in Texas, he was becoming paranoid.

Hunter: "He was leery about letting Noah handle his money...'cause if he didn't have it in his hand he couldn't control it."

While Jeff remained in prison, in touch by telephone, Robinson did business with the El Rukns, setting them up with drug dealers Blue Burnside, Damon Williams, and Schoolboy Dodd.

Jackie Clay, another general, testified in Judge Conlon's courtroom that Jeff Fort "wanted us to treat Noah Robinson like he's Number One."

Soon Clay and other El Rukns were riding with Robinson everywhere, opening doors for him, acting as bodyguards, carrying weapons, and listening to him criticize Jeff Fort.

Eugene Hunter testified that Noah said, "'The stinking motherfucker not give you any money?! ...I can't understand why you don't have any money in your pocket. You all got to be the stupidest people. You need to be with me and make some money. You all are crazy! ...You're all doin' a lot, but not getting a lot out of it, except giving it to Jeff!'"

And in the ambassadors' trial, Ted Poulos had asked Toomba, "All this money that's being discussed on these tapes from the sale of heroin, cocaine, and marijuana, if you or the other generals wanted to spend $10 of that money, did you need anybody's approval?"

"Yes," Toomba had answered, "you had to get Jeff's approval."

Jeff Fort's stinginess enlarged the vacuum that his absence had created, the vacuum into which Robinson hoped to step.

And Toomba, in spite of his loyalty to Jeff, told Noah Robinson's lawyer, "Me and Mr. Robinson became very close, sir."

Drugs may have been the El Rukns' main business, but murder was never far behind. There was some question whether Toomba, the good organization

man, was also a good murderer. We heard no evidence in any of the trials that Toomba had ever killed anyone. "But not for want of trying!" snorted a defense attorney when this came up.

In November 1985 Noah Robinson needed a man killed in Dallas, Texas. So off went Derrick Kees, a talented hit man, and the bumbling Toomba, his Sancho Panza, to kill Robert Aulston, a business partner of Robinson's.

Toomba described the attempt. "We started plotting and planning, trying to figure out what's the best way to take this guy out, and it became kind of complicated,...the mayor, the governor, or somebody, of Dallas, was frequenting the hotel.... There was a lot people there.... [Kees] wanted to use the 9-millimeters, and I says, 'No way we're going to make it out of here alive,' and we argued back and forth...."

Arguing kept them from acting, and soon Jeff Fort called them back to Chicago.

Robert Aulston, a thin and dapper black man who didn't look like someone who could be intimidated, later testified on behalf of Noah Robinson. As though enjoying a practical joke, he smiled indulgently at his old friend, Noah, grinning back at him from across the courtroom.

Leroy "Hambone" Barber was not available to testify.

A letter that Noah Robinson wrote to Barber on March 19, 1982, was introduced into evidence in the generals' trial:

> If you had even a spec of a conscience, you'd recognize that I treated you kinder and took better care of you than your blood family. Think about the money, trips, clothes, girls, the international life style, you treacherous dog.
>
> Bitter? You think you're bitter. On December 9, 1980, my life was thrown into the hands of a drunk, drug-using mad man. Whether I lived or died was solely up to Ronnie Powers, thanks to you. You put the gun in his hand, and told him in advance, "Don't miss, because Lo will come after us if you don't kill him!" Fag, you were right on both counts!

Noah had decided to give Toomba another chance to become a murderer

and recruited him to kill Leroy "Hambone" Barber. Introduced into evidence was Toomba's chronicles' version of this episode:

> Time went on now, and years passed, maybe 1 or 2 year, I was sent on a mission to Greenville S.C. to kill a man by the name of Leroy Hambone Barber who was a friend of Noah Robinson, half brother of the famose [sic] Jesse Jackson. Somehow this guy lost his job working for Noah.... Somehow Leroy had punched Noah, in the faces when he was in Greenvill [sic] on a routin [sic] visit to his mother house.... So my hands was tied down, business had to be takin [sic] care of.

Toomba testified that in December 1985, Noah Robinson met with Toomba and Eugene Hunter in his Chicago office.

Toomba: "Mr. Robinson got up, closed the door, turned on the radio, sat back down and he said, 'Look, I need some business tookin' care of.... I need a hit.' And I say, 'Who?' He say, 'This guy Leroy Hambone Barber....

"'I want this SOB tookin' care of right away. And I want you all to seek Jeff approval to take care of it for me, and let Jeff know that I'll pay $10,000.'"

Toomba spoke to Jeff Fort on the speakerphone.

Toomba: "I told Jeff that Mr. Noah Robinson requested our services.... He wants a canvas [as in the painting of the Rider, which hung in the El Rukns' headquarters] tookin' care of, and that he was willing to pay $10,000 if we can take care of it.

"Mr. Fort say, 'No problem. We'll take care of it for Mr. Robinson.' He say, 'Ten grand, huh?'... Jeff say, 'Well, let Mr. Robinson know that you have my approval as long as he take care of the expenses.'"

Jeff chose the other members of the hit team.

Toomba: "Melvin Mayes was sent to orchestrate it and direct it. Jackie Clay was to be the shooter. And Eugene Hunter was to point the guy out."

In Greenville they looked for Hambone Barber all over, including in the Robinson building on Broad Street. Toomba described the building: "It's so many barbershops, there is pool halls, there is taverns, there is a disco upstairs, there's a restaurant."

After two days of searching for Barber, Toomba and Melvin Mayes began to argue. Again Toomba proved an inefficient hit man.

Toomba: "I was running off at the mout ...and me and Melvin Mayes also got into an argument on how to kill Mr. Hambone.... I said, 'Look, brother, Mr. Robinson say he don't want the hit did at his building.... Noah [had] confided in me. He knew if it get tookin' care of, it was gonna be did right. And I had a problem getting it across [to Jeff Fort]. I knew what it was. Jeff just know I was getting pretty close to Noah Robinson, and he didn't like that."

Jeff found out about the dispute and summoned them back to Chicago. A few days later he put together another hit team, this time without Toomba.

Eugene Hunter testified about the second hit team. He quoted Jeff Fort on the speakerphone: "'We gonna put that demonstration back together right now with some more brothers.'"

One of the group around the telephone had butted in: "Ha Ha on the scene reaching for some star," which meant Edgar Cooksey is here looking for money.

Hunter: "[Jeff said,] 'Ha Ha! That's the brother! That's the brother right there!...he can have some star, but let him know we have something for him to do!'"

In Judge Marven Aspen's courtroom, Edgar "Ha Ha" Cooksey sprawled comfortably at a defense table. He was big and benevolent looking; when he made eye contact with members of the press, he smiled. He listened calmly to the second day of Eugene Hunter's testimony as though he were hearing a bedtime story.

Earlier another witness had quoted him: "'They call me Ha Ha because when I shoot people, I say 'Ha Ha!'"

Hunter testified that when Edgar Cooksey, Alan Knox, Jackie Clay, and he arrived in Greenville on January 1, 1986, they went directly to Noah Robinson's building. They found someone who said he would let them know when Hambone arrived at the lounge.

Then they "just laid around the [hotel] room...got some reefer" and waited. When they got word that Hambone had arrived, they went to Robinson Plaza and began to follow their plan.

Hunter: "I was hopefully going to bring him out of the lounge.... I was

William Hogan, Edgar "Ha Ha" Cooksey, and Eugene Hunter.

supposed to...make him feel comfortable."

In the bar Hambone approached Hunter in a friendly way, addressing him as Maurice Wright.

Hunter: "'Maurice, what you doin' here? Have a drink!'"...I said, 'No, I don't have much time.'"

Prosecutor Bill Hogan asked the witness to come and stand where the floor plan of the Robinson building tilted against an easel. He instructed Hunter to mark his own and Barber's positions with colored pens; then he had Hunter show how the two men had faced each other, pretending that Hogan was Barber.

Hunter put his brown hand on the taller Hogan's sleeve and gently moved him into place.

Standing stiffly before the chart, Hunter described how he and Barber were talking when he saw Edgar Cooksey come up from behind. At the defense table Cooksey craned his neck to see.

Hogan asked Hunter how close together the two men stood. Hunter said, "Closer," and nudged the prosecutor. They were an inch apart, the tall, pale lawyer and the stocky black man.

Hunter: "As we were talking, he was shot in the head."

Hogan: "How did you know?"

Hunter: "I saw it.... I did like this here...."

Hunter suddenly doubled up and covered his head with his arms.

Hunter, resuming the witness stand, described his getaway: "I paused for a minute. I hesitated, I didn't run. I walked. I went to the car, I paused at the car for a minute.... I didn't know where I was going. I went straight to the highway."

He had gone, not to the car they had driven from Chicago, but to one they'd borrowed from a friend of Robinson's.

Hunter: "I didn't know what direction I was going; all I wanted to do was find a sign for Chicago."

High in the dark mountains he came upon construction work. "The road begin to...merge into one lane."

By the side of the road a man waving a 45 mm flagged him. It was Alan Knox and the other El Rukns, whose own car had broken down.

Hunter testified that when they got back, he went to Noah Robinson's office.

There the secretaries asked him, "You know what happen to Hambone?"

Hunter answered them, "No, what?"

"'He got killed.'"

"'Oh,' I said, and I left it at that."

At the defense table, Edgar "Ha Ha" Cooksey chuckled into his big hand.

To become the El Rukns' "Godfather," as Bill Hogan had claimed in his opening statement that Robinson wished to do, and usurp Fort's power, he needed to exercise his charisma over the whole gang. So Robinson had Eugene Hunter bring him to the Fort one afternoon in April 1986 during a meeting of the El Rukn government.

Jeff Fort was on the speakerphone when Hunter and Robinson came in, and he instructed that Robinson be introduced to his men. Hunter described the scene: "Melvin Mayes got the attention of the whole government. He

yelled out, 'I got Chief Malik Kaabar Archangel!' the government say, 'Yes, sir!'..."

The men chanted, "El Rukn Al Lek Allah!" to Robinson.

Robinson yelled out, according to Hunter, "Me, you, and the Nation! Solidarity!"

Later Toomba testified that Robinson said, "You, me, and the whole Nation, together we're going to do it all! Together we're going to run the city! Together we're going to make millions!"

The prosecution played the tape of Jeff Fort on the speakerphone when Robinson met the meeting—the tape for which the press had been waiting.

From loudspeakers around the room, we heard Jeff Fort talking to Trammell Davis.

Davis: "We drawin' Lo." In the jurors' transcript notebooks, the translation read, "Noah Robinson (the Local) is here."

Fort: "Local on the set, on the scene?"

There is a pause as though Jeff Fort is thinking this over.

Fort: "Maybe we need to introduce Local to our brothers there.... Just tell them that this is, this is person who, ah, ah, a friend and anytime anyone see him in adversity they, they should aid and assist immediately...anywhere.... Introduce him in that type of fashion."

Davis: "Yes, sir."

Fort: "Got a lot of our mens there?"

Davis: "Ah, yes, sir."

(Toomba later put the number at 500.)

Trammel Davis went to introduce Noah Robinson to the El Rukn government and the Nation, the Mosiliks, or high officials, and everyone in the tribe. From the courtroom speakers came a great roar of male voices, like the Red Army Chorus.

Robinson took the phone.

Robinson (referring to one of Jeff's sons): "Just met you boy. He, he a big-timer."

Fort: "Yeah."

Both men's voices are full of friendliness.

Robinson: "Told 'im I'd let 'im hang with me."

Both laugh.

Robinson: "Man, it's good to hear your voice."

Fort: "Hey, it's good hearin' yours, man.... In a minute we'll be, we'll be demonstratin' face-to-face."

Robinson: "I like that."

Fort: "OK, then."

Robinson: "Alright."

Fort: "Alright now."

Trammel Davis reported to Jeff that when the whole El Rukn Nation saluted Robinson, he "got a smile on his face from ear to ear."

Fort chuckled.

Though the media were often bored with these trials that stretched on through the spring into the summer, they wanted this tape of Jesse Jackson's brother meeting the El Rukns. It was perhaps the most important evidence, evidence linking Jesse Jackson's half brother and Jeff Fort. This was news.

After court the press, like a greedy octopus, grabbed transcripts and tapes from government lawyers. With the other TV people, I skimmed the transcripts, marked the best sound bites, and rushed the tapes downstairs to the recording equipment. At a time like this, sketches are forgotten; I'm better used as a field producer.

In the scramble of lines and boxes on the lobby floor, earmuffed sound-men made copies. Then cassettes and transcripts were rushed to "live trucks" throbbing at the Dearborn Street curb, their masts pointing to the antennae on the Sears Tower. Reporters swayed like buoys, earpieces dangling over their shoulders, scribbling and crossing out words on their notebooks, rehearsing their lines.

Within the hour, the conversation of "Mr. Wood," calling collect from a Texas prison five years earlier, was beamed to the city at dinnertime. Thus several hundred thousand Chicagoans heard the roar of Noah Robinson's introduction to the El Rukn Nation.

Toomba testified that about 1987 he began to fall out of favor. He had separated from his wife, Jeff's sister, and moved in with a woman named Ola Morris. Some people believed he'd had an affair with Diane Fort, Jeff's wife.

Jeff took away some of Toomba's drug business and gave it to someone else.

In the ambassadors' trial, Toomba described a visit to his wife at the

home of his mother-in-law, Annie Fort.

Toomba: "The mother came up to me, 'Toomba, Toomba!'"

He imitated her, throwing out his fat arms toward an exuberant embrace.

She hit him in the head with a frying pan.

Toomba: "All the others started punching me. I got outta there!"

Toomba opened up his own narcotics spot on 47th Street. He went to live in Indiana. He begged Jeff to let him start a new life there.

Toomba: "I told Jeff that I'd like to settle my peoples up there in Gary and Jeff said no."

He bellowed in imitation of Jeff Fort's voice: "'You take my sister to Gary, my sister, not this other girl!'

"I said, 'Jeff, I no longer with this sister here, I feel for this young girl.'

"I got in an argument with Jeff."

"'I raised you, boy,' said Jeff. 'And now you reach the age where you talk back to me. I don't want to talk to you no more. Get off the phone. *Get off the phone!*'"

On the witness stand, Toomba reached under his glasses and wiped away tears with a white handkerchief.

There were other incidents that made Toomba understand that he was no longer an El Rukn in good standing. For instance, William Doyle showed up one day and told Toomba, "Jeff told me to kill you."

Toomba got himself a bulletproof vest and had it on one day when someone shot him twice in the back.

The stage was set for Toomba's turning against his brother El Rukns.

As Toomba reminded the courtroom, "*Doorknobs*, that was the term that we used to represent an informant that had turned like a doorknob turns."

Anthony Sumner, alias Sundown, one of the shooters of Gilbert Conner, was the first doorknob. He "turned" in 1985 after his arrest for the murders of Dee Eggers Vaughn and Joe White. These were the murders in which he and Earl Hawkins shot and hacked two drug dealers while the couple's children watched. The most hideous of all the El Rukn murders, even Jeff Fort had disapproved of it.

Earl Hawkins turned in April 1987, almost a year after he was convicted of another murder.

Between June and December 1988, four more generals—Eugene

Jeff Fort before Judge Michael Toomin at the Willie Bibbs murder trial.

Hunter, Henry Harris (Toomba), Harry Evans, and Jackie Clay—began to cooperate. Derrick Kees came over in March 1989, four months after he was convicted in the Willie Bibbs murder.

These high-ranking men opened the door for the government and showed them the way to prosecuting their fellow El Rukns.

Toomba paid tribute to the ones who didn't testify against their friends: "These brothers stood strong and the majority of the brothers went on to the penitentiary and is serving time to this day for murders that they committed, and never, not one time did they open their mouth about it. And I thought it was important to add this."

Toomba, when he turned on his fellow El Rukns, turned slowly. He told the story in Noah Robinson's and the generals' trial.

Toomba went to see Noah Robinson and told him about his troubles with Jeff Fort.

Toomba: "[Robinson] said, 'That dumb son of a bitch. You gonna start

working for me now…we gonna set up our own operation and gonna get away from this—this bullshit. And when he get to Marion [prison], I'm gonna have some of my friends in the organization, the Mob organization, take care of his ass.'"

But Noah Robinson didn't have Jeff Fort bumped off, and Toomba's troubles multiplied as he tried to maneuver in the slippery purgatory outside the El Rukns' circle. Noah Robinson, a dubious guide, led him around.

One day General Alan Knox called Toomba from the MCC.

According to Toomba, Knox said, "Listen, Toom, you the only one that can take us down. Chief want to know, you know, where your loyalty stands." And then Knox suggested, "Why don't you call up to Milwaukee and talk to your parents there. Something happened to their place of business."

So Toomba called his parents and found out that masked gunmen had shot up their tavern, Hank's Fun House.

One day Toomba got word that Jeff wanted Toomba to be interviewed by Carol Marin, a local television reporter and anchorwoman. He was to report to Jeff Fort's lawyer's office.

Toomba: "I told Mr. Robinson that I'm going to be giving a TV interview with Mrs. Carol Marin probably the next following day. [Robinson said,] 'Well, hell, if you are going to do that, you might as well stick me in there somewhere.'"

And Toomba had said, "Yes, sir."

Toomba: "And Mr. Robinson told me, he said, 'Take off them clothes you got and put these clothes on.'…

"He gave me a jumpsuit to put on with his name on."

It was a maroon jogging suit and it had "Noah" written over the breast.

Toomba: "He told me…when I get interviewed to make sure that I tell the peoples in the world that he is a Christian man and that he has no criminal ties with the organization and excedera. And I said, 'Yes, sir.' And I did what Mr. Robinson asked me to do."

Toomba, wearing the "Noah" jogging suit, went to Jeff's lawyer's office to meet Carol Marin and her camera crew.

While they were waiting, Fort's attorney, Terry Gillespie, and Toomba talked.

On the witness stand, Toomba mimicked Terry Gillespie, the white attorney, as believably as he had Fort and Robinson and all the others.

Toomba quoted Gillespie: "Look, Harris, I am not going to beat this case with Jeff. The government got him, got him dead to the right. Matter of fact, they could really put him on a firing squad and shoot him and charge him with treason and shoot him, you know, because of this Libyan thing there."

When Ms. Marin arrived, Gillespie told her he didn't want the interview done in his office.

Toomba got Carol Marin's voice right, too: "'Henry, would you come? Toomba, would you come to another place with me?'...I said, 'Where?'...She said, 'To the Merchandise Market [*sic*].'"

Hogan: "And did you go to the Merchandise Mart and give the interview?"

Toomba: "Yes, sir."

Hogan: "And what did you say at the interview?"

Toomba: "I lied for everybody.... I had to perform in front of that TV to try to convince them peoples that the organization was not involved in nothing, that Mr. Robinson was a churchgoing fellow. And I did my best."

Hogan: "And at the time that you were doing that, were you wearing this jogging suit that Robinson had given you the day before...with his name emblazoned on the breast...?"

Toomba: "Yes, sir."

In the fall of 1987, Toomba set up yet another drug operation. One day two of the El Rukn generals came to Toomba's house.

Toomba: "They say...Jeff was to call at a certain time. Jeff called, and Jeff bawled me out.

"Jeff told me point blank, he say... First of all he asked me did I have the combination—did I still remember the combination to his safe. And I told him, 'Yes, sir, I still remember it.'"

Jeff was talking about the safe at Diane Fort's house, where Toomba and two of the ambassadors had buried it. In the safe the El Rukns had secreted more than a quarter of a million dollars in cash that were proceeds from the Gorilla family operation, as well as diamonds and gold.

Jeff instructed Toomba to open the safe and give the diamonds to Mrs. Fort and give the money to William Doyle.

Toomba: "I was supposed to get half of everything in the safe if I remembered the combination."

William Hogan in the last El Rukn trial.

So Toomba went to the house on Elizabeth Street, and while a group of El Rukns watched, he confronted the safe.

Toomba: "I fumbled with it for a minute and it clicked in. I knew I had it. I gave up the money and I was waiting for my half."

"What happened?" asked Bill Hogan, as the courtroom waited with Toomba.

"William Doyle walked up to me, gave me $300, and told me, 'Jeff say you ain't got nothin' else to do with nothin'. Don't come back around this family. Don't call nobody, don't be in touch with absolutely nobody.'"

So Toomba went home with his $300.

According to Toomba, two El Rukns came and told him that "Jeff say he want me out of 68th Street by sundown."

Toomba: "Immediately, I contacted Mr. Noah Robinson.... I say, 'Look, Noah, look, I don't know what the hell is going on. I know I'm gonna die sooner or later, man.... But right now I got to take care of my kid and I got

to put this girl up where they have a place to stay.'

"Noah say, 'Well, junior, you can stay at my rooming house out here.' I say, 'Well, look, anywhere Noah. It's gonna be between me and you. Don't tell nobody where I'm at or nothin.'

"And immediately...we moved down the street into Mr. Robinson's rooming house...me and Ola Morris."

As he testified in the generals' trial before Judge Aspen, Toomba became more of a "character"—knowing when he could get a laugh, knowing when he could slide past a lawyer's objection. He expressed his feelings as though he had no other place to show them, as though he had no other life but as a witness. Sometimes, through the force of his intensity, he seemed to be the person most in charge in the courtroom.

"Mister Hogan, sir," he would say, pseudo-politely, adjusting the top of his spectacles with his middle finger. His answers were wistful, funny, and bitter. He created different selves on the spot, sometimes an Amos 'n' Andy, Jack Benny's Rochester, or Stepin Fetchit—sometimes a tough black leader, a Jeff Fort himself. His mimicry of Fort's voice was so perfect it seemed to be his own.

During these trials, his seven or eight shots at getting noticed, before he was led away from the microphone forever, he seemed to want to give it everything he had.

(No one knew then that Toomba was going to be basking in that strange limelight for much longer than had been scheduled.)

Toomba testified that in July 11, 1988, officers of the Bureau of Alcohol, Tobacco and Firearms apprehended him at Robinson's rooming house on South Michigan Avenue.

According to Toomba, one of the officers said to him, "Henry, we know the whole story. We'd like to get the rest of it from you. You are charged with the murder of Leroy Hambone Barber." Toomba told the court, "Immediately, I started confessing in the backseat of the squad car."

Noah Robinson was arrested for Barber's murder shortly after that, but it didn't stop his machinations. In October, Ola Morris received a letter

from Noah with another letter enclosed inside, addressed to the Court of General Sessions, 13th Judicial Circuit, County of Greenville, State of South Carolina. Ola Morris was supposed to sign it and send it on.

Dear Judge Moore,

I am writing to you on behalf of Mr. Noah R. Robinson, who has been charged with the crime of murder in the death of a Leroy Hambone Barber.

…Toomba and I have known Noah Robinson for several years. I have worked at one of his businesses, Wendy's, at 86th and Stony Island. We, Toomba, myself, and our son, have lived in one of Noah Robinson's buildings when we lost our apartment and neither of us could find work, rent free.

Mr. Robinson has been kind to us…even providing us food when we were hungry and without money. Neither I nor anyone in our family has any fear of Noah Robinson….

I just recently had another child in September 1988 and have been unable to work and provide for myself and my kids…. I'm alone since Toomba was arrested, and…falsely accused in the Barber murder…. Mr. Robinson…is still supportive of us. I believe he is an innocent man falsely accused, too.

Sincerely, Ola Morris

There was a notation that a copy had been sent to Noah Robinson.

Judge Moore never received the letter. On Toomba's instructions, Ola Morris turned it over to the federal prosecutors.

I had been sketching Toomba's big round head for months in two different trials; I'd been listening to his stories, often the same ones over again. My daughter, home from college, was also attending the El Rukn trials; at dinner we discussed their exploits, laughed at their eccentricities. It was as though Toomba and the El Rukns had colonized all my waking hours. In the

morning of July 18, Toomba came into my dream, stepping off a federal building elevator in his dark blue jump suit, surrounded by defendants, lawyers, and marshals.

"Come on, Toomba," I said, "leave me alone."

That morning Toomba's cross-examination before Judge Aspen began. This time Robert Simone, Noah Robinson's lawyer, didn't say, "I'm Local's Perry."

Toomba answered each question in a robotic, but testy, voice. He seemed exasperated, angry, bored.

"Now hold it, sir, hold it.... Let's play this straight," he told Simone.

As Toomba had told a defense attorney in the previous trial, he was not told by the government what to say, he was his own man, now.

"I've been controlled and manipulized [sic] by too many people. I'm in this courtroom because I done wrong and others done wrong."

Now he told Simone to "lay a further foundation," and later, when Simone wanted to retract a question, he said, "Yes, sir, strike that."

Simone: "Do you know if Mr. Robinson had a conversation with Ola Morris...do you know whether or not he...asked her to write such a letter?"

Toomba: "Sir, at that time, there was a lot of shaky things goin' on. Mr. Noah Robinson was seeing Ola at the time."

Simone: "So Mr. Robinson was seeing Hunter's wife. He was seeing your wife, when did he have time to sell drugs?"

Toomba: "Well, when you say seeing Hunter's wife and seeing my wife—." (He paused.) "Sir, the man impregnated my wife."

Simone acted surprised.

"You are saying that Mr. Robinson made your wife pregnant?"

"Yes, sir," Toomba answered slowly, almost as if he were proud of this.

"Of course, that didn't make you mad at him, did it?"

"She wasn't married to me."

"The question is, did it make you mad at him or angry with him?"

"I've did some things in my life, too, sir."

"The question is," insisted Simone, a terrier snapping at a St. Bernard, "did it make you mad at him or angry with him?"

"Well, if you trying to get ready to testify on the man, and he goes and

Noah Robinson sentencing by Judge Marvin Aspen.

do that to your wife, I'm sure that will kind of stir your emotions up, sir."

"...Were your emotions so stirred that you were out to bury this man?"

"No, sir, as I repeat, I do not hate Mr. Robinson.... Sir, all I know is, the sister told me she was pregnant by Mr. Robinson.... It was a shock to me. I accepted it. And today I am the father of that child for Mr. Robinson, and I will try my best to raise him good, if I get a chance, sir."

By April 1992 Bill Hogan, Ted Poulos, and their fellow assistant U.S. attorneys had won guilty verdicts in all the El Rukn prosecutions tried so far. Every indicted gang member except one minor defendant, as well as Noah Robinson, had either been found guilty or pleaded guilty; only three men were yet to be convicted.

Because he had become the star of the Chicago office of the Justice Department, chief prosecutor Hogan would soon be posted to Los Angeles

to help with gang problems there. In August, Poulos joined a prestigious small firm to work on white-collar crimes.

Judge Holderman had conducted two trials, of the ambassadors and the drug dealers Burnside, Griffin, and C.D. Jackson; Judge Aspen had presided over Noah Robinson and the generals; Judge Conlon over another group; and judges from outside the Northern District of Illinois had presided over others. The defendants changed, but the testimony was mostly the same, the witnesses were the same "doorknobs," the same former El Rukns telling different versions of the same stories, over and over.

In April 1992 the last case Bill Hogan and Ted Poulos tried together was ending. I went to watch Toomba testify at this sixth trial, before a judge from Indiana. The two defendants—Eddie Franklin, who had killed the man in the Crest Hotel, and J.L. Houston, who had let his brother serve time for his murder of Ronnie Bell—wore kufis. Houston was reading the Koran in Arabic.

A third defendant, Isaiah "Ike" Kitchen, had been severed from the trial after complaining that the red-haired juror in the front row had been gesturing suggestively to Bill Hogan. Kitchen was sure she was fantasizing about "getting Mr. Hogan to a hotel room."

Poulos questioned Toomba, who looked thin and balding in his white sweater, taking him through all the history, all the stories. Between answers Toomba raised his eyes as though examining the underside of the pressure hanging over him. On redirect examination Poulos got him to knot together the last strands of testimony.

Toomba: "All the cards is laid on the table... Everything I possibly know concerning the El Rukns I have revealed to the government."

He sighed like a bitter Ancient Mariner, forced to tell his tale yet one more time.

"I have no more secrets about the organization, I have no more secrets about myself."

But there were more secrets, and the story didn't end there. The cards that Toomba said were on the table would soon be tossed into the air, and when they fell again, the fortunes of those involved would be totally reshuffled.

The person most drastically affected, the person hurt the most, would be the one who had seemed most a hero up to now: Assistant United States Attorney Bill Hogan himself.

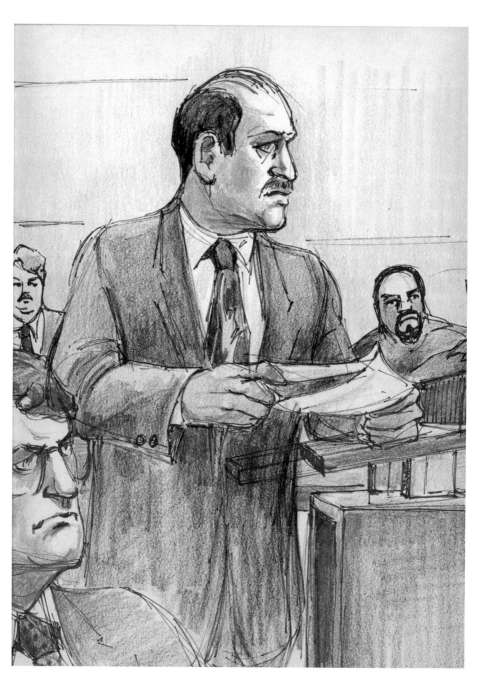

Barry Elden at an El Rukn post-trial hearing.

8

A MENAGERIE OF ALLEGATIONS:
THE EL RUKN POST-TRIAL HEARINGS

What we human beings, grossly insensitive, macroscopic
objects that we are, conceive of as a single reality is actually
a tapestry of many simultaneous realities.

—Alan Lightman in an article on Richard Feynman, *New York Review of Books*

In the spring of 1992, court buffs and others chattered about something badly amiss in the Chicago office of the Justice Department. It was rumored that when witnesses testified in the El Rukn trials, they'd been taking drugs smuggled into the Metropolitan Correctional Center, and also that witnesses had had sex with visitors in government offices. Defense lawyers claimed that Bill Hogan and his colleagues had known about the whole sordid mess but kept it secret in order to win their cases.

One day in May a group of El Rukn defense lawyers were laughing outside a courtroom. "The doodoo is about to hit the fan," said one of them, gleefully. They said some lawyers had filed motions for new trials in an El Rukn case based on the fact that the prosecution had hidden valuable information that would have impeached their witnesses.

Richard Kling, for the defendants, and Mike Shepard, for the government, discussed the matter with Judge Holderman at his next status call. They only

talked about scheduling and documents; it seemed no one wanted to say anything publicly about the real issue. Once the judge caught himself beginning to and then changed his mind.

"No, I don't want to make a record on that," he remarked.

Mike Shepard told the judge that he had turned over a list of Harry Evans's and Henry Harris's (Toomba's) MCC visitors and the dates that they had come to visit.

Then in September two former assistant U.S. attorneys from Chicago dined together in Washington. Larry Rosenthal had prosecuted the mobster Albert Tocco before Judge Holderman; Mike Shepard, who talked to crooks as though they were little children, had gained the convictions of Senator John D'Arco, Judge David Shields, County Clerk Morgan Finley, Alderman Fred Roti, and many others.

Rosenthal and Shepard had recently left the Chicago office of the Justice Department after successful careers, and they talked about their ex-colleagues, Bill Hogan and Ted Poulos. Under Hogan and Poulos, 16 El Rukns had pleaded guilty and juries had convicted 36 others, ridding Chicago of the gang's leadership after 20 years of narcotics dealing, extortion, and murder. It had been a great triumph for the department.

At dinner Shepard told Rosenthal that Judges Holderman and Conlon were now hearing defense motions for new trials because two of the cooperating El Rukns may have taken drugs at the time they were testifying. The Brady and Giglio rules, which mandate open and shared discovery, may have been violated. Hogan and Poulos insisted they'd known nothing about any drugs at the MCC.

Rosenthal was reminded of something upon hearing this. He said he'd shown Bill Hogan a memo from the MCC that reported positive urine tests for Harry Evans and Henry Harris while they were testifying before the grand jury. In October 1989, just before the U.S. attorney planned to return the indictments, Rosenthal said he had stopped Hogan in the hall and told him that this was something he should know about.

Rosenthal later testified: "I thought this would be a real problem for the investigation.... I indicated I thought [the memo] was discoverable. Mr. Hogan said in substance that it was not a problem."

Rosenthal said that Hogan had glanced briefly at him and his piece of paper and then dismissed the matter.

"From his tone of voice and demeanor, it was clear to me he was not interested in having a long conversation."

Later Bill Hogan said on the witness stand: "If Mr. Rosenthal said what he said he did, I never heard it."

In the federal building corridors, the court buffs whispered that the tall, good-looking Hogan and the diminutive Rosenthal had both been interested in the same lady prosecutor and felt little warmth for each other. Perhaps this was a vendetta, they speculated.

Where was this MCC memo, Judge Holderman wanted to know, after hearing about the dinner in Washington. No one could produce it, and the U.S. Attorney's Office had asked for some time to make "an internal investigation."

It was Holderman himself who suggested they look in the Tocco file, for Rosenthal had been trying Albert Tocco at the time in his courtroom. And there in the trial file of the mobster and murderer they found the incriminating document, henceforth known as the Rosenthal memo.

As it unfolded, this court story didn't follow the organization of most judicial proceedings. Usually there's a precipitating act, a murder or whatever, an investigation, a charge, a probable cause hearing, an indictment, discovery, pretrial maneuverings on both sides, and, finally, a trial. After the trial and before sentencing, lawyers usually file post-trial motions. Each phase is mostly finished before the next begins. In this case everything overlapped—even the defendants seemed to have been switched; everything got jumbled, with conviction and sentencing taking place before the indictment was even scripted.

These would be legal proceedings about legal proceedings. In other words, they were metaproceedings. They afforded a behind-the-scenes look at how cases are prosecuted, how witnesses are treated, how the system works or is supposed to. To put it another way, if the El Rukn trials were a movie, this story about Hogan and the El Rukn witnesses might have been packaged as an additional curiosity on the same DVD.

Almost as much as the Conspiracy 8, these were most curious legal proceedings.

Bill Hogan, because he had headed the El Rukn prosecution, was one of the first witnesses in the reconvened proceeding, once the Rosenthal memo had been found. Soft-spoken and unsmiling as usual, he wore a light greenish jacket and wire-rimmed glasses.

The enmity between him and the judge, once an assistant U.S. attorney himself, was well known. Fred Foreman, the U.S. attorney, had asked Judge Holderman to recuse himself from hearing this motion for a new trial because it "wouldn't be fair to Hogan after numerous clashes with him at a Rukn trial" (Matt O'Connor, *Chicago Tribune*, Tuesday December 8, 1992).

Holderman had refused and now glared down at the man whose background and experience were so much like his own.

It was odd to see Bill Hogan as a witness. Lawyers may jump to their feet or roam about the well of a courtroom. Defendants can loll about, stretch, scratch, and squirm, but a witness has the mobility of a paraplegic.

Three large black men in dark blue jumpsuits, El Rukn drug dealers, slouched at the defense table, watched impassively as the man who had put them behind bars suffered the indignity of suspicion himself. Hogan was the most imprisoned person in the room.

The evidence showed that Harry Evans and Toomba had tested positive for drugs when they testified before the grand jury in 1989, as the Rosenthal memo reported. Then Toomba had refused to be tested in the summer of 1991 when he was appearing in the trials before Holderman, Conlon, and Aspen. Now all the convictions in all the trials where Toomba and Harry Evans testified had been put at risk.

Bill Hogan's own credibility and career were at risk as well. How galling it must have been for him to observe the defense lawyers now sporting the cheerful arrogance of prosecutors in what people were calling *United States v. William Hogan*.

Hogan gave a history of the El Rukn investigation and prosecution, showing an amazing memory for dates and dispositions.

He described hectic weeks with attorneys working in "constant all day meetings" and dealing with five or six "flippers" at once in different offices while police officers stood outside each door. There were meetings at the same time with agents from Alcohol, Tobacco and Firearms and with federal marshals and Chicago police; they organized teams and discussed raids to grab the El Rukn defendants from all over Chicago.

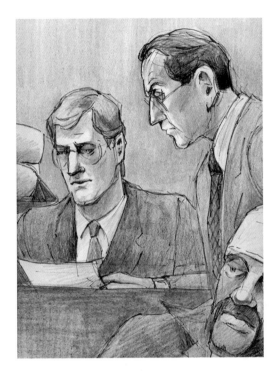

William Hogan and Tom Sullivan.

Hogan: "It was a complicated, intense process."

They had to call the indictment off at the last minute because of "major plea problems" with the cooperating witnesses. They'd planned to return the indictments October 19, about the time Larry Rosenthal claimed he showed his memo to Hogan. But the indictments were not returned until October 26.

His timing might have been thrown off if Hogan had read the memo, as Rosenthal suggested, and worried about it.

Hogan: "I'm certain in my mind I did not have a conversation with Mr. Rosenthal about…that document."

He was sure the flippers couldn't have been on drugs at the time. "There's no way that these witnesses were coming up dirty at the MCC and I would fail to catch it."

Asked if there were any instances when Henry Harris did not testify truthfully, Hogan answered, "In my opinion there were no such instances."

Judge Holderman questioned Hogan: "You weren't aware Mr. Harris was in segregation...weren't aware of the disciplinary hearing?!"

Hogan said he thought this was because he and Derrick Kees got in a fight over a seat in the television room.

Judge: "You got to know Mr. Harris pretty well, he looked to you for advice?"

Hogan: "I would say so."

Judge: "But he never once mentioned in all the times you talked to him that he'd tested positive for drugs?"

Hogan: "He never did."

"He doesn't believe him," hissed a court buff.

The Metropolitan Correctional Center is a wedge-shaped sliver of a building a block away from the federal building. From the pressroom windows you could see man-shaped dots playing ball on its roof. Inside the building, odd floor plans and bright nursery school colors give the place a cockeyed cheerfulness. It's said, though, that inmates find it one of the most depressing, claustrophobic jails in the system.

None of the speculation about occurrences on the sixth floor of this peculiar building had much "news value" in the beginning, but the court buffs and I had spent many hours with the El Rukns; we wanted to find out what would happen. I started attending the hearing on my own, after finishing the cases I'd been hired for.

One day a well-known Mob defense attorney called one of our reporters and told him he'd heard Judge Conlon was throwing out all the El Rukn convictions because of prosecutorial misconduct. So, though this information was premature, I was assigned to cover the proceeding.

Like travelers in a European train compartment, a collection of bored people, mostly MCC employees, sat for days in a small room outside Holderman's courtroom, waiting to testify.

They included a bumbling assistant warden who, when he was called to the stand, caused Judge Holderman to explode, "What do I do with a jailer that's held in contempt?!"

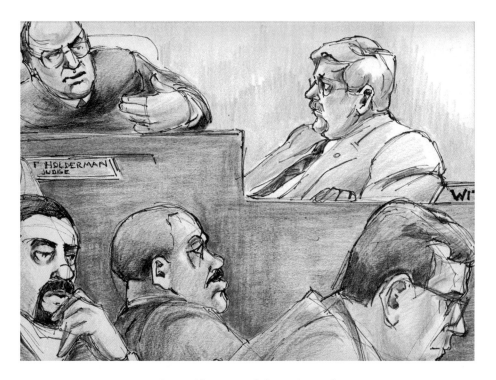

Judge Holderman and the MCC warden.

They included the MCC's paralegal, Miss Charvella Christmas. Miss Christmas was worthy of the name. "Ah, Christmas is here!" exclaimed the judge one day as she sashayed into the room, in Matisse colors, gold jewelry flashing at her bosom, her wrists, her fingers, the top of her head, and the ends of her bouncing braids.

"But it's only November," whispered a wise-guy court buff.

Hogan waited in his shirtsleeves and smoked as he paced in and out of the witness room. He had hired his own lawyer to advise him, but this lawyer had no standing to appear in court. Hogan's defense and his reputation were in the hands of Assistant U.S. Attorney Barry Elden. Barry Elden represented the government in these proceedings; it was his charge to fight against over-turning the El Rukns' convictions. Through the glass rectangle in the door, Hogan could watch Judge Holderman shower tirades of impatience upon Elden's bald head and big ears.

Also smoking and watching through the courtroom's window was a

paralegal who had worked on the El Rukn case. Clarissa McClintock was responsible for fetching the government's documents. Boxes and boxes of them covered the tables and the judge's bench. The documents, which included the MCC's yellowish green urinalysis log, were as important and frustrating as witnesses.

Judge Holderman made no secret of his suspicion that the government was withholding materials. He had requested such-and-such a memo weeks ago, he would roar, where was it and why hadn't he received it? Why had the defense lawyers, and not he, received copies? Didn't the government have someone who could produce such things for him? And he had granted the government several weeks of recess to do its own investigation!

The post-trial hearing that was supposed to take two days stretched into its third week. As if to demonstrate that things were out of joint in the building, the clock in Holderman's courtroom ran exactly one hour fast, and upstairs in Judge Conlon's courtroom, where a similar hearing was going on, the clock ran one hour slow.

The issue of whether Evans and Harris had taken drugs in the MCC seemed a simple one, but missing files, bungled records, and muddled memories complicated it. Two governmental entities, the Justice Department and the Bureau of Prisons, were bouncing the blame back and forth between them. Still, the whole mystery might have been solved, or at least contained. But it was decided to bring back the El Rukns themselves as witnesses, and that's when what the defense lawyer had predicted in May really began to happen.

Back on the witness stand in Holderman's courtroom, Toomba seemed sleeker and more satanic. It wasn't just that he was dressed in black; it was because he wasn't wearing the big round glasses that had made him look like a schoolteacher. The marshals let me sit in the jury box near him, and now that I could see his eyes, he seemed more truly mad.

Toomba turned the witness stand into a small stage as he rambled on about "corruption at the MCC." He said that a guard had put Nova Histamine 8 in his specimen and thus created the "dirty urine" he'd been charged with. With elaborate pantomime and a voice hoarse with passion, he told of being placed in the "pop-u-la-tion" when he was a "turncoat general" and should

Richard Kling, Judge Holderman, and Toomba.

have been protected from the other El Rukns. He told of being handcuffed by a guard so that another El Rukn, one of his "separatees," could attack him with a razor blade melted into the end of a toothbrush. He said that two of the guards were actually working for Noah Robinson.

Toomba: "I'm struggling at the MCC for my life!"

He recounted how a guard allowed him into a female prisoner's cell for a few seconds so he wouldn't report on the guard's smuggled Derringer.

Toomba: "We just kissed a little bit and you know, that's all.... I'm a gentleman!"

Asked about visits to Hogan's office by Ola Morris and their three-year-old son, he mimed the ATF agent searching Morris's purse and pockets and patting down their little boy: "just being friendly, 'How you doin,' Michael, how you, Michael!'"

Toomba told how he tried to give Ola hope for their future. He reached out his plump hands and then pulled them back to his chest in

mock yearning: "I was trying to hold—to hold on to my girl."

He expressed his rage at the assistant U.S. attorneys for not listening to his complaints about prison life, not protecting him from the "58 charismatic men" lodged with him.

Toomba: "Mr. Hogan didn't care about nothing, 'bout nothing 'cept his case.... I'm a government witness, man, I'm alienated from all the things in life that I love—all I got is the U.S. Attorney's Office!"

Asked if he had an opinion about Mr. Hogan's truthfulness, he said, "I think Mr. Hogan is a fair and just prosecutor...dedicated to his work, but there's room for improvement.... There's a few things I may have to bring to his attention."

When Toomba finished testifying, Richard Kling said, off the record, we could all pretty much agree that what Toomba had said was "bullshit."

Toomba then disappeared back into WITSEC, the Witness Security Program.

The defense attorneys and the judge wanted to hear from Harry Evans, the other El Rukn turncoat witness accused of having dirty urine.

Court buffs and other watchers had always found Evans ironic and articulate. They liked how he described Jeff Fort's brainwashing of his followers; he was one of their favorite El Rukns. The government attorneys appreciated him, too; they kept him alive by providing his dialysis treatments. Defense lawyers said they kept him alive only so that this diabetic, kidney-less, wreck of a man could testify against their clients. After General Toomba, Harry Evans (a.k.a. General Bebop) was their most compelling witness.

I never heard Evans much during the trials, but I heard about him, and I would glance in at him in witness rooms waiting to testify. Now every day he waited in Holderman's witness room, slouched, lumpy, and collapsed like a Halloween effigy of newspaper-stuffed clothes. Then his guard would take him away again. There were more urgent witnesses with more important schedules.

On December 2 he finally lumbered to the witness stand to tell not just about drugs but about how he was caught having sex at the MCC.

Perhaps it was because he was close to death that Evans seemed his own man, wistful yet unperturbed by the swirl of flotsam around him. He began

to describe without embarrassment his attempts at intercourse with one of his common-law wives in the MCC visiting room. He said he didn't know whether to blame their lack of success on his medical condition or on the guard who came bursting in the door.

Then, to the merriment of spectators, the lawyer asked him to demonstrate.

Evans: "But I would need a female!"

None provided, he reluctantly came down off the stand and took the extra court reporter's chair in front of the judge's bench, inches from where we in the jury box tried not to giggle.

He lowered his great rump onto the tiny seat and then spread his thighs, circled his arms and held the pose, like a child playing statues.

For several seconds this fat, teddy bear man, dressed in tan coveralls, embraced his imaginary lover at the front of the vast courtroom.

His lawyer bought the sketch I made and gave it to him as a present.

In federal penitentiaries all over the country, prisoners heard about these proceedings. Prisoners from California to Massachusetts who had been incarcerated with Toomba and other El Rukns spoke up to their government attorneys and said that they might have something to add. Judge Holderman was determined to find out what had happened and wanted to hear from any who knew about drugs and sex on the sixth floor of the MCC or in the office of Assistant U.S. Attorney William Hogan. Confidential letters faxed and mailed by U.S. attorneys in other states were discussed in loud whispers at sidebars.

Two suburban drug dealers I had drawn years before took turns on the witness stand. They had lived with Henry Harris on the sixth floor.

"[Toomba] told me he was a good liar.... He said, 'The better you can make your testimony, the less time you serve.'...he thought he was the link that put this whole [El Rukn] case together. 'If you can make up something really juicy they're gonna love you.'"

Both these drug dealers said they knew drugs were used at the MCC; they had seen Toomba snorting a white powder.

Another prisoner, Californian Phil Walsh, now incarcerated with Toomba at an "undisclosed location," was flown in to testify.

Walsh, a slick, wiry young man with long hair and cowboy boots, had been convicted of moving stolen property over state lines. He had let his sponsoring U.S. attorney know that he had information on the case in Chicago.

He quoted Toomba: "'The U.S. attorney has taught me how to lie, how to use sophistry and subterfuge.'"

Walsh and Harris had spent time together in the prison library, while Toomba was working on "some charitable organization." He had heard Toomba raving to himself about, "subterfuge and sophistry, subterfuge and sophistry."

There was a rumor in his prison, Walsh reported: "Mr. Harris was allowed to have sex in Mr. Hogan's office."

The hearing on a motion for a new trial continued on its bizarre course with revelations and plot twists worthy of television but that court-room observers knew the rules of trial procedure made unlikely. "Surprise witnesses"—convicts who had been incarcerated with the El Rukns and whom neither side had "pretried"—said surprising things.

Lawyers rushed up waving new documents that caused judge and lawyers to hustle to sidebar and tersely discuss.

High-ranking assistant U.S. attorneys who'd had nothing to do with this case were summoned and charged through the courtroom to meet with the others in chambers.

The court buffs were delighted.

Judge Holderman seemed more amazed than anyone. One night after court, as I gathered up my pencils from the floor, he stopped to chat. If Scott Turow, once an assistant U.S. attorney in the building, wrote about such a hearing, he remarked, shaking his head and laughing, people would say it wasn't possible.

One surprise witness was not a convict, but Clarissa McClintock, the paralegal who had anxiously watched through the window in the court-room door.

Clarissa McClintock had worked on the El Rukn case for years, squir-reled away in the "war room," in the warren of offices on the eighth floor. In that cluttered space, under a tacked-up copy of Jeff Fort's mug shot, Clarissa

toiled with Toomba and Eugene Hunter, transcribing and translating tapes of hundreds of hours of Jeff Fort's coded calls from prison. Their efforts ended up in the thick black notebooks that jurors had held on their laps and read while listening to recordings.

Clarissa McClintock had wanted a job as an assistant U.S. attorney, but her "writing skills" weren't strong enough, so she was hired as a paralegal. She hoped to impress her superiors and become a full-fledged colleague. Working hard on the El Rukn investigation, hidden away for months, this pretty young woman grew plump and pale.

We'd heard her name in testimony because she was the only government lawyer whom Toomba told that he had refused to take a drug test in the summer of 1991.

Judge Holderman had asked Ted Poulos, when the former prosecutor came back to testify in this hearing, why McClintock did not pass this information on to her superiors.

Judge: "She knew that Mr. Harris refused to take a drug test just days before he took the witness stand in my courtroom!"

Poulos: "I could only speculate."

Judge: "I'm going to ask you to speculate."

Poulos: "She worked with Henry Harris for a long period of time. Harris often told her various stories or anecdotes.... If Harris told her in confidence...."

On the morning of Tuesday, December 1, as soon as Judge Holderman took the bench, Barry Elden requested a sidebar. The only press person at this neglected hearing, I listened discreetly to the huddled men in the corner. I was able to separate the words *tape* and *transcripts* but not much else. The judge looked very disturbed.

Something new had been brought to his attention. I overheard him saying, "I'm going to review it in camera because of the nature of the material.... I'm not sure the best way to present it to counsel."

He addressed the government lawyers: "I'm going to need that equipment."

When court resumed at 12:30, they were back at sidebar.

From across the room came the words *inappropriate conduct*, *violation* and *sexual*.

Judge: "Let me tell you my concern.... Miss McClintock had access to

information.... Subsequent conversations similar to the one on the recording must have occurred...."

Turning to Barry Elden, the judge said, "When did you find out about this December 1991 tape?"

The judge announced another recess, and the lawyers went into the jury room, apparently to listen to the mysterious tapes. They were joined by Nancy Needles, a high-ranking assistant U.S. attorney; soon after, Tom Durkin, the first assistant, marched purposefully through the courtroom.

The building reporters had joined me in the jury box, where we waited and speculated. There had been nothing in open court all day, but behind the scenes a real story was forming like a tornado.

More than an hour later they all came out—the government lawyers looking grim, the defense lawyers smiling, shaking their heads, calling this new development "unbelievable!"

Clarissa McClintock was called to the witness stand. The defense lawyers waived their examinations and allowed Judge Holderman to question her directly.

The judge, glaring down, asked if she ever had a conversation that was "sexual in nature" with cooperating witness Eugene Hunter.

Clarissa McClintock's mouth fell open.

"That was the subject of a disciplinary hearing," she finally answered.

When she said that she wanted to consult a lawyer, the judge said she had no attorney-client privilege; she must answer or be held in contempt of court. She kept saying only that "it" was the subject of a disciplinary hearing. As the judge continued to question her, she stared at him openmouthed from under her long dark bangs.

Judge: "Did you have an infatuation with Eugene Hunter?"

McClintock: "No."

Judge: "Did you have an infatuation for Earl Hawkins?"

McClintock: "No." It was the other way around; Hawkins felt something for her.

Judge: "Did you have an infatuation with Bill Hogan?"

McClintock: "Yes, I think that is a fair characterization."

Nancy Needles testified later that when she first heard the tape of the paralegal, Clarissa McClintock, and the cooperating witness, Eugene Hunter, the year before, she was "very shocked...angry.... Someone who wanted a

job…had betrayed our trust…. It made me very, very sad. I heard a lonely woman who was very stressed and very tired…. Clarissa tried to explain that the conversation was 'tongue-in-cheek, it was a tease.'…I said, 'It was more than a tease, Clarissa; Hunter had an orgasm during that conversation.'"

When I telephoned back to the station after McClintock's testimony, I said there was no story, just a personal humiliation, not news. It seemed to me like a federal building family squabble.

The producer said, "OK, we won't do it."

The next morning outside the pressroom, across from Holderman's courtroom, defense lawyers buzzed with talk of new scandal. They spoke of a second tape on which Clarissa talked with Eugene Hunter about smuggling contraband drugs into the MCC. I told the assignment desk there would be a story.

The judge was furious; from many sidebars his voice escaped to the courtroom. He chastised Elden: "That tape should have been transcribed a year ago…. There should have been an investigation…. I'm still reeling from the way that was handled!"

And, "One of the problems was Miss McClintock was running the document procedure in this case…. I hope she is no longer."

The judge wanted to hear from Eugene Hunter. "Let's bring him in cold and see what he says."

But Clarissa, taking the stand again, interrupted Hunter's first day of testimony. She walked in, head down, wearing a simple navy blue dress that she'd probably bought for job interviews. Michael Monico, her new attorney, took an almost military stance at her side. Monico, a sharp-nosed, dark, dapper man, had defended the spy William Kampiles years before in Hammond, Indiana.

At each question from a defense attorney, Clarissa turned to Monico, her straight hair swinging, and they consulted before she answered.

Again and again she invoked the Fifth Amendment, refusing to answer on the grounds that it might incriminate her. Monico hovered over her, cradling his chin in his fist like a Mediterranean duke protecting the honor of his women. Finally, everyone seemed to understand the futility of further badgering the terrified witness. Monico told the judge that Ms. McClintock would testify only if given immunity.

Judge: "She's excused for now."

That evening downstairs in the lobby, a defense attorney in one of the other El Rukn cases talked off the record.

"Ex-Lax," she said. Ex-Lax was the contraband discussed on the second tape—Ex-Lax was the contraband that Clarissa had smuggled to an inmate in the MCC.

Everyone—the reporters, the TV people, their colleagues at their stations, the court buffs, the spectators—was eager to hear the so-called Clarissa tapes. All we knew was that on one tape McClintock and Hunter spoke of sex, on the other of smuggling drugs. On Thursday, NBC sent a lawyer to ask the judge for permission to broadcast the tapes as soon as they were in evidence. The judge told the lawyer yes, that is the policy—as soon as they are played in the courtroom and are accepted into evidence, they would be available to the media.

Barry Elden and Michael Monico pleaded that Clarissa not have to testify, that the tapes not be played, the transcripts not released.

Elden: "Don't destroy her life!"

Monico, more troubled than just a lawyer arguing for the usual client: "[It would] be a tragedy if you allowed this to go into evidence. The effect of it is to destroy a woman's life to no point."

The judge countered with his outrage at her "shocking improprieties."

Clearly he suspected McClintock had smuggled drugs into the jail, that he believed *Ex-Lax* to be an El Rukn code word.

Like that other paralegal, Charvella Christmas, and her bumbling colleagues at the MCC, Clarissa McClintock was becoming a scapegoat.

The MCC people were the focus of interest when the whole hearing was about bureaucratic bumblings. They and their stacks of documents had been replaced by the more glamorous scenario offered by Clarissa, Eugene, and a box of laxatives.

The marshals escorted Hunter from the back of the courtroom, in front of the reporters and artists (who now filled the jury box), in his rumpled blue prison jumpsuit, a brown elbow poking out of a hole in his sweatshirt's sleeve. This wasn't the silk-tied ersatz businessman who had told us a year and a half ago how he was groomed to be the new Noah Robinson.

Eugene Hunter.

The judge ordered Michael Monico to man the recorder so that he might play the tape and then stop it or lower the volume during the worst parts. Monico found an electrical outlet near the minute clerk's place and sat in her black leather chair fiddling with knobs on the machine. The judge, seeing Monico there, berated him sharply for taking such a liberty, and Monico, apologetic, disappeared with the equipment onto the floor.

Finally, Monico reemerged and placed the small black-and-gray machine on the railing of the witness stand.

I had already drawn it there when they then decided not to use it. Even the defense attorneys, who could have insisted, seemed to have some feeling for Clarissa and settled for reading parts of the transcript.

Richard Kling quoted the transcript to witness Hunter: "'You just don't want to give that hot skirt a rest, do you?' Did you say that to Ms. McClintock?"

Eugene Hunter admitted that he had.

Kling: "'You need to get laid—good....'"

After each quote, Kling looked to the witness stand, where a squirming Hunter affirmed its accuracy.

Kling read from the transcript Clarissa's words describing how she felt about Earl Hawkins's life sentence for murder. "'...And then there's that bleeding heart liberal in me that, that would really like to know that someday he is gonna see the light of day again. And that it's just not gonna happen and that hurts. And, see, I, you know, I can, I can live with the thought that maybe you're gonna do five more years and get out. Because it's not gonna be the end of your life, you know?'"

(Later when reading the transcript myself, I saw that Hunter suggested they could be like Angela Davis and George Jackson. "Go buy the book *The Soledad Brothers* and read it," he told her.)

The judge grew angrier. Why hadn't the government gotten McClintock immunity yet? Why hadn't the transcript of the tapes been faxed to those in Washington who must OK the granting of it?

"I don't know who to trust anymore," he thundered.

The NBC lawyer who had wanted the tapes released complained that she wasn't getting the "usual cooperation" from the U.S. Attorney's Office.

The judge, chuckling, replied, "I'm not getting the usual cooperation, either!"

"Go down and get your notes!" Holderman yelled at Barry Elden at one point.

Elden bounced back from each whack like an inflated balloon man on cardboard feet.

"Who are you representing?" the judge roared at him.

Elden: "The United States Attorney and the people of the United States."

Judge: "No, you aren't, you're just trying to cover up for a colleague!" He meant Bill Hogan.

Soon it was like watching the end of an opera, with all the heroes, villains, and courtiers singing at each other across a huge stage. The judge's strong baritone sailed out over the rest: "This hearing has turned from a motion for a new trial into a scandal... It's absolutely outrageous!"

Monico, a former assistant U.S. attorney like the judge, pleaded with him: "As an officer of the court...[we should]...recess...to allow tempers

to cool…. I don't like to see the U.S. Attorney's Office accused of the things that Your Honor has [accused it of]!"

But the judge wasn't through; someone brought up the Attorneys' Registration and Disciplinary Commission, and Richard Kling tightened the screw. "If there were other lawyers in the U.S. Attorney's Office who failed to report [Miss McClintock's misconduct], they are also liable."

The judge agreed and made a list out loud: "I believe the first assistant U.S. attorney was aware of it…the U.S. attorney himself…the chief of the Civil Division…."

He demanded of Barry Elden: "When were you aware of it?"

Elden (meek but uncowable): "I was aware of it about a month ago."

The coming weekend and Monday I had to be in New York. From the courthouse I grabbed a cab to the train station, where the Lake Shore Limited panted white steam. Bumping my luggage against its padded walls, I found my small compartment in the long humming tube of the Amtrak Slumber Coach. All night long its wheels seemed to click out her name: "Clarissa McClintock, Clarissa McClintock, Clarissa McClintock," as they carried me along the sparking tracks to New York.

In the train returning I read a magazine article about the physicist Richard Feynman. Alan Lightman explained Feynman's understanding of all possible routes of a subatomic particle by analogizing them as all possible routes from New York to Los Angeles.

> Such a description leads to a strange picture of the world, where all the different ways in which something can happen are happening at the same time. What we human beings, grossly insensitive, macroscopic objects that we are, conceive of as a single reality is actually a tapestry of many simultaneous realities.

The description fit the hearing in Judge Holderman's courtroom. The hearing tried to get from the *here* of the motion for a new trial to the *there* of an explanation about drugs in the MCC. Yet the evidence, like subatomic particles, seemed to travel every possible route at once.

The hearing had been scheduled to take only two days. In the beginning, it had investigated the MCC and its bureaucrats. But documents had been lost and then found, leading to other documents that had to be found. The custodians and generators of the documents, called to the stand, told about Bureau of Prisons policy, and for a while it seemed that the answers to the mysteries of the sixth floor might be discovered in the pages of urinalysis logs or in Toomba's file.

Then the morning Barry Elden came rushing in with the Clarissa McClintock–Eugene Hunter tapes, the proceedings veered off on a different course. When the men in federal prisons learned that the Chicago U.S. Attorney's Office was in trouble with one of the biggest mass prosecutions in its history, their "help" forced Holderman's hearing onto yet another route. Men in prisons have time to scheme, time to think of ways to improve their futures.

"I thought they were supposed to be making license plates," said a defense attorney.

When I reclaimed my seat in the 21st-floor theater, there was a different drama playing. Clarissa was no longer its star.

Mushtaq Malik, a mysterious Pakistani, was testifying about what he had heard when sharing a cell with Henry Harris in the WITSEC program and listening to his boastings. Malik was a convicted drug dealer and government witness who claimed to be involved in Pakistani politics.

During a recess in the pressroom, a tense-looking man with a natty beard stood over the City News desk firing off quotable phrases. Malik's lawyer halted after each one so that the reporters could get them right.

"He wired the truck that was driven into the barracks.... The largest detonation...in the history of the world except for the atom bombs... more marines were killed than at Iwo Jima.... He advised Malik he was associated with the PLO at the highest levels."

After a while it became clear that the connection between the bombing of the Marine barracks in Beirut and Henry Harris's urinalysis was not that close. The man on the stand, dubbed the Beirut Bomber, had been a defendant in a case in which a certain Hocheny had testified. It was this Hocheny (Toomba would later refer to him as Ho Chi Minny) who really deserved

Mushtaq Malik and Judge Holderman.

the epithet the Beirut Bomber; it was Hocheny who had "wired the truck that was driven into the barracks."

Malik's lawyer warned the press, "When Malik gets through testifying today, he will have to have protection because of what he's going to [say] against the United State's Attorney's office!"

An arrogant brown man in a pinstriped suit and open collar, with shiny black hair, furious eyebrows, and a mustache, resumed the witness stand. "I am known all the world over as the Black Prince," he boasted. In his deep British accented voice, Mushtaq Malik let the courtroom know that, as the Black Prince, international drug dealer, and freedom fighter, he was above all this.

He gestured grandly as, not stopping for objections, he interspersed tales from his shady career with information about cellmate Toomba. "Toomba said since he was very brilliant and Mr. Hogan had a certain affection for him…he [Toomba] learned very fast sophistry and subterfuge…. He always said, 'Yes

sir, yes sir!'

"Mr. Hogan gave him the most thorough preparation.... Everyone loved him.... He told me he lied 60 percent."

Malik testified about the El Rukns' Libyan exploits. "It was all bullshit and Mr. Hogan knew it...was no terrorist acts.... He [Toomba] lied right in their faces and nobody could break him."

Toomba had told Malik that he had motive to lie against the others, because the El Rukns had shot up his father and mother's place and because of "the girl that Noah Robinson took away from him."

Toomba boasted to him, he said, of having made love to Bill Hogan's secretary on a table during one of his visits to the federal building. Toomba told him he also had had sex with his own girlfriend there, and she had passed him drugs. Toomba referred to himself as the King of Heroin at the MCC.

Malik testified that he didn't always believe Toomba. Toomba was too much of a liar to trust.

So Mushtaq Malik gave the hearing a new version of the Liar's Paradox. When Toomba the liar said he was lying, was he lying about lying?

Suddenly, testimony was interrupted for "security reasons," and Malik was taken from the stand and hustled out the back. His lawyer said he might return if he received a grant of immunity.

Our cameraman waited at the top of the ramp leading out of the building's underground garage. After a long stakeout, an agent drove Malik out into heavy traffic but was unable to get away quickly. The cameraman shot into the backseat and "got" Mushtaq Malik, who sat there grinning like the prince he thought himself to be.

The El Rukn generals and Noah Robinson had also filed motions for a new trial, so Judges Marvin Aspen and Suzanne Conlon also held hearings. Now Judge Conlon questioned whether the government was stalling in giving immunity to some of the WITSEC witnesses for fear they would damage the government's case. Each witness so far had received immunity from prosecution before he testified. But each witness's testimony might form a chain leading to possible prosecution of Bill Hogan himself, and so it seemed to be taking forever to get immunity for former El Rukn general

Jackie Clay.

The defense lawyers complained that the government was delaying Clay's grant of immunity because "Mr. Clay may have testimony that's very damaging."

Judge Conlon: "His 302 certainly doesn't reflect very well on the government position, Mr. Elden."

Then she added ominously: "There is an offense called obstruction of justice, and it applies to prosecutors as well as defense attorneys."

Phil Walsh, who had been incarcerated with Clay, Toomba, and Malik, testified in Judge Conlon's courtroom about what he'd done when he came back to prison after testifying before Judge Holderman.

Walsh: "I went to Jackie right away just to talk to him…about what had happened here…. I was concerned for him."

Walsh said that Clay told him he would only testify if a judge took control.

Walsh: "Clay told me 60 people were going to jail for a long time for things [that they hadn't done]…. A number of people were doing life sentences that wouldn't have gotten those sentences if the truth had been told."

Fred Foreman, the U.S. attorney for the Northern District of Illinois, recused himself from the hearings, "because of the serious nature of these allegations."

A U.S. attorney from Michigan was appointed in his stead, and as the hearings continued there seemed to be a problem of who was in charge.

And then the hearings veered off onto another tangent. Mushtaq Malik had been granted immunity, and the government called him to testify again. As with the other witnesses who had come back, not only did the hearings themselves become part of his story, but they also added new material that necessitated new witnesses.

These appearances and reappearances recursively contained the action of the one that followed; they looped back as they progressed.

Knotted in with Mushtaq Malik as witnesses were his sponsoring U.S. attorney in Springfield, Massachusetts, the hapless Massachusetts public defender who had defended him there, and a new player named Brock.

The government attorneys brought all this up in hopes of discrediting Malik and his tales about Toomba. Elden conducted a long and laborious examination of Malik, asking him questions about his irrelevant, shady past in South America and the Middle East, including a planned assassination of Benazir Bhutto in Pakistan, then coming back to Massachusetts.

"Mr. Elden," exclaimed the judge, glowering down at him, "you're attempting to intentionally delay these proceedings!"

But Elden, punched and punched and bouncing back, kept right on trying to impeach Malik, to show that the Pakistani had lied at previous trials.

Mushtaq Malik's assistant U.S. attorney joined the fray. The U.S. government was vouching for his client's credibility in Massachusetts and saying in Illinois that he lies!

Malik went on talking about that "undisclosed location" where he had been incarcerated with Toomba, Clay, Walsh, and Brock. In that slimy world of the WITSEC program, they had all slid around the same tilting floor.

He said that Brock, whose real name was Harry Martin, had to "protect Mr. Hogan, no matter what."

Thirteen hours later in Holderman's courtroom, the judge harangued the government about other prison phone tapes, about procuring a copy of the Bureau of Alcohol, Tobacco and Firearms Regulations, about the letter Fred Foreman wrote recusing himself, about the problem of getting into Clarissa McClintock's computer files without destroying them in the process.

"Why don't you produce these things as required?" he demanded. "We have the acting U.S. attorney, the former acting U.S. attorney, the U.S. attorney's press secretary, and, I believe, a paralegal sitting in the courtroom!

"You're trying to goad me!" Judge James Holderman, a decent man driven to distraction, seethed at them all.

The most senior marshals brought Toomba in once again to Judge Holderman's courtroom. They watched him closely as he testified.

Undeterred by attorneys' objections, Toomba told about a discussion he

Judge Holderman and Toomba.

had with Jackie Clay when the imprisoned El Rukns first heard about the U.S. attorneys' trouble in Chicago.

Jackie Clay had made a phone call and reported back.

Toomba: "Some stuff goin' on in the city.... Jackie then turns and says, 'What you gonna do, boy?...Why don't you quit being an Uncle Tom so we can all go home?' He started calling me...'house nigger' and excedra [*sic*] ...call me Mr. Hogan's pet.... He wanted me to lie on Bill, he specified me having sex over at the U.S. Attorney's Office."

Toomba testified that Jackie Clay was bitter about his plea agreement: testimony in exchange for an 80-year sentence.

Toomba: "Most of Jackie's friends that he hang with are from New York City, they murder, they get ten years."

Jackie instructed him, said Toomba, "to tell on the generals and to let the ambassadors go."

A government attorney asked him, "Did Mr. Hogan ever tell you to lie?"

Toomba: "No, sir!"

He was asked if Hogan taught him to use sophistry and subterfuge.

Toomba's whole body jiggled with amusement: "No, sir!"

"Were you supplied with drugs at the MCC?"

"No, sir."

"Were you ever king of heroin at the MCC?"

"No, sir, sir."

"Did you ever make love to a secretary in Mr. Hogan's office?"

"...anybody on a table? No, sir."

"Did you lie in the grand jury or at any of the trials?"

"Ridiculous," answered Toomba. "No, sir."

When it was their turn to question, Toomba scrapped with the defense attorneys.

"I done a lotta things positive since I been inquarcerated," he said, producing a hybrid word with *quarantine*. "[The defense] is making me into a junkie!

"I am the star witness in Mr. Bill Hogan's case!...One is impugning my reputation!...I gotta 'greement with the government, but I don't have an agreement with the defense!"

He was having a good time now, teasing them. He nodded over toward the portly Brian Collins.

"You got the big guy here, likes to jab me!"

He nodded toward Richard Kling.

"And then you got the clever professor...."

In the audience, people were laughing.

"I have threw myself on the mercy of the court."

He told how Jackie wanted him to lie.

"I go back to the institution [after testifying in these hearings], and there's Jackie standing there with all his friends.... Jackie's under the impression that if all the cases get overturned, ours gets overturned."

Toomba had told three different stories to explain his positive urine test: that a guard put a medicine in his urine; that he, Toomba, took drugs to aid prison officials in an investigation; and that Harry Evans handed him a soft drink with heroin in it. Now he was asked about the third explanation.

"I consider myself progovernment," said Toomba, as if this explained everything. "I believes in the government, and that causes me problems out

there in the institution."

He told how they put him in solitary confinement when he went back after testifying the last time. Toomba quoted the prison officials: "'Well, Henry, we believe it's best for you to go in the hole.'"

Toomba had always richly entertained all those who hear him testify. On every occasion he took the witness stand, and there had been many, he made people laugh. Perhaps it was because the lawyers knew the days of Toomba's testimony were coming to an end that one of them sought to extract one last bit of fun. At the end of his cross-examination, a defense attorney asked Toomba, "You're involved in teaching inmates to improve their grammar and syntax skills?"

Toomba answered affirmatively.

Had it been Toomba's madness that propelled these hearings? It seemed that every time Toomba, the loose cannon, roared, everyone scurried. Or was it Jackie Clay's belief that they could get their convictions overturned if they put Hogan in enough trouble? Or perhaps Clay just wanted revenge.

These El Rukns, a virus once thought eradicated, had mutated under prison conditions and emerged more powerful than ever to attack its most vulnerable host, the U.S. Attorney's Office for the Northern District of Illinois.

Early the next day the judge told Toomba, "You may step down."

The star witness slouched out of the courtroom, his hands deep in his pockets, his posture that of a bitter and frustrated man.

On the afternoon of December 30, we were told that Fred Foreman, the U.S. attorney for the Northern District of Illinois, would testify before Judge Holderman. The press had to stay and wait for him.

In the meantime, Harry Martin, a.k.a. Brock, took the stand.

He had dressed up for the occasion, the first prisoner witness to do so, in a gray suit with wide lapels and a narrow red tie. He'd slicked his hair back and made a skinny pigtail like a lever bouncing behind him.

Harry Martin was a fellow inmate and advisor to the El Rukns, privy to their intrigues, a pal to the plotters, and smarter than they.

Martin: "I been going through the legal system since I was nine."

He boasted how he started as a pickpocket and had been convicted of

armed robbery, armed violence, unlawful use of a weapon, burglary, theft, and drug possession. He was in the federal system because he had agreed to testify against some county sheriffs.

He described meetings of the conspirators, Mushtaq Malik, Phil Walsh, and Jackie Clay, which he had attended or learned of as a "legal expert." Martin testified to what he heard others say; sometimes he repeated double and triple hearsay. Judge Holderman allowed all of it in his effort to understand.

Martin: "Clay explained a scenario [in which he would] withdraw his guilty plea…if [the El Rukn] cases were overturned…. Clay said the witnesses would be too tainted in terms of their credibility…[to testify in new trials]…. Bill Hogan was on the ropes…. Clay wanted to launch an attack on the Justice Department…he was elated that the hearings were going… downhill."

Clay had said that "it was a just cause."

Malik told Martin that he, Malik, planned to say "personal things" about prosecutor Bill Hogan. He would say that he "smokes…is a chain smoker… that he has a girlfriend who is a U.S. attorney."

Malik told Martin that, no, this wasn't what Toomba said, but that he, Malik, was going to say these things in Chicago anyway, "to set the brothers free, the other Muslims."

Malik would also say that prisoners had sex in the U.S. Attorney's Office.

Harry Martin testified that Malik, Walsh, and Clay were "antigovernment," they felt they had been wronged, they were "always putting things together against the government."

As for the bombing of the Beirut barracks, "[Malik] put that story together [too]," said Martin.

Martin said that Phil Walsh told him he was going back to get the El Rukn cases overturned because he felt bad for Jackie Clay. Jackie hadn't had a lawyer before going to the grand jury and had to take a plea for 80 years.

So Phil, to help Jackie out, "would call his prosecutor and tell him he had information about Chicago… [that] he overheard Henry Harris [say] that Hogan told Harris to lie."

Aligning himself with Toomba and the government, Harry Martin called his own prosecutor and offered to testify himself. Assistant U.S.

Attorney Kristina Anderson had once been Bill Hogan's girlfriend.

Now another government attorney asked him if he ever saw Harris with drugs at the MCC.

Martin: "No."

Attorney: "Did Harris say that he lied in the trials?"

Martin: "No."

Did any other cooperating witness say he lied?

Martin: "No."

On cross-examination Martin told Defense Attorney Donald Young that he did see Harry Evans use drugs at the MCC. Once, in an effort "just to see if he would feel it," he had picked something out of Evans's back pocket.

"I opened my hand and there was a plastic bag with cocaine in it."

Harry Martin knew that drugs were being used on the sixth floor of the MCC. But he didn't tell Ms. Anderson because, according to Martin, "I didn't think they wanted to know."

More witnesses took the stand. Nancy Needles recounted the saga of Clarissa McClintock, relating the paralegal's anguish and the administration's attempts to punish her. We continued to wait for Fred Foreman, the U.S. attorney. Both defense and prosecution had promised that they would call him.

At 5:15 the air-conditioning went off, and from then on we breathed warm stagnant air. As hours went by, the women's makeup faded; attorneys fanned themselves with documents. For dinner we ate stale potato chips and candy left over from the pressroom Christmas party. Sticky cellophane wrappers accumulated with colored pencil stubs in my black leather juror's chair.

Outside the courtroom, Fred Foreman, the tallest lawyer in the Northern District of Illinois, paced back and forth. He looked like a frightened child waiting to be called before the school principal. When he came into the pressroom searching for scissors to cut a loose thread on his suit, he tried to seem jovial and relaxed.

For three hours he paced between pressroom and courtroom. At 8:15 Barry Elden told the judge that the government had decided not to call Foreman after all. Elden also objected to the defense doing so. Judge Holderman fell silent, while the lawyers stood silently beneath him. For a

long time we sat quietly, trying to guess what the judge would do. It was hard to believe Judge Holderman would let the government win this very important point and forfeit the chance to learn from the highest source how deeply the U.S. Attorney's Office was involved in this scandal; Holderman, who had been so harsh with his former employer, Holderman who had dug so deeply into the mess the El Rukn prosecution had become.

Finally, he denied the defense motion to call Fred Foreman as a witness.

When we returned to the courtroom the next morning, it seemed only a few hours later. Richard Kling was delighted, having just learned that the government had a new secret witness, Mr. Doe. Mr. Doe could testify about the MCC, but the government had a dilemma—it didn't want him seen in public because he would be a witness in several upcoming "public corruption trials."

In the hall high-ranking assistant U.S. attorneys were in urgent conversation with each other and with defense attorneys. Inside the courtroom, lawyers huddled with the judge at a sidebar; Holderman's words came sailing across the room.

"I want to put the witness on the stand.... You should have put a subpoena on the witness yesterday.... This hearing's taken longer than the trial took, and if I order a new trial, that new trial's gonna take longer than these hearings.... I want Mr. Doe on the stand now!"

The lawyers returned to their seats, and Barry Elden, who looked amused, went alone to the podium.

"The United States admits as follows," he read from a piece of paper, "that the person identified as John Doe would testify as follows...."

He read a list of all the illegal acts that John Doe had said he observed on the sixth floor of the MCC: all the transgressions charged by the defendants and then some.

"Inmates regularly received visits from African-American women" and were able to "make physical contact...engaging in sexual conduct was a regular occurrence...up to four times a week."

The inmates were "provided drugs." Eugene Hunter "maintained two to three thousand dollars in a gym shoe," for the purpose of buying drugs.

The list went on about drugs and sex. As for Bill Hogan, the worst Mr.

Doe could say was that he "made efforts to intercede with the warden" regarding inmates' complaints about the food, and "the warden was irritated thereafter with Hogan."

Though the government didn't want him seen yet, John Doe turned out to be Michael Corbett, a crooked sheriff from a suburban town, serving time on corruption charges and for aiding in a murder. I had sketched him many times, most recently in the trial of a businessman who had his young wife killed for having a love affair with a community college professor. Later he wrote a book claiming to solve every Mob murder in recent Chicago history.

On this New Year's Eve as on recent days, Jackie Clay's lawyer and his pretty associate came in and out of the courtroom. Today the government had finally granted Clay immunity. At last we would hear the testimony promised to be so dangerous to the government; we would hear from the man who tried to overturn the El Rukn trials.

Though Clay had been an unimpressive witness in the original trials, his anger now fueled his stories of fellow inmates Harris and Evans and drugs and sex in the MCC.

"I seen him talkin' on the phone," he said of Evans, "snortin' his drug."

He said that he saw Toomba snorting brown powder and once pulling coke out of his sock. Evans, he said, acted like an addict, always "noddin', scratchin', droolin' at the mouth."

He quoted Evans: "'Hope Beverly can come on out here so she can bring me my package!'"

He told of Toomba receiving drugs and Evans banging on the wall of his cell, hollering, "'Give me my part now, man!'"

He quoted Toomba yelling back, "'Wait till the shift changes!'" and then Evans, "'Man, I'm washing up over here—send me some deodorant!'" Clay said that Toomba put Evans's share of the drugs in a deodorant package and gave it to a guard to give to Evans; the guard promptly confiscated it.

Clay testified that in the summer of 1989, Evans told him of having sex in the U.S. attorneys' offices.

Eugene Hunter, too, boasted of having "tabletop sex."

Clay testified that he told Toomba, "'You need to straighten your life out,

you need to stand up on your own. You acting like Bill Hogan your dad!'"

He himself, testified Clay, had tried to tell Hogan about drugs in the MCC back in 1989. "I said, 'Man, these guys over here are dope fiends, man. They slobbering and nodding.... I don't wanna be around this type of atmosphere.'"

Clay on the witness stand began shouting: "I'm not with these guys! They lump us together!"

The defense attorney asked if he had an opinion as to the character and reputation for truthfulness of Mr. Hogan.

"Same as everybody else!" he spit out. "I do not trust him or believe anything that he say!"

Becoming even more agitated, he shouted, "I resent drug fiends.... A sister died in my arms, literally with a needle stuck in her arm!"

His mother and grandmother died of narcotics, too, and now he swore on their graves. Like an avenging angel glowering in his dark blue sweat-shirt, the man on the witness stand seemed to be willing the downfall of the system that trapped him. How he hated them all: Evans, Harris, Hunter, Hogan, and Elden.

Had he hated them enough to school Phil Walsh, Mushtaq Malik, and others to lie as Harry Martin had claimed?

No one would probably ever know the whole truth, but listening to him testify, it did seem that Jackie Clay played a leading role in this mess. Toomba turned his cartwheels and sang his songs partly to entertain himself, but Jackie Clay, hearing that the hearings in Chicago were after Hogan, could have been the puppet master who made the other players dance.

Tall, thin, pale, blond, and neat, an ice water man after the bombastic, rumpled African-Americans with their Southern gumbo passions, Bill Hogan was the final witness late in the afternoon of New Year's Eve. His story remained the anticlimactic same—he had not known about the drugs or the drug tests.

He said that Evans's extreme physical difficulties were caused by kidney and other ailments—his symptoms only aped those of a drug addict. He said that several times Evans had almost died, and he blamed Evans's dirty urine tests on medication. According to Hogan, Evans was "extremely

upset that anyone would accuse him of taking drugs."

When Hogan was asked what he thought of Henry Harris's truthfulness, he replied, "My opinion is that Henry Harris is a truthful person."

In those last hours of 1992, the post-trial hearing seemed a postmodernist happening, governed by an illogical logic, turning back in on itself like a computer virus gone mad.

Unlike courtroom proceedings when they are bound by the rules of evidence, discovery, Brady material, and the pretrying of witnesses, this extraordinary hearing kept bursting and spilling out accusations, gossip, and shameful personal secrets. Courtroom rules generally slow proceedings down, and recesses are called for preparation, consideration, and research. This one, in its hurry, was more like real life.

"A menagerie of allegations" Barry Elden called it after they quit on New Year's Eve.

Suddenly, at 5:00 P.M., Judge Holderman had said it must stop.

Perhaps he realized how psychotic it was becoming; perhaps he noticed the little smile that had begun appearing under Barry Elden's pointed nose. Perhaps it was during that long, long pause the night before, when he was trying to decide whether to excuse U.S. Attorney Foreman from testifying after the Justice Department's highest official in Chicago had waited three hours outside the courtroom, that the judge, as he cradled his head in his hands alone on the bench, decided that things had gone too far.

"Happy New Year," he called down in a surprisingly festive way to the exhausted lawyers before he left the bench, and he thanked them all for helping to bring this to a close before the end of the year.

Like his fellow judges Suzanne Conlon and Marvin Aspen, who had also conducted El Rukn post-trial hearings, Judge Holderman took what he had heard under advisement and waited to rule until after the trial of Thomas J. Maloney.

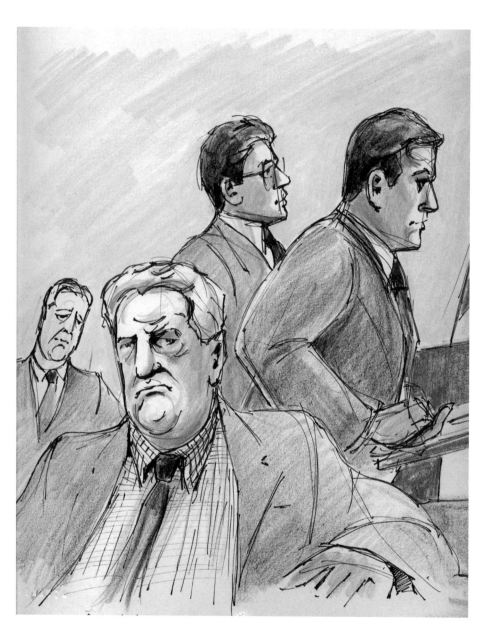

Tom Maloney and Scott Mendelhoff.

<p style="text-align:center">9</p>

THE STAR AND THE ROBE

United States of America v. Thomas J. Maloney
& Robert McGee

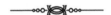

The Past, then, is a constant accumulation of images...
a generous chaos out of which the genius of total recall
can pick anything he pleases.

—Vladimir Nabokov, *Ada*

That mysterious excitement...that comes at the two changes of the year.

—F. Scott Fitzgerald, *The Great Gatsby*

I n the snowy early spring of 1993, the El Rukns, the Mob, the crooked First Ward politicians, and even the inscrutable Chinatown merchants came together in the trial of Thomas J. Maloney and Robert McGee. In a sense there was a third defendant, and that was its chief prosecutor, Assistant U.S. Attorney William Hogan. The post-trial hearings, which had made Hogan himself seem to be on trial, had concluded, but their judges hadn't ruled. Everyone was waiting to see what happened to Tom Maloney, the crown jewel of the El Rukn investigation.

Perhaps because the Maloney trial wove together so many threads of Chicago judicial history, perhaps because I had known almost all its participants for years, this trial seemed special. It seemed a reunion, a culmination, not just for those officially involved, but for me as well.

I knew all the lawyers and the judge. I knew those who testified against Maloney and McGee, and I knew Bill Swano, the star witness. I could have told funny, or poignant, stories about almost any of them. I had drawn them all.

I had also drawn most of the lawyers who played hooky to see Tom Maloney on trial; as I looked behind me in the courtroom, their faces were spotlit by familiarity. I knew all the old gentlemen court buffs, too. I'd gone to their Christmas parties, their cafeteria birthday parties; I'd advised them about buying perfume for their wives. I'd read about myself in their newspaper. I'd been mentioned in it more than once.

For almost 24 years I'd worked with the reporters who covered the trial: Hugh Hill, whose loud voice led me to my job at the Conspiracy 8 trial, and Jim Gibbons, with whom I had worked more than anyone else.

By this time Gibby had been fighting leukemia for four years; he had chemotherapy one afternoon a week, took the next day off, and then would return looking slightly stunned and vulnerable.

It had been ten years since my divorce, 17 since my son was killed. My life in court had grown to cover, if not to fill, the holes gouged by those events.

As for Tom Maloney, I had drawn him when he was a dapper defense lawyer and later when he was an imperious white-haired judge. I drew him when it was rumored he would be indicted in the Greylord investigation, which had targeted corrupt judges, clerks, and lawyers; I drew him after Greylord's statutes of limitation passed, leaving him unscathed but still wondered about.

When the El Rukn investigation's net finally caught him, I drew him during pretrial matters, including the day he tripped and fell in his pin-striped suit trying to punch a cameraman who was chasing him out of the building.

On the first day of his trial, he nodded to me graciously as he shrugged

off his overcoat. He then exclaimed, "You've drawn me as an attorney, as a judge, and now as a defendant!"

The federal indictment of Maloney and McGee charged extortion and bribes by Maloney and his alleged bagman McGee, but as it unfolded the case proved to be about the culture of a part of Chicago itself. In an austere modernist courtroom six floors below where the Conspiracy 8 had been tried, a courtroom of dull colors and flat rectangles, testimony told of that other building to the west: the infamous Criminal Courts Building at 26th and California, baroque, intricate, shadowy, and full of secrets.

In Room 606 of the Criminal Courts Building, Judge Maloney had delineated a sacred circle around himself, not letting lawyers or defendants near the table at the front of his bench. In other 26th Street courtrooms people hung all over that table while the court reporter struggled to catch their words at the edge of it. But in Room 606 heavy chairs for participants were set out away from the bench, and neither artists nor reporters were allowed in the jury box.

Now in federal Judge Harry Leinenweber's courtroom, former judge Tom Maloney sat at the first defense table, never smiling, always dressed in gray and black, writing furiously for seven weeks.

All day March roared in the downtown streets. Snow spiraled between the great steel and glass blocks of the federal buildings. It obscured the windows of the IRS, FBI, ATF, INS, Secret Service, post office, Metropolitan Correctional Center, and Dirksen federal courthouse. Even whiter against dark stone, the flakes whirled around older, fatter edifices at the corners of Adams and Jackson streets, making the Marquette and Monadnock buildings look like fortresses under siege.

All day on the 17th floor of the federal building, the jurors listened to opening statements in *United States v. Thomas. J. Maloney and Robert McGee*.

It had taken two days for the lawyers to pick this jury. When they finished Judge Harry Leinenweber had joked, as he unhooked his robe, "You guys knocked out all the Irishmen!" A federal judge, he presided in a far more relaxed manner than State Court Judge Maloney ever had.

"I know it is snowing outside," said Terry Gillespie when it was his turn to address the jurors in Maloney's defense. He said he knew it was late; he

Tom Maloney and Robert McGee.

asked them to bear with him a little longer. He continued, "Who is on trial here today is Thomas Maloney, this man sitting right here, flesh and blood, a real human being."

But aside from saying that Maloney was 68, was the son of a South Side Irish cop, and had attended the University of Maryland on a boxing scholarship, Gillespie didn't say much that was interesting. The problem was not Gillespie, the hour, or the snowstorm—the problem was Tom Maloney.

During recesses the buffs mingled with the lawyers, reporters, and artists, smoking, chatting, eavesdropping. The buffs were usually men, but lately there was a woman hanging about. A winter's worth of clothes hung from her tiny frame, and her gray hair, long as a college girl's, hung over the hood of her grimy parka. The buffs ignored her, seemed afraid she might be considered one of them.

The buffs and I knew the first witness, Terry Hake, the hero of

Greylord. When he was an idealistic young assistant state's attorney at 26th Street, Hake had offered himself to the U.S. attorney to pose as a crooked attorney and wear a wire.

In the late '70s he practiced in Branch 66, where the freshest murder and rape cases are casually processed. One after one, the "overnights" are pushed out to stand before an associate judge. For two or three minutes they stand head down, surrounded by deputy sheriffs while the young assistants read grisly narratives from police reports. The judge grants a continuance or hears enough evidence to determine probable cause. There was enough time, however, for Hake to learn that something was wrong.

Hake explained: "In Branch 66 I especially observed...murder and rape cases that weren't being decided on the evidence." He had captured on tape the bribe passing between attorneys and judges and their bagmen, between attorneys and clerks.

Hake continued making recordings of crooked lawyers when he went into private practice; he made 368 recordings in all. During the Greylord trials, we heard days of Hake's tapes, his voice friendly, hesitant: "I want to see you about this," and the bagman answering, "Come and see me when this is over."

Now the government played tapes of Hake plotting with Lucius Robinson, setting up a meeting to pay a bribe. Robinson had been a well-known character at 26th Street, Judge Maurice Pompey's "personal," or personal bailiff. Swaggering about in a fringed cowboy jacket and snakeskin boots, he acted as the judge's chauffeur, chief of security, bodyguard, and bagman.

"If Lucius is in the [jury] box, that means the fix is in," people would say about bench trials, when the judge alone decided.

From the speakers we heard Hake's and Robinson's voices whispering in the vast, echoing stairwell at the Criminal Courts Building.

Behind me Roy, the retired IRS employee who produced the court buffs' newspaper, shared his expertise with his bench mates. "Do you know that Judge Maloney acquitted one of the biggest mobsters in the history of Chicago...Tony Spilotro?"

The bent and grizzled buffs commented in their deaf-men's whispers,

their bunched-up jackets, squashed caps, and noisy little packages from Walgreen's beside them. It was March 8, the fourth day of the trial.

Lucius Robinson slouched deeply into his big sweater as Assistant U.S. Attorney Scott Mendelhoff questioned him. The puffs of hair at the side of his head and goatee had gone white against his brown skin since I'd seen him last.

Mendelhoff: "During the 18 years you worked at the Circuit Court of Cook County, did you ever break the law?"

Robinson: "Yes."

"How did you do this?"

"Taking bribes."

"How many judges did you give bribes to?"

"Three...Pompey, Wayne Olson, Judge Maloney."

Yes, he said, reluctantly, he could identify Judge Maloney in the courtroom. Lucius Robinson wrestled the microphone down as though it were a snake. He seemed to be in pain. He carried bribes to judges from hundreds of lawyers, he said.

Mendelhoff: "Within the Circuit Court of Cook County, was there a slang term for the job you did, carrying money to judges?"

"Bagman," Robinson answered flatly.

The witness around whom the U.S. attorneys had built their case was William Swano, a young lawyer who had defended El Rukns. It was he who had procured the police reports containing the name of the witness to the Mouse Smith killing, whose sister, Rowena James, they had mistakenly killed. Swano, a codefendant in the Maloney indictment, had pleaded guilty and agreed to testify against Maloney and McGee. Now Scott Mendelhoff had Robinson introduce Swano into the narrative as he had had Hake introduce Robinson.

Robinson said he had known Swano since Swano was an assistant public defender at 26th Street. Swano in the '70s had been one of an energetic bunch of young lawyers who partied at Jean's or Febo's and enjoyed their work as much as their play. Most had become successful private attorneys, at least two, judges.

Robinson testified that after Bill Swano went into private practice, he came to see Robinson one day. Swano wanted to know, Robinson said, "if I could talk to Judge Maloney in his behalf."

Lucius went to Maloney, and before long a bribe was arranged. Several hundred dollars of Swano's money, nicely wrapped, was passed between Maloney and Robinson in the cocktail lounge of the old McCormick Inn on South Lake Shore Drive.

Soon after that, Swano told Robinson he didn't need his help with Maloney anymore. When Robinson asked why, Swano said, "McGee."

At that, half the people in the courtroom looked over at the second defense table against the wall, where the pointy-nosed Robert McGee sat with his lawyers, looking as though he was trying not to exist.

On cross-examination, Terry Gillespie insinuated that Robinson was only testifying to save himself more jail time.

Robinson disagreed: "I come in to clear up my conscience about all the lies I told in the grand jury and elsewhere.... Whether I go back to jail or not I feel a lot better."

Lucius did seem to be feeling better, to enjoy sparring with Terry. Often streetwise witnesses relax on cross-examination, as though more comfortable as adversaries than as tattletales. The old twinkle was back, the sense of mischief, of something going on behind closed doors.

Later I was in the elevator with Lucius Robinson and the two lady marshals who were taking him back up to the lockup. "Remember how I always treated you good?" he asked me. "Let you sit in the jury box so you could see?"

On March 11, as snow flurries powdered the Loop again, the lawyers asked to approach the bench.

"They've just notified us that they are going to call a witness I never heard of," complained McGee's attorney, Ronald Neville. "I don't have any 302s or 3500s."

302s are reports of interviews with a witness, and 3500s are other discoverable materials. Scott Mendelhoff answered that neither existed.

Neville: "No paper at all?"

Mendelhoff: "Right."

Judge Leinenweber: "Who is he?"

Mendelhoff: "A woman named Nawracaj."

The reporters held their pens still, wondering how to spell this name.

Mendelhoff: "She is a...."

Judge: "A what?"

Mendelhoff: "A witness."

As the little woman with closely cropped hair walked hesitantly toward the stand, a court buff hissed loudly, "Couldn't be. She's not good looking enough."

Virginia Nawracaj testified nervously that she had known Tom Maloney for 23 years, ever since he was a lawyer for her husband.

"My ex-husband," she corrected herself.

She started "seeing" him, she said, about 22 years ago and continued after she moved to Arizona. Terry Gillespie had said that Maloney was married for 25 years, until his wife died from "the ravages of cancer." These two relationships overlapped.

How she must have hated the way the microphone boomed her timid voice out over the courtroom, over the lawyers, the jurors, the reporters, the curious spectators who thought she wasn't good looking enough to be Tom Maloney's mistress—over Tom Maloney himself, who sat writing furiously, not looking at her.

When his turn came, Terry Gillespie strode toward the witness with a mixture of outrage and concern.

"May I call you Virginia?" he asked.

Gillespie: "Over that 20 some years, Virginia, [Tom Maloney] has been a friend of yours, isn't that right?"

Virginia: "Yes."

Gillespie: "As a matter of fact, Virginia, over that 21 years he was your only friend for a good many years, isn't that right?"

"Yes, that's pretty right."

"Over that 20 some years—and I don't mean to be disrespectful...you had troubles with drinking, did you not?"

She had a pretty bad drinking problem, she admitted.

"Tom stayed your friend and helped you a little bit through those hard times, didn't he?"

"Yes, he did."

"When nobody else would, right?"

"Right."

"That girl friend," said an old gentleman behind me after she left the

stand. "She was a loser if ever I saw one."

A prosecution, like any dramatic production, has to be planned to hold its audience's interest. Now the government's plan was beginning to be clear: testimony swirled from the furthest periphery down to the important center. Terry Hake had described the whole galaxy of corruption, then introduced Lucius Robinson who introduced Bill Swano, the star witness, and finally defendants McGee and Maloney, who operated deep inside the vortex. The circles would overlap as more important witnesses testified about bigger and bigger bribes in more serious cases.

Virginia Nawracaj belonged to the financial testimony that would come toward the end; she testified about Maloney paying hundreds of dollars of dental bills for her. But taken out of order, she seemed highlighted. Terry Gillespie turned her into a defense witness, a receiver of kindnesses, who made Maloney glow for a time in her dim light.

The government brought in El Rukns Derrick Kees and Earl Hawkins to describe how Jeff Fort had tried to bribe Judge Maloney in a murder case. Two El Rukn murder cases had been assigned to Judge Maloney, and Bill Swano had felt a bribe necessary on only one of them. Jeff Fort had misunderstood which.

Bill Hogan conducted Kees and Hawkins through all the wild El Rukn stories like a veteran maestro who knows the score by heart. His unsmiling poise gave no clue that his immersion in this very subculture might be a fatal flaw. The jurors could not know that some of the convict witnesses had betrayed him by testifying that drugs and sex were rampant at the Metropolitan Correctional Center.

Kees was called as an expert in the El Rukn language who would allow the government to get El Rukn tapes into evidence. This had been Toomba's job in the other trials.

Drawing the smooth dark oval of Kees's head, I missed Toomba, the great chronicler of the El Rukn saga. Toomba had made their sordid adventures sound like pirate tales, like movie cartoons; his narrative gusto had turned crimes into innocent fiction. When Kees described the same events in his passionless voice, they were truly horrible.

Hogan directed Derrick Kees's attention to the vendetta killing of

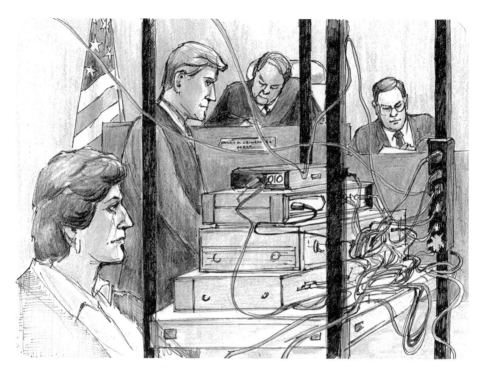

*FBI agent Marie Dyson, William Hogan, and Bill Swano
with tape equipment at Maloney trial.*

Disciple leader Mouse Smith.

Hogan: "Who represented Rudy Bell?"

Kees: "William Swano."

Kees described the El Rukns' efforts to find witnesses and how Bill Swano had procured the police report naming Audriana Thomas.

Kees: "...after they knew who the witness was...they went to look for this person to kill her."

Hogan: "What actually happened?"

"There was a misidentification," said Kees, and he explained how they killed Rowena James instead.

"Her head was blown off."

"How?"

"With a shot gun."

For days the sound of low male voices speaking the gobbledygook of the El Rukn language filled Judge Leinenweber's courtroom. Maloney sat

writing more furiously than ever while trying to riffle through tape transcripts. The jurors had transcripts and translations to read as they listened, so they knew that *robe* meant "judge," *star* meant "money," and *demonstrate* and *manifest* were all-purpose verbs used to describe whatever is already understood to be happening. Over and over, the voices discussed how they would bribe Tom Maloney to acquit Earl Hawkins and Nathson Fields for the murders of Fuddy Smith and Talman Hickman.

The El Rukns were unhappy about Judge Maloney. "He was a notorious guy for giving death penalties," Kees explained.

But Bill Swano had something else in mind.

"They gonna try to do a deal with the Robe through Swano," said Kees, using code words. There would be a "cash money deal for $10,000.... Once we pay the judge, everything going to be all right."

We heard the "legal team's" low excited voices on pay phones telling Jeff Fort what was happening inside Room 606, where Hawkins and Fields were on trial. They told him witnesses could see the El Rukns in the audience watching them.

Then a voice tells Fort, "The robe don't want to demonstrate in that sign. So he [Swano] saying, ah, that didn't go through."

Fort: "It didn't go through?"

Voice: "It didn't go through."

On the tapes of the last day of the murder trial before Maloney, tensions mounted in the voices—the callers talked faster, tripped over words. Voices told Fort that extra deputies had been called into Room 606; two well-known gang specialists, Detectives Brannigan and Kolvitz, had been sighted in the audience.

At 12:02 Alan Knox calls the other El Rukns at the Fort.

"Guilty," he says.

After a long pause, Jeff Fort says, "We could have went with a jury...one man's voice decided the whole thing."

The last tape the government played that day was made Saturday, June 28, 1986. In it the legal team is explaining to Fort that assistant state's attorneys have told Swano the El Rukns have ordered a hit on him. By the end of the conversation, Jeff Fort and his men are discussing the appeal of

Judge Maloney's decision they plan to file. They may ask Alan Dershowitz to handle it.

"This perry, he's the best in the country."

BOOM! BOOM! BOOM! The marching bands thundered down Dearborn Street as shivering people with red noses and green hats watched. Outside the Berghoff Restaurant, matrons in fur coats drank beer from paper cups, sniffling children hung off their fathers' shoulders. The smells of corned beef and alcohol filled the frigid air on Chicago's favorite holiday. At 24 bright and sunny degrees, it was the coldest March 17 anyone remembered.

In the federal building's second-floor cafeteria, some buffs lowered their stiff limbs onto the heating unit next to the windows to watch. *Boom. Boom. Boom.* The high school bands, firemen's bands, military bands, the Sprinkler Fitters' float, the Irish Fellowship float, the WBBM Radio float, the ward floats, the dancing leprechauns—all went by in the street below.

At least half of the people in the courtroom wore touches of green, at least half the jurors and all the Irish lawyers. But Irish Tom Maloney was dressed as always in gray slacks, black-and-white checked shirt, black blazer, and squared-off black knit tie.

Earl Hawkins wore a preppy dress blue shirt and gray V-necked sweater that did nothing to disguise the fact that he was a scary-looking character: muscle-bound, bent, and balding, his eyes close together in dark recesses, and his teeth a jumble inside his mouth. In his deep, gravelly voice he shouted, "Yessir!" when Hogan asked him about his youthful adventures.

He said he was a member of the Bossa Nova Playboys before they joined the Blackstone Rangers; he told of his convictions and incarcerations.

He gave his version of the Mouse Smith killing and of Bill Swano, representing the perpetrators, procuring the police report with the name of the witness on it. He told how he participated in the murder of Rowena James.

He said he was convicted of another murder in 1986 and sentenced to death. From his prison cell he wrote a letter to Chicago Police Sgt. Daniel Brannigan suggesting, "We might could help each other."

He began cooperating.

The next day shards of plastic cups littered the sidewalks around the federal building. While those in Leinenweber's courtroom waited for a late

juror, the buffs spent their time assessing the lawyers. One of them asked if Terry Gillespie was as good as another prominent lawyer.

"Probably better," came the answer.

"Probably better," echoed another.

"In the Infelise trial he got the guy off."

When the juror arrived, Earl Hawkins described how he was there when Nathson Fields killed Black Goon Squad Disciples leader Fuddy Smith after Jeff Fort ordered it from prison.

On April 28, 1984, someone spotted Fuddy "standing by hisself" outside a building, so Hawkins and his men, ski masks rolled over their heads, "was driving our car real slow trying to time it...." when someone else came out, looking to Hawkins like he just "came off the elly vator." The men in the car shot and killed both Fuddy and the other man who was standing near him on the sidewalk.

Hawkins told his version of the aborted bribe. He said he was surprised that when this case was assigned to Maloney, Bill Swano seemed happy about it: "Like Judge Maloney was something good."

Hawkins: "He was telling me he could work with Judge Maloney...he said the only case he ever lost was an armed robbery where the guy didn't give no money to the judge."

On the third day of his trial, Swano came to Hawkins's cell.

Hawkins: "'Say, I got some bad news...,' he say, 'the judge give me the money back.'...He was saying the case was too hot...someone in the organization had leaked it to the FBI and he didn't want to go through with it no more."

"'A deal's a deal,'" Hawkins quoted himself. "'You got me a bench trial.'"

Hawkins continued, quoting Swano: "'The judge gave me the money back, what can I do?'

"'You better do sompin,'" Hawkins told his lawyer.

Hawkins: "...He was acting scared...he knew he was dealing with Jeff Fort and the El Rukns. His life was on the line.

"...We went back. We were found guilty."

Whenever a case depends on testimony of witnesses promised help by prosecutors, the defense lawyers make much of it. On cross-examination defense lawyer Marc Martin asked Earl Hawkins what sentence a person

can get for murder in state court.

"Lethal injection," said Hawkins slowly, tasting the syllables like lozenges in his mouth.

Martin: "On death row, now, you're basically locked up in a cage, aren't you?"

Hawkins thought a long time. "Basically."

"You can touch both sides with your hands, can't you?"

Hawkins waited—perhaps he was imagining his arms held out on each side: "Yes."

Judge Leinenweber was late after the lunch break and in his usual good mood. He said he heard that people were saying, "Where's the robe, the robe back yet?"

Earl Hawkins, already on the witness stand, thought this was funny and smiled his jack-o'-lantern smile.

Marc Martin asked Hawkins, "You developed a friendship with the paralegal who worked with Mr. Hogan, didn't you?"

Bill Hogan leaped to his feet as though shocked by an electric current. The judge sustained his objection.

Martin: "You got the paralegal's phone number, right?"

Hogan objected again and was sustained again.

It came time for the government to unleash its most dependable weapon, Robert Cooley. Unlike Terry Hake, Cooley hadn't had to pretend to be a crooked lawyer; he had been well connected to the right wrong people from the beginning. What a godsend for the U.S. Attorney's Office when Bob Cooley walked in and offered to wear a wire against his friends and colleagues.

Cooley, brought in by agents, stood stiffly waiting to be sworn. "Sharp as a tack," a buff commented.

"See how he puts his hands," said another, "like he's King Shit."

Cooley described his background: "I knew I would practice in Cook County Court…I knew the judges were corrupt, the lawyers were corrupt…it was part of the system at the time."

He boasted to the jury about his gambling habit; he'd often bet more than a million dollars a week. He used the word *again* again and again.

Cooley had engineered one of the bribes charged against Maloney and McGee—not an El Rukn bribe, but one in which Chinese merchants were involved. This had not been government engineered, like Cooley's bribe of John D'Arco, but a real bribe back in 1981, while Cooley was still a real crook.

Cooley testified that First Ward Alderman Fred Roti had contacted him, when the First Ward encompassed Chinatown.

Scott Mendelhoff put a large photograph on an easel. It was of 100 North LaSalle Street, Counsellors' Row Restaurant—all browns and oranges, leatherette booths, Formica tables, and gleaming brass fixtures. You could almost hear the canned music, the clicking knives and forks, the chewing, muttering, and bursts of raucous laughter.

Cooley identified it as the unofficial headquarters of the First Ward where Alderman Roti and his crony Pat Marcy ate almost every day. "They had a telephone put there specifically for the First Ward…[Marcy] was the First Ward Secretary, [that] was his title."

A reporter had looked it up and found there was no such office as *ward secretary*. But that was how Marcy, one of the most powerful men in Chicago, was always known.

The plotting of the Chinatown bribe took place at this table and in a nearby broom closet.

Cooley explained what Roti had told him one day: "I'd be receiving a call from a Wilson Moy…more or less the unofficial mayor of Chinatown…not to let him know in any way I'm connected to the First Ward."

Pat Marcy was going to fix a case for Wilson Moy, but Wilson Moy shouldn't be told the connection.

After meeting with Moy, Cooley reported to the First Ward table. According to Cooley, "I said, 'Pat, this case is up before Tom Maloney.' He said, 'No, that's no problem. That's been taken care of.'"

Continuing, Cooley said that Roti told him, "'Don't worry about money, money is not a problem with these people."

There had been a shooting in Chinatown, the result of a feud between restaurant owners. A gang called the Ghost Shadows had been fighting another tong.

Cooley testified that people had been brought in from New York and Boston to do the shooting, and a William Chin had been badly wounded.

The shots were fired from the balcony of the On Leong building.

Cooley described the On Leong building with admiration as the head-quarters of a "major gambling organization.... They had like a courtroom in there."

Years before, Jim Gibbons and I had stopped in Chinatown on the way back from 26th and California. After lunch Gibby, who had friends all over the city, asked if I'd like to meet the unofficial mayor of Chinatown. Perhaps he would show us the Chinese Merchants' Association On Leong Building.

We sought out Wilson Moy in an odd-smelling shop crowded with paper fans, figurines, silk and bamboo objects. With exquisite politeness the tiny man took us across the street to the elaborate red and gold building.

As always, there was a sign saying it was closed for business meetings, but Moy had the keys in his pocket.

Moy opened the great doors and bowing, welcomed us into a splendid foyer. We followed him through silent, cool, deserted rooms; we admired elaborate statues, paintings, and birds-of-paradise in enormous urns as he stood by patiently. Upstairs he showed us a courtroom far more impressive than the one we were sitting in now. Here, he explained with great pride, the Chinese people dealt with their community's difficulties. Any word of problems amongst the Chinese need travel no further than the walls of this room.

Even though a judge may be in the middle of conducting a trial, he will still have other bits of business to attend to. On Friday, March 19, before the trial started, Judge Leinenweber swore in as new citizens two swarthy men with the same last name. They stood before him with their hands up; his was raised, too, the light shirtsleeve angling up out of the black robe. In heavy accents they said they would renounce allegiance "to any foreign prince, potentate, state, or sovereignty" and defend the Constitution and laws of the United States against "all enemies foreign and domestic."

As I listened, I wondered if the country in which they had been born would have bothered to prosecute a man like Maloney, and if it did, whether the proceedings would have been as fair.

As they passed the defense table to leave, Maloney's attorneys called

out, "Congratulations!" The older of the two men had tears in his eyes.

The next time Bob Cooley was brought in, he stood waiting with his arms folded, looking down at the courtroom.

A buff whispered: "Oh, I've heard this stuff so many times."

Another buff: "Did you enjoy Hawkins?"

"I heard him so many times."

"Hawkins was good, he talked back to Martin."

Roy, the publisher: "Cooley is the best franchise player.... He's won six in a row."

"He's a nice guy."

"That don't mean anything. Rocky Infelise is a nice guy."

Roy: "There he is, that's his pose, he thinks his shit don't stink...see, 'I'm the Boss.'"

Cooley described how, after seeing the police reports of the shooting, he quoted to Wilson Moy the figure of $100,000 to buy an acquittal for the Ghost Shadows gang. Price agreed on, he filed his appearance in May of 1981 in the case of Lenny Chow, Sik Chin, and Hung Tang, all out on bond.

Mendelhoff: "Who was the judge on the case?"

Cooley: "Judge Tom Maloney."

Almost immediately problems arose in the Ghost Shadows case. Within a week of the first court appearance, the victim died. Wilson Moy worried that bond would be revoked when the charge was upgraded to murder. But Pat Marcy took care of everything, and the defendants remained on bond, even after the case was reindicted.

In August 1981 the case went to trial. The Chinese had paid $10,000 and $90,000 would be forthcoming when there was an acquittal.

Cooley: "Never at any time did I ask about the facts of the case."

On the second day of the trial, the state tried to admit into evidence William Chin's deathbed statement.

Cooley explained why this is an exception to the hearsay rule.

"It is a statement, when given under those circumstances, is assumed to be gospel, assuming a person would not lie when they know they are about to meet their maker. It is allowed in evidence whereas hearsay would not be."

In the hospital William Chin had said that it was Lenny Chow who shot him.

Cooley reported this to Pat Marcy at Counsellors' Row Restaurant. "'Pat, we've got a problem,' I said. 'This judge—it looks like this judge may be allowing in a deathbed statement and if he does, that's it.... It's the same as God Himself coming down and saying that this one person in fact did the shooting." According to Cooley, Marcy told him that he'd "take care of it."

Tom Maloney did, in fact, accept the deathbed statement into evidence, and yet the next day, when the judge announced his decision, it was, as Marcy had predicted, not guilty.

After Cooley had described all the jury needed to know about the Chinatown bribe, Mendelhoff directed his attention to another area. William Swano's name came back into the narrative, as Cooley described a most fortunate coincidence for the government.

Cooley said that he had been informing for the government for four or five months when, out of the blue, he received a phone call from Bill Swano. Swano was not under investigation at the time; the fact that he and Cooley had both defended a murderer named Paul Baker was his reason to call. In a Le Carre–like twist, Paul Baker was himself working undercover for the government, and a sympathetic young agent had tipped Swano off about what Baker was saying.

Swano wanted to show Cooley some documents in which Baker had given damaging information about both of them to the government.

So Cooley, the good snoop, telephoned his own FBI contact, and the agent set him up to tape-record what Swano had to say.

Cooley arranged for Swano to stop by his townhouse one evening. Cooley had put a recorder in his boot—a bad idea, as it turned out, because when he moved, the leather stifled the machine. Cooley and his cat, Sam, welcomed the unsuspecting Swano.

Swano showed Cooley "a whole stack of 302s...reports written by FBI agents."

Cooley: "[Baker] had indicated that both Swano and myself had been doing some illegal things...he indicated he would be willing to work a case against either Swano or myself."

We'd heard Swano's voice before, arguing with the El Rukns, desperate to get the money for the Maloney fix. Now it was gentler, convivial,

worried in a different way. Swano was talking to another young defense lawyer, another crooked one.

Through the squeaking of the boot and the squealing of the cat, we heard that Baker had told the FBI he had given Swano three ounces of cocaine as his fee.

Cooley testified that the next morning he met Swano at 26th Street and Swano withdrew from representing Paul Baker. Cooley was wearing a wire.

Mendelhoff played the tape.

Swano: "I gotta go upstairs before Maloney."

Cooley: "He's not my favorite guy. How do you get along with him?"

There was something inaudible and then we heard Swano say, "He fucked me."

Cooley: "What do you mean, fucked you?"

Swano: "...what's the worse fuck you can have?"

Cooley: "He stole your girl."

Swano: "No, worse than that...takes the money...."

Cooley: "On a case?"

The next answer was again frustratingly inaudible.

Cooley: "You're kidding!"

Swano: "No, no. But I got the money back."

"He took the money on what?" persists Cooley. He wants more specifics for the FBI.

Swano: "...just trust me, it just happened."

Cooley: "...that murder case?"

Swano: "Yeah...he takes the money, finds them guilty and then gives the money back...fucking nightmare.... I mean Maloney and I have been like this for years.... I've always won up there...he's nuts, he's not to be trusted."

"I could have told you that," said Cooley, the tape recorder whirring away in his clothes.

When the tape was over, the transcript books were closed, and everyone's heads were up and looking at the witness again, Scott Mendelhoff began going over what we'd heard. It was important that the jury understood it was Bill Swano and not Bob Cooley, the mole, who first mentioned that Judge Maloney had taken money on a murder case.

Mendelhoff: "At that point you are standing in the hallway... Does anyone walk by?"

Cooley: "Tom Maloney walks right by then."

Mendelhoff: "Can you tell us what look was on his face?"

Cooley: "He had a shocked look. When he turned the corner, and there was Billy and I standing here, he just looked right at both of us, and his eyes like opened, and he then walked down the hall. Billy turned around and saw it and got kind of nervous."

Mendelhoff: "The kind of look that somebody gives when he sees two people who fix cases...."

Lawyers for both Maloney and McGee jumped to their feet, and Judge Leinenweber sustained their objections.

"Some springtime, huh?" one court buff said to another, on Monday, March 22.

Only the buffs and a few other curious people were in the courtroom as Tom Maloney and Robert McGee's trial continued. The television station had me "babysit" the case as long as nothing else was going on, but they didn't send reporters. Though Tom Maloney was one of the few judges in the country tried for bribes in murder cases, they were old, complicated, murder cases; after the Greylord prosecutions, the spectacle of judges on trial had lost its shock appeal.

Nor did many care about the fortunes of Assistant U.S. Attorney Bill Hogan in this hiatus between the end of the post-trial hearings and the three judges ruling on whether the El Rukn convictions would stand.

But on this Monday the government had promised to play a videotape. TV is allowed to air tapes that have been introduced into evidence in federal court, and the tape would be better than sketches or "walking shots" in the lobby. Many TV news decisions depend on the availability of such visuals, and now my station decided to do a package —a real news report with a real reporter. Jim Gibbons joined me on the first bench.

The videotape was made on June 23, 1987, in Bob Cooley's office. It showed Bill Swano seated in front of Cooley's desk while for 16 minutes they discussed Swano's troubles.

Cooley tells Swano what happened when the bribe on the Fields-Hawkins trial fell through.

Cooley: "There were some guys out to whack you.... During the trial

they had agents all around…all around 26th Street…following you, and also following…guys who were actually with guns out there looking to get you…. I mean this thing…when all this stuff does come out, it's supposed to be almost like a book…this thing could make a hell of a movie!…You…damn near got killed…. 'cause these guys, to say they were angry, is an understatement!"

But Swano seems more worried about the federal government.

Swano: "Do you think they're gonna indict me?

Cooley: "Oh…there's no question."

Swano still refuses the bait. "What federal crime has been committed, by me?…if I fixed the case, who did I bribe?…Just, just, ya know, hypothetically."

Cooley: "They have information that you bribed Maloney, period…. Again, being Maloney they know damn well that it's feasible."

Scribbling, Maloney listened as the two voices on the sound track described him: "A strange guy."…"He is nuts."…"The guy's a maniac."…"The guy is a nut."

In spite of his virtuoso acting, Cooley can't get Swano to say on tape that he actually tried to bribe the judge.

Finally, a rueful Swano alludes to all the previous investigations: "You know what pisses me off is I was never in traffic court. I was never in divorce court or any of that shit…. I was never a first-floor hustler…. And then I get caught up in this shit."

With the playing of the videotape, the direct examination of Bob Cooley came to an end. As we recessed for lunch, the reporters told each other that not much in Cooley's direct testimony had implicated Maloney. Though there was plenty of innuendo, not much evidence connected Maloney to a bribe. There might be a connection between Cooley and Marcy, and between Cooley and Swano, but not the final link to Maloney himself.

"Swano better be good," the reporters agreed. "Swano better be good."

For days the fog had been playing in the tops of buildings, rearranging the skyline, obscuring the Mies van der Rohe rectangles, silhouetting lower, more fanciful edifices—a turret here and a tower there. From the bus windows I saw

that the fog had been designing new alleyscapes; a bit of light would pick out a cluster of glistening cables on a pole then, as lovingly as an artist, follow them as they arched back into the mist.

In the spring fog the occupants of the Dirksen Federal Building went about their business of reinforcing law and order. In Room 1719 Robert McGee's lawyer peered over his spectacles at an FBI agent; he questioned her about a thick stack of records of phone calls one by one, on and on. The juror in the back row, who used to be a waitress at Jean's near 26th Street, appeared asleep on her hand. The prosecutors seemed to be teasing. Ever since Bob Cooley left the stand, they'd been putting on boring witnesses who, like warm-up comics, were not the star we had come to see.

Finally, Mendelhoff left, presumably to fetch William Swano, and the courtroom hushed. Some turned toward the main doors like wedding guests expecting the bride, but Bill Swano, as Cooley had, came in from the back.

He was older and plumper than I'd remembered him, but still I couldn't think of him except as a cheerful friend. When I tried stripping away this connection and really seeing him, the thinning hair combed across the top of his round face made him look like a neck-tied egg.

He seemed nervous. In answer to Hogan's questions, he said he was 46 years old, had been an all-American swimmer and the head of his student council. He had participated in the civil rights movement, had marched for voting rights in Selma, Alabama. He married while in law school in Michigan and then quit to support his family.

Swano: "So we returned to the Chicagoland area."

The testimony entered dangerous territory as Hogan led him to when he left the public defenders office and became a lawyer for the El Rukns. Hogan questioned him about his defense of the murderers of Mouse Smith.

Swano said he had routinely obtained police reports for his clients, police reports that contained names and addresses of witnesses—names like that of Audriana Thomas.

And in this case, did he to it as well?

Swano: "I most likely did."

Did he have any idea what the El Rukns would do with them, asked Hogan.

Swano: "Of course not."

It had been among the most compelling evidence in the El Rukn trials, that of Rowena James's stepfather, mother, and son telling about that rainy morning. They said that when she'd stopped the car at a red light, it had sounded like thunder, the shotgun crash that shattered the window and crumpled Rowena across the steering wheel.

The questioning turned to Lucius Robinson.

Swano: "Lucius Robinson had a reputation as a bagman for Judge Pompey."

He told how Lucius came up to him when he defended a case of date rape in front of Pompey.

"He asked me if I wanted some insurance.... I asked him how much the premium was.... [He said] two hundred dollars.... I told him I'd meet him in the hallway."

As I drew I seemed to see the image of Swano's younger self, calling hello in the crowded Criminal Courts Building corridor. He always called hello, even from far away, so that on my way to the elevators, I could turn and pick out his smiling face from the throng.

Swano became less and less nervous as he testified; when he got to the first mention of Maloney, he was a strong and articulate informer.

In 1980, he said, he had two cases at 26th Street. One was a motion to suppress evidence in front of Judge Maloney; the other was a murder case before Pompey. One day Lucius Robinson came up to him in Pompey's courtroom.

Swano: "He said that he could work with Judge Maloney.... I was surprised. I said, 'I find that hard to believe.'"

Maloney had a reputation for being "stern, a heavy sentencer, state oriented."

But Pompey's bagman insisted, and Swano arranged to provide police reports so that the judge could acquaint himself with the facts.

When Robinson told Swano the price, "I told him I would like to hear it from the horse's mouth.... I was suspect of Lucius because Maloney was so state oriented.... He said he'd set it up."

They went up to Room 606 and, according to Swano, "Maloney met me outside the back courtroom door."

Swano quoted what he said to Maloney: "Lucius tells me you can help with this case, is that right?"

Maloney gestured toward Robinson. "He said, 'He's my guy—deal with him.... I gave Lucius an envelope with $2,000 in it...[while] Maloney was still there."

In June of 1971 Judge Maloney found Swano's client not guilty in a stipulated bench trial where both sides agreed to the evidence and no witnesses were called.

After that Swano said he fixed another felony case with Maloney and was about to fix a murder when Robert McGee approached him.

Swano: "He asked me if he could talk to me out in the hallway."

Now from the furthest defense table, Bob McGee looked as though he were trying to kill Swano with his eyes.

Swano: "He said he knew I had been working with Lucius Robinson on cases with Maloney.... [He said that] Judge Maloney wanted him to work with me...the judge thought that Lucius was too hot.... I was happy, I was more comfortable dealing with a lawyer."

McGee told Swano that Judge Maloney had reviewed the police reports and there was no way the judge could find the defendant not guilty; the best he could do was find him guilty of voluntary manslaughter and sentence him to nine years. It would cost between $4,000 and $5,000.

"He was a friendly sort of guy," said Swano of his former colleague McGee; he could have been describing his former self.

Swano said that he gave McGee the money at a restaurant opposite the Daley Center.

Hogan had Swano describe his situation after he separated in 1980 from his wife, Cheryl. Swano twitched when he had to say "Cheryl." He said that he "had a town house in the De Paul [University] area," and that his social life was "pretty intense...going out for dinner, partying...."

He had begun using cocaine in 1975, maybe three times a month but only when drinking. "I played pretty hard...," he said.

Swano testified that he had an aggravated assault case where he was convinced the man was innocent; even the victim wasn't sure who the perpetrator was. He didn't offer to pay Judge Maloney a bribe.

"The case was a 'not guilty' in any courtroom in the building."

Judge Maloney found Swano's client guilty of aggravated battery, armed robbery, and other minor charges. He sentenced him to a minimum of six years.

Swano: "After that, I knew that to practice in front of Judge Maloney you had to pay."

Then it was Swano's turn to tell his version of the story that Kees and Hawkins had told, the story of the aborted El Rukn fix.

William Swano had represented Earl Hawkins when Swano was a public defender. Now, as a private attorney, he was contacted by the El Rukns to defend him in both the Talman Hickman–Fuddy Smith case (the revenge shooting at the housing project) and the Joe White–Dee Eggers Vaughn case. In the White-Vaughn murders the drug dealers' children had watched from a closet as Hawkins and Anthony Sumner hacked and shot their parents to death. Anthony Sumner was the first of the El Rukn generals to flip, and he had told the police everything.

Earl Hawkins wasn't the only common denominator in the cases; both were assigned to Judge Thomas Maloney.

Swano had told Hawkins, "This isn't so bad; I can work with Judge Maloney."

But Swano also told him he would not get involved unless the El Rukns came up with bribe money. And he wanted Jeff Fort to assign him a trustworthy liaison with the gang.

Swano: "I would not, could not deal with the cast of characters who had been coming to my office.... I found them [the legal team] irresponsible and kind of flaky."

Fort assigned Alan Knox, General GG, to act as the go-between.

The Vaughn-White case, in spite of the fact that Sumner would testify, was weak, said Swano, because the couple's children had identified the wrong men. The Hickman-Smith case was the one that Swano really needed the money for. In January 1986 Swano explained to Alan Knox: "I told him I wasn't going to get involved unless I knew Jeff Fort was going to approve the amount of money that I needed to go ahead...."

"He said, 'No problem.'"

Swano called Bob McGee. "I told him I had a hot case in front of Judge Maloney."

The two lawyers met at a restaurant called Le Bordeaux, which used to be down a dark flight of stairs just off State and Madison. In a warren of little rooms at tables with red-checkered cloths, real Frenchmen served some of the best food in the city.

Swano told McGee, "The judge had screwed me on the last case," but on this one, "I could give him $10,000."

Jeff Fort agreed to pay the bribe, and as the day set for the trial approached, Swano kept expecting Alan Knox to bring the money to his office on Plymouth Court. When Knox finally showed up the night before trial with two other El Rukns but no money, Swano yelled at them, "What are you guys doing, this is being drawn out so long!!??...Now we've jerked the judge around so much that you've jeopardized the bench trial!"

Now he needed $15,000 for the judge, he told them, and $1,000 for the bagman.

Hogan: "Were you rainmaking?" (Meaning, was Swano planning to keep some for himself?)

Swano: "They're a ruthless group of killers; if they thought that I'd crossed them, they'd kill me."

Though it was late, the El Rukns directed Swano to come down to the Fort to get the money. Before he started out for 39th and Drexel, he sent someone down to the dark street to see if anyone was watching.

"I had the feeling...either it was just nerves or vibrations...."

Just south of the federal building, Plymouth Court occupies a part of the city whose monolithic grayness reminds one of an older city. In recent years trees had been planted and developers spruced up the graceful old buildings whose offices are popular with small law firms. But except for Binyon's (then the favorite restaurant of lawyers at lunchtime) and the Standard Club (meeting place of the Jewish establishment), Plymouth Court was not a street that lived its life at night.

The street was usually empty at that hour, testified Swano, but when he crossed over to pick up his automobile, he saw an older car parked there with the motor running.

Thirty blocks south, Maumee (a.k.a. Melvin Mayes) and Alan Knox (a.k.a. General GG) were waiting for Swano at the Fort.

"Wherever there's a large transaction of money, there has to be two generals present," he explained.

But still they didn't give him the money.

The next morning Bill Swano found some El Rukns waiting for him outside Maloney's courtroom. Just before court started, they told him that the deal was off.

Swano: "I went nuts."

He called Alan Knox and told him he was coming down to the Fort. He left the courthouse and from his car phone called Maloney's courtroom to tell them he was going to be late.

At the Fort he pleaded with Knox and Mayes.

"I told them that they're blowing the whole thing...their guys are going to go down the tubes!"

Driving fast, he was back by noon at 26th Street for preliminary motions. He told Judge Maloney that his client waived being tried by a jury of his peers, that he would take a bench trial.

Shortly after 1:00 P.M. he met Alan Knox.

"Out by the freight elevator...Alan gave me $10,000...it was fairly thick—four or five inches," so when he put it in a file envelope, he had to "sort of spread it out."

Swano took the awkward envelope to the public defender's office. "I put it in an empty drawer in one of my lawyer friends' desk."

Then he went back and began to try the murder case against Earl Hawkins.

At 6:02 that evening he called Bob McGee, and they arranged to meet at Mayor's Row Restaurant so that he could transfer the El Rukn money to the bagman. At a little table for two, he gave McGee the money. Then Swano went to a pay phone in the restaurant and called his office to see if he had messages. General Omar happened to be on the line, and Swano's assistant put them together. Omar put Alan Knox on and Swano talked to Knox.

In the tape Alan Knox tells the astonished Swano that Fort wants the bribe money returned. Fort had supposed the payment to be for the murder of the drug dealers Vaughn and White. Fort hadn't planned to pay on the Hickman and Smith murder; confused, he had authorized the wrong fix.

We heard Fort join the conversation on the other line with Knox; Swano was talking to Knox, Knox talking to Fort, then Swano again, and back to Fort.

"Trust me!" yells the irritated Swano at Knox, who bore the brunt of each man's anger. They needed the money for the Hickman-Smith case; the other one was easy! Besides, it's too late, he already passed the money.

Swano hangs up in disgust, and Fort orders Knox to call him back. But

the now abandoned pay phone in Mayor's Row Restaurant just rings and rings. Finally, someone unknown picks up the receiver and hangs it up, killing the connection. On the tape we heard a long, long pause as Jeff thinks, and behind him his fellow convicts talk and laugh in Texas.

Swano testified, "I couldn't believe what had transpired the last few days…that he was now telling me they wanted the money back.… I was mentally frazzled."

On the third day of the trial, he had a conversation with McGee in a little room behind Maloney's courtroom: "He told me he had to give the books back that I'd given him the other day.… I said, 'Why?'…He said the state's witnesses were too good.… I was really shocked now with this new turn of events."

Swano was really worried. He had to get Maloney and McGee to keep the money. "If they don't, these guys will kill me!"

On the next day Swano was able to whisper to Judge Maloney during a sidebar.

Now in Judge Leinenweber's courtroom, Prosecutor Hogan walked backward from the podium until he stood next to where Tom Maloney sat glaring at him.

"Did you talk to Judge Maloney?" Hogan asked Swano, pointing in Maloney's face. "What did you say?"

Swano on the witness stand quoted himself: "'We've got an agreement.… You've got to live up to your end of the bargain and I'll live with mine.'"

Judge Maloney whispered back to him, "'Put on your case and we'll see.'"

When the trial was over, Judge Maloney said he would take the case under advisement before deciding.

That night Swano got a call from Bob McGee.

"He told me the judge wasn't going to fix the case.… I didn't even ask…it had been a roller coaster two weeks."

The next day Maloney told him "a lawyer had left a file folder for me and to get the sheriff to get it for me."

But the sheriff knew nothing of a file folder. So Swano knocked on Maloney's door and said, "'I can't find it!'"

"…[Judge Maloney] said, 'Here it is,' and he picked it up off his desk

and gave it to me."

Swano took the envelope with the $10,000 and locked it in his brief-case.

Then he told Hawkins to prepare to be found guilty.

Uncharacteristically, when Maloney came out to announce his decision, he simply declared the defendants guilty with minimum explanation.

As Swano left Maloney's courtroom with the cash in his briefcase, three Chicago Police Gang Crimes officers approached him and his cocounsel.

"I was afraid they were going to arrest me for trying to fix the case," said Swano, but instead they told him that they had it from a reliable source that the El Rukns had a contract out on the defense lawyers.

Swano: "Actually, I was relieved."

Hogan: "You'd rather have a contract by the El Rukns on you?" The jurors laughed.

At the end of his direct examination, Hogan asked Swano about his two marriages and his children. Swano gulped when Hogan asked how old the children were.

"Two and seven," he answered, in a suddenly high voice.

His face turned purple, and his mouth pulled up to one side like a fish on a hook. He took a handkerchief from a pocket and mopped his eyes under his glasses.

When it was his turn to cross-examine, Terry Gillespie attacked.

Gillespie: "Are you composed now, Mr. Swano?"

The usually gentle Gillespie seemed the cruel one. He yelled at Swano about the Rowena James murder: "Were you so devastated that you couldn't go on representing El Rukns?"

Bill Swano had begun his testimony looking neat, polished. His round face had showed little expression, and his answers were crisp and to the point. Under Gillespie's barrage, he slumped in his seat and lost control over his facial expressions. But his answers remained strong.

In spite of, or because of, Terry Gillespie's tough treatment, Swano came across as a good guy who had strayed, a sinner who knew the right course and admired those who trod it. Now he called another 26th Street judge "one of the finest jurists" he ever met and made sure that everyone understood that of all the El Rukn lawyers he'd worked with, he himself was the only dishonest one. He let the jurors know that he supported his

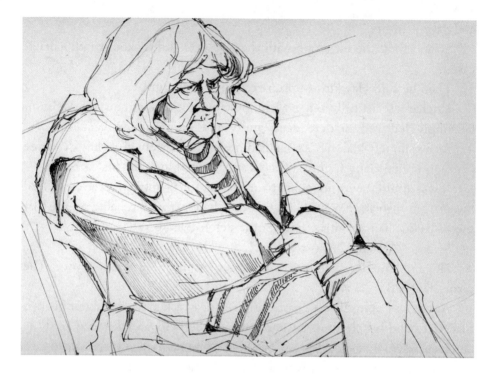

The bag lady at Tom Maloney's trial.

aging parents. He admitted his own peccadilloes without hesitation.

Swano gave direct answers; he refused to show off or decorate his sordid story. At the end he had dragged a little heroism out of the mud. Later Bill Hogan told me that Bill Swano was the best witness he ever worked with.

On Monday, March 29, the city sparkled with clarity at last. High above the buildings jet trails marked the blue sky, blurred, widened, and fell away.

Court began with the lawyers at sidebar. At the edge of the little group Defense Attorney Tom Breen straightened Marc Martin's tie. Martin was a bright young man who had joined one of the best firms in town without making the usual stop at a state or federal office. You could hear the inflections of the older lawyers, his mentors, when he questioned a witness.

One of McGee's lawyers was complaining about "boxes and boxes" of something. The government had just turned over to the defense unexpected

evidence not produced during discovery. Robert McGee's phone records of calls made from his apartment at the time of the El Rukn bribe had surfaced long after they were thought destroyed. A subcontractor of Illinois Bell had produced them.

While they conferred, Maloney's alleged bagman sat miserably alone at his table. Since Swano started testifying, McGee's face had changed from amiable to comically criminal. His dark hair stuck straight up from his face, his eyebrows arched quizzically, and his beaklike nose protruded beneath tired eyes.

The judge ruled that he would allow the government to offer this documentary evidence—times and places of calls made by McGee to Swano. These connections between the bagman and the star witness were what the government badly needed. Hogan, Mendelhoff, and McArthur were thrilled and, using charts with huge numbers and letters, laboriously explained it all to the jury.

You know a case is winding down when the interstate commerce stipulations are read to the jury as Mendelhoff did the next day. These make a criminal case into a proper federal crime because interstate commerce has been involved.

While the lawyers were at a sidebar some of the court buffs made fun of the bag lady who had been watching the trial, pointing at her and chuckling behind her back like naughty little boys. She pulled herself deeper into her layers of different colored clothes and ignored them.

Now Hogan came out of the sidebar and, as the others took their seats, stood in the middle of the courtroom. He seemed to have something caught in his throat. After he'd finished coughing, he held his head in his hand while everyone waited quietly. His cocounsel Diane McArthur got up and touched him gently on the elbow, peering up into his face to see if he was all right. He nodded to her and said, "Your Honor, the government rests."

Judge Maloney's lawyers put on a defense that was anemic at best. People who had worked in Room 606 testified about the strictness of his courtroom. A clerk said that lawyers were not allowed in the back: "It was a rule in all courtrooms but in our courtroom it was enforced."

None saw anything unusual happen with William Swano.

Behind me the bag lady hissed, "Stop it!" at the buffs.

Finally, Judge Leinenweber told the jury, "We will suspend until Tuesday, April 6th," and everyone except for the government attorneys left. As they pushed out their evidence carts, Hogan and Mendelhoff asked reporters, "Well, what do you think?"

Like physicists who have found a new particle exactly where the theory predicted, Mendelhoff and Hogan boasted about the telephone records they had discovered. Illinois Bell destroyed their records much sooner, and they had assumed McGee's were gone. But because McGee's apartment building was part of another system, the government now had corroboration of all the bagman's phone calls at exactly the times Swano remembered them.

Mendelhoff wanted to make sure the press understood; we were a stand-in jury for him.

"I knew the jurors were probably sick of the charts, but I remembered I had to make sure you guys get it, too."

On Tuesday, April 6, Robert McGee took the witness stand. As he left the defense table and walked across the room, I found myself rooting for him, no matter how guilty he was.

Throughout the trial I had run into McGee in the cafeteria getting coffee for defense staff. He always made cheerful little jokes about sketching. Once, on one of those first days of continuances before the trial started, only the two defendants, NBC artist Verna Sadock, and I were in the courtroom. McGee went into the coatroom grimacing with pain and lay down flat on the floor of the big closet. He looked like a business-suited corpse stretched out there, his midsection framed by the open door.

As Maloney was paying no attention to this, Verna and I whispered about what we should do. Finally, I went up to the former judge and asked, "Is Mr. McGee all right?"

Maloney smiled kindly and said that it was only a muscle spasm in McGee's spine; he would be OK.

Before Ronald Neville had gone very far questioning his client, he suddenly asked him, "How do you feel up there?"

"Very, very nervous. I know what's at stake here."

McGee testified how he had first known Tom Maloney as a lawyer "on the other side," when he, McGee, was an assistant state's attorney. Later, in

private practice, he was flattered when Maloney asked him if he wanted to share an office.

"Tom at the time had one of the largest practices in Cook County.... I accepted the offer; it was a fine offer."

He said he had no memory of meeting Swano at the place everyone called LA Bordeaux. To explain his many phone calls with Swano, he said, "He was having some sort of trouble...he needed time...to solve the problem, whatever the problem.

"It was more like, he would call me, leave a message...telephone tag is how people call that...maybe four calls for one conversation."

Neville went over the phone calls with him. Those damn phone records, McGee must have thought.

Neville: "Did you ever discuss fixing a case with Bill Swano?"

McGee: "Never."

Neville went through the cases that McGee had been indicted for fixing, and McGee called out, "No, sir," to each one, strongly and loudly.

Neville: "Were you ever involved in any bribery whatsoever?"

McGee: "No, sir!"

Hogan started his cross gently, like a doctor saving the worst for last.

"You told us you have very little recollection of conversations with Bill Swano, is that correct?"

"They never happened," blurted McGee.

A drawing made of a defendant-witness on direct examination will never accurately depict him on cross. His body speaks a different language when he is answering the questions of an adversary. Now McGee's hands, which had remained calmly in front of him on direct, popped up and waved around.

Again and again he insisted he didn't remember calls and meetings.

Bill Hogan: "Did you [say] that people who had been coming forward [to testify in investigations] weren't getting very good deals?"

Before his lawyers could object, McGee spat out, "Yeah, you people turn on people like snakes!"

On April 7 Tom Maloney told Judge Leinenweber that he would not take the stand in his own defense.

While we waited for court to start again, the *Daily Law Bulletin* reporter asked the court buffs, "Did you guys make a prediction if he's going down or not?"

Roy the editor smiled blissfully and nodded.

"He's going down?"

Roy nodded happily again.

In the last minutes of trial, the massive specter of El Rukn General Toomba, a.k.a. Henry Harris, reappeared. In his rebuttal case, Hogan had called as a witness a paralegal who had taken Clarissa McClintock's place. She told of the long hours she had worked in the last year, "including some weekends," transcribing El Rukn tapes with Derrick Kees.

George Pappas, one of McGee's attorneys, cross-examined her about changes she had made in translations from other trials.

"These tapes were transcribed by another expert witness?" he asked.

She answered that they were.

George Pappas: "Is he an El Rukn?"

Paralegal: "I don't know."

Tom Breen rose from his seat and called from Maloney's table.

"Was Mr. Hogan the prosecutor in those other cases?"

Paralegal: "Yes."

"Do the translations change depending on the witness?" called out Breen.

Hogan objected.

Breen: "They do, don't they?"

"Oh, give me a break!" groaned Hogan and everyone laughed.

Pappas yelled from way across the room: "Is Henry Harris an El Rukn?"

"I believe he was."

Bill Hogan read one last minor stipulation to the jury and with that, the evidence came to a close and both sides rested.

On the first day of closing arguments, Hugh Hill, whom I hadn't worked with for years, blustered into the courtroom, covered with makeup. "Prematurely orange" is how Jim Gibbons used to describe Hugh's hair, which was about as mean as Gibby ever got.

"What's your name?" he roared at me with a familiar twinkle in his eye,

sticking out his hand for me to shake. Lowering himself onto the bench, he boomed in the same loud voice that I'd overheard at the Conspiracy 8 trial, "I don't know anything about this case! I don't know who the prosecutors are, who the defense attorneys are!"

Verna Sadock giggled a friendly greeting as he, calling her Rona, basked in her attention. The three of us reminisced about how most of the court-room artists had begun their careers drawing the two Hoffmans, Judge Julius and Abbie.

Hugh wondered loudly: "How many people from that trial are dead?"

While Scott Mendelhoff summarized the evidence all morning, Hugh Hill in his front-row seat riffled through clippings and wire copy, trying to catch up. Toward the end of the morning, Hugh asked, in a voice that turned nearly every juror's head toward us, "What time does he usually recess?"

After lunch everyone reassembled except for Hugh. Before ordering the jury in, a smiling Judge Leinenweber called to me, "Is Hugh Hill coming back? We'll have to wait for Hugh...."

They didn't wait for Hugh.

Scott Mendelhoff went over the intricacies of the bribes, particularly the complicated Earl Hawkins bribe. He laid it out in chronological order: the phone calls between Swano and the El Rukns, between the El Rukns and Jeff Fort, between Swano and McGee, and between McGee and Maloney. He put in order all the trips to court, to the Fort, to Le Bordeaux, to Mayor's Row. He connected the dots of the bribe being given and then being given back.

He stressed the importance of McGee's phone records. "These records were produced *after* Swano testified," he told the jurors, "...the government couldn't have known about them, Swano couldn't have known about them...those records mesh [with the spoken testimony] exactly."

Maloney had resumed writing; McGee sat staring miserably.

Tom Breen argued for Tom Maloney. Earlier, Breen had represented First Ward Alderman Fred Roti just as Terry Gillespie had represented Jeff Fort. These lawyers talked earnestly and yet in contradiction about the same people, depending on whom they were defending. Now Breen blasted his former client, Fred Roti, and his First Ward pals as "a bunch of politicians getting fat on the action."

He called Cooley "self-authenticating," "self-corroborating," "babbling

Bob Cooley!"

He debunked Swano's youthful civil rights activism. Swano had protested in Selma, Alabama, shouted Breen, but "he marched hand in hand through Woodlawn with...Derrick Kees, with Earl Hawkins...leaving behind death and destruction...."

In the afternoon my assignment desk wanted me in juvenile court; an unwed mother had put her newborn baby in a freezer. (The child, in what my assignment editor called the "Babe-sicle" case, survived.)

Even in the hot, brown corridors of the juvenile courthouse, people were talking about Maloney's trial.

"The trouble with Tom Maloney," said a juvenile court judge, "he was a good defense lawyer and a charming man, and then when he got on the bench he got arrogant."

Hogan was addressing the jury when I returned late in the afternoon. Unlike Breen, he stayed stiffly in place at the podium and hardly raised his voice.

He told how when Bill Swano was indicted, "It made Bill Swano change his life radically...when that indictment came to him he decided to change.... He told the truth about Maloney and McGee, he told the truth about himself...and some of that wasn't pleasant."

He referred to the government's lucky break of finding McGee's phone records and how they corroborated Swano.

"The night before at midnight...on the 19th, you can reasonably conclude that Tom Maloney called Bob McGee and told him to call the fix off.... He, just as Bill Swano did, picked up on the surveillance."

Hogan turned to Maloney: "Tom Maloney, you disgraced yourself."

Hogan walked toward Maloney as Maloney stared back.

Hogan turned to the jury: "Your verdict can tell Tom Maloney that...he is foul...that he is despicable...he is a hypocrite of the worst sort!

"Find both Thomas Maloney and Bob McGee guilty!"

"Members of the jury, the evidence and arguments have now been completed," Judge Leinenweber read on the morning of the third day of the seventh week of the trial. He intoned the familiar phrases to an almost empty courtroom; no one wants to sit through jury instructions who

doesn't have to.

"You are the sole judges of the credibility of the witnesses...."

Robert McGee looked worse than ever. Even his nose looked guilty. He kept trying to arrange his features in a neutral configuration and only made them worse. He had begun the trial as a nice, friendly looking guy; now he'd make you want to cross the street to avoid him.

Wanting a close-up of McGee, I moved across the aisle and sat behind Maloney. He turned and gave me a wan smile.

I strained to see what Maloney could be so busily writing, even after the arguments were finished.

I was shocked to read: "You will receive a copy of the indictment."

Maloney had put this in quotes on the top of his page. Underneath he had rows of numbers and pieces of sentences. He was taking down the instructions; he could easily have obtained a printed copy. Perhaps, as he sat exposed to brutal scrutiny, this note taking had been a way of keeping himself together, of his face avoiding the fate of McGee's.

April, that moody adolescent, was pretending to be November. The federal building seemed alone in the fog, the city gone.

The jury "stakeout," as the TV people call it, began in earnest on Thursday, the 15th. For two days I waited, either on the scratchy blue press-room couch or in a seat in the empty courtroom's jury box.

A jury stakeout is an odd time. The familiar routine of the trial over, there is nothing to listen to or draw; yet I am still tethered to the court-room. The TV station likes me to give advance notice that a verdict has been reached. And I am good at it, snooping around, watching and eavesdropping. I sometimes find out before the attorneys.

Knowing that any minute emptiness can explode into frenzy makes the idle days exhausting, and it is difficult to read. But it's a good time to think, and the Maloney trial, which seemed a reunion of people and trials, caused a reunion of memories in me.

I considered my life.

I loved my job. It combined a favorite hobby with the indulgence of a profound nosiness. No one can live more than one life, but one can live many lives vicariously. And for someone like me, brought up in a modest

amount of privilege, the variety and even the scum were invigorating.

I loved working for television. Before the equipment became more efficient and complicated, before the digital age, before computers and videotape and remote capability, it was like putting on a school play every night. In the newsroom, in the studio, people were running, shouting, swearing, bumping into each other and things, sheets of paper everywhere. I was a part of it because I had been in court, knew the story, and could identify the people on film. I worked with cameramen, telling them where to zoom, where to pan on sketches. I sat with editors as their white-gloved hands chopped strips of celluloid, hung them up like prom decorations, whirred images back and forth on a monitor until they found the right frame. I worked with producers, telling them what had transpired in court as they took notes. At times I even directed the director, watching over his shoulder in the control room as the camera moved on my easel-propped sketch: "Go in tight on the guy lower left. Then pan up...." All in "real time," as they say. It's hard to imagine it now, in this day when the sense of cause and effect is hidden deep within the technology, and no one steps outside the limits of his expertise.

I loved working with good reporters like Jim Gibbons and Hugh Hill, but I also loved working alone, being responsible for facts as well as sketches. I scribbled the good quotes on the margins of my sketches, extracted the kernel of news, and judged whether a reporter should be sent. If it was yes, I cajoled participants into waiting after court for the microphone.

And I loved being a courtroom "artist," a strange offshoot of the artist-journalist tradition. Perhaps it began with the cavemen—perhaps the cave artists were reporting about bison. British watercolorists sailed with the Royal Navy to document faraway harbors so the beaches and cliffs could be recognized on the next voyage. Before cameras, artists provided the visuals for newspapers and broadsheets. Before cameras, artists were *necessary*, and when news cameras aren't allowed, they still are.

I've always thought of myself as "reporting" or "recording" as opposed to "making art." I envy the French painter David for the greatest of all quick sketches said to have been done on the spot: Marie Antoinette in the tumbrel on her way to the guillotine.

I wish I could consider myself heir to the great photojournalists like

Robert Capa and Henri Cartier-Bresson. But except for the occasional restraining (Bobby Seale), cane banging (Genson), or fainting (mothers at 26th Street), courtroom artists don't draw the real action. The precipitating act, the decisive moment that a 35mm camera might catch, takes place off-stage. We draw its aftermath: people describing, arguing, listening, and deciding.

I love the language of the court; I love to hear people think on their feet. And though there are still lawyers and judges whose words are a pleasure to hear, I think perhaps the great wordsmiths are gone.

Federal Judge Prentice Marshall was the best.

"Do you have a mouse in your pocket, sir?"

"Why, no, Your Honor!"

"Then why are you using the first-person plural?"

In court I heard all the problems of our times being discussed and received my tourist's education. And I felt fortunate that the vast landscape of the courtroom had kept me from brooding too much on the foreground of my own experiences. It had kept me moderately sane when my world fell apart.

I love drawing, the intimacy of it, the visual knowing of all kinds of people. Through the explorations of my pens, I had come to know the faces and gestures of lawyers, judges, and crooks often better than those of my own family and friends.

Except for my son. I had drawn John often from the time he was a baby. Even as a child, he had grace and strength of character that came through and made his likeness easy to capture.

Now that it was April again, John had been dead for a year longer than he was alive. He had stood and moved as though he owned the earth, and then was killed just at the furthest edge of childhood. I could see him running backward down the sloping meadow looking up, ready to leap for the Frisbee, his hair copper against the sparkling blue bay behind him.

When I was little, summer birthdays like mine were celebrated in my grandmother's house in Maine. We played a game for which my mother and aunt tied colored twine around the upstairs hall. Above the curving stair-case, from drawer handle to doorknob, around the railing and back again,

they fashioned a net like a rainbowed cat's cradle, or a chart with too much data. At the end of each string they tied a gift-wrapped package and let it dangle down between the banisters. Then each starched and white-socked child wound a different colored twine around a cardboard spool until he reached his present.

That children's game seems a perfect metaphor for a life. As I did as a child, I have had to lift and lower my own twine to let others pass under or step over. In the generous chaos of my memory, I can see my bright thread weaving from then to now; taut, then looping, weighed down with knots in places; but identifiable as mine alone, in the tangle of all those people, those events, those stories that have happened since.

A cold wind blew the fog away; in the gerrymandered rectangles between the buildings, clouds smudged the sky, like splotches of Payne's gray on wet paper.

On Friday, April 16, around noon, the Maloney-McGee jury had a question and everyone gathered. The curious press and court buffs weren't allowed to know what it was. After consulting with Judge Leinenweber, Maloney's lawyers went off to Cavanaugh's pub across the street. George Pappas, McGee's attorney, said he would get a Coke and check in later. "They know where to find us."

The buffs were predicting the verdict. "Three o'clock," said one.

"Three forty-five," said another.

I was again alone in the courtroom when an assistant U.S. attorney in shirtsleeves came over to the jury box. He chatted about his colleague Bill Hogan.

As Hogan had prosecuted Maloney and McGee, he may have been fighting for his professional life, but nothing in his demeanor had betrayed the heavy weight upon him.

"He's grace under pressure, believe me!" the lawyer said.

At 2:35 Judge Leinenweber's secretary crossed from one entrance, his clerk from another. Both looked tense. I asked the secretary, "Verdict?"

"Possibly. They need the lawyers again."

The court reporter mouthed the word, "Verdict."

I ran to alert the assignment desk.

Now the bag lady whom the court buffs disliked came in and took a seat. She and I were the only people in the courtroom. Her presence for the first time in days convinced me the jury indeed must have reached a verdict. Only this troll-like little woman would somehow know that *this* was the exact time to come in off the street to Leinenweber's courtroom.

Who was she, anyway—my future self?

At 2:50 the lawyers arrived.

"I think it's a question," said one, pulling off his coat.

"It's a question," said another, heading for chambers.

There was noise in the back, and then the lawyers reentered. The judge's secretary handed Tom Breen a sheet of bright yellow foolscap. It was the brightest color in the room, and he studied it with a worried look while his colleagues looked over his shoulder.

Behind me all the pews were filling with laughing, chatting assistant U.S. attorneys.

More lawyers and press people were arriving out of breath, taking every seat. At 3:30 Tom Maloney appeared, dressed in his usual gray and black. His face contorted as though in pain; he seemed to be frantically giving his lawyers instructions.

At 3:32 Tom Breen called out to Judge Leinenweber, "Your Honor, Defendant Maloney is ready for the verdict."

One of McGee's lawyers said that he was ready, too. I made sure I had three extra sheets of paper in case of an outburst.

After the judge ordered the jury brought in, we waited silently, no one even coughing, all eyes on the open door through which the jurors would come.

Judge Leinenweber read the verdicts quickly. Every count was guilty, every predicate act committed except for one. A couple of times Maloney shook his head as though to disagree; a couple of times he flinched. When the judge got to predicate act four, Tom Breen wheeled his chair beside Maloney's and put his arm not around Maloney but around the back of his chair.

Downstairs in the lobby the reporters and photographers crowded around Bill Hogan, Scott Mendelhoff, and Diane McArthur. Mixed with the

reporters were court buffs, other curious people, and, squeezed in amongst them, resolute in her right to be there, the bag lady who had attended every day of the trial. Tiny, with long gray hair and ragtag clothes, she looked the opposite of Hogan, who seemed to stand apart, regal in his triumph.

I wanted to capture, not for TV but for myself, an image of Bill Hogan, still and victorious, after convicting Judge Maloney and the crooked Chicago courthouse that had been his kingdom.

In a notebook I started to draw Hogan's face, chiseled by the cameras' lights against the rain-dark glass: one long hook for the head, a slanted triangle for the nose. As usual it felt ridiculously insufficient. No matter how accurately I tried to record what was before me, it would always get away and evaporate into the future.

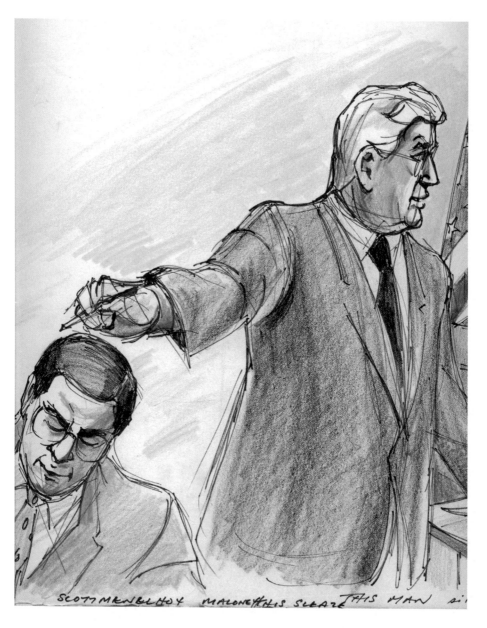

Tom Maloney pointing at Scott Mendelhoff.

10

A SURREAL LANDSCAPE: THE SENTENCING OF THOMAS J. MALONEY

All the world's a stage,
And all the men and women merely players:
They have their exits and their entrances;
And one man in his life plays many parts.

—William Shakespeare, *As You Like It*

O n June 5 Judge James Holderman ruled against the government in the El Rukn post-trial matter. He granted the El Rukn drug dealers' motion for a new trial and threw out their convictions. Hogan's triumph had been superseded.

Matt O'Connor wrote in the *Tribune:*

One of the government's most impressive court victories in recent years, its dismantling of the notorious El Rukn street gang, is threatening to unravel.

In an embarrassing setback for the U.S. Attorney's Office, a federal judge ruled Friday that the government intentionally concealed drug use by imprisoned Rukn

witnesses at one of a series of Rukn trials in 1991 and ordered that the three defendants be retried.

But much more than three convictions is at stake. If other judges agree with U.S. District Judge James Holderman's harsh opinion, dozens of convicted leaders of a gang that prosecutors had likened to Al Capone–era mobsters for sheer violence could ultimately be walking free again.

Concluding that chief Rukn prosecutor William Hogan Jr. covered up drug use by key cooperating witnesses at the Metropolitan Correctional Center, Holderman ordered a retrial for three defendants who were convicted by a jury of supplying kilos of cocaine to the Rukns.

Judge Suzanne Conlon's ruling echoed Judge Holderman's, and on September 20, 1993, Judge Marvin Aspen was the last of the three judges to decide against the government in the El Rukn post-trial matter. He overturned the convictions of his seven El Rukn defendants and ordered new trials for Edgar Cooksey, Charles Green, Sammy Knox, Felix Mayes, Jeff Boyd, Andrew Craig, and Noah Robinson.

In recent years there had been a movement in Illinois to bring the prairie back. On Michigan Avenue that summer small rectangles of silky grasses and wildflowers sprouted on the pavement in front of Crate and Barrel and Saks Fifth Avenue.

At the corner of 39th and Drexel, time and the weather had the same effect. Pale grasses and brilliant wildflowers thrived where the El Rukn Fort once stood. South of the Loop, close to where the White Sox play, across the street from the Ida B. Wells housing project, there was a strange configuration of angled streets with lots full of prairie and garbage, where old structures had been torn down. Here and there abandoned mansions stood aloof in degenerate elegance.

The court activities all year had also seemed surreal. The system had insisted that, on the chance that the rules had not been followed in convicting the El Rukns, three judges had decreed that it was better to start over.

Bill Hogan and Ted Poulos and others had worked hard for the convictions. But the right to a fair trial had remained absolute.

The TV reporter jostled my arm.

"Look who just walked in," he whispered.

The third day of Tom Maloney's sentencing hearing was beginning, and Scott Mendelhoff, hanging onto the podium with both hands, was exclaiming to Judge Leinenweber about Maloney's deceit and evil. Everyone's eyes were on Mendelhoff. The newspaper reporters in the jury box were trying to get as much of the argument down as they could, so they didn't notice the man who was moving sideways toward a seat in the back row. With strawlike hair brushing the open collar of his shirt, he looked sun-bleached, dried out, shipwrecked.

No one in the federal building had seen Bill Hogan for months. The magazine and newspaper articles reported that he was on administrative leave somewhere in the south, spending his time on boats. One said he was thinking of sailing around the world alone.

It was July 21, 1994, more than a year since Tom Maloney had been found guilty. It had been more than a year since Judges James Holderman and Suzanne Conlon, after weeks of hearings, had granted all the El Rukns' post-trial motions for new trials. It was almost a year since Chief Judge Marvin Aspen, after hearings of his own, had also ruled against the government. The Rosenthal memo and the testimony of prisoner witnesses had convinced the three judges that Assistant U.S. Attorney William Hogan had known of drug use and sex by his witnesses, that he had given them special treatment, and that he hadn't disclosed this to the defense. Thus all of the El Rukn prosecutions had been thrown out, all of the defendants, including Noah Robinson, would be granted new trials or plea bargain to lesser charges.

For the last two days, we had been hearing testimony from witnesses in aggravation from the prosecution and mitigation from the defense. Terry Gillespie called the government's witnesses "the vilest of jailhouse creeps."

Vile or not, their stories about Maloney as a crooked lawyer and judge were believable. Now that the jury had done its job and was long gone, the government (before the Booker decision) was allowed to bring in evidence

in aggravation that might not rise to the standard of reasonable doubt. They could bring in evidence about Tom Maloney's deep connections to the Mob.

Witnesses testified about the Tony Spilotro fix and about the Harry Aleman fix. Judge Leinenweber ruled that the main witness for the Spilotro fix was "insufficiently reliable" and it would be unfair for him to consider it.

The evidence about the Aleman case, however, he allowed.

When the witnesses were finished, Judge Leinenweber informed Tom Maloney that he might speak in allocution.

Maloney strode to the podium with a sheath of papers in his hand. Perhaps he would finally show something of himself.

"On my farm with my wife and my son. That's how I live my life...away from sleaze and slime...," he began, waving a white ballpoint pen.

Tom Breen got up and put a cup of water on the podium for him.

"...not with D'Arco, not with Marcy, not with Roti.... I've never had anything to *do* with them!" he shouted.

The speech went on for more than an hour. In his stentorian voice, he attacked all the charges in the indictment. He explained in a long and convoluted way that none of it could have happened. He gave intricate reasons for every bit of testimony against him. The carefully thought-out arguments were the reasoning of a madman.

Maloney harangued against "the diabolical fiend Hogan," who he could not know was listening.

He pointed to Scott Mendelhoff. "By the way, *this* man sitting here smirking was a fit partner for Hogan!"

Bill Hogan had almost disappeared in the back row amidst the court buffs; it was as though they were shielding him from Maloney.

"In 1976 my wife died after her third cancer operation," Maloney was saying. "Even Marin here knows that!"

Carol Marin, the local anchorwoman who had reported on Maloney, the El Rukns, and the Mob, and who was an expert on all of them, was sitting with the rest of us in the jury box.

"Marin...the bag lady of television!" he snarled.

As he spoke, the doors to the courtroom opened and Maloney's real bag lady, who had attended almost every day of the trial, came in. The little woman's long gray hair fell over a dark velvet jacket; she looked almost elegant.

Maloney went on attacking Marin, accusing her of being the government's leak, accusing her of prejudicing the jury pool because she "had her cameras film me coming into the courthouse...22 times she showed that film!"

"She stayed on the case and she's still on it...and evidently she's deteriorating along with it!"

Hearing this, Terry Gillespie put his head down on the table.

After at least an hour and a half of Maloney's ranting, Judge Leinenweber said, "I hate to interrupt, but we're not going to retry the case."

Maloney, undeterred, continued. It distressed him, he said, because, "never in my life I've had to look to others...."

He talked of pursuing this case for the rest of his life. Files would be opened, he threatened.

"It will boil and sizzle and erupt for years! And the longer it does, the worse this fellow Hogan is going to look!"

Then Maloney asked Judge Leinenweber to consider an appeal bond. Maloney, he said about himself, would not be a flight risk; he had never been out of the country.

"I haven't been to most places on this earth."

He was acting as his own attorney now, a defense attorney as in the old days. In a low voice he told the federal judge his health problems, the medications he needed.

Finally, he seemed to have exhausted himself.

"I'm sorry I took so long," he told the judge.

Judge Leinenweber: "We've finally heard your version at length this afternoon...[it was] too little and too late."

"I personally agree 100 percent with that jury verdict," he went on.

Judge Leinenweber sentenced Tom Maloney to 15 years and nine months in custody and ordered him to pay a $200,000 fine.

As Leinenweber pronounced the sentence, the bag lady hissed at the court buffs.

The judge said he would not allow an appeal bond and ordered Maloney to be taken into custody.

"We'll stand adjourned," he said, leaving the room quickly.

The deputy marshals had risen to their feet but were standing back, politely waiting. Maloney's friends and relatives gathered around him; one

by one he shook their hands or embraced them. They looked like mourners at a funeral.

A young man in coat and tie came from the back row. He stood at the end of the line of people waiting to say good-bye. When Maloney got to him, the young man embraced him awkwardly.

Later someone told me that Tom Maloney's illegitimate son, Thomas Maloney Jr., had come to wish his father well.

When everyone had finished hugging and shaking hands, Maloney turned to the marshals and they opened the door to the lockup for him.

Thus Thomas Maloney, who had been a lawyer, a judge, and a defendant, now left Judge Leinenweber's courtroom a federal prisoner.

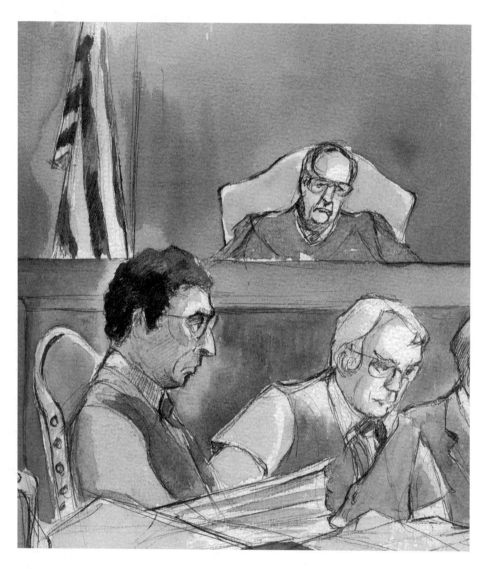

Harry Aleman at his 1977 murder trial.

11

AN ENIGMA

The People of the State of Illinois v. Harry Aleman

*For always our villains have hearts of gold, and all our
heroes are slightly tainted.*

—Nelson Algren, *Chicago: City on the Make*

In one of the ponderous old courtrooms on the fifth floor of the
Criminal Courts Building I noticed something that startled me and
made me remember. The letters *W-I-L-S-O-N* marched up the backs
of the heavy legs of the chairs around the defense and prosecution tables.
Someone must have painted them there years before the federal Gambat
investigation exposed the entanglements in which Judge Wilson got caught.
Now another judge sat where Frank Wilson once had, and this new judge
had put potted plants on the windowsill. Otherwise, the room looked as it
did the day Judge Wilson acquitted Harry Aleman of murder.

Because Aleman had chosen a bench trial back in May 1977, the press
occupied the jury box. Across from us under the high window sat the
defendant, his swarthy face masked in shadow, his frizzy hair a reverse
penumbra against the light. His slight body seemed to have been made
heavier by the accretion of his reputation, like the surprising weight of the
piece of lead on a fisherman's line or of a bullet held in the hand. People

who watch the Mob have always talked a lot about Harry. They speak of him with a sort of perverse affection, not quite the robust admiration that New Yorkers felt for John Gotti, but something subtler, an acknowledgment that he is our local villain, the most evil person in town.

Though the light was dim, Bobby Lowe, the state's main witness, sat close to us and we could see him well. I believed him as he testified about walking his dog that night he saw Harry Aleman shoot Teamsters' steward Billy Logan dead.

Cross-examination unearthed some minor inconsistencies in his testimony, but they were only the stumblings of memory that occur across a span of time.

Yet the judge, when he returned to his seat after a short recess, said he could not find the defendant guilty beyond a reasonable doubt.

I felt a sort of queasiness of illogic, as though some strange force had thrown cause and effect off their course. Perhaps the gentle white-haired jurist was afraid for members of his family if he found the Mob's top hit man guilty.

Now we know that Robert Cooley was the agent of that force. He paid Wilson $2,500 up front and the rest of his $10,000 after the acquittal. Ensuing investigations have peopled that mystery with familiar characters, such as First Ward Secretary Pat Marcy, Alderman John D'Arco Sr., and former judge Thomas Maloney.

Judge Wilson retired not long after that trial and lived in Arizona until his suicide.

Harry was later found guilty in federal court of home invasion and related charges. He spent the next few years as a cook in a federal penitentiary.

Then just before his coconspirators Rocco Ernest Infelise, Solly DeLaurentis, Bobby Salerno, Louis Marino, and Bobby Bellavia went to trial in 1991 for murder, extortion, gambling, and tax fraud, he pleaded guilty to lesser charges and was sentenced to yet more time.

It was September 22, 1997, the first day of fall, and the autumn section of Vivaldi's *The Four Seasons* played on the radio. The nervous eighth notes accompanied gray and pinkish clouds that streaked the sky over Lake Michigan, as though different weather patterns were arguing to music. After the beguilements of summer, life was about to get serious again. It

was the first day of Harry Aleman's second murder trial for the 1972 killing of Billy Logan.

The week before in the federal building, the court buffs talked about the Harry Aleman retrial. One of them claimed to have known Harry's father. "I was there," he said about the first trial.

"I don't know if you know who Moustache Pete was," the buff told his seat mate. "Harry, see, was the nephew of Moustache Pete; Moustache Pete was Aleman's uncle," he went on. "He was Mexican. Half Mexican and half Italian. One of his jobs was he used to deliver the scratch sheets.

"I got a article at home. According to this article, this is what caused all those investigations. This is the start. Greylord and the others. Wilson, the judge, he killed himself."

"That kind of tells you something," said the other old gentleman, "if he committed suicide."

Later Seymour, the buff who made ceramic paintings and had been on TV with his talking dog, came in chewing loudly as usual. "Where are all the guys at?" he asked. He meant in which courtroom were the other buffs watching a trial.

"I don't know," answered another. "They all died."

He was almost right. The ranks of the buffs had thinned considerably since the Judge Thomas Maloney trial. I had never seen the odd little bag lady again. Of the old men that were left, several said they were going to make the trip out to 26th Street and California Avenue to watch the Aleman trial.

It was dark in Room 400. Judge Michael Toomin had the nicest courtroom in the Criminal Courts Building; it still had the stenciled ceilings and other touches from the old days. But he kept the blinds down and the overhead lamps gave little light. The reporters and artists sat in the jury box facing the windows for the pretrial motions. Harry Aleman and his lawyers standing against the glare might have been cut out of black crepe paper, for all the details we could see.

The colorful Allan Ackerman was no longer Harry's lawyer. People said that this new one, Kevin McNally from Kentucky, got Harry's cousin off death row and the cousin had recommended him.

(A neat and shiny nut-brown little man with courtly good manners,

Cruz would attend every day of the trial. After it was over, he disappeared while hanging Christmas lights on his house. In March 2007 construction crews digging a new sewer in Du Page County discovered his body eight and a half feet down, wrapped in a tarpaulin and a carpet.)

Now Kevin McNally told Judge Toomin he didn't want to be "sucker punched" by some witness mentioning the Mob in front of the jury. The names of the old Mob-connected politicians Pat Marcy and John D'Arco came up, but McNally didn't want the words *Mob*, *Outfit*, or *Syndicate* used. The jury also wouldn't know that Alex Salerno, the young lawyer who was assisting Kevin McNally, was the son of Bobby Salerno, one of the defendants in the Rocco Infelise trial. Bobby Salerno, who owned a store called Fishy Business, was still in prison.

Jim Touhy, one of the older reporters, asked Alex how his old man was doing.

"He's doing good," answered Alex, who helped Terry Gillespie defend the elder Salerno in 1991, and later defended his father in a retrial.

As the prospective jurors filled the courtroom behind us, the CBS artist Marcia Danits and I sat very close to the defense table, very close to Harry Aleman. Sometimes Aleman pretended to be interested in the long speech Judge Toomin was giving about the evolution of the jury system, but mostly he fidgeted and looked around. He was hard to draw.

Aleman's face was small and almost delicate. A very sharp pencil on archival paper might have brought out all its little planes and pockets, but its subtleties eluded my thrashing black marker. His eyes, deep inside dark hollows and shaded further by long eyelashes, were hooded like a snake's, like Bob Cooley's. His lips were a thin tight line under a prominent nose, over a receding chin. His frizzy hair had turned to dirty gray; a prison haircut elongated his head and pushed out a foolish little shelf in back. My own hairdresser used to know him in the old neighborhood.

"They called him Hook," my hairdresser told me, "because of his nose."

Inside the halls and the elevators of the old courthouse, the regulars knew where I was going with my black case. "400, right?" they'd say cheerily.

On the second day, a man in the elevator told everyone that his brother-in-law grew up in the same neighborhood as Harry Aleman. Said Harry was

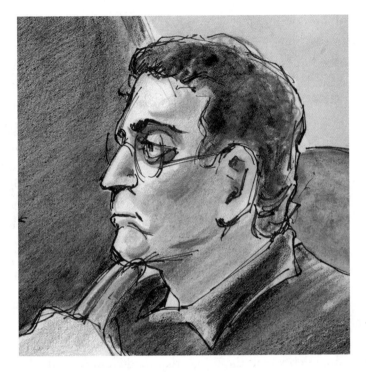

Harry Aleman.

the nicest guy on the block, always had candy for the little kids.

Security was tight. Outside of Toomin's courtroom, we surrendered our press passes in exchange for tags to clip on our lapels. We went through a machine, had our bags searched.

The opening statements of Neil Linehan for the state and Kevin McNally for the defense made an interesting contrast.

Linehan in his Chicago neighborhoods voice told the jurors that the judge in Aleman's first trial had been paid a bribe. "This defendant's trial was a sham!" he shouted, pointing backward at Harry.

He kept repeating the phrase, "This defendant!"

Kevin McNally seemed not to know how to strike the right note with a Chicago jury. He began by standing right next to Aleman and saying, "'This defendant,'" mocking Linehan, "has a name. His name is Harry Aleman."

This was not a good idea. Jurors' memories might be jogged to remember that Harry Aleman was a notorious name in Chicago, synonymous with

contract killings for the Mob.

The sister of the victim, Billy Logan, was the first witness. She told how she rushed outside that early morning in 1972 when she heard gunshots, how she held her bleeding brother in her arms. We learned that Harry was a cousin of Logan's wife. Logan and his wife were in the process of divorcing when Billy was shotgunned to death. When Linehan asked what the status of their divorce was at the time of the killing, Mrs. Betty Romo answered, "Very bad."

This was real news. For 20 years people had assumed that Billy Logan was killed because he was a shop steward for the Teamsters. But now the possibility that the problem was a personal beef, not a union beef, was raised for the first time.

At 3:20 Neil Linehan announced grandly, "At this time the people would call Bob Cooley."

Linehan led Cooley through his usual recitation of bribes made, cases fixed, gambling debts—all the things that made him once the bad guy.

When Linehan asked Cooley to describe the boundaries of the First Ward in those days, Cooley used the possessive pronoun. "We had Taylor Street," he said, "we had Chinatown, we had Greektown...."

Cooley testified that one day John D'Arco Jr. introduced him to First Ward Secretary Pat Marcy, at Counsellors' Row Restaurant.

Marcy wanted to discuss a murder that had happened five years before.

"I have a very important case over at 26th Street," Marcy had said. "Do you have someone who can handle it?"

"These are very dangerous people we're dealing with," he added.

Cooley said that he thought his friend Frank Wilson might be a good judge to bribe.

"He had a daughter in college.... I thought I would be doing him a favor."

Tom Maloney, who was still a defense attorney then, was defending Aleman. The problem was that Maloney had already asked for a substitution of judges (SOJ) from Frank Wilson. Marcy assured Cooley that that could be taken care of; if Wilson accepted the bribe, Marcy would see that the clerks reassigned the case to Wilson.

Cooley described meeting Wilson in the men's room of Greco's, a

Cooley.

restaurant in which Cooley was a partner.

"If you can handle this, there's $10,000 in it for you," Cooley told Wilson. "Think about it. It's very serious."

Wilson agreed to take the case and the bribe as well, but only on the condition that Tom Maloney, who had SOJed Wilson, was replaced by another lawyer. So Cooley paid Wilson $2,500 up front out of his own money.

Now Cooley described the various problems with that long-ago trial. There was trouble with some of the witnesses, and there was Wilson's anger with the way Frank Whelan, the lawyer brought in to replace Tom Maloney, was behaving.

Cooley testified that he was not optimistic. In fact, he was really worried. He decided to leave town. "I was in my car. I heard it on the radio.... My bags were packed. I was ready to go. I heard that the judge had acquitted him; I turned around, went back to Counsellors' Row. Pat Marcy was all smiles."

Marcy handed Cooley two envelopes. The one for Cooley had $3,000

in it, not even enough to cover Cooley's expenses and the initial outlay. The second envelope Cooley took to Frank Wilson.

Cooley: "We went into the bathroom."

Linehan: "What happened then?"

"I gave him the envelope. He opened it.... 'That's all I get?'"

Now Cooley on the witness stand stopped talking. Everyone waited because Cooley seemed to be having difficulty. Was he choking?

"'You destroyed me,'" he finally quoted Wilson. We could barely hear him. "'You killed me,'" I thought I heard him say.

Cooley went on: "Then he turned around and went out."

We all knew what had happened next. In other trials we had heard how, years later, after Cooley reformed, the FBI sent him to Arizona to reminisce with the retired judge while wearing a wire. Wilson did not want to talk about the old days with Bob Cooley; he kept refusing to say anything. After Cooley left, Wilson went out to his patio and shot himself in the head.

At the end of the day, Harry began to get loquacious, a little friendly. From the beginning he had been waving, smiling, and blowing kisses to family members who filled the second row. During a break he started chatting with some of us in the first row. He said something to veteran journalists Jim Touhy and Rob Warden, then to Maurice Possley from the *Tribune*. Then he looked over at me with a smile on his face.

"Verna?" he asked.

Wednesday, September 24, 1997, a glorious day, felt like a reprieve, a postponement of something dreaded.

Driving north on Lake Shore Drive toward I-55, there is a rise near McCormick Place from which you can see the whole city laid out like the backdrop of a gigantic stage set. From one end to the other, all the tall buildings of Chicago—the rectangles, parallelograms, and triangles—stand blue and gray and rust red against the bright blue sky. This day the gentlest blue and gray clouds hung low over the great lake, awash with yet another variation of the same colors.

It was hard on these brilliant days to go into Judge Toomin's gloomy

courtroom, where only the palest stripes of sunlight slid in through the blinds to the plants on the high windowsill.

Kevin McNally cross-examined Cooley all morning, shouting occasionally, suddenly, startling us, trying to get attention. He asked sarcastically, "Is there any way we can tell we're being deceived by you? Do you shake, do you sweat?"

Cooley held his own. He did not sucker punch McNally by mentioning the Mob, but he talked a lot about the First Ward.

In the story Cooley was telling, Tom Maloney was a bit player, but an important one. Years before Maloney was bribed as a judge himself, Maloney was in the business of bribing other judges. As Aleman's initial defense attorney, it was Maloney who started this famous bribe in motion. Then Wilson forced Maloney off the case, made his leaving a condition of taking the case.

Cooley: "Maloney is real upset, because he went to Pat for help and now he's being kicked off."

McNally: "*You* wanted to get rid of Maloney, isn't that right?"

Cooley: "I agreed with the judge [Wilson]. I learned to totally despise this individual after he became a judge."

Cooley seemed less boring than usual. He testified about all the same things he always testified about; he used all the same verbal affectations, the *indicated*s, the *basically*s, the *again*s. Had Cooley himself changed? Had living in hiding these years changed him? His demeanor seemed more compelling in this trial.

Perhaps it was because he'd returned to the scene of the crime—perhaps this had closed some circle for him.

We'd all returned to the scene of the crime. This was the shadowy courthouse at 26th and California, where the big bribes and the little bribes were transacted, where Lucius Robinson and the rest of the bagmen and crooked judges plied their corruption. This building of stairwells and closets, corners and alcoves, and broken-down plumbing was a place where almost anyone could sneak into the back to use the jurors' bathroom or the sheriff's telephone. Even when the corridor door to the back of a courtroom was locked, I could get in. I had knocked on those doors often, when I came early for a good seat or to deliver a sketch that a judge or deputy had bought. Now I remembered my knuckles angling in between the bars, rapping on the cold rough glass, watching as the blurred

silhouette inside solidified, coming forward clanking keys. It was a place where people could hide and whisper, and no one could ever keep track of everything in the mountainous piles of papers and dust. During all my years spent in that building, where I had come to feel quite at home, how little I had known about what went on.

Cooley seemed at home here, too.

When Cooley finished testifying, his equally neat FBI guards took him away, crisp in his navy suit and familiar striped tie.

Minutes later Bobby Lowe in baggy wash pants and long-sleeved knit shirt came in from the back, preceded by his equally casually dressed guards. Lowe was Billy Logan's neighbor and the eyewitness to his killing. He was the witness I'd drawn 20 years earlier in the fixed trial before Judge Wilson.

Bob Cooley was a strong witness, but Bobby Lowe was a powerful one. Assistant State's Attorney Scott Cassidy knew how to use Lowe's anger. Seven times he had Lowe point out and identify Harry Aleman sitting at the defense table under the great windows. Any Chicago lawyer would have stood up and yelled, "Objection! Asked and answered!" but McNally let him do it.

The first time, Cassidy instructed Lowe to come off the witness stand, cross the room until he stood directly in front of the defense table, and point at Harry. The artists hurried to draw the scene; we knew it would be the most important sketch in the trial. It would show a man whose life had been defined, if not ruined, by what he saw that early morning when he took his dog Ginger for a walk; a man who had to give up his familiar life and hide in the Federal Witness Protection Program for years. Here he was pointing again at the murderer whom he saw standing over the bleeding victim a quarter of a century ago. Twenty years ago when he pointed at this same man before in court, it seemed at first that the judge hadn't believed him. And then later Lowe learned he had risked his life to testify against the Mob in front of a bribed judge. In this moment he had his final chance to give some meaning to the mess of his life.

Every day the members of Harry Aleman's family looked over my shoulder to see how I was doing.

"That's not my husband. My husband don't look like that. My husband's good looking!"

Bobby Lowe and Harry Aleman.

"Yeah, that's Grandpa. That's good of him."

"That one's better than the last one."

"Leave her alone, she's doing her best."

"Why don't you put a halo over my husband's head?"

Later in the elevator someone else asked the same question: "Why don't you put a halo over my father's head?"

I didn't like the way I was drawing Harry either. Perhaps being on the first row so near the defense table, I was too close. The details—the long lashes, the edge of the mouth, the slight pouch that had formed beside it—fascinated me and I spent too much time on them. The barely moist outer corner of his eye in profile seemed to be where Harry Aleman was most himself. I sacrificed the structure to the details; I hadn't treated Harry's head as a geometric object. The drawings came out wobbly looking.

As so often happened, I was under the illusion that the outward and visible details would lead me to some explanation of the inner man. For

behind them resided the beloved husband, father, and grandfather who killed in cold blood for a living.

On September 25 the witness Louis Almeida looked like Lenin encased in his tight-fitting suit. But when Almeida opened his mouth, it was the same old monosyllabic Louis, who, when asked his occupation in Aleman's federal home invasion trial, had answered proudly, "I'm a teef."

Jim Gibbons had loved the way he said, "I'm a teef." He thought Almeida the perfect Damon Runyan character, honest about his position in life and somehow naive.

Gibby and I had covered hundreds of trials together, heard thousands of stories together, delighted that our professional lives were peopled with characters like Louis Almeida.

Gibby continued to work for five years after he was diagnosed with leukemia, taking those weekly days off for treatments that seemed to do no good. In the winter of 1994 he decided to go for broke and have the bone marrow transplant that his doctors and he knew would probably kill him. We used to talk about it over coffee in courthouse cafeterias.

"I went out and bought a grave," he said one day. "I didn't want her to have to do it later." It was typical of this kind man that he tried to save his wife some extra agony.

Louis Almeida testified about his part in the murder of Billy Logan. He said that he and Harry went over to Billy's house twice.

"Why did you go over there?"

"To kill him."

"That first time what happened?"

"Nobody come out."

The second time they met at the Survivors' Club, the local mobsters' "social club," at nine in the evening. Then they went to the garage to pick up the "work car."

"What do you mean by 'work car'?" asked the prosecutor.

"It's a high-speed car...fast engine...heavy suspension...phony plates on it."

"Why was it used?"

"To work, you know. It's used to a—to do—a—bad things with it, I imagine."

With Almeida at the wheel, the two assassins circled the Logans' block a couple of times, and then they "seen somebody walking a dog."

At about 11:15 they "seen Billy Logan coming out of the house."

So Almeida pulled the car alongside Billy Logan so Harry "could get a clear shot at him."

When Logan started to walk away, Harry yelled, "Hey, Billy!"

Almeida: "So Harry shot him. He shot him twice. [Billy] just hollered, 'Oh my God!' as he was going backward. He tried to grab the bushes at the same time. Billy Logan was hollering, you know, 'Please call a doctor!' So Harry says, 'Let's go, he's gone.'"

As they drove away, Almeida told Harry to put on his hat so he wouldn't be recognized. But Harry told him, "Don't worry about it."

The prosecution rested on September 25, after reading into the record the 1977 trial testimony from one of Aleman's alibi witnesses. The witness was one of many who said that at the time Logan was killed, Harry was hitting bushels of golf balls with his pals. He said that Harry and his pals often went out to the club to practice their golf swings at midnight.

Because she was a defense witness, Mrs. Phyllis Napoles came in from the back of the courtroom. She walked down the aisle holding her lawyer's hand tightly. Her white hair was poufed in abundant waves around her plump but pretty face; like all the women in the Logan and Aleman families, she obviously spent a lot of time at the beauty salon.

She testified that she was once married to Billy Logan. After she left Logan, who she claims was often "drunk and abusive," she became "intimate" with Butchie Petrocelli.

Butchie asked her to marry him, she testified, but she refused.

"I had a great respect for his dark side."

One day Billy Logan came over when Butchie was there, and the two men had a terrible fight.

Phyllis Napoles.

Napoles: "They struck each other physically. There was a lot of profanity; it was a violent encounter."

Even after they went out in the alley, she could still hear them from the house.

"They threatened to kill each other."

Conveniently for the defense, Butchie Petrocelli was dead. His body was found months after he disappeared one winter; it wasn't until the spring thaw that anyone noticed anything strange about the car. When they looked in the backseat, they saw someone had blowtorched Butchie's face off.

The jury was not to know this; I learned the details from my hairdresser, who grew up around Taylor Street with Harry and Butchie. He told me all this in a loud voice as he wrote the bill for my haircut at the Elizabeth Arden Salon on Michigan Avenue. At the reception desk he paused to point out the scar over his right eye, where Butchie had shot him with a BB gun when they were kids.

Outside the high-rise buildings in my neighborhood, janitors had been exchanging impatiens for chrysanthemums now that autumn was here. In the resurgence of prairie along the railroad tracks and the West Side factory streets, bright yellow ragweed and black-eyed Susans bloomed exuberantly.

We could see through Judge Toomin's courtroom windows that the days were glorious. Behind the silhouetted plants glowed a bright September sky.

The lawyers argued to the jury on September 29. Because every seat was taken, at least 25 people stood, motionless against the walls.

Prosecutor Neal Linehan threw his words around like footballs; they piled up into a kind of eloquence.

Not being allowed to mention the Mob, he shouted about how all these people—Almeida, Harry, and Butchie—were in the Survivors' Club. "They were all in the same group, they were all in the same *group!*"

He kept mentioning the First Ward. He listed the names of the First Ward luminaries.

"Bob Cooley gave you a history lesson of the corruption of the city of Chicago!" he yelled.

"The First Ward is nothing but a swamp!"

He lowered his voice, "Unfortunately, so was this courthouse back in the 1970s."

"Who really destroyed Judge Wilson?" he asked, flinging his arm out and pointing at Harry. "He's sitting right here—his hands folded—couldn't look more complacent. *He* destroyed Judge Wilson."

Linehan was good. His Chicago copper's voice rang true.

Linehan: "I assume most of you are pretty intimidated by this building...."

"That case back in 1977 was a sham!... You have an opportunity to straighten that out.... Think about Bobby Lowe.... He gave up his life.... You have an opportunity to say, 'You can't fix a case in Cook County—you can't get away with murder in Cook County.'...The American system means something, and guys like Harry Aleman can't buy their way out of it!"

McNally's shouting wasn't as effective as Linehan's. "Does it make you hesitate that the *defense* wants to talk about the physical evidence and not the *state*?

"Is there something wrong? Is there something disturbing? Does it make you wonder? Isn't it odd?"

And then, shouting even louder, McNally pointed at someone standing against the wall, someone who hadn't been able to get a seat. Everyone turned to look.

"*That's the man*! I'll never forget his face!'"

Had the ghost of Butchie Petrocelli emerged through the dirty wall of the courtroom to lean there with the others? But it was only one of the detectives who had worked on the case.

McNally turned back to the jurors.

McNally: "[Bobby Lowe] was *told* to say that."

He called the jurors "an American jury," the way Bruce Cutler, John Gotti's lawyer, had when he defended Solly DeLaurentis. Calling a Chicago jury an American jury is something only someone from outside of Chicago would do.

At the break the detective who had been standing against the wall during McNally's argument came up to him and said, "What am I, one of your props?" and clapped McNally good-naturedly on the back.

"I just happened to see you out there," said McNally, laughing with him.

After lunch Scott Cassidy argued in rebuttal. He told the jury not to be fooled by the way Harry Aleman had been acting in the courtroom, "blowing kisses at his family."

Cassidy: "His persona is that of a hit man,"

He talked about an unnamed "they."

Cassidy: "*They* want the city of Chicago to know that *they* run things!"

He wanted the jury to know that there are not two different systems of justice in Cook County.

"The poor kids, the South Side kids [at whose trials] there are no sketch artists... who think there are two systems.... One for them and one for the Harry Alemans, the First Ward people.... I stand here for them, too!

"Justice to you, Billy Logan! Justice to you!" Cassidy shouted, and then he moved over to point at Aleman. "Hey, Harry, justice to you, Harry Aleman, justice to you!"

At 7:40 the family members suddenly came pouring in through the great double doors. They looked grim. "There's a verdict," several of them told the others who had been waiting.

I started to draw Ruth Aleman, who had taken a seat at the edge of the pew across the aisle from me. She sat alone, tense but proud. If there were to be an outburst, it would come from her or from her relatives in that row.

Soon a phalanx of deputies strode in. They took positions all around us, posturing, looking tough, several of them blocking my view of Mrs. Aleman. I drew three of them around her and the revolver of the one whose back was to me.

Judge Toomin, resuming the bench, warned sternly against "displays of emotion." Then we stood as the jurors filed in. A young woman with long brown hair looked as though she had been crying. The foreman handed over the verdict to the deputy, who handed it to Judge Toomin. Toomin pronounced it "in order" and handed it to the clerk, who read it aloud in his automaton's voice.

"We the jury find the defendant, Harry Aleman, guilty as charged."

Perhaps Harry winced a little when he heard the words. Ruth Aleman reached out stiffly to clutch the wrist of the woman next to her.

Ruth Aleman waiting for the verdict.

The men in the Aleman family seemed to be taking it the hardest. In a big huddle, they held each other under the tall windows; some of them seemed to be sobbing.

On the Tuesday before Thanksgiving, Judge Michael Toomin sentenced Harry Aleman. Like so many of the mornings of the trial itself, someone in the elevator, this time a young gum-chewing state's attorney pulling his evidence cart, asked, "400?"

"Today's the big day," he added.

Kevin McNally was back from Kentucky to argue the motions for a new trial. The press sat in the jury box of the shadowy courtroom, with McNally at the lectern to our right and Judge Toomin high on the bench to our left. Small, stern, and expressionless, the judge listened from between his red United States Marines flag and the usual red, white, and blue one. McNally

did a better job talking to the judge than he had to the jury.

After Linehan had countered McNally's points, the judge denied the motions for a new trial. The last and most compelling was the double jeopardy argument. Toomin had previously ruled that it did not apply, because the first trial had been a "sham." The defendant, knowing that his case was fixed, had never been "in jeopardy."

Toomin: "As of this point, no court of review has taken issue with this court's finding as to double jeopardy."

He went on to say that to accept the argument of double jeopardy would be to allow form to triumph over substance.

In the hall downstairs, while a cameraman was shooting my sketches, Aleman's son came up.

"Get any good pictures?" he asked cheerfully.

He was leaving now; he had to get to work. Why should he hang around anyway, "just to see [his] dad get 25 years."

I asked him if he didn't want to testify, and he said, "I'd just tell the judge to go fuck himself."

"That wouldn't help much, would it?"

He laughed and went off to work.

Before the 2004 Booker decision, a judge could hear evidence in "aggravation" in a sentencing hearing that would not meet the standard of "beyond reasonable doubt." The defense is allowed to counter with evidence "in mitigation."

The first two witnesses in aggravation were assistant U.S. attorneys: Gary Shapiro, former head of the Federal Strike Force Against Organized Crime, who had prosecuted Aleman for home invasion; and Mitchell Mars, who had prosecuted Infelise et al.

On cross-examination Kevin McNally asked, "Mr. Aleman has been subjected now for two decades to prosecution by state and federal authorities working in cooperation...for things that happened 20 years ago, isn't that right?"

Shapiro answered calmly that there had in fact been one state matter, followed by two federal and then one state.

Mitchell Mars explained how Aleman had pleaded guilty in 1991 in the Infelise case, to lesser charges of accepting money while on parole from a felon. As in most federal racketeering cases, the indictment had

been complicated; it included charges of extortion, murder, sports wagering, bribery, and tax evasion.

Mars testified that the indictment had originally included the murder of independent bookie Anthony Reitinger, but they had not been certain they could prove it and had not charged Aleman with it.

Mars read from Harry Aleman's plea agreement in the Infelise case: "The defendant admits the following…illegal activities of the Ferriola Street Crew…[control of bookmakers with] violence and the threat of violence."

After Mars and Shapiro, a suburban policeman named Kuskuska testified that on October 31, 1975, when he was 17 years old, he was having lunch at Mama Luna's restaurant. Two men wearing ski masks came in. The one in the flesh-tone mask "produced a shotgun,…walked up to a patron…. He shot him in the head…. He moved the table where the victim lay,…put another round in the gun…[and] shot him again."

When the federal building buffs used to tell the story of Anthony Reitinger's murder, they made you see a scene from a Mafia movie, blood and tomato sauce spattering everywhere.

A wild gray-haired drug felon named Monty Katz took the stand. He said he had been in the same tier at the MCC with Rocky Infelise's gang, that he had roomed with Solly DeLaurentis. Later at Oxford Penitentiary he had gotten to know Harry Aleman when they were both orderlies. Harry was an artist who painted really well, he said. Together he and Harry played ball, cards, and boccie ball, and they cooked together.

Prosecutor: "What did you cook?"

Katz: "Spaghetti."

In October 1993 he said Harry got a phone call telling him he was going to be indicted again for the Logan murder.

Katz: "He was pretty pissed off."

A group of inmates was discussing it over a meal, and "an older guy assured him it was double jeopardy…."

After some further talk about double jeopardy and how good Aleman's lawyer, Allan Ackerman, was, Harry "walked away from the table pretty nonchalantly."

Katz: "I asked him how he beat the case originally…. He had a lawyer named Tom Maloney; Maloney reached out to a fellow named Pat Marcy…and they fixed the case… His uncle paid Pat Marcy and that's how

that come about."

Katz said Aleman told him Gary Shapiro took a personal interest in getting Harry, because Harry had had his childhood friend, Butchie Petrocelli, "flattened." Apparently Petrocelli had been useful to the federal government.

"He was found in the backseat of a car…blowtorched."

In the pressroom at lunchtime, Jim Touhy, who had been writing about Chicago crime for decades, said that Harry had committed 23 murders that he knew about. Touhy, rich with statistics, said there had been 1,035 Mob hits in Cook County and that Aleman was the first in Cook County ever to be found guilty of any of them.

Alex Salerno had cross-examined Kuskuska and now, in the afternoon, he rose to question Monty Katz. Kevin McNally watched him like an anxious coach and every now and then interrupted him with a note or whisper. Alex took it in good grace and didn't allow it to spoil his tempo.

Salerno, during his cross of Katz, listed all the defendants in the Rocco Infelise trial except his own father, Bobby Salerno.

Neil Linehan read into the record a statement from a man named Vince Rizza, who was not able to come from Arizona to testify. Rizza was an ex-Chicago cop and bookmaker closely connected to Harry and the Mob. Linehan read that Anthony Reitinger had refused to pay, had insisted on operating his gambling operation independently. He told Harry Aleman "to go fuck himself."

In return, Harry, according to Rizza's statement, "said he would kill that motherfucker."

Harry and his pals intimidated Reitinger to the point where he actually agreed to join them, but by then Aleman had decided that it was too late.

In his statement, Rizza said, "Aleman told me to forget about it, Reitinger was a dead man."

When the day came, Harry told people not to walk down the street near Mama Luna's restaurant. He also told them, "Watch the news," and

later, "We killed that motherfucker."

When Aleman's lawyers put on witnesses in mitigation, it became Alex Salerno's show. McNally watched from the defense table.

As the afternoon went on it became easier to see in the dark court-room. The glare at the windows dissipated, no longer competing with the dim lights in the ceiling. It was easier to see the many witnesses that came to sit below the judge. I lost count after seven.

They were all friends and relatives of Harry and seemed to adore him. Alex Salerno questioned them, gallantly walking some of the older ladies down the aisle from the hall outside. When those waiting outside were finished, Alex called out to see if anyone else wanted to speak; hands rose in the audience. Harry and his friends looked around and pointed them out; Alex called him or her to the stand. He knew every one by name.

Perhaps the Taylor Street neighborhood would finally explain the enig-ma of the beloved murderer.

"He's a devoted family man," testified Harry's sister-in-law. "Very good husband. I see no wrong with Harry Aleman. Everybody loves him. This man has done no wrong. When is this going to end. I don't understand. I mean, enough is enough...."

Another sister-in-law: "Harry always told kids, 'Always be good, always stay away from crime, always be good.'"

A cousin: "In my opinion he is not the person they're talking about today.... He is caring and loving.... We love him very much in our family and we want him home...."

In the second row one of Billy Logan's sisters began to cry, and her brother put his arm around her.

One old lady was barely audible; the next one shouted: "I've known Harry from the day he was born.... I been his aunt and second mother.... He did very good in school.... Went to the Chicago Academy of Fine Arts.... Very, very respectful and he's a *beautiful* artist!... They were brought up strict, very strict father.... Married a woman with four kids and he raised them.... Very loving.... I couldn't find a better nephew!"

As he helped her down from the witness stand, she said to Alex Salerno, "And I always loved *you*."

Harry Aleman and his lawyer, Kevin McNally.

Neither Neil Linehan nor Scott Cassidy got up to cross-examine until a former son-in-law shouted, "[Harry is] a man of strong family morals, family values; he loves his children and they're his stepchildren.... I would lay my life down for this man.... This courtroom's a sham!"

Scott Cassidy rose to his feet at this. "You know a person named Billy Logan?"

Both Logan sisters were crying now.

The witnesses went on, one after another, outdoing themselves with praise for Harry Aleman: "a gentleman...calm, polite, respectable.... The man is a very good man...wonderful grandfather...."

"Harry doesn't have any DNA going for him; he's just got common people like me and my brother!"

"I love him and he's not the monster he's made out to be. He didn't do it."

One told how Harry had sponsored a hockey team.

Another said people would come in to his grocery store who couldn't pay their bills, and Harry would take money out of his pocket and pay for them. "Boy, if this is a mean person, you've got to prove it by me!"

And there were more.

When they were finally finished, Judge Toomin called Aleman and the lawyers to the bench. He let Alex Salerno argue first. For the first time Alex Salerno seemed to lose his polish; in his beautifully tailored suit and sharply shined shoes, the neighborhood kid didn't know when to stop talking. All those witnesses in mitigation were his friends and relatives, too; now he seemed one of them again, pleading for their old friend Harry.

On and on he went, repeating just what a good guy Harry was; how, he, Alex Salerno was only "about 36," not much older than Harry was in 1972. (I did the math—Alex was John's age.) Harry had paid his debt already, he'd spent 19 of the last 20 years in prison, where he'd been a really good guy, learning seamanship and navigation, taking courses on Principles of Success and Clear Thinking, and doing all that beautiful painting.

Judge Toomin listened patiently and then turned to the state.

Scott Cassidy blustered in indignation: "I ask that he just rot away in that cage!"

Judge Toomin, peering down from the high bench at the slight man in the maroon shirt and gray jacket, asked if Harry Aleman had anything to say.

"Alex said it best [sic] than anybody," answered Aleman, simply.

Judge Toomin: "[Harry Aleman] has forfeited his right to live among civilized people."

He sentenced the defendant to "not less than a hundred or more than three hundred years" in prison.

When the judge left the bench, Harry Aleman stood in the middle of the well of the great courtroom while his family and friends strained toward him, leaning over the backs of the pews, waving, blowing kisses. The deputies allowed him into their midst and the relatives clustered around, weeping, hugging, reaching to touch him.

After all the kissing and hugging, Harry Aleman, with deputies following, walked out of the courtroom to the lockup. As he passed us in the jury box, he raised one hand to smooth the back of his hair, as though concerned that it had become disheveled from so much embracing.

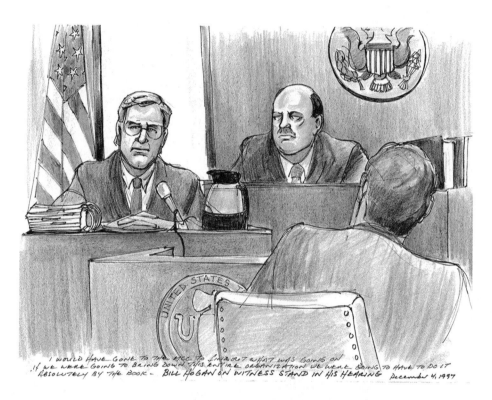

William Hogan on the stand at his own hearing.

12

THE ADMINISTRATIVE APPEAL OF ASSISTANT UNITED STATES ATTORNEY WILLIAM HOGAN

But listen to
the voice of the wind
and the ceaseless message that forms
itself out of silence.
It is murmuring toward you now from
those who died young.

—Rainer Maria Rilke, "The First Elegy," *The Duino Elegies*
(translated by Stephen Mitchell)

November 1997 had magnificent storms. Waves crashed over the rocks, the embankments, the guardrails, onto the Outer Drive; police cars with flashing blue lights blocked the entrances so no cars could travel in the northbound lanes. The surf and winds ripped leaves from the trees; even the leaves of the maple trees, which had lasted longer that autumn than any I could remember, finally lay like yellow shadows under the boughs from which they'd fallen.

Downtown on the 39th floor of the Kluczynski Federal Building, across from the courthouse, William Hogan went to trial. It was an administrative

trial, Hogan's appeal to the U.S. Merit Systems Protection Board of his firing by the Justice Department. Though he hadn't worked as an assistant U.S. attorney for years, he'd been officially dismissed the year before after a lengthy investigation that corroborated the 1993 rulings of Judges Holderman, Conlon, and Aspen. These were the rulings that overturned all the El Rukn convictions and brought disgrace to Chicago's star prosecutor.

In the intervening years, 15 of the El Rukn gang members and their associates either had been retried or had pleaded guilty. Others had been able to negotiate shorter prison terms. Noah Robinson was one of the last to be retried and resentenced.

At Robinson's sentencing the week before, Hogan and some of the El Rukn cops, had hung around outside the courtroom.

"I came to say good-bye to Noah," Hogan said, getting up from the Barcelona chair to shake hands.

Tan, in a black leather jacket, his modishly cut hair now dark ivory, he looked more like a movie actor than a disgraced federal prosecutor.

He said he was looking forward to the Merit Board proceedings. "Finally, after four years we go to trial," he said.

He and his lawyer would have a chance to cross-examine the department's witnesses and call their own for the first time. He mentioned names of some of the 70 witnesses. It sounded like the 1990s employee roster of the Justice Department for the Northern District of Illinois. No prisoner witnesses would be called; there would be no Derrick Kees, no Earl Hawkins, no Toomba.

On the first day of testimony, Bonnie Osler for the Justice Department called the former warden of the MCC to set the stage for the notorious Rosenthal memo. This was the anonymous memo telling of cooperating witnesses' positive drug tests just before the El Rukn indictments that Assistant U.S. Attorney Larry Rosenthal claimed to have shown Bill Hogan.

When it came time for cross-examination, Hogan's lawyer, Shelly Kulwin, charged like a racehorse out of the gate. Kulwin had sat through the El Rukn post-trial hearings that had implicated Hogan, but he'd never had the standing to participate. He had been reined in for so many years that now he kept tripping over himself in anger. Judge Howard Ansorge told him, "Mr. Kulwin, I'm going to caution you not to make wise-ass remarks."

*William Hogan, his lawyer Shelly Kulwin, Larry Rosenthal (center, on stand),
and Judge Howard Ansorage.*

Larry Rosenthal testified in the afternoon. Asked by Osler about his
own work at the Justice Department, he answered, "My recollection is that
I was evaluated as outstanding."

She asked him to explain the Brady and Giglio opinions and what they
mandated about pretrial disclosure of material about witnesses.

"*Any* material should be disclosed," he answered emphatically. "If it
hurts, disclose it."

He was shown a copy of the Rosenthal memo, accompanied by an
acknowledgment that Mr. Rosenthal himself didn't like it being so titled. He
said that he didn't know when in the fall of 1989 he received the document,
who sent it to him, or why.

"I began by asking Mr. Hogan, in substance, if he knew why I had
received this memorandum. He said he did not know. I expressed that I
thought there may be a problem."

Hogan had told him that he did not think so. Hogan said this in a

"forceful and impatient manner which I took to mean that he was eager to return to his work.... He seemed quite impatient with me."

They went through it all again: the dinner in Washington with Michael Shepard, losing the memo, finding the memo in the Albert Tocco file, the possible romantic rivalry of the two young assistants over Kristina Anderson. Only this time, unfamiliar Washington lawyers were asking the questions and an unfamiliar administrative judge in a business suit was listening—passionless functionaries brought in years later to settle a bureaucratic matter.

Outside the 39th-floor windows, the setting sun lit the tops of the tall buildings, turning their south facades an incandescent orange, their windows into jewels, their east sides to dark purple. When the hearing ended, Larry Rosenthal left the room too quickly to share the long wait for an elevator with anyone, certainly not with Hogan.

On November 7 Matt O'Connor's piece in the *Tribune* was headlined HOGAN HEARING LIKE A SOAP OPERA.

> A hearing into the firing of lead El Rukn prosecutor William Hogan Jr. took on overtones of a soap opera Thursday as Hogan's lawyers opened their case with an assault on the reputation of [Larry Rosenthal] his chief accuser.... [Kristina] Anderson, now in private practice, denied on Thursday that she ever had any romantic relationship with Rosenthal, although she said she did have one with Hogan in the early 1990s.
>
> That led Howard Ansorge, an administrative judge for the Merit Systems Protection Board, who is deciding Hogan's appeal on his firing, to quip, "This case has everything."
>
> ...In an attempt to establish a possible bias in favor of Hogan, Bonnie Osler, who is representing the U.S. Justice Department in trying to make Hogan's firing stick, brought out Anderson's later romance with Hogan.
>
> "I haven't thought about or seen Mr. Hogan in some years," said Anderson, who described herself as now happily married to someone else.

In the corridors and elevators of the federal building, people talked

about the proceedings across the street. Many assistant U.S. attorneys had testified for Bill Hogan, as had many former assistants, including Scott Turow. Anton Valukas, once U.S. attorney, had testified, as had many judges. The court buffs agreed that it looked good for Bill.

"The three judges who ruled against him, they never heard these witnesses."

Hogan's former partner Ted Poulos testified. He had grown a lush beard to make up for what he'd lost on top, and he'd become stockier. He looked more Greek and prosperous than before.

Poulos talked about the problems he and Hogan had at the very beginning of the El Rukn prosecution when Judge Aspen severed the trials. The prosecutors had fought hard to keep them together.

On cross-examination Osler asked, "It's fair to say that Mr. Hogan is not the kind of person who wears his emotions on his sleeve, isn't that right?"

Poulos thought about this for a while, a slight smile playing over his face. "I've seen him get angry....

"I guess it depends on what emotions you're talking about...." He paused. "I guess I want to say I've never seen him get mushy.... He kept a stiff upper lip at his daughter's funeral."

Poulos tried to describe to Osler his own feelings about the El Rukn witnesses. "I came to appreciate their personalities," he said thoughtfully.

"I grew up on the South Side," he went on, trying to give his answers some background.

"You learn their stories from the time they were little kids growing up in the ghetto.... After you get to know them and work with them, they are no longer the monsters that I walked into this case believing them to be."

"You liked them, right?" accused the Justice Department's lawyer, not getting Poulos's point. They were all bad guys to her.

"Yes, some of them," answered Poulos. "Henry Harris, for instance, was a likable guy...could have been a leader in society."

On redirect Ted Poulos told Shelly Kulwin, "I can state without any equivocation that Bill is an absolutely truthful person.... I hope Bill is returned to the department. I believe with all my heart that would be justice."

When Bill Hogan took the stand as the last substantive witness in his own

case, Judge Howard Ansorge said, "OK, Mr. Hogan, you know how this goes."

Shelly Kulwin: "Mr. Hogan, how old are you?"

"Forty-six."

Hogan, in a voice barely audible even in the small room, said that he had attended the Holy Cross College in Massachusetts but left when he got married. He'd had two children and gone to Loyola University in Chicago and the University of Illinois at Urbana-Champaign. He majored in history and philosophy.

"I had always wanted to work for the U.S. Attorney's Office."

Hogan's voice strengthened as he testified about the El Rukns: "The state [of Illinois] had been unsuccessful at getting the top of the El Rukn organization," he said. "We were going to cast a wide net...try to get the whole organization."

In 1988 Susan Bogart, another assistant U.S. attorney working on El Rukn investigations, had taken him to the room on the 39th floor of the Kluczynski building near where we now sat.

Hogan: "The walls were full of boxes, floor to ceiling...30 feet long...boxes of documents, information about long-forgotten trials... Susan Bogart...said, 'Well, this is yours. Take it over.'

"We were literally looking at a hundred subjects...600 open murder files."

Hogan testified about his concern for the safety of the families of the men who had turned against their friends.

Anthony Sumner's mother was shot twice. The day Trammell Davis took the stand in the Libyan trial, his mother's apartment was shot at and his two sisters-in-law were shot as they got off the elevator in the Ida B. Wells housing project.

He testified about the Stones' case in state court. "Jeff Fort's trial at 26th Street took all our resources...for example, what did the state need from the federal government to provide to the defendants.... In November of 1988 I finally got some help with this...." And he described how Ted Poulos was brought in on the case and how impressed he had been with Poulos.

"Two days before Christmas, Jackie Clay turned himself in," he went on, all the facts, all the events spilling out of him, all the stories that I had heard so many times.

Kulwin: "Keep your voice up, will you."

Hogan described shuttling the El Rukn prisoner witnesses back and forth

Jeff Fort and Tramell Davis in the 1987 Libyan trial.

across the country, writting them in and out of their places of incarceration (here he turned to explain to the administrative judge that the term *writting* meant getting permission for prisoners to leave briefly to testify), relocating the cooperators' families—constantly involved with, "for lack of a better word, bureaucracy." And all the while, the government lawyers "talking to witnesses, talking to cops, talking to bosses."

Earl Hawkins had told the state that he and Derrick Kees had committed the Bell murder but the wrong guys had been locked up. The state hadn't disclosed that, and this was another problem.

The few reporters in the room had stopped taking notes. All of this was old stuff and it was getting close to their deadlines. The *Sun-Times* reporter looked at his watch. Matt O'Connor of the *Tribune* got up and left.

Hogan described Derrick Kees: "He's an extraordinarily dangerous guy,

if not a little crazy."

Harry Evans, he said, started taking drugs at the age of ten. He committed "murder after murder after murder."

Shelly Kulwin asked Hogan if he thought the cooperating witnesses were ever on drugs.

"I had an extensive history of dealing with people on drugs.... I grew up in the '60s.... I spent thousands of hours with these people.... I am as confident as I am of almost anything that they were not using drugs."

Hogan said he worked hard to find all the Brady and Giglio material to turn over to the defense lawyers, "so there would be no surprises."

Hogan's testimony showed how obsessive he could be. He remembered thousands of facts about crimes, defendants, witnesses, and the baroque bureaucracy in which they were all caught. On the stand before Hogan lay an enormous three-ring notebook stuffed with pages that he hardly ever looked at, his prompter's box, which he didn't really need.

"These [prisoner] witnesses were in many ways the heart of the case.... Each of them was involved in 25 to 30 murders.... There are 20 to 30 members of this organization whose full-time job is shooting.... Your Honor...they would have daily meetings, and I mean *daily* meetings at the Fort.... It was like Jim Jones in Guyana, it was that kind of control!"

He was trying so hard to make this administrative judge understand the panoramic craziness of the El Rukns and their devotion to the charismatic Jeff Fort. Could someone who hadn't heard the stories from the El Rukns' own mouths ever grasp how it had been?

On December 4 Hogan was still on the stand talking about the El Rukns' families. Occasionally, Ms. Osler would object that the questions were leading or irrelevant, but mostly Judge Ansorge let them go.

"Overruled. That isn't remotely leading," he snapped at her once.

Hogan described how he had tried to find housing and work for the various El Rukn wives and girlfriends.

Kulwin asked, "How is that part of the job?"

"Because when you take on responsibility for these witnesses, you take them on full scale.... That is the role of the federal prosecutors and it has been since the time I began to practice."

When cooperators go into the Witness Protection Program, "they have to cut ties to their life, indeed to their family," Hogan went on, as if he had been a gigantic puppet master, moving all these men around, taking them out of harm's way, keeping them apart, making them dance, and, most important, making them sing.

"They had gotten these draconian sentences.... They were uniformly miserable with these plea agreements.... You have to develop a certain level of trust.... You don't take a guy who's been running around the streets all his life, shooting everyone in his path...and turn him into a cooperating witness overnight."

During a break a tall, good-looking young man with curly blond hair came in; he was greeted warmly by two blond women spectators and with a hug from Hogan. The kid made some sort of a joke, and they all laughed. I had never seen Hogan laugh before.

When testimony resumed Kulwin asked the key question yet again. "Did anyone...come to you with information that cooperating witnesses were taking drugs?"

Hogan: "I want to make it clear that I don't have any recollection of any-body—including Larry Rosenthal, *particularly* Larry Rosenthal—coming to me during that week."

Shelly Kulwin asked if Hogan had taken a break in the spring of 1990.

Hogan answered quietly. "In the spring of 1990. Yes.... My daughter became very ill, spent several weeks in the hospital, and died."

Then they got right back to the El Rukns, picking up the tempo.

Hogan: "If we were going to bring down this entire organization, we have to do it absolutely by the book.... When I came back to the office in May, Judge Aspen issued an order that the government had to sever its own indictment."

At lunchtime I rode down in the elevator with Hogan, the two blond ladies, and the kid. Hogan introduced the others as his sisters and his son. Then he asked me, "Am I going on too long? Talking too much?"

I answered that I thought it important for the judge to see the magnitude

of Hogan's involvement in the case.

Hogan agreed: "I think he needs to see it in context."

"We should call you as a witness," he said.

I laughed.

"I was telling some of the buffs we should call them. They sat through all of it."

He was right. The buffs and I had probably spent more time watching the trials and hearings over the last six years than anyone else.

We chatted a little about the crazy post-trial hearings, about the prisoners, many of them murderers, who came from all over the country to testify about whatever they wanted, without the restraint of the rules of evidence and without Hogan being able to cross-examine them.

"It was just bad luck," said Hogan almost cheerfully, as we parted on the post office plaza near the giant red arches of the Calder stabile.

Shelly Kulwin: "Did there come a point in time when a paralegal was assigned to work on the case?"

Hogan: "Yes, there did."

"Who was that?"

"Clarissa McClintock."

They had had to create a new position to work on the voluminous El Rukn case.

Hogan: "Clarissa applied and was hired...overlapping trials...massive amounts of 3500 material...needed to be organized.... She was able to take care of...hundreds of transcripts [of tapes] scattered throughout the U.S. Attorney's Office...."

He described how Henry Harris and Eugene Hunter came from the MCC at 6:00 A.M. every day to the eighth floor of the Dirksen Federal Building and spent hours listening, figuring out what was being said in the bizarre El Rukn language.

Hogan: "I'd decided the only way to put this into literal English was word for word; *uh uh uh uh*, for *uh uh uh uh*."

Kulwin asked if Hogan had discussed with McClintock the El Rukn personalities and what was involved.

"She had a tremendous amount of exposure to the grizzly details,"

Hogan responded. She had seen the pictures of the blood and the bodies. "I explained to her the kind of people they were…that they were extremely dangerous, she should be extremely careful…don't let them know anything about our personal lives."

The worse Hogan made them sound, the more the El Rukns must have intrigued Clarissa McClintock; she certainly wasn't the first person to be intrigued by murderers. Undoubtedly, they opened up for her a secret world, and coming to know these people so different from herself must have thrilled her.

Hogan learned of the infamous Hunter-McClintock phone sex tape when he was called into his supervisor's office on December 19, 1991.

"I sat down, put on a pair of earphones, listened to the tape. I just about threw up all over the table."

Kulwin: "[Had you ever seen] anything that showed she might be capable of doing something like that?"

Hogan: "No…I was just, like, stupefied!"

The U.S. Attorney's Office kept Ms. McClintock on, just for a while, just for specific duties.

Then came the Maloney trial.

Hogan: "I had indicted Judge Maloney with William Swano on June 19, 1991,…a very complicated trial…. We kept indictments sealed for many months out of Sixth Amendment concerns for our defendants…until the El Rukn trials were over…. There were 162 recorded tapes…. [The FBI agent] went to her supervisor [and said], 'We need to listen to these tapes, we need someone who can transcribe them'…[so] they gave 162 tapes to Clarissa McClintock…."

The day that the last of the first round of El Rukn trials started, Clarissa McClintock was called to Judge Holderman's post-trial hearings. I remembered the day well. It was one of the strangest days I had ever spent in court.

"She took the Fifth Amendment… It was *all* over the newspapers!" said Hogan, and he spread his arms out for emphasis.

It was getting late; most of the spectators and all the reporters had left. Hogan rambled on, all of it was important to him: the danger all the witnesses' families were in, how responsible he felt for everybody, the different characters of the various flippers. A medical report said that

Henry Harris was bipolar. He was "wacky," said Hogan. "He wrote letters to people everywhere...."

At 5:45 only the buff known as Bob the Carpenter and I were left in the pews.

Hogan: "Harris was an incredibly polite person."

Kulwin: "What was the relationship between you and the witnesses?"

"A working relationship, except that it has to go beyond that...because of the responsibility for their families.... In my view we never crossed the line except with Clarissa McClintock.... As I said, I was shocked.... *We were not friends ever, ever, ever, ever.*"

Bonnie Osler's petulant cross-examination was interrupted to put Judge Charles Kocoras on the stand; Kocoras obviously cared a lot about Hogan, his former law clerk. Kulwin got Kocoras to tell about his own relationships with turncoat witnesses when he himself was an assistant U.S. attorney.

Kocoras: "[There was] a police sergeant who we believed had become a killer for hire."

Stanley Robinson was the policeman's name; when he was acting as a hit man, he had called himself the Fox. I covered his trial.

Kocoras: "[Witnesses were] former members of the Black Panthers...people you wouldn't necessarily ask to dinner at your home.... The main witness, I spent a lot of time with him...the ones I became close to were naturally the ones who were important to the case...."

He was talking about Willie O'Neal, the chief of security for the Black Panthers on December 4, 1969, the night Fred Hampton and Mark Clark were killed. O'Neal, who later testified that he'd been working for the FBI that night, was now also dead, an alleged suicide.

Kulwin asked if Kocoras had formed an opinion as to Hogan's integrity and honor.

Kocoras: "Yes, I did.... I believe Bill to be a person of unquestioned integrity and honor.

"In my judgment he is without personal blemish."

The small courtroom on the 39th floor of the Kluczynski Building was located between Senator Carol Moseley Braun's office to the east and

Congressman Sidney Yates's to the west. Because the whole north wall is glass, one can look east, north, and slightly west across the whole city. The tops of the tall buildings of the Loop form a great aerial city of spires, lightning rods, weathervanes, roof gardens, terraces, and turrets. Each era's architects differently disguised their elevator apparatuses and water towers; each expressed a different whimsy at the top. The scene is a playground for pigeons and the peregrine falcons recently introduced by ornithologists. I wondered how often CEOs' daydreams, like mine now, danced in this fanciful place.

To the northeast beyond Michigan Avenue, the great lake slumbered, passive and flat.

The testimony about Harry Evans's testing positive for drugs came up again when cross-examination continued. Hogan insisted that Evans's "dirty urine" was the result of drugs he'd taken in conjunction with his dialysis treatments.

On redirect Shelly Kulwin asked Hogan how he knew so much about dialysis.

"My daughter spent three weeks in the hospital," Hogan answered calmly but slowly. "She spent the last week on dialysis. I learned everything I could about dialysis.

"She died on the dialysis machine."

His words jolted my lazy drawing and listening. Death, the ultimate impostor, had broken into Hogan's life and stolen his child as it had once stolen mine. Hogan had been in the midst of fashioning the El Rukn prosecution when it happened, and then after a short period, he had gone back to what he'd been doing before.

I thought of the lovely early spring of 1976, of how the forsythia in the family plot was already in bloom when we buried John in his jeans and beloved leather jacket, of how the freshly flowering, newly green world had seemed a transparent curtain made of mist.

When Channel 7 assigned me to illustrate from police reports the story of a family who had murdered their abusive father, I didn't know if I could still draw.

I spent a long time with the cop in charge of the investigation. The

phone receiver cradled against my collarbone, I asked about the suspects: how tall, how fat, how they wore their hair; about their crime, angles, positions, and every other question I could think to ask. I was afraid to hang up, to disconnect and turn back to a world that was now so empty.

December 1997 was a busy month. The Gresham District police officers, who stole from drug dealers instead of arresting them, were on trial in Judge Norgle's courtroom. Jeremiah Mearday, a black gang member who had his jaw broken as he resisted arrest, appeared in branch courts. The white officers who arrested Mearday fought their suspensions before the police board. A young Hispanic alderman was being tried for bribery as a part of Operation Silver Shovel. The usual "overnights" appeared in Branch 66.

I had to leave the Hogan hearing to draw the window washer homosexual lover of an important Chicago politician. The window washer was scheduled to plead guilty to tax fraud. I hated missing the last bits of Hogan's testimony because his story, like Tom Maloney's, was so much a story of the courts. Hogan had been a hero, then a victim, a prosecutor, then a sort of defendant, and now a plaintiff. Now that he was appealing his firing, there was hope that he would regain his earlier triumphs for convicting the Mob-connected judge and the El Rukn murderers.

It was cold and dark when I left the courthouse late Friday afternoon to return to the Kluczynski Building. Snow dusted the people rushing past the brightly lit windows of the Monadnock and Marquette buildings' shops on their ways to trains, buses, and parking lots.

I crossed back over Dearborn Street and took my seat again in the little courtroom on the 39th floor. Hogan's trial was coming to a close. Except for Bob the Carpenter, two women, and me, the pews were empty.

After the last bit of testimony, Shelly Kulwin said, "Judge, I have a motion to look for the Rosenthal memo at the MCC."

Judge Ansorge: "I'm going to deny that."

They recessed.

Everything was finished except for the final arguments. That day I was

again assigned elsewhere.

Matt O'Connor wrote in the *Chicago Tribune* on July 25, 1998, under the headline EL RUKN PROSECUTOR'S FIRING OVERTURNED:

> William Hogan, Jr., a rising star in the Justice Department before he was fired amid allegations of wrongdoing in his stewardship of the prosecution of El Rukn street gang members, was ordered reinstated Friday to his $98,000-a-year job as a federal prosecutor in Chicago.
>
> In a voluminous written decision, an administrative judge ruled that the Justice Department did not prove its case against Hogan by a preponderance of the evidence.
>
> The long awaited ruling by Howard Ansorge of the U.S. Merit Systems Protection Board flies in the face of findings by three federal judges in 1993 that Hogan concealed drug use in jail by two of his star witnesses. After a subsequent FBI probe of the case, the Justice Department fired Hogan in 1996.
>
> But Ansorge, who presided over Hogan's appeal of the dismissal last fall, had a more complete record in front of him than was available before, said Hogan's lawyers.
>
> The local U.S. attorney's office had no comment on the ruling and a spokesman for the Justice Department said it had not determined if the decision will be appealed to the full merit board.

For years Bill Hogan had been spending much of his time sailing. Like a restless character in a Conrad novel he sailed the Atlantic, the Carribean, the Mediterranean, and off the coasts of England and Holland. But even on the high seas the El Rukns were with him and he could never completely relax. The summer after the Merit Board hearing he crossed the ocean in a 42-foot sloop to Majorca and then sailed on to Spain. Every Friday he called Shelly Kulwin to learn if there had been a decision on his

case. When Kulwin finally gave him the good news, Hogan was on a pay phone in Granada. As they spoke, Hogan looked up the hill at the real Alhambra, prototype of Toomba's "Alla Hambra," the El Rukns' infamous building.

The government did not appeal Judge Howard Ansorge's decision, and Bill Hogan went back to his old job as an assistant U.S. attorney in Chicago. In the winter of 2005 he left for Kabul to organize the new Afghan government's justice department. There he wrote drug laws, and set up a multinational task force and an elite court to enforce them. In late 2006 he returned to Chicago.

He told me he'd felt "very much at home in Afghanistan," that it was "just a bigger and more corrupt Chicago." He said he hoped to go back there someday. In the meantime he was thinking about taking another overseas assignment. He added that he felt strongly about our participation in Iraq. "If we don't get that right, nothing else matters."

Hogan may not be in the country when his nemesis Tom Maloney is released from prison in 2008. Because Maloney was found to have taken many bribes, many of his decisions as a judge were reversed, and some of these cases have still not been resolved. The Fuddy Smith and Talman Hickman murder on which Maloney almost took a bribe has yet to be retried more than 20 years later. Earl Hawkins is expected to get himself a deal by testifying against his co-defendant Nathson Fields.

While the worst of the El Rukns still serve their time, Toomba is a free man. He may or may not be in the witness protection program. Those who administer it questioned whether he would be capable of maintaining a low profile and refrain from sending book manuscripts to publishers.

Sons and grandsons of the men Hogan and Poulos prosecuted have inherited the El Rukn gang. The call themselves the Black P. Stones again but they operate with less efficiency and virulence than their sires. According to the Chicago Crime Commission, where I now live is still their territory.

As for some of the others, Harry Aleman continues to serve his life

Court buffs.

sentence; Rocco Infelise died in prison; and Solly DeLaurentis has served his time.

Bob Cooley is still in witness protection and so bored that he spent several minutes on the phone the other day with someone he doesn't know, but who knows him. He told me he isn't through yet—that he has plans to bring down two of the city's best-connected people. It will be his last gift to the people of Chicago he said.

John D'Arco was resentenced after pleading *nolo contendere* to another indictment, served his time, and now lives in Florida.

John Wayne Gacy was executed in May 1994. The defense's psychiatrist, who attended our post-trial party, managed to get ahold of his excised brain and keeps it in a jar in her basement.

William Kampiles was released in December 1996 after spending 18 years in federal custody.

Tom Hayden has had a career in California politics, Bobby Seale has published books about the Black Panthers as well as a cookbook called

Former governor George Ryan, co-defendant Larry Warner (left), Judge Rebecca Pallmeyer, and Prosecutor Zach Farden at the George Ryan trial.

Barbeque'n with Bobby, and Rennie Davis became a follower of the Guru Maharaj Ji. David Dellinger continued to protest war until he died. Abbie Hoffman, Jerry Rubin, Bill Kunstler, and Judge Julius Hoffman are also dead.

Jim Gibbons, like John, is dead. Occasionally, a court buff will say, "Remember that big fella you used to work with—what was his name? He was the best."

The court buffs are almost all gone. For a newer generation of retirees, television "reality" must have supplanted the entertainment of trials. In 2003 the last few declined Judge Ilana Rovner's offer to continue their traditional Christmas party.

The few remaining buffs have plenty to watch in the federal building these days. The current Northern Illinois U.S. Attorney, Patrick Fitzgerald, has indicted hundreds of people, many of whom have Arabic names. Several "terrorist" trials have taken place or are ongoing. Fitzgerald indicted ex-

Abdelhaleem Ashqar and Muhammad Salah.

governor George Ryan, making him, after Otto Kerner and Dan Walker, the third Illinois governor I have drawn as a convicted felon. Fitzgerald's prosecutors have convicted people close to the current Mayor Daley. He has also charged a collection of mobsters, including Joey the Clown, with 18 murders, most of them years old. Motions at a recent pretrial hearing concerned false teeth, hearing aids, and an MRI scan. Tom Breen suggested the trial should be held in a hospital so the defendants could remain hooked up to their IVs.

In spring 2007 Fitzgerald's office began to prosecute Canadian press baron Conrad Black and several of his colleagues. The indictment alleged that Black *et al.* had defrauded Hollinger International's stockholders by pocketing millions of dollars from phony non-compete agreements when newspaper properties were sold. Former governor Jim Thompson, as the

Muhammad Salah and prosecution.

chairman of Hollinger's audit committee, came to testify for the prosecution, for the U.S. Attorney's Office that he himself had once led. He admitted that he had only "skimmed" documents that might have alerted him to the possible fraud, had he read them carefully. His testimony made it clear that he had shirked his fiduciary duty and even on direct examination, the former federal prosecutor seemed as though he himself were a defendant. His squirming posture on the witness stand betrayed his discomfort. "I have long legs," he explained to Judge Amy St. Eve when she asked him to move closer to the microphone. Occasionally she glanced down to make sure his chair was not about to tumble off the edge of the platform.

Not far away Anton Cermak Kerner, who as a young man had seen U.S. Attorney Thompson destroy his beloved father, watched from the audience. And behind Kerner, in the very last row, sat Bill Hogan, still waiting to learn what would be the next chapter in his own saga.

As for myself, I still sketch, eavesdrop, and learn.

Perhaps I should credit Toomba with having helped me find a new husband. In December 1992, when Toomba was lying about lying in the El Rukn post-trial hearings, some reporters and I were at a Christmas party. I wanted to explain to them the Liar's Paradox because it seemed so apt. A philosopher whom I'd met recently, but hadn't liked much, was also there. When I asked him to describe the "'All Cretans are liars,' said the Cretan" problem, he did so with such clarity and elegance that I changed my mind about him. The spring after the Maloney trial we were married, and as of this writing we have lived "happily ever after."

The Criminal Courts Building at 26th and California is seedy still, though efforts are made to touch up the paint, shine the brass, and polish the floors. Increased security is the big difference in both courthouses. In the great granite lobby of the Dirksen Federal Building, glass walls block many passages, and metal detectors are permanent furniture. Concrete barriers appeared on the sidewalks after September 11, 2001; as the Iraqi war approached, they were replaced with granite slabs.

The stairwells have been painted like kindergartens—the pipes a cheerful red, the railings and risers two yellows: cadmium and lemon.

There have been other changes since that fateful September. Occasionally courtrooms have been closed to the press and public. Recently when I was assigned to cover an immigration hearing, a deputy turned me away. When I demanded to know why, he answered "nine eleven," as if that explained everything.

In the winter of 2006 those of us who work in the 21st-floor pressroom were asked to move our dusty junk out of the way so the windows could be "blast proofed." The world viewed from these windows now looks a little bit darker.

Across the street, Calder's giant red "Flamingo" still arches high against the black glass buildings, then bends back into the pavement as though digging for some precious substance. Nearby a new generation of protesters beats drums, carries signs, and yells into megaphones, for and against new wars.

Attorney Sam Adam (standing) and mobsters.

GLOSSARY

A Layperson's Understanding of Legal Terms

302s: Reports of their interviews written by government agents.

3500 material: Discovery material that the prosecution is required to provide to the defense: documents, 302s, depositions, grand jury testimony, and so forth.

acquittal: A verdict or judgment of *not guilty*.

agents: Federal Government Agents from many different agencies work on federal prosecutions, often together with local police departments. At a trial there will usually be one or two case agents seated at the assistant U.S. attorneys' counsel table. They could be from the FBI, IRS, Post Office, or other agencies.

aggravation: An attempt to make a person or an act seem worse. At sentencing, prosecutors often offer evidence *in aggravation,* evidence that was not allowed at trial: "And, he also beat his mother…" This is an attempt to get a harsher punishment for the defendant, though it is less permissible than it was before the *Booker Decision (see below).*

allege: A legal synonym for "accuse," the usage carries with it the idea that the accusation may not be true. As such, it is a favorite word of defense lawyers, but not of the media or the police. It should be used when describing any illegal activity or its possible perpetrator until guilt is proven. John Gacy, therefore, no matter how strong the evidence—even if he had confessed—was an *alleged* murderer until the verdict was reached.

Allen Opinion: The short-lived 1969 opinion stating that a defendant must be kept in the courtroom during his trial no matter how badly he behaves. Thus it allowed, according to Judge Julius Hoffman, his binding and gagging of Bobby Seale. The Allen Opinion was overturned by the U.S. Supreme Court in 1970, as was Seale's *contempt.*

allocution: The making of a speech. A defendant's *right of allocution* is his right to speak on his own behalf just before sentencing, his last chance to persuade the judge to be merciful. The strongest of men are often reduced to tears at this time.

appeal: Unless appeal rights have been waived, almost any judge's decision, or jury's verdict, can be appealed to a higher court. The government may not appeal an acquittal however. The United States Seventh Circuit Court of Appeals in Chicago is the highest federal court in Illinois and only the U.S. Supreme Court

can overrule it.

argument: A lawyer's speech in which she tries to convince a judge or a jury of something. During a trial, lawyers are not allowed to argue about guilt until all the evidence is in. Hence, there is no such thing as an *opening argument,* and editors show their ignorance when they allow the phrase. Lawyers can argue to the judge any time the judge allows it, but to the jury only at the end of the trial.

arraignment: When an *indictment* has been handed down, or *probable cause* found by a judge, the defendant is presented with a copy of the charges against him and pleads *not guilty* at an *arraignment* before a judge. He never pleads *innocent* (*see* innocence *below*). Of all court proceedings, arraignments take the least time, sometimes less than a minute; they are therefore the most difficult to draw.

bagman: Someone who passes bribe money between a briber and the person bribed.

bench trial: A trial in which the *finder of fact* is the judge and not a jury. Sometimes when complicated law is the defendant's best hope, or when the crime is so heinous that a jury may be prejudiced from the outset, a defendant will choose a bench trial over a jury trial.

Booker Decision: This 2005 decision and the 2004 Blakely Decision which it incorporates, put an end to the federal "sentencing guidelines." They say that aggravating evidence cannot be brought up at sentencing unless a jury hears it. Judges no longer need to follow the long recipes for adding and subtracting *aggravation* and *mitigation* points as they had been accustomed to doing. The guidelines are now advisory. (Though judges complained about the sentencing guidelines, now that they are advisory, judges often seem to display nostalgia for them.)

Brady Material: (From the decision in *Brady v. Maryland.*) Evidence that might be favorable to the defendant. It must be disclosed by the prosecution in its discovery materials.

building press: The print media reporters who work in a court building and have desks there—not to be confused with official *court reporters* who take down the exact words spoken in court for the official transcript. Traditionally the City News Bureau, the *Daily Law Bulletin*, and at least two newspapers had desks in the federal building pressroom. In the spring of 2007, the room was as full as it's ever been, with regular reporters for the Associated Press, *Daily Law Bulletin*, *Chicago Sun-Times*, *National Law Review*, Bloomberg News Service, and two for the *Chicago Tribune*. WBBM Radio also maintains a desk there, though most of the electronic

media stay in the lobby. Recently they have been confined to a pen, so can no longer chase people with microphones and cameras.

burden of proof: The standard that must be met for a prosecutor or a plaintiff to succeed. In a criminal case it is the obligation of the government to overcome with evidence *beyond a reasonable doubt* a defendant's innocence. In a criminal case the government always has a heavy burden of proof. That is why they are allowed the first opening statement and the last rebuttal argument. The theory is that they have a more difficult job than the defense.

case in chief: The part of a trial that happens after *opening statements* and before *rebuttal*. In other words, the government's first offering of evidence followed by the defense's attempt to counter (if they want to) this evidence. After each side has put on its case in chief, each is allowed to rebut points brought up by the other.

character witness: An upstanding sort of person, often a nun, rabbi, priest, celebrity, or do-gooder, whom the defense calls to attest to the defendant's good reputation in the community. The questions the defense attorney may ask are limited. The prosecutor often demolishes the character witness's value by asking something like, "If you knew she murdered ten people, would your answer be the same?" Only the defense can put on character witnesses; the prosecution is not allowed to offer testimony as to bad character.

closing argument: The argument presented to the judge or jury at the end of a trial. Now, finally, the lawyers may try to convince the *finder of fact* that the evidence either has or has not proved the defendant guilty.

consensual monitoring: When a person allows a government agent to place hidden recording equipment on his person. Where it is hidden usually remains a secret, even in court afterwards.

contempt: A person can be cited by the judge for *contempt of court* when she refuses to obey a court's order. This usually occurs when she refuses to testify, even when granted immunity, or when she behaves badly in the courtroom. Lawyers as well as defendants can be held in contempt of court.

continuance: A postponement of a trial or hearing. Lawyers can ask for them, but only judges can grant them.

cooperating witness: A person, usually a co-defendant, who agrees to help the government convict someone (and expects leniency for doing so), usually after pleading guilty to his own role in the crime. He helps by telling what he knows about the alleged crime, and also sometimes by *wearing a wire*. Also called a *flipper*,

a *snitch,* or by the El Rukns, a *doorknob.* He *rolls over, rats on, squeals.*

coroner's jury: Until the late 1970s in Cook County, a coroner and his jury of citizens inquired into the cause of any violent death. Dr. Robert Stein was the first Cook County medical examiner.

court reporter: A stenographer hired by the court to take down every word *on the record* that is spoken in open court. This becomes the *official transcript.*

cross-examination: What the opposing lawyer does to impeach or discredit the other side's witness through asking questions that he hopes will show inconsistencies, lapses, reasons to lie, and other deficiencies in the testimony. The *hearsay* rules are more relaxed in cross-examination and *leading* is allowed. These more relaxed rules also govern when a lawyer calls someone as a *hostile* or *adverse witness.* The *crossing* lawyer, however, is limited to subjects brought up during the *direct examination.* He can't bring up new subjects; his questions will not be allowed because they are *beyond the scope* (of direct testimony).

direct examination: The questioning of a witness by a lawyer who hopes that witness will help his client. Direct is followed by *cross-examination,* then by *re-direct,* then *re-cross,* then *re-re-direct,* and so on, until the lawyers stop or the judge puts an end to it.

discovery: Anything that may be used in evidence by one side; it must be shared with the other side prior to trial. (*See* 3500 Material)

double jeopardy: *See* Fifth Amendment.

entrapment: If the government traps the defendant into doing a criminal act that he would not otherwise have done, such as in a sting, an *entrapment* defense may be used. If the government counters the entrapment argument by claiming disposition, however, the defense would have to show that the defendant would never have even thought of doing such a thing on his own, or that the defendant tried to refuse to do it.

evidence, rules of: There are many rules of evidence, such as the necessity to *lay a foundation* for a question or document, the *hearsay rule,* and using the *best evidence,* among many others. These intertwining rules attempt to keep testimony as narrow as possible and free of innuendo, gossip, falsity, and other impurities.

exclusion of witnesses: Lawyers almost always move to *exclude witnesses* so that no witness will be able to hear what others have said in the courtroom. Witnesses wait, sometimes for days, in a *witness room* waiting to be called. The exception might be an *agent* or an investigator.

Muslim women listening to testimony of Israeli secret agent at Salah Ashar trial.

expert witness: Each side in a criminal or a civil case may call *expert witnesses* whom they pay to testify on issues pertinent to their specialties. Examples are psychiatrists, evidence technicians, economists (as in a personal injury case), and so forth. However, the witness must be *qualified as an expert*, and both sides may ask questions without the jury present to determine whether he knows enough to testify.

federal investigations: In the last few decades, the United States Attorney for the Northern District of Illinois has embarked on extensive investigations to root out the political corruption for which this city is famous. These have included *Greylord, Silver Shovel,* and *Gambat.*

felony review: A branch of a county state's attorney's office where a lawyer is always on duty to approve (or disapprove) the detention of crime suspects for questioning and court appearances.

fence: To sell stolen property. (Or, a person who buys and sells stolen property.)

Fifth Amendment: "No person shall be held to answer for a capital, or otherwise infamous crime, unless on a presentment of indictment of a Grand Jury, except

in....time of War or public danger; nor shall any person be subject for the same offense to be twice put in jeopardy of life or limb; nor shall be compelled in any criminal case to be a witness against himself, nor be deprived of life, liberty, or property, without due process of law, nor shall private property be taken for public use, without just compensation." The *Fifth Amendment right* typically refers to the right against self-incrimination and is invoked when someone refuses to testify about something that may get him into trouble. "On advice of counsel I refuse to testify on the grounds that it may incriminate me"—or some version of this—is what such witnesses recite. A *grant of immunity* removes the possibility of self-incrimination.

first appearance: The first time a defendant comes before a judge, which must be within a certain time limit after his arrest. The judge at a first appearance finds out if the defendant understands the charge, inquires whether or not he has a lawyer (if not, one is appointed), and counsels him that he need not talk to anyone about his case. Bail (bond) is discussed at this time, and a date is set for the next appearance. An *arraignment and plea* usually comes later in front of the judge who has been assigned to the case. (*See also* Sixth Amendment)

foundation, lay a foundation: Part of the *rules of evidence*: The *when, where*, and *who was there* that must precede the offering of a narrative or a document or other evidence. Laying a foundation helps establish whether this particular witness has enough knowledge to testify about a particular incident.

Giglio: The decision in *Giglio v. United States*, which ruled that prosecutors must disclose any information that might discredit their witnesses.

hearsay: Part of the *rules of evidence*: This refers to statements someone heard someone else say, and they are not admissable in court. An exception is when the statement quoted is "not offered for the truth" but to show how it led to what happened next. An interesting exception is a *death bed statement,* which is often allowed on the theory that people about to die always tell the truth.

hostile *or* adverse witness: The rules of *cross-examination* apply when a lawyer for one side calls as a witness someone who is clearly from the other side. Lawyers are assumed to vouch for the credibility of their own witnesses, but the opposite is true when they call a hostile witness. *Leading*, for instance, is allowed.

immunity, grant of: The government grants *immunity* when it promises not to prosecute a person if he testifies about someone else and in doing so implicates himself in a crime. If granted immunity, he must waive his *Fifth Amendment right* not to testify. If he still refuses to testify (as many Mob people do), he can be jailed for *contempt of court.* (*See also* Fifth Amendment)

in camera: Literally *in chamber,* it means things that happen in secret with the judge alone, and not in open court.

indictment: The charging document that a *grand jury* crafts with the help of prosecutors to set a prosecution in motion. It alleges various *counts* charging various crimes. *RICO* indictments are complicated because they charge *overt acts* within the RICO charge.

innocence: There is no such thing as *pleading innocent*! One of the most treasured foundations of our system is that an accused person continues to be innocent until *found guilty.* His innocence is assumed until proven otherwise, or until he pleads *guilty* himself in a *change of plea*, almost always at a later date. (The news media use the phrase *pleaded innocent* for fear of losing the "not" in the "not guilty" through typographical error or misspeaking.)

insanity defense: If a lawyer can convince the finder of fact that his client could not "conform his actions to the requirements of law," and other specific criteria are true, he may be able to win a *not guilty by reason of insanity*. The defendant can still be incarcerated in certain cases, but in a hospital rather than in a penitentiary. There is also a finding called *guilty but insane*.

interstate commerce: This is the concept that allows *federal jurisdiction*. If the federal government wants to prosecute a certain crime all they have to do is assert that some of the supplies of the perpetrators, be it notebooks or ammunition, were manufactured in other states. If the defendants mailed letters, called long distance, used an FDIC insured bank or the Internet, these involve *interstate commerce* as well.

judgment: A decision or ruling by a judge. A judge cannot give a *verdict*; only a jury can give a verdict.

jury, grand: A *grand* (big) *jury* is a large number of jurors, usually 23, who sit off and on for a long time to hear evidence presented only by the government. Their work is to find *probable cause* that a crime has been committed and that a certain person or persons probably committed it. Grand jurors produce a *true bill* or an *indictment*. The grand jury's work is supposed to be secret. If someone called before a grand jury lies in her testimony, she can be tried for *perjury*. If she refuses to testify before a grand jury she can be jailed for *contempt*.

jury, petit: A *petit* (small) *jury* is the group the jurors (and *alternate jurors* serving as back-up in case someone get sick) who hears evidence and is the *finder of fact* in trials. In criminal cases 12 jurors deliberate at the end of the evidence, though sometimes only eleven remain to do so. In civil cases usually fewer than 12 sit. Jury verdicts must be unanimous. In order to convict in criminal cases, jurors must find

the defendant guilty *beyond a reasonable doubt*. In civil cases, they must find the defendant *liable* by a *preponderance of the evidence*.

jury instructions: When the judge tells the jurors how to think or how not to think about the evidence. For instance, she can tell them to disregard statements that were not allowed into evidence, or to consider evidence as to only one defendant. At the end of the testimony, and usually after the arguments, the lawyers and the judge come up with a set of *jury instructions* to guide the deliberations. (If one enjoys the intricacies of the law, listening to lawyers and judges hammer out jury instructions, particularly in white collar crime cases, can be fascinating.) The reading of these by the judge is usually the penultimate and most boring half hour of a trial. "If you find *x*, and *x* is not *y*, then you must also find *w*. On the other hand, if you find that *p*…" is how they sound. Courtrooms are often locked at this time so as not to disturb jurors' concentration, meaning spectators and reporters grab their stuff and run for the door before the judge starts reading jury instructions.

leading: A question that suggests its answer: "You were at the Libertyville Yacht Club that night, fair statement?"

Miranda Rights: Technically, the right of the accused to be informed of his rights, such as his Sixth Amendment right to a lawyer and his right to remain silent. As police officers are required to read the rights to those they arrest, rookies tend to carry little cards with the *Miranda Warnings* written on them inside their hats— at least until they have it memorized.

mitigation: An attempt to make someone or something sound better, as when a defense attorney says at sentencing: "But, Your Honor, he has spent many hours helping the poor and destitute."

motion, to move: *Making a motion* or *moving* is the formal way a lawyer asks a judge for something, as in, "Your Honor, I *move* for a mistrial!" A motion can be made orally but is more usually in writing, when it is then called *filing a motion*.

nolo contendere: Literally *I don't want to fight or pursue it*. A defendant pleads *nolo contendere* when he doesn't want to admit he's guilty, but neither does he want to fight the charges.

object, make an objection: What a lawyer does when she thinks the opposing lawyer has asked an unfair question or made an unfair comment.

opening statement: The first speech that a lawyer makes to the jury or to the judge at the beginning of the trial. It is supposed to be confined to "what the evidence will show" and though *arguing* at this point is forbidden, it often happens

anyway. (*See also* argument)

opinion: A judge's ruling or decision on a case, which then becomes *case law* or *precedent* until or unless it is overturned on *appeal*.

overrule: What a judge does to a lawyer's *objection* if he disagrees with it. The wording objected to is allowed.

pretrial, post-trial: The parts of a prosecution or a civil action that come before and after a trial. Hearings of this sort can take more time than the trial itself but are necessary to ensure that the trial is fair. Pretrial matters can include *motions to suppress* evidence, for example, if the defendant had been tortured in order to obtain a confession. If the defense wins such a motion, then the evidence is not allowed. Courtroom artists probably spend more time drawing pretrial matters than any other part of a case because the news media prefer cases when they are fresh.

precipitating act: The murder, rape, theft, or other alleged illegal act that causes the prosecution.

preliminary hearing: A bond hearing or a *probable cause*, pretrial hearing.

presumption of innocence: See innocence.

pro se: Literally *on behalf of oneself*, as when a defendant acts as his own lawyer. That's usually not a good idea except in Pro Se Court, where very small sums of money are at stake.

rainmaking: Among civil lawyers, this means bringing new business to a law firm. Among criminal lawyers, it more frequently refers to a *bagman* accepting a bribe for someone and then, instead of delivering it, pocketing it himself.

reasonable doubt: Probably the second most important concept in a criminal trial and one that judges are often loathe to define: A juror or a judge must find that there is *guilt beyond a reasonable doubt* in order to convict. The concept is the darling of defense attorneys, because if they can raise *reasonable* doubt in the mind of just *one* juror, they may get an *acquittal*.

record, *or* **to record:** The words of the court proceeding as taken down by the official court reporter, it becomes the history of the case. The *record* is necessary so that the judge or lawyers can review what's been said in an ongoing case, or— more importantly—so that lawyers can see after the trial if *reversible error* occurred and what grounds for appeal they may have. Also, the higher courts can understand from reviewing the record what occurred, and eventually the record

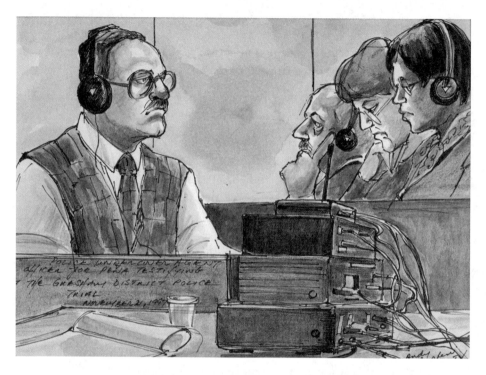

Undercover agent with jurors and tapes.

may become *precedent*, literally part of the law itself. When a judge says, "Let's go off the record," the court reporter stops using his stenographic machine and pauses his tape recorder.

recuse: When a judge has a personal interest in the outcome of a case (let's say her daughter is married to the defendant), she should *recuse* (excuse) herself and let another judge take over. Any official can recuse himself.

reversible error: Mistakes made by a judge that can cause a *judgment* or verdict to be overturned on *appeal*.

RICO: A favorite of federal prosecutors, the *Racketeer Influenced and Corrupt Organizations* provisions of the 1970 Crime Control Act. It was enacted as a weapon against the Mob, a *continuing criminal enterprise,* but is widely used against all sorts of groups including violent anti-abortion proponents, drug dealers, big business, and terrorists. It contains *forfeiture provisions*, meaning that those convicted of RICO can have almost everything they own taken away from them. In a RICO *indictment*, a wide variety of crimes can be charged as *overt acts*, including murder.

This makes RICO indictments enormously complicated and hard to understand.

side bar: When lawyers and judge don't want people to hear what they say, they go to *side bar*, literally the side of the bench. There they whisper while everyone else waits and tries to eavesdrop. Lately some judges use a white noise gadget so no words can escape. The court reporter usually goes with them so that their discussion will be *on the record.*

Silvern Instruction: An instruction read by the judge to a jury that has been deliberating a long time. It basically says, "Keep at it." Reporters like to be present at this time so they can scrutinize the jurors' demeanors and guess what they might be thinking.

Sixth Amendment: "In all criminal prosecutions, the accused shall enjoy the right to a speedy and public trial, by an impartial jury of the state and district where the crime [was committed]…and to be informed of the nature and cause of the accusation; to be confronted with the witnesses against him; to [obtain] witnesses in his favor, and to have the Assistance of Counsel for his defense." This Sixth Amendment right makes it possible for a defendant to claim ineffective assistance of counsel on appeal.

SOJ (Substitution of Judges): When a defendant is allowed to change from the assigned judge to the next one in the rotation with out giving a reason. This is of course a gamble because he might end up with an even harsher judge than the original.

SOL: In state court it stands for *stricken off call with leave to re-instate.* Prosecutors jokingly say it stands for *shit out of luck.*

stipulated evidence: Evidence that both sides agree is true, and therefore the finder of fact must accept.

stricken: When an objection to a question is sustained but the witness answers anyway, if a lawyer changes his mind while asking a question, or if other such verbal mishaps occur, lawyers may ask to have the words *stricken [off the record].* But as Judge Julius Hoffman loved to point out, only a judge can order something stricken.

sustain: What a judge does when she agrees with an *objection.* This means that the wording objected to can not be *allowed in.*

testimony: The answers that a witness gives to questions after being sworn to tell the truth.

Title Three: A statute that gives federal law enforcement permission to make undercover recordings by tapping a telephone.

tong: Originally the word for a Chinese-American benevolent or protective society, it has come to be associated with criminal activity. As such the word's history is like that of *syndicate*. It is also reminiscent of the origins of *mafia*, which back in the depths of Sicilian history was used for secret societies formed to oppose cruel absentee landowners.

transcript: The written record of what is said in open court, in a grand jury, at a deposition, during an interrogation, in an undercover recording, or any other transcribed words pertinent to the proceeding. Anyone may order a transcript of a trial from the court reporter, but it's expensive, and takes time, so news reporters usually make do with their own notes and with checking with their colleagues. Often after something extraordinary is said in court, the pressroom echoes with many slightly different versions of the quote. (*See also* record)

true bill: A document produced by a *grand jury* charging a defendant with a crime, more or less synonymous with *indictment*.

verdict: A decision as to *guilt* or *not* by a jury. A judge cannot give a *verdict*. A judge pronounces a *decision*, makes a *judgment* or a *ruling*, or *mandates* (orders) something, but does not give a verdict. A *directed verdict* or *judgment of acquittal* is argued for at the end of the government's case, when the defense moves that "even if taken in a light most favorable to the state," the government's case is not strong enough to have the jury continue to hear evidence.

voir dire: Literally *to say the truth*. Picking a jury involves *voir dire* as the lawyers and judge see and hear how each juror responds to the questions asked to determine their suitability. Lately prospective jurors have been required to fill out lengthy question-naires with questions such as "Have you ever been convicted of a crime?" or "What is your favorite TV program?" Some feel that this makes it easier for jurors to lie, as some did in the ex-governor George Ryan case, because you can't see their faces. And though questionnaires are efficient in some ways, they deny those of us cover-ing a jury trial insight into what is perhaps the most important element in a trial. Open court jury selection presents a fascinating cross-section of contemporary life.

Witness Protection Program, WITSEC: A program in which the government re-locates a *co-operating witness* so that his former pals whom he testified against can't find him and kill him. If not in custody he must change his name, quit his job, move far away from his home, say goodbye to most of his friends, and lead a totally new life.

Concert.

BIBLIOGRAPHY

Arlen, Michael. *An American Verdict*. New York: Doubleday & Co., 1973.

Barnhart, Bill and Gene Schlickman. *Kerner: The Conflict of Intangible Rights*. Champaign: University of Illinois Press, 1999.

Cahill, Tim. *Buried Dreams*. New York: Bantam Books, 1983.

Kerner, Anton Cermak. "Kerner on Kerner, Otto Kerner's Son Defends His Father's Reputation." *Chicago Tribune*. 19 March 2000, Perspective.

Lemann, Nicholas. *The Promised Land*. New York: Alfred A. Knopf, 1991.

Linedecker, Clifford L. *The Man Who Killed Boys*. New York: St. Martin's Press, 1980.

Lukas, J. Anthony. *The Barnyard Epithet and Other Obscenities*. New York: Harper & Row, 1970.

Mailer, Norman. *Miami and the Siege of Chicago*. New York: Signet Books, 1968.

Possley, Maurice and Rick Kogan. *Everybody Pays: Two Men, One Murder and the Price of Truth*. New York: Putnam, 2001.

Schultz, John. *Motion will be Denied*. New York: William Morrow & Company, 1972.

Sullivan, Terry. *Killer Clown*. New York: Grosset & Dunlap, 1983.

Barry Elden at El Rukn post-trial hearing.

INDEX

Page numbers in italics refer to illustrations and photographs.

ACKNOWLEDGMENTS

This book would never have seen the light of day but for Jane Brouder Stephens, my good friend, colleague, and former assignment editor at Channel Seven (WLS-TV News). After years of procrastinating I had learned to live with the idea that the manuscript was like a monster college term paper that would never be handed in. Jane, an excellent journalist and a decisive, energetic person, took the manuscript to Sharon Woodhouse at Lake Claremont Press, rightly guessing Sharon would be the perfect publisher.

Jane not only got the book to Lake Claremont, but she stayed with it, checking all its facts, delving deeply into legal lore and Chicago history. I will never be able to thank her enough.

I thank Sharon Woodhouse for everything that has happened since. Sharon has been in every way a pleasure to work with, cheerful, helpful, and understanding. The people Sharon brought to the book have been wonderful too. I love the cover Tim Kocher designed and how Mike Wykowski designed the inside of the book. I thank Laura Gabler for a careful job of editing and Elizabeth Sattelberger for the many ways she helped. It's been not only fun to work with lisa scacco but her efficiency has given me confidence that all will be well. I couldn't imagine a better publisher than Lake Claremont; I love being a part of its effort to celebrate Chicago.

Jane is not the only one at Channel Seven to whom I owe a lot. If I listed all of them the list would be longer than this book. From the very beginning of my career, people at WLS-TV and ABC-TV have been wonderful. At the start they let me learn on the job, and they have continued to be supportive and generous for 38 years!

Specifically I need to thank Hugh Hill who "discovered" me and taught me, and Richard Rosenbaum, the bureau chief who hired me and kept me on in spite of my inexperience. I would also like to single out managing editor Andy Porte who, besides teaching me how one should talk on the phone (briefly and to the point), took me seriously as a newsperson years ago when I needed it the most.

Channel Seven deserves to be the number one TV news station in Chicago. Its people have always made it a great place to work. When I tell other stations' reporters that I'm sorry, they can't use my sketches because "I'm exclusive to seven," I feel proud.

This book has been with me for 20 years. I despair of recalling all the ways

people have helped—all the acts of kindness, the questions answered, the transcripts and other printed matter produced. I apologize to all whom I've forgotten to mention. I have not forgotten, however, that the following people read parts of the manuscript, made good suggestions, and encouraged me: David Burnham, Barbara Trentham Covington, Erin de Witt, Paula Duffy, the late Lawrence Freedman, Rupert Getzen, David Halfen, Morris Philipson and his late wife Susie, and my "oldest friend" Patrick Shaw.

Many people helped with fact checking, among them Judith Dobkin, Terry Gillespie, Bill Hogan, Anton Cermak Kerner, Richard Kling, Marc Martin, Michael Monico, Ted Poulos, Devorah Shubowitz, Pat Tuite, and Donald Young. Terry Sullivan's book on John Wayne Gacy, *Killer Clown* was immensely helpful. Former Judge Louis Garippo explained to me aspects of that trial that I hadn't understood at the time.

Judge John Grady, when he was chief judge of the Federal District Court, allowed me access to the Gacy trial transcript. Judge Jeffrey Cole, when he was still in private practice, let me come to his office and work from the Thomas Maloney trial transcript. Judge Michael Toomin with his amazing memory helped with the Harry Aleman chapter.

I would like to thank two old friends who helped save my career when they argued brilliantly against cameras in courts: George Cotsirilos and Edward Genson. They listened to my ideas and let me feel that I was a part of their efforts.

To all the judges and lawyers who appear in the book, I'd like to say that I have worked hard to record scrupulously their (and others') words, relying either on transcripts or on my own carefully and simultaneously taken notes. I realize, however, that in some cases it may seem that I have fictionalized real people. I apologize to any who feel that I have "gotten them wrong." Real life has a way of rearranging itself when it becomes narrative, and people may come across distorted when only parts of their lives are observed. All I can say is that, if I did distort, I never meant to. I changed the names of only two people in the book; neither are public figures, nor do they live in Chicago. Their stories took place years ago, and I felt no need to give them further discomfort.

I would like to thank those who helped my sketches become book illustrations. I am not technologically inclined and it must have challenged these people's good humor and good manners. Joel Snyder and Howard Timms taught me how to wrestle the drawings into TIFF files. My cousin Phoebe McMillan with patience, humor, and homemade carrot soup, spent hours showing me the secrets of computer designing and related mysteries.

I thank Tommy Larson who rescued the whole project when my computer swallowed everything in one manic gulp days before a deadline.

I'd like to thank all the inhabitants of the pressrooms where I've exercised my squatters' rights over the years. These print reporters have been a pleasure to know and eavesdrop on. Matt O'Connor of the *Chicago Tribune*, Andy Stern of Reuters, Mary Wisniewski of the *Chicago Sun-Times,* and Mike Robinson of the Associated Press all contributed to this book in different ways, as did Camille Bennett, Pat Manson, Bill Crawford, and Maurey Possley.

I thank Jack Cella of the Seminary Co-op Bookstore and Lucy Hahn of the J. Paul Getty Museum for helping me track down some of the epigraph quotations that feel like the written equivalent of lucky charms.

I need to acknowledge people who make my life easier in practical ways, and put up cheerfully with my sometimes impatient demands: Brian Flax and Dana Fisher of Flax Art and Frame and Bill Anderson and Eric Hedgepath at Viking Printing.

I could never have produced the glossary without the help of my defense attorney stepson, Amos Cohen. He explained legal concepts and offered cogent definitions; he also saved me from embarrassing mistakes. Any mistakes that remain are mine alone.

I thank my talented daughter, Sasha Austin Schmidt, a classics scholar and teacher, not only for her touching translation of the Ovid epigraph for Chapter Three, but for her excellent note-taking at the El Rukn trials (it was like being in two places at once). Her good-humored encouragement of my various projects over the years has always delighted me.

Alane Rollins is in a category by herself when it comes to my gratitude. She took the manuscript when it was much too much in every way; and sentence by sentence, page by page, day by day, week by week, with her poet's chisel, she sculpted the book that was hidden inside. Alane has helped me many times in my life, and I thank her for all of them.

Finally there is Ted Cohen, my funny, brilliant, and irreverent husband. He came into my life when I thought it might be winding down, and as though it were one of those old fashioned tin toys he likes so much, he wound it up again and sent it spinning. When I caught my breath I found that, not only was I living in a wonderful new world, but I was full of the confidence and the optimism that comes from happiness. Because of Ted, everything became possible after all, including finishing this book.

Andy Austin, 2007. (Courtesy of Constance Gibbons.)

Andy Austin, 1970s. (Courtesy of WLS-TV Chicago.)

ABOUT THE AUTHOR

Artist **Andy Austin** has been present at many of the most exciting and important trials in Chicago courtrooms over the last 40 years, drawing for the public the historic scenes that Rule 53 prevents cameras from documenting. She has honed the keen observational skills and humanistic eye that enliven her penetrating sketches over a lifetime of arts, adventure, travel, and extensive reading. Though long admired for her talent of capturing the world of the courtroom in images, it is now clear that her gift extends to the written word as well.

Andy Austin was born in Boston to an artistic father bred of puritans and sea captains and a mother from Chicago who attempted to be a proper hostess, including the night Salvador Dali showed up for dinner with a dead bird on his head. When she was thirteen, her family moved to Florida so her father could photograph polo ponies and society women. Having previously attended only private, all-girls schools, Andy found her two years at a large, co-ed public high school in Florida made a deep impression on her. After graduating from Shipley, a boarding school in Pennsylvania, Andy went on to Vassar College, where she majored in English and minored in philosophy (she took no art classes). She was accepted into Berkeley where she intended to do graduate work in Latin American studies, but after wandering around Europe for a summer, she was inspired to stay in Italy and studied (though she says that's too strong a word) art in Florence at the Accademia di Belle Arti. She enrolled in the School of the Boston Museum of Fine Arts when she returned to the United States.

That autumn she met her first husband, a Harvard Law School student. She gave birth to their son at the end of her second year in art school. They moved after that to Washington, DC, where her husband worked in the Justice Department while Andy stayed home and tried to paint. When the Berlin Wall was built, her husband's reserve unit was called up and suddenly their family was moved to Oklahoma for a year at Fort Sill. When he was discharged, they moved to Vienna, where he wrote music and studied conducting and she was a *hausfrau*. When they moved back to Chicago, her husband was hired as a music teacher at the Latin School just before Andy gave birth to their daughter. In 1969, when their son was nine and their daughter five, Andy was hired by ABC News to cover the Chicago Conspiracy Trial and has worked for the local television station ever since, her prolific career the subject of this book.

In 1994 Andy married Ted Cohen, a philosopher at the University of Chicago. They have traveled all over the world (Australia, New Zealand, Denmark, Poland, England, Scotland, France, Spain, Canada, Italy, Turkey, Germany, and Israel), often for philosophy conferences. She always draws at the lectures and, as she does, finds herself blissfully happy because she's provided what she loves most— new faces to explore accompanied by an interesting soundtrack.

LAKE CLAREMONT PRESS

Founded in 1994, Lake Claremont Press specializes in books on the Chicago area and its history, focusing on preserving the city's past, exploring its present environment, and cultivating a strong sense of place for the future. Visit us on the Web at www.lakeclaremont.com.

SELECTED BOOKLIST

The Chicago River: A Natural and Unnatural History

The Politics of Place: A History of Zoning in Chicago

Near West Side Stories: Struggles for Community in Chicago's Maxwell Street Neighborhood

For Members Only: A History and Guide to Chicago's Oldest Private Clubs

I Am a Teamster: A Short, Fiery Story of Regina V. Polk, Her Hats, Her Pets, Sweet Love, and the Modern-Day Labor Movement

From Lumber Hookers to the Hooligan Fleet: A Treasury of Chicago Maritime History

Wrigley Field's Last World Series: The Wartime Chicago Cubs and the Pennant of 1945

On the Job: Behind the Stars of the Chicago Police Department

Great Chicago Fires: Historic Blazes That Shaped a City

Chicago TV Horror Movie Shows: From Shock Theatre to Svengoolie

The Golden Age of Chicago Children's Television

A Chicago Tavern: A Goat, a Curse, and the American Dream

Today's Chicago Blues

Graveyards of Chicago: The People, History, Art, and Lore of Cook County Cemeteries